THE NATIVE
MEXICAN
KITCHEN

A JOURNEY INTO CUISINE, CULTURE, AND MEZCAL

BY RACHEL GLUECK

Recipes by
NOEL MORALES

Photos by
**MEG PATTERSON &
RACHEL GLUECK**

Skyhorse Publishing

Skyhorse Publishing books may be purchased in bulk at special discounts for sales promotion, corporate gifts, fund-raising, or educational purposes. Special editions can also be created to specifications. For details, contact the Special Sales Department, Skyhorse Publishing, 307 West 36th Street, 11th Floor, New York, NY 10018 or info@skyhorsepublishing.com.

Skyhorse® and Skyhorse Publishing® are registered trademarks of Skyhorse Publishing, Inc.®, a Delaware corporation.

Visit our website at www.skyhorsepublishing.com.

10 9 8 7 6 5 4 3 2 1

Library of Congress Cataloging-in-Publication Data is available on file.

Cover design by Daniel Brount and Erin Seaward-Hiatt
Cover photo credit by Meg Patterson

Interior photos by Meg Patterson, unless otherwise specified

Photos by Rachel Glueck are on pages iv, viii, xii, 11, 38 (top left), 40 (bottom right), 42, 50, 65, 67, 105, 107, 108, 109, 110, 128, 133, 134, 136, 137, 146, 148, 149, 173, 174, 176, 177, 179, 206, 208, 210, 213, 214, 231, 233, 234, 235, 236, 237, 244, 254, 264, 265, 270, 271, and 273.

Print ISBN: 978-1-5107-4524-7
Ebook ISBN: 978-1-5107-4525-4

Printed in China

This book is dedicated to the indigenous peoples of Mexico.
May the next five hundred years be a vast improvement over the last five hundred.

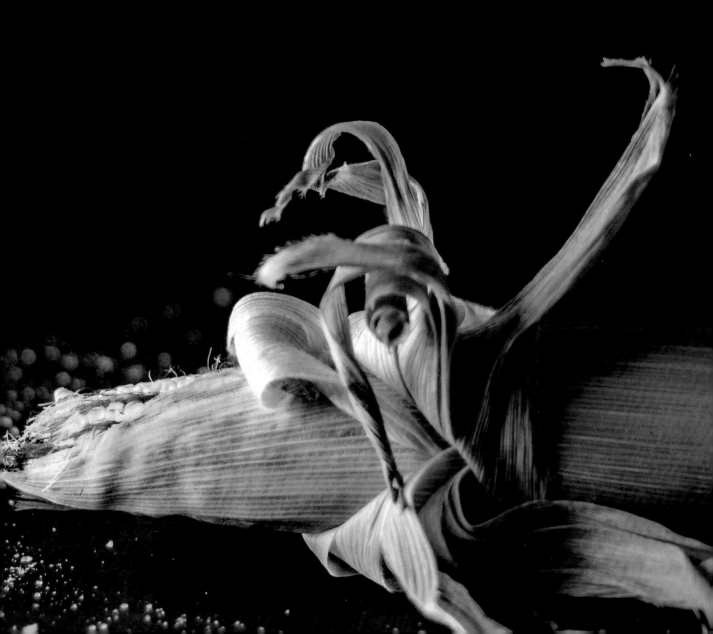

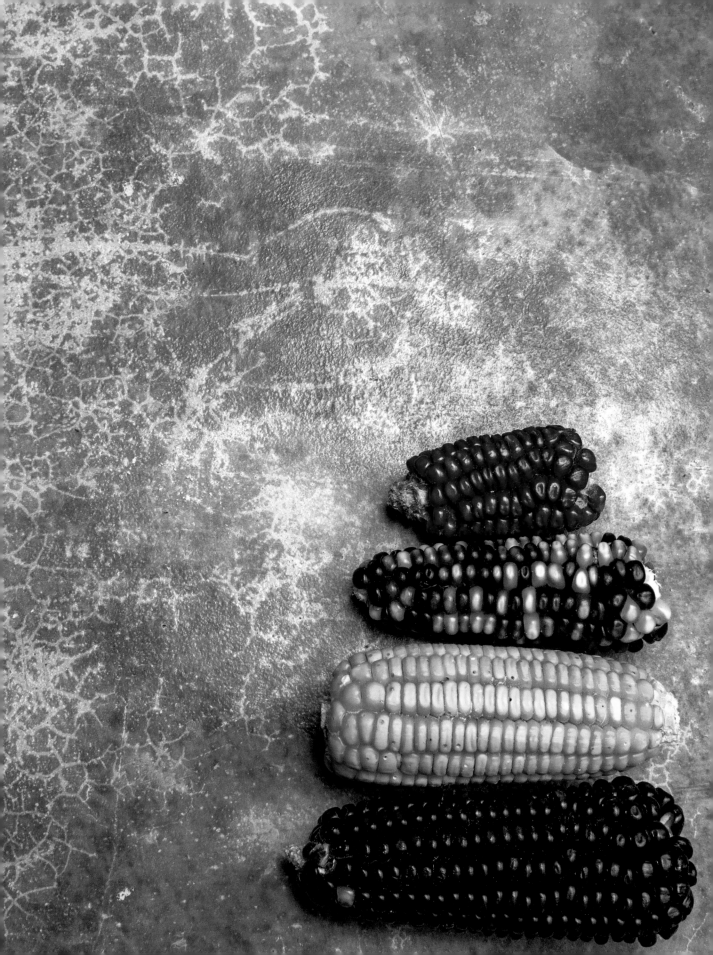

Contents

Acknowledgments

Rachel Glueck

This book owes its existence to a confluence of beautiful people and incredible circumstances. First off, of course, I thank my parents—for raising me to be the person I am (though it was often probably not what they'd gambled for), and for their unceasing love and support in all of my harebrained ideas and unorthodox decisions. My husband, Noel, for inviting me into his world and for helping me to grow every day. My longtime friend and our photographer, Meg Patterson, I thank for agreeing to fly to Guerrero on a week's notice and drive around Mexico with a baby in tow, photographing things she'd never even imagined. Her vision and patience, as well as her photographs, have been instrumental in the creation of this book. It should be noted that it was this Meg who first came up with the idea of creating a cookbook. But it wasn't until a mere ten days later when the other Meg—our agent—made the suggestion and offered to represent it that we took it seriously. And for that we give Meg Thompson our deepest thanks for believing in us, our voice, and our vision.

There are countless others to whom we owe our gratitude as well: Vicky Hernandez for sharing her time and wisdom on prehispanic cuisine and medicinal herbs; Max Garrone, Lou Banks, and David Zamora for being early readers; Lisa Jackson for letting us invade her house and take photos; Matt Champagne, Kymber Henson, and Jay Bachemin for recipe translation and editing; our editor, Kim Lim, for her immense patience; Rob Mang and Laurie Bauer for photography help; and our fantastic guests at El Refugio Mezcaleria who make all of the struggle worth it—with special thanks to our numerous, enthusiastic recipe testers for decrypting our first draft of muddled-up recipes. None of this could have happened without a significant number of laboring hours from our staff at El Refugio. We're so very grateful to have you as part of our team.

Lastly, but most important, we thank the many people of Mexico who shared their time, stories, food, wisdom, and mezcal with us.

Noel Morales

I'd like to thank all the women that have been in my life. I thank my mother, my wife, my sister, my nieces, my daughters, and even my exes. One way or another—positive or negative—these women have taught me to be a better person and have led me to be where I am today.

Meg Patterson

I'd like to thank my ever-supportive husband, Halsey, for always encouraging me to pursue my dreams (as wild as they may seem at times) and for his infinite patience as I run to far-off corners of the globe to achieve them. My parents, for their love and support through all phases of my creative endeavors. My siblings, who've always been my sounding boards and sanity-checkers. Countless other friends who've stepped in to make this possible by puppy-sitting for us at the drop of a hat. And, above all else, the welcoming communities of these towns and villages that embraced us and allowed us to tell the world their story.

Preface

Let it be said: this book is a divine accident. As is the conjoined lives of its authors. By some will of the universe (which the authors have been quite happy to follow) and against all logic, Noel and I met (in a prehispanic sweat lodge), married (with four ceremonies), and opened a mezcaleria-cum-restaurant that very early on caught the attention of a literary agent, and here we are today. Little of our personal or business life was preplanned. We are not certified by culinary or academic institutions; Noel did not set out to become a chef, he only discovered he had the gift, the ancestral knowledge, and a family to feed. This is to say that the words and recipes herein are not based on months of formal academic research, but on years of personal and, in the case of Noel, ancestral experience.

Noel was raised in the mountains of Guerrero amid the flavors and traditions of his native people. As a young boy, he helped his mother in the kitchen by preparing family meals or at the market selecting *guajes* (a type of legume) for salsa, turkey for barbacoa, *ciruelas* (plums), chayotes, and various chiles. In the evenings, he joined the native dancers: Diablos, Tlacololeros, Tigres, and Huashkixtles—each with their own particular costume, legend, and choreography.

By his late twenties he was the leader of two Aztec dance groups and well-respected for his knowledge of Mexican history, Náhuatl theology, and Mesoamerican cosmovision. He worked as the curator for a gallery of traditional, high-end Mexican art, traveling the southern and central regions in search of the finest works and rare archeological pieces and gathering the stories and

visions of Mexicans on his quest. And, of course, eating his way through hundreds of marketplaces and festivals as he went.

For my part, it has always been the stories and cultural essences behind what we eat that have sparked my passion for food. It was for love of the story that I founded the food blog for one of San Francisco's most beloved restaurants, Nopa, covering issues in sustainable agriculture and its relevance to humankind's cultural and spiritual psyche. Every few weeks I would ride my golden 1969 Honda motorcycle out to Bay Area farms to collect the visions, methods, and aspirations

of their proprietors, later spinning them out in tales that allowed urban foodies to traverse the bridge that connects farm to table. From there I continued writing about the cultures and people I encountered in my travels through Europe, India, Nepal, and Mexico for my personal blog. The motivation behind my writing has always been to shed light on cultures, lifestyles, and world visions that reach beyond the consumer culture that has so deeply influenced the modern psyche.

My own love for Mexican cuisine was born on a plastic, citrine plate in the chaotic, grimy marketplace of Oaxaca. In that moment, the essence of the Oaxacan spirit manifested on my palate: rich, complex, brimming with history, and roiling with revelry. My enthusiasm for mezcal followed shortly after, when Noel's

Aztec dance group gave me a proper introduction: swigging papalote mixed with Fresca from a five-liter plastic jug in Acapulco's "Central Park." As my education in the spirit progressed, my palate became more discerning. In 2014, Noel and I traveled through Jalisco, Michoacán, Guerrero, and Oaxaca, meeting with rural producers and sampling from urban mezcalerias, on a mission to discover some of the best agave distillates of the country. The wealth of knowledge of the mezcaleros and the culture and mythology of the tradition made for the richest of fodder, prompting me to create a blog on the subject.

In 2016, we decided to open a mezcal bar, serving a bit of food on the side. We took the only affordable place we could find: a cheap, run-down house that required us to reroute the plumbing (the

gray water was running directly into the street) and build a bar, dish pit, and prep tables. We threw sand down on the dusty front lawn, strung up garden lights, and set out rickety secondhand tables and chairs for our guests. On December 6, El Refugio Mezcaleria was introduced to Todos Santos with a Náhuatl ceremony, free shots of mezcal, and pozole verde cooked on a camping stove (the makers of our professional stove having absconded with the money we paid them). We began with two dishes a day (always one vegetarian), which would change daily. Our sous chef, Ricardo (aka "Chino")—a longtime friend of Noel's and one of the Aztec dancers from the group he led in Zihuatanejo—arrived two weeks later and moved into the storage room. A lovely seventy-eight-year-old lady we'd befriended in Maine moved into the back bedroom and paid her rent in pies.

We had no idea what to expect.

By January, word had spread that Noel's food was pretty damn tasty. And the mezcal—well, you wouldn't find anything else like it in Baja. In February, our soon-to-be literary agent arrived, fell in love with the food, the mezcal, and the stories, and proposed we write a cookbook.

From the beginning, the restaurant has had a momentum of its own, keeping Noel and I running to catch up. Our second year, we moved to a larger location complete with a roof over the dining room and real plumbing. Today our menu has expanded to four dishes that change daily, always with an eye to add new recipes and pre-hispanic ingredients. Noel hosts cooking classes (which double as entertainment shows) and cultural talks; together we offer mezcal tastings and cater weddings and private events.

At El Refugio, the food and mezcal are more than sustenance, more than flavor. They are the medium we use to share the stories, the wisdom, and the generosity of the indigenous peoples of Mexico with our guests. So when we set out to write a cookbook, we knew it had to include those stories, and, above all, a focus on the mores that give native Mexicans an inestimable value unrecognized in the world of modern consumerism.

The five main points that head each section of stories and recipes address what we find to be principal values among the indigenous communities we have spent time with: intuition, humility, faith, community, and happiness (a combination of gratitude and generosity). These are values that have rapidly diminished with the expansion of modern, consumer culture—a loss that is keenly felt (though rarely acknowledged) by humankind. We would go so far as to say it is the lack of these values that has left a gaping hole in the psyche of consumeristic society, which places a far greater emphasis on the *show* of what is than on the reality of what lies beneath. It is a vastly complex problem that manifests itself in myriad ways, but like many illnesses, the what and how of our diet is an excellent starting point for a cure.

Food is what brings us together. It is what strengthens and heals our bodies and our relationships with one another. It is the common table of all humanity. How we arrive at that table is as important as the sustenance that it holds. It is these very elements that give the culture—and therefore the cuisine—of Mexico its depth and richness. We believe the preservation and sharing of these values is as important as the preservation of the cuisine itself. A cuisine, after all, is nothing without its culture, and the culture of Mexico is nothing without the values and traditions of its indigenous peoples.

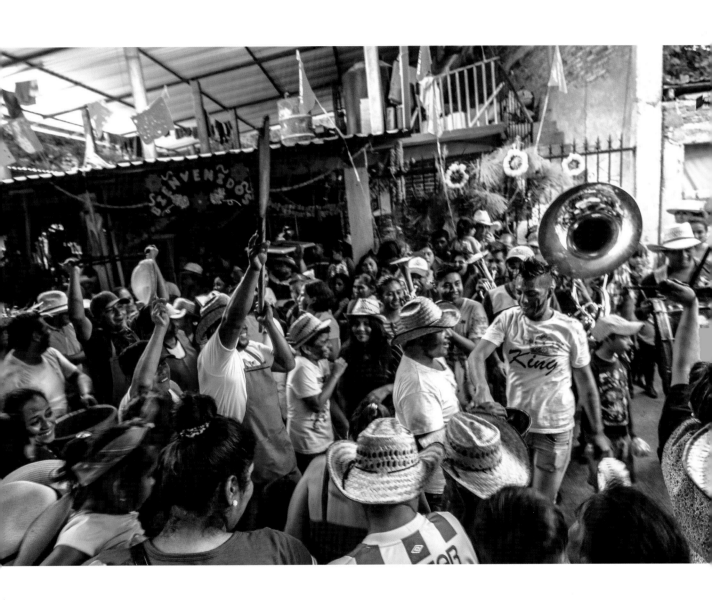

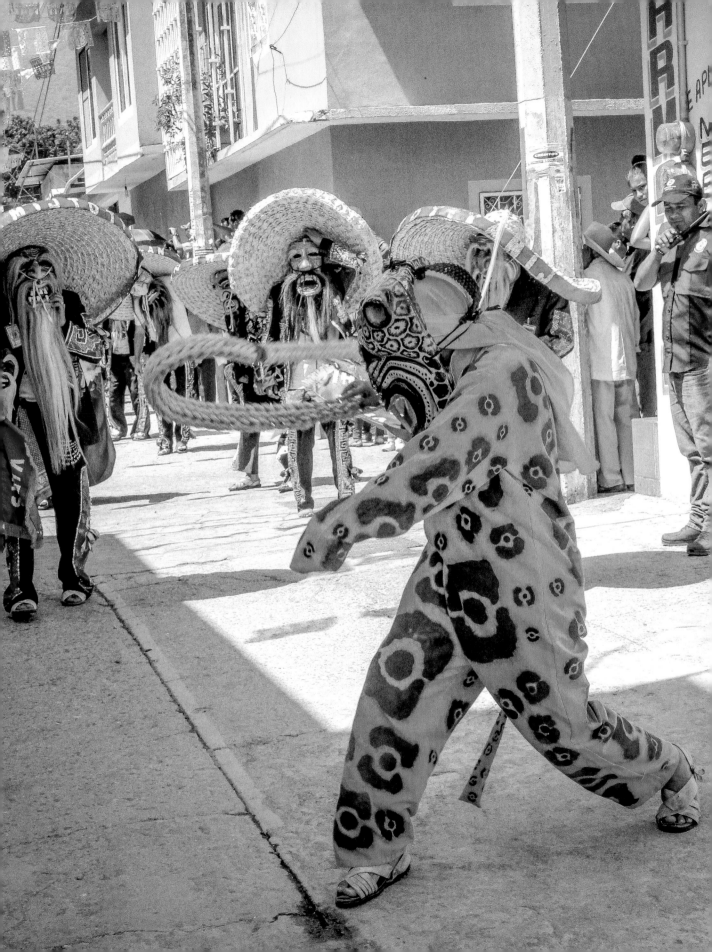

Introduction

"What I'm speaking of is recovering the narratives across time, connecting all of us into one idea—that our food has not just been fodder for our journeys, but embodies the journeys themselves."

— Michael W. Twitty

What do you travel for? What makes you seek out new cuisines, new chefs, new flavors? Is it—could it be—you're wishing for something to *wow* you? Could it be that beneath the guise of adulthood, you're longing for that sense of wonder that filled your every day as a child? Maybe we're all extraordinarily bored as adults, and food and travel are our way of reconnecting to the mystery and magic that flooded our childhood with a sense of adventure and possibility. We all want to believe in that magic, but we've forgotten how. And so we seek out extraordinary meals and surreal cultural experiences. Not to fill a void, but to create a void where we *don't* know everything, where we *can't* be in control, where the *how* doesn't make sense, but it fills us with awe. Where we can, for a moment, be at peace with the unknown.

Contrary to what the trillion-dollar tourism industry would like you to believe, it's not the food itself that holds the mystery—not the million-dollar view from your Airbnb, not the traditional dance show performed at your resort. The magic isn't in the *thing*, but in the people who create it. And in the case of Mexico, it is the native peoples and the tapestry of their histories—their blood, their sacrifices, their celebrations—that create the cuisine the world so loves today. Above all, the magic is in their worldview, their faith. If all the Mexicans who believe in

spirits; in nahuales; in the miracles of the Virgin de Guadalupe; in the power of their dances, prayers, and ceremonies to bring rain and fertility . . . if they were all to disappear tomorrow, within two generations we would have lost the touchstone of Mexican cuisine. Within four we'd be left with only a flavorless, bastardized version wrapped in sugar skull–printed sandwich paper.

Maybe it wouldn't matter. Maybe if we're told it's the real thing, we'd be satisfied with that. I'm doubtful. I think that on a cellular level the body recognizes the soul of something. You can tell the difference between a handmade burger from your grill and the one ordered from the McDonald's drive-through, can't you? And not just in taste. There's a tangible residue you're left with: one is vibrant and satisfying; the other resembles a sticky porno sandwich.

In my short time in Mexico, I've been blessed to have been invited into various native circles, thanks to my husband's experience, reputation, and, no doubt, his charm. Soon after my arrival, I began to grasp the complexity of Mexico and get a sense of just how deep its history and how rich its culture is; one could spend lifetimes exploring it. Life here takes on a new dimension. Over time, I came to see there were core values that form and direct the culture of my hosts. Values that my own society, as a whole, does not embody. These values make for a radically

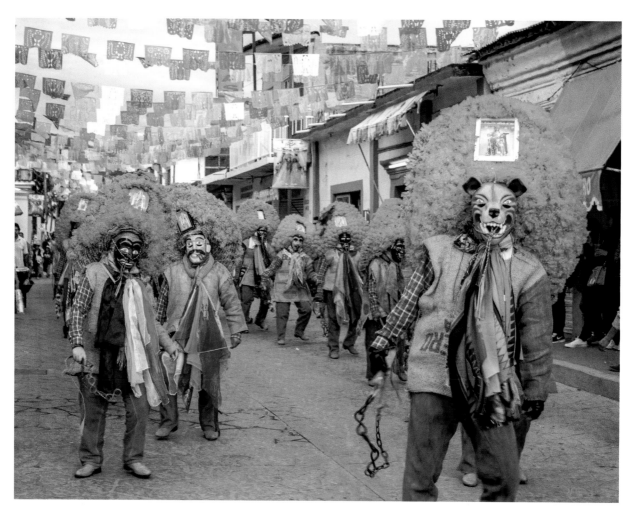

different experience of life—in the kitchen, at work, within the family, and with one another. The values of any one group are what form its world vision, direct its actions, and influence its art and cuisine. The goal of this book is to recognize the contribution of indigenous Mexicans toward global cuisine; we would be greatly remiss if we did not highlight their foundational values.

Within Mexico there are sixty-five different indigenous ethnic groups,[1] each with their own language, customs, and food traditions. The values we speak of, however, we've found to be generally held by different native groups throughout the country. This book is in no way an anthropological examination attempting to cover the numerous social, cultural, and culinary aspects of all of Mexico's indigenous peoples. That would require the work of multiple experts over several lifetimes and result in something far more ambitious than a cookbook. Our intent is simply to provide you with a glimpse of a native Mexican vision of life, to share with you their stories, their recipes, and their wisdom, and to create a bridge between your world and theirs. I have little doubt

1 Wade, Lizzie. "People from Mexico Show Stunning Amount of Genetic Diversity." *Science*, 12 June 2014, 2:00 p.m., www.sciencemag.org/news/2014/06/people-mexico-show-stunning-amount-genetic-diversity.

that these social mores are also deeply rooted in many other cultural groups around the world— particularly ones that have a history of strong ties to the natural habitat. How those values play out in different regions of the world is what makes the human planet and its many cuisines so endlessly fascinating and so remarkably diverse.

When the world speaks of Mexican food, it is all lumped together. For the majority, it means tacos, burritos, guacamole, and any number of plates that have only trembling ties to Mexico. For a growing number of foreigners, that vision expands to encompass carnitas, *sopes* (a thick tortilla topped with meat and/or beans, salsa, cheese, and cream), mole, and pozole. But for the most part, it's all still "Mexican," without differentiation between Oaxacan, Jalisqueño, or Guerrerense cuisine. As the West imports

Mexican culture at a maddening rate, the culinary traditions of the Zapotec, Nahuatlacah, Chontal, Mixtec, and any number of the sixty-five different native groups become mixed up, watered down, and further adrift from their home ports, like a ship cut from its moorings. It's a natural part of globalization and emigration and it can result in the evolution of gastronomy. It can also result in a terrible misinterpretation of an ancestral cuisine. To be clear, what we refer to here in this book as native food is far from unadulterated, pure-blooded prehispanic cuisine. Little of that is left. Native Mexicans have incorporated the imports and influences of their immigrants. Namely, the Spanish and Americans. Where once meat was a rare luxury saved for celebrations, now it is the dominant portion of the plate. Pork, now the favored meat of Mexicans, wasn't eaten

with regularity here before the Spanish arrived. Neither was beef, or any number of herbs, spices, and vegetables now considered essential parts of the traditional cuisine.

A Note on the Term *American*

It should be noted that the term *American* applies to all of those living in North, Central, and South America—not just citizens of the United States of America. While we strongly dislike using this name as most of the world commonly does (i.e., in reference to USA citizens), we have yet to find a comprehensive replacement for it. As such, with our sincerest apologies, the use of the term *American* here is in reference to citizens of the United States of America.

This book does not take a purist approach to indigenous Mexican cuisine, nor does it attempt to be an encyclopedic manual. When we speak of native Mexican cuisine, we speak of the culinary traditions indigenous Mexicans have carried forward into the present, complete with their influences of foreign cultures—i.e., the food they are still eating today. Most contemporary Mexican cooks use grinders instead of metates and take advantage of pressure cookers to save on time. While, admittedly, a tortilla made from a masa hand-ground on a metate is incomparable, we understand that most people today are not going to go to that length for dinner. The recipes here are rooted in Noel's tradition and inspired by his experience but presented the way he actually cooks: for his family, his friends, and for our restaurant. A mole prepared for a festival might cook for twelve hours. A mole for a small gathering of friends does not.

Our intent is not to create a romanticized, frozen version of the prehispanic peoples of Mexico or record labor-intensive recipes from their cuisine. Our intent is to celebrate their knowledge, their traditions, and their skills, and to present them in a way that allows you, our reader, to participate.

The recipes in this book are mostly traditional Mexican plates presented in Noel's particular form (as every cook makes their own adjustments to traditional recipes). Several of the recipes are from other cooks or mixologists, and are noted with their names.

In certain sections, we've included boxed texts with unconventional descriptions of some of the mezcals we serve at our restaurant. This is our particular way of presenting mezcals to our guests, as we feel it represents the strong storytelling aspect of native culture. It also is a much more open approach to discovering the flavors and emotional inflections of the spirit. Feel free to use this free-association technique when tasting mezcals, wines, or anything else!

You will notice that this book is written primarily from my perspective: a white woman who emigrated to Mexico from the United States of America, who married an indigenous Mexican, and who spent the past seven years immersed in his world. I do not claim (nor aim) to be an expert, nor do I claim this culture as my own. My desire to write this book springs from how much I have learned, and continue to learn, from the people I have come to know here.

Ingredients and recipes are only one element of gastronomy. What gives Mexico's cuisine such depth and richness are the relationships, the history, and, above all, the faith and intuition, of its masters. Our goal is to share with you a sliver of that perspective as we know it. For this I've

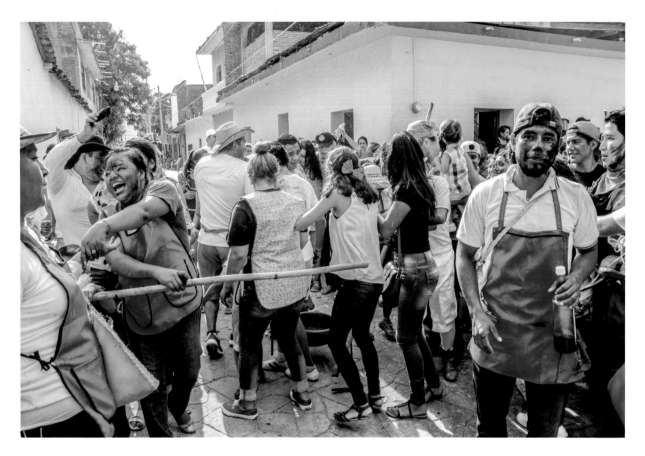

sprinkled a few notes on each of these foundational values throughout the book, along with stories of our time with native cooks, hunters, mezcaleros, healers, and dancers. Much of the subject matter comes from what I've learned through Noel himself. Noel is an incredible oral storyteller. In order to best represent his voice, I've placed the majority of his stories and opinions in italics (as well as those of a few others we have met) to give a better sense of that vision.

We use Spanish and other foreign words throughout the book—if you don't recognize a certain word, you may look it up in the glossary (page 8). Words that aren't included in the glossary are italicized, with explanations or translations beside them.

It's exhilarating that Mexican cuisine is finally getting the attention and accolades it deserves on the world stage. We have many contemporary Mexican chefs to thank for that—chefs who paint masterpieces sprung from their personal visionary genius. But without the ancestral knowledge that makes up their palette, those masterpieces would never materialize. This book is a tribute to that knowledge and the people who carry it forward. It is also a prayer that one day the native peoples of Mexico are given the respect and the opportunities they deserve.

And finally, a note from Noel:

I hope this book contributes to your understanding and enjoyment of one of the greatest cultures on this planet. I hope reading this book generates so many questions in you that you come to visit Mexico. If you come to Todos Santos, visit us at El Refugio Mezcaleria—your first mezcal is on me.

The Basics: Tools & Tricks

Ingredients

A number of the ingredients used in this book, such as epazote, tlayudas, and asiento de puerco, are quite common in Mexico but may be difficult to find in your regular supermarket, depending on which part of the United States you live in. We suggest first searching in your local Mexican grocery store (you may be surprised to find they are actually quite common throughout the country). This is also a great way to support locally owned businesses and learn more about Mexican culture. If you cannot find it on the shelves, speak to the staff—they may know where you can source the ingredient. Should that fail, all of these ingredients are available online: try a google search to find specialty importers.

Substitutions are noted in the recipe where possible. In certain cases, there are no substitutions (epazote, for example).

Pressure Cookers

Pressure cooking seems like cheating. It also would seem like it cooks at higher temperatures and destroys nutrients. In fact, a pressure cooker cooks at lower temperatures than generally used in oven and stovetop cooking, and, in many cases, preserves more nutrients than other forms of cooking. It also saves a lot of time. The use of a stovetop pressure cooker is extremely common in Mexican households today. Many of our recipes are written with this in mind, but for those who don't have a pressure cooker or are averse to using one, we've included options for cooking in a regular pot.

NOTE: We haven't tried these recipes with an Instant Pot—the cooking times and quantities may or may not be the same. If you experiment with that, let us know how it goes!

The Coin Trick

There's a trick that you can use to figure out if your pot has run out of water while steaming: place a few coins in the water at the bottom of the pot. Several of these recipes require lining the pot with banana leaves, and since it's hard to know whether the water has run out without turning off the heat and removing the contents, the coins will warn the cook by clanging inside a dry bottom if and when all the water has cooked off.

On Beans

It is always recommended that you sort through your beans to check for pebbles or other foreign material—particularly if buying in bulk. Be sure to rinse the beans before cooking, as well. You can soak the beans overnight to decrease cooking time; however, as we cook them in a pressure cooker, our recipes do not include this step.

On Chiles

When we moved to Baja California Sur from Guerrero, we came to discover that the names they gave certain chiles were sometimes different from the names given in Central Mexico. We also noticed the names can vary in the United States. For this, we offer you a chile guide to use with the recipes in this book. Those marked "always fresh" or "always dried" mean that we, at least, only ever use them that particular way.

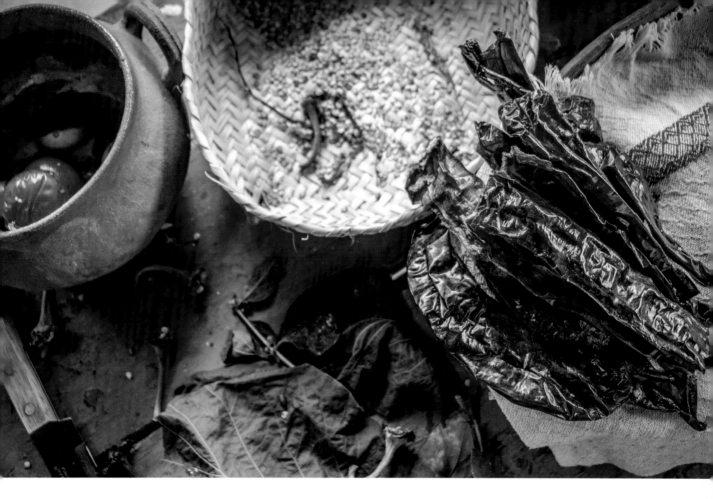

Name of Fresh Chile	Name of Dried Chile
Serrano (always fresh)	
Habanero (always fresh)	
Poblano	Ancho
Anaheim	Colorado
Jalapeño	Chipotle
Marisol	Guajillo
Bola	Cascabel
Chilaca	Pasilla
	Árbol (always dried)
	Mulato (always dried)
	Morito (always dried)
	Chilhuacle negro (always dried)

Glossary

Cultural Terms

Abuelito/Abuelita—grandfather/grandmother

Almuerzo—brunch. Mexicans typically eat a piece of sweet bread and coffee first thing in the morning and then a heavy breakfast (almuerzo) around 10 a.m.

Barrio—a neighborhood

Brujo/Bruja—someone who works with dark magic and herbs to harm others. In Mexico, this term has a negative connotation, unlike its current use in the USA, where it describes people who consider themselves shamans, healers, or witches with the goal of helping others.

Calendas—festive parades

Campesino—a farmer or someone who works in the fields

Cervecería—a brewery

Chancla—a flip-flop

Cohetes—fireworks

Compa (short for *compadre*)—godfather; sometimes used as a term for a friend

Criollo (in reference to a social group)—people born in Mexico, but of pure Spanish blood

Cumbia—a type of music and dance that originated in Colombia. Mexico has its own versions.

Curandero/Curandera—a traditional healer that works with medicinal plants to help others

Guelaguetza—an annual indigenous cultural event in Oaxaca

Gusto—pleasure. "*Con gusto*" is often said as a response when someone asks for something.

Jefe/Jefa—this can refer to either someone's father or mother, or their boss

Maestra/Maestro—teacher

Mestizo—a person of mixed race, usually Spanish and native American

Muertos—the dead, or dead ancestors

Nahual—[nah-**wahl**] a sorcerer or bruja that can change into the form of an animal or natural force, such as lightning

Náhuatl—[**nah**-wahtl] the indigenous language spoken by the Náhuas; also refers to the culture of the same group

Nahuatlacah—[nah-waht-**la**-cah] the group of indigenous peoples of Central Mexico that descended from tribes that populated the Valley of Mexico basin and spread out in other territories. Or the indigenous populations that speak Nahuatl. Also known as the Nahuas. They are the largest indigenous group in Mexico today.

Pedimento—a sacred pilgrimage site where devotees give thanks and ask for a favor of a particular deity/virgin/sacred energy

Pinche—technically, a kitchen assistant; colloquially, it's an all-around filler of a swear word and an insult-enhancer

Puesto—a market stall

Quinceañera—a celebration honoring the transition of a girl into womanhood on her fifteenth birthday. It is often an extravagant affair, starting with mass and followed by a party with formalwear, an official court, and rehearsed dance.

Rebosa—a long, woven scarf used for many purposes by native Mexicans (in birth, carrying children, or as a supportive belt, for example)

Tequio—community work

Veladora—a place in a church or sacred site where candles are left as an offering or prayer

Xipe Totec—a Náhuatl deity of spring; the patron god of seeds and planting; and a symbol of life, death, and rebirth. His Náhuatl name translates to "Our Lord the Flayed One." His chosen attire was the flayed skin of a sacrificed human.

Food-Related Terms

Agua fresca—a light beverage made from blending water and sugar with fruits, cereals, seeds, or flowers

Asientos de puerco—the sediment from lard

Atole—a prehispanic corn-based beverage, served hot

Barbacoa—a Mexican dish consisting of a type of meat that's been slow cooked with seasonings

Birria—a spicy stew typically made from goat or mutton

Cacahuates—peanuts

Cajeta—a thick syrup of sweetened, caramelized goat's milk

Cal—the common term for calcium hydroxide (or lime) used for soaking corn kernels for nixtamal. It can be found in Mexican grocery stores and online.

Calabaza—squash

Caldo—stock or broth

Carnitas—a shredded pork dish that's been braised or roasted in lard

Cecina—thinly sliced grilled beef, served in Morelos, Guerrero, Puebla. In Morelos, they often spread it with manteca before grilling it.

Chapulines—grasshoppers, commonly served toasted in a taco or tlayuda or as a bar snack.

Chayote—an edible plant of the gourd family, also known as mirliton squash

Comal—a smooth, flat griddle used to cook tortillas

Crema—a thick cream used as a topping in many Mexican dishes (not sour cream)

Criollo—(in reference to seeds or plant) native or heirloom variety

Epazote—an aromatic herb, the leaves and stems of which are used for cooking. Commonly used in beans to reduce gas.

Esquites—a popular street food consisting of corn (off the cob) with crema, cheese, and chiles

Fonda—a restaurant with everyday food that's attended to by the owner

Frijoles—beans

Gorda peppers—known as *allspice* in English

Guise—a plate made of spices, chiles, and aromatic herbs. Basically, anything cooked that combines several elements.

Jamaica—a type of hibiscus flower (also known as Jamaican sorrel) used to make agua fresca and marmalades.

Jarrito—a clay cup

Jicara—a dried gourd used as a cup for drinking prehispanic beverages, such as mezcal or tejate; or as a bowl for eating from or making a sacred offering

Maíz—corn. The scientific name is *Zea mays*.

Masa—corn dough

Manteca—pork lard

Mercado—market

Metate—an oblong stone used to grind corn and other grains

Milpa—a system of intercropping traditionally practiced in Mexico, usually mixing beans, squash, chiles, and/or tomatoes with the principal crop of corn

Molcajete—a precolonial version of a mortar and pestle used for grinding various foods; made of stone

Mole—a complex salsa

Nixtamal—corn that has been partially cooked and soaked with calcium hydroxide (cal)

Nopal—known as the prickly pear cactus in English. Its paddles (also called *nopal*) are an important part of the indigenous diet in Mexico.

Pollo—chicken

Pozole—a traditional Mexican stew with prehispanic origins that contains hominy

Puerco—pork

Quesillo—also known as Oaxacan cheese. It is semi-hard with a string-cheese-like texture.

Relleno—stuffed or stuffing

Res—beef

Tasajo—thinly sliced beef that's served grilled; from Oaxaca

Tlayuda—a traditional Oaxacan dish consisting of a large, thin, crunchy tortilla spread with asientos de puerco, refried beans, a meat, lettuce, tomato, avcado, cheese, and salsa

Mezcal Terms

Agua Miel—the sweet water that collects in the center of the agave. It's nonalcoholic when first collected.

Fabrica—the term used in Guerrero for where mezcal is mashed and distilled (a palenque)

Fogonero—the person who oversees the roasting of agaves

Jimador—the person who harvests agaves

Maguey—the common name for agave

Magueyero—the person in charge of growing and harvesting the agaves

Mezcalero—the person in charge of making mezcal

Palenque—a place where mezcal is made

Papalote—the common name used in Guerrero for *Agave cupreata*

Pencas—the leaves of the agave

Pulque—a prehispanic drink made from the fermented juice of certain agaves

Quiote—the flowering stalk of the agave that grows upward when the plant has matured

Tlachiquero—the person who collects agua miel from the agave

Maíz: Sustenance & Sacrament

Sin maíz no hay pais. Without corn there is no country.

It sounds like a romantic hyperbole, doesn't it? If anything, it's an understatement.

Gods made the Maya from maíz. The Huichol socio-psycho existence depends upon corn. Olmec, Nahuatlacah, Zapotec, and Teotihuacan civilizations could not have existed without it. The cultivation of corn is not simply an advancement that allowed nomadic peoples to settle, technologies to evolve, and empires to grow. Corn is the cosmovision of the native peoples of Mexico. It is their art, it is their offspring, it is their sustenance. It is their faith and their flesh and their blood.

In return for creation and propagation by the human hand, maíz has given back a thousandfold to the indigenous populations of Mexico. The natives of Mexico owe their civilizations, their art, their culture, their offspring, their understanding of astronomy, and their architecture all to maíz. For without the ability to cultivate this crop, their civilizations could not have arisen. Their art would have remained rudimentary, their population limited, their structures basic, their gods numbered. The Nahuatlacah have at least seven gods associated with maíz, the planting, and the harvest; the deepest lineages of their gods are all linked to water and the fertility of the earth. Their cosmology, their pyramids and cities (which were, in many ways, far more advanced than those of Europe at the same time), their rites and rituals, their advanced understanding of planetary movements and the measure of time all

of this is reflected in the Nahuatlacah and Maya calendars. It was for the sake of cultivation that they watched the cosmos and took note of the passing of time. Mexico owes its entire existence to *Zea mays*.

But things are changing at an astonishing rate.

Today, Mexico buys 25 percent of USA corn exports,[2] thanks both to its neighbor's enormous surplus of commodity corn and the North American Free Trade Agreement (NAFTA). Many Mexicans have been persuaded to plant lab-produced hybrid varieties with promises of higher yields over that of their native heirloom varieties, increasing pesticide use and dependency, while decreasing genetic diversity, flavor, and self-sufficiency.

While modernity gnaws on the thighbone of Mexico, crunching its way ever closer to the navel with each passing year, and while each new neoliberal government feverishly sells off its inheritance, today's eagle warriors amass in the milpa, fighting for their future—for the future of the Maíz Child their ancestors birthed and the children she herself bears into this world. Nonprofits such as Fundación Tortilla Maíze Mexicana work to preserve the culture and consumption of heirloom variety corns. Businesses such as Maizeajo—a tortilleria in Mexico City that buys from small-scale criollo corn farmers to make their own masa and tortillas—are popping up to serve and educate the public on Mexico's great patrimony.

2 https://grains.org/buying-selling/corn/

The heralding of maíz as the lifeblood of Mexicans is not just about its practical and culinary uses. It doesn't just come down to "Yeah, yeah, they really like tortillas, and they eat a lot of 'em." That much I, as a foreigner, could intellectually understand. Yet, as we traveled around central Mexico, I felt I was missing out on something key. As if there were a secret understanding of corn that I didn't have access to.

I gave this long thought over many months—even waking up in the night with it turning over in my mind—until I realized that I couldn't, and probably won't ever really, understand. The reason is simple: as a modern Anglo-Saxon American, I have almost no ties to my ancestral cuisine, and very little to corn (despite being raised in corn country). What do I know of seasonality? What do I know of the fragility of depending upon a decent harvest to survive? What will I *ever* really know of hunger? I grew up having supermarkets and processed, globally traded goods to feed me. Worst-case scenario, I have food stamps to fall back on. Most indigenous Mexicans don't have that kind of security.

I gave Noel my verbose hypothesis on why I have a difficult time really feeling the connection that Mexicans have to their food staple. His answer came in typical Noel form, like a smack in the face: brief, stinging, but so full of truth you ask for more.

"Basically, you don't eat corn," he said.

Yeah, that's another way of putting it.

"You don't eat it the way we eat it," he clarified. That is very true. Store-bought corn on the cob and high-fructose corn syrup aren't quite the same as corn in five colors grown in the garden, harvested, ground, and kneaded into a dough by hand.

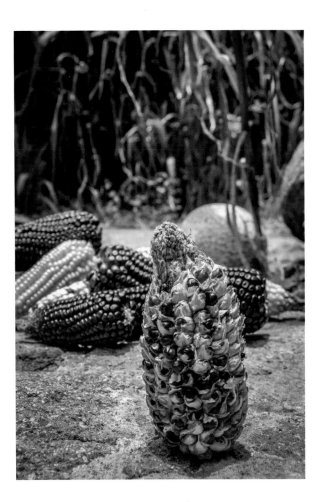

Intuitively, I feel it's so important to have that connection to our food. Ideally, to grow it ourselves. And not only to know where it's coming from and its impact on the environment and society; there's something else I can't quite put my finger on—an unseen something we get when we eat what we ourselves grow. But Noel disagrees with me.

"You don't have to grow your food to have that connection to it. Many people today don't have time or space to grow their own food. But they appreciate that they *have* food to eat. That is the important thing."

With those words, so many things fall into place. That spiritual connection we feel with food that was grown by someone we know, or cooked

from scratch, comes from understanding that it required hard work. We put greater value on things when we know the taste of the sweat and tears required of us than we do for those that come to us freely. It's an unspoken, scarcely noticeable value that is carried along from field to table. In a world where everything is readily available at any time of year, where life itself is produced on an industrial scale, we have forgotten what it is like to lack, and therefore how to appreciate an individual ear of corn, a tomato, a loaf of bread. These are as common as stones to us now. But in places where people have struggled for centuries to survive through drought, fire, and disease, and in the aftermath of conquest, a tortilla is the greatest gift.

It wasn't until I patted out my own tortilla that a kindling of understanding was sparked in me. Our nanny, Bertina, offered to make handmade tortillas for Noel's birthday party and stood over a large bowl filled with dough, a steel comal on the stove behind her. She handed me a small lump and demonstrated how to flatten it out, cupping the edges as she turned it round in her palms, and finally patting it back and forth from hand to hand just so. The first one came out a bit thick and lopsided. The second was deemed quite passable. But the result didn't interest me so much as the process. It's one of those techniques that looks so very simple, yet is only perfected with months of practice. As I patted that soft disk between my hands, hoping to shape the moon, I felt the whisper of a connection to a long line of women who had lived the enormity of their lives in this very motion, spreading back behind

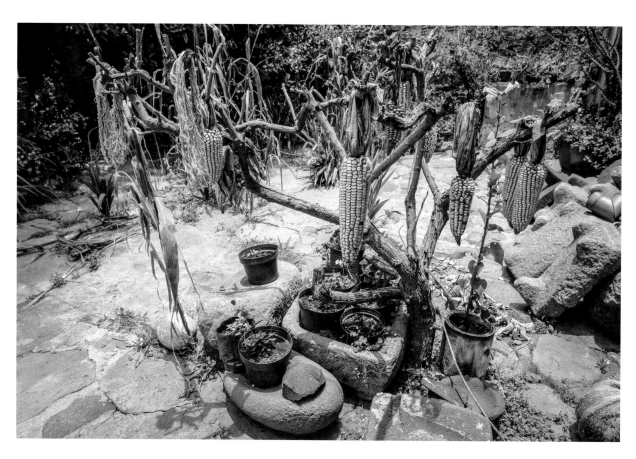

me through time to ghosts of my child's ancestors and out to this very moment to the women surrounding me in the kitchen. In some inexplicable way, the very motion of patting out a tortilla felt connected to childbirth—a process one can never hope to understand without having experienced it.

A month later, Noel brought home maíz criollo from Tlaxcala: purple, red, yellow, and white. "I don't think it will grow here," he said. "It's so much colder in Tlaxcala. But try."

Bertina, my daughter, Lila, and I planted them in three rows, twelve feet long each, in a small patch behind our house. And we waited. The first shoots to break the soil thrilled us. Up and up they grew until they were reaching for the heavens, waving far over our heads. They grew so fast and so tall there didn't seem to be enough soil to support them. The corn silks sprouted from the ears, which fattened over the days. In three months' time, we had a harvest of gorgeous multicolored corn. From this tiny patch we collected three large boxes of maíz. We ate them fresh and raw off the cob (so tender!), we sautéed them with butter and salt, we served them as a welcome taste to our guests at the restaurant. Planting that corn was one of the simplest things I've ever done. Harvesting it was one of the most rewarding. And so, finally, I had the vaguest glimmer of understanding.

Maíz is both sustenance and sacrament for the people of Mexico. It is their origin story, their present, and their future. It is their grounding to this world and their bridge to the other world. Maíz is faith manifest.

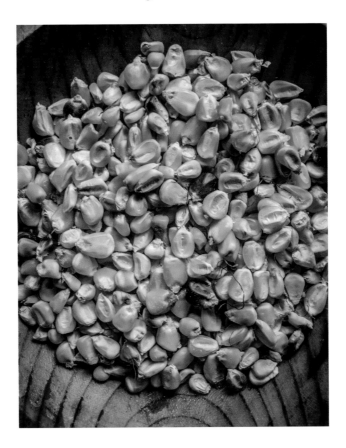

How to Make a Tortilla

There is *nothing* like a handmade tortilla. The corn tortillas commonly eaten in Baja Sur—made from industrialized, processed corn flour and spit out by the thousands from the mouth of a belted machine—are vastly superior to the ready-made, store-bought variety in the USA. And yet they are absolutely shameful when compared to those tortillas derived from handmade nixtamal and flattened in a hand press, as commonly found in Central Mexico. And even *those* cannot hold a candle to a tortilla from a nixtamal of native corn, patted out by experienced hands and cooked over a fire-heated comal. The former two serve a functional role and little more; the latter two can satisfy even the most refined palate with nothing more than a pinch of salt and squeeze of lime.

If you are game for the challenge, try making your own nixtamal at home—with heirloom corn, if possible. For days when you're not feeling quite as gung-ho, you can begin with the instructions for the masa using store-bought corn flour.

Nixtamal
Makes approximately 15–20 tortillas

1 pound dried corn (preferably an heirloom variety)
18 cups water
1 tablespoon cal

Remove the kernels from the dried ears of corn using your thumbs. Once you've removed all the kernels, check your batch of kernels well for any stray pieces of cob, husk, silk, or other material and remove.

Boil 18 cups or enough water to cover the corn kernels by 1 or 2 inches. Once boiling, add the cal, stir well, and then add the dried corn. When the water returns to a boil, turn off the stove and leave to sit for overnight (8 to 12 hours).

Rinse the corn in a colander under cool water to remove most of the skin and cal.

Masa
Add the corn to a mill and grind to the desired thickness (a medium-fine grind for tortillas; tamales require a more coarse grind). Add a little cold water, bit by bit as needed, to facilitate grinding. Take care not to add too much, which makes the masa sticky. Place the ground flour into a mixing bowl and add a little hot water, then a little cold water, in a ratio of two parts hot water to one part cold water. Add the water little by little until you have a perfect dough. The dough shouldn't be so wet that it sticks to your hands or so dry that it forms cracks.

To Make the Tortillas
Take a handful of masa and form a ball. Cover the rest of the masa with a damp cloth while making tortillas to prevent it from drying. Place a thin sheet of plastic (plastic bags or cut resealable bags work well) on your tortilla press and place the ball of masa in the middle. (If you don't have a tortilla press, you can try patting the tortilla out in your hand, although this takes a lot of practice to get right.) Place another piece of plastic on top of this, then press well.

If the masa sticks to the plastic, it's too wet. Knead a bit more corn flour into the entire batch

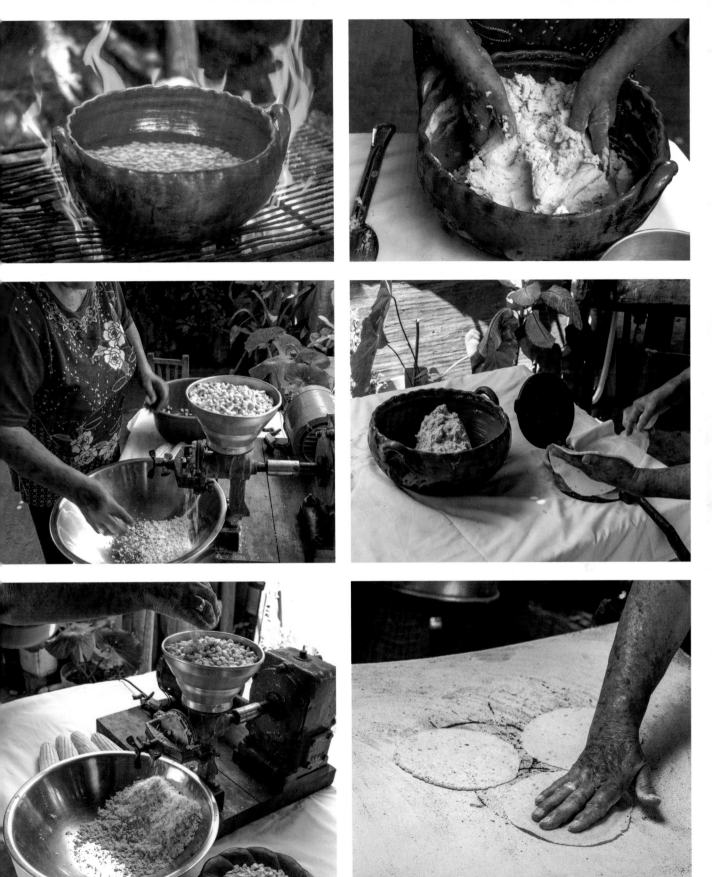

and try again. You can also try placing the masa in the fridge for thirty minutes to an hour to dry it out. If the tortilla forms cracks around the edges, it's too dry. Add a bit more water to the entire batch of masa and knead it well until you have the right consistency.

Remove the tortilla and place on a hot pan or griddle. If you have a clay comal you can use, this is ideal. Cook until the top side changes color slightly and appears a bit drier. Flip and cook for another 40 seconds or until the tortilla begins to lift slightly from the comal.

Flip again and press down gently on the tortilla. Ideally, this will cause the tortilla to puff up in the middle.

Place the tortilla in a basket lined with a kitchen towel; cover. Once you've filled the basket with your tortillas, they are ready to serve!

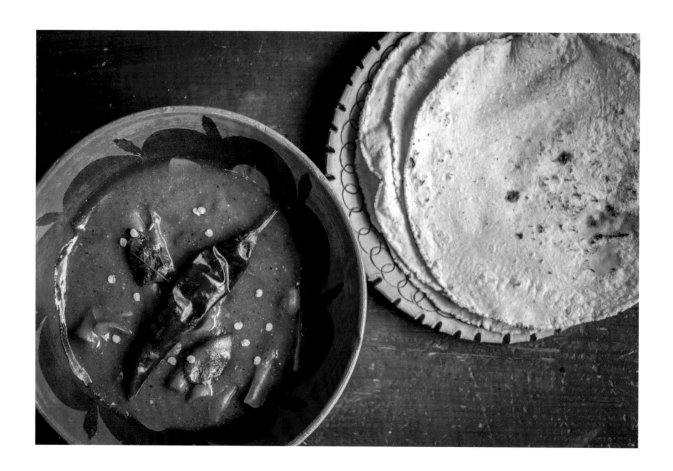

Salsas

Salsas are the base of Mexican cuisine. A good salsa *makes* a dish. The salsa is more important even than the meat it goes with; it's what gives flavor to your life. Most of the salsas below work well with most dishes—it's all a matter of personal preference. If possible, purchase a molcajete to use for making chunkier salsas. The taste is divine.

Salsa Guajillo

YIELDS 2 CUPS

This is a fundamental salsa of Mexican cuisine, made with the correct technique using dried guajillo chiles.

8 guajillo chiles
1 cup water
3 medium red tomatoes
2 cloves garlic, peeled
¼ medium white onion, peeled
2 tablespoons cumin
¾ teaspoon tablespoon dried oregano
¾ teaspoon whole black peppercorns
2 tablespoon vegetable oil
Salt and pepper to taste

Slice the chiles lengthwise and remove the seeds and veins. Place them in a pan and toast for 2 minutes. Add 1 cup water, then simmer over medium heat for approximately 10 minutes or until the chiles are soft. Remove the chiles from the pan and set aside for later. Reserve the chile water.

Toast the tomatoes, garlic, and onion directly over the stove flame if you have a gas stove (otherwise, toast in a pan), rotating occasionally, until the skins begin to burn slightly.

Place the chiles, tomato, garlic, onion, cumin, oregano, and black peppercorns in a blender and blend until the salsa is a uniform color. Add the chile water you saved earlier bit by bit to achieve the thickness you desire.

Heat oil in a pan. When oil is hot, add the salsa and sauté for 5 minutes. Add salt and pepper to taste.

Salsa Verde
Green Salsa

YIELDS 4 CUPS

This is the most popular salsa in Mexico. It's easy to make and is great for giving an acidic touch to a dish.

3 tablespoons vegetable oil
1 pound tomatillos, husks removed
½ medium white onion, julienned
3 serrano peppers
2 garlic cloves, peeled and chopped
Water or chicken stock to thin salsa as needed
Salt and pepper to taste

Heat a pan and add oil. Add the tomatillos and sauté until they begin to change color. Remove from the pan and set aside.

Sauté the onion on medium heat in the same pan until it becomes translucent. Add the serrano peppers and sauté for 3 minutes. Add the garlic and cook for another 3 minutes.

Blend the tomatillos, onion, serrano, and garlic in a blender, adding the water or chicken stock bit by bit as needed until the salsa is the desired thickness.

Add salt and pepper to taste.

Salsa de Chile de Árbol

YIELDS 2 CUPS

This is a classic, very spicy salsa for tacos and *guises Mexicanos* when you need a little extra spice. If you want to give it a slightly sweet flavor, add 2 tablespoons of piloncillo or brown sugar during the last 5 minutes of heating the salsa.

10 árbol chiles
4 tablespoons melted manteca or vegetable oil, divided
½ medium white onion, chopped
2 large red tomatoes, sliced
2 garlic cloves, peeled
Few slices of onion (optional)
2 tablespoons piloncillo or brown sugar (optional)
Salt and pepper to taste

Remove the stems from the chiles and place in a hot pan with 2 tablespoons of the manteca or oil. Sauté on low heat until the chiles begin to change color, stirring constantly so they don't burn. (Burnt chiles yield bitter salsa.) Set chiles aside.

Sauté the onion in the same pan with the remaining 2 tablespoons of manteca or oil; cook until it becomes translucent. Add the tomato slices and sauté over medium heat for about 10 minutes. Finally, add the garlic and sauté another 2 to 3 minutes.

Add all the sautéed ingredients to a blender. If the salsa is very thick, add the chile water bit by bit until you achieve the desired consistency.

If you plan to use the salsa for a meat or chicken dish, add a bit of oil to another hot pan. Then add a few slices of onion and sauté for a few minutes before adding the salsa. Leave the salsa to simmer for 10 minutes over medium heat, stirring regularly.

Season with salt and pepper.

Salsa de Cacahuate
Peanut Salsa

YIELDS 2 CUPS

The peanut is another one of Mexico's contributions to world cuisine. This salsa is an important part of the Guerrero cuisine and has an unforgettable flavor.

1½ cups water
6 ancho chiles
3 pasilla chiles
3 guajillo chiles
2 tablespoons vegetable oil or manteca
¼ medium white onion, julienned
4 medium tomatoes, chopped
3 garlic cloves, finely chopped
1½ cups roasted, unsalted peanuts
Salt and pepper to taste
¾ teaspoon black pepper
¾ teaspoon cumin
¾ teaspoon oregano

Put the water in a saucepan and bring to a boil.

While water is heating, cut the chiles lengthwise and remove the veins and seeds. Toast the chiles lightly in a pan for 2 minutes on each side, being careful not to burn them.

Remove chiles from the pan, and place in the saucepan of boiling water. Cook for 5 to 10 minutes until they soften. Remove the chiles from the pan and set aside. Reserve the water for later.

Heat oil or manteca in a pan over medium heat. When the oil is very hot, sauté the onion until it becomes translucent. Add the tomatoes and sauté for 5 minutes. Add the garlic and sauté another 3 minutes.

Next, add the peanuts, stirring the mix constantly. Sauté for a few minutes until the peanuts slowly begin to change color, then reduce the heat to low. Cook approximately 10 minutes total.

Season with salt and pepper.

Place the peanut mixture in a blender with the chiles, black pepper, cumin, and oregano; blend while adding a bit of the chile water as needed to create a thick salsa.

Place the salsa in a pan and simmer on medium heat for 5 minutes.

Salsa de Habanero

YIELDS 3 CUPS

This mythic Amazonian chile makes a very spicy salsa. This is a salsa for the brave.

1 small, white onion (5–6 ounces)
4 medium tomatoes
5 tablespoons manteca or vegetable oil, divided
2 habanero chiles
2 garlic cloves
2 tablespoons apple cider vinegar
Pinch of dried oregano
2 tablespoons chopped cilantro
Salt and pepper to taste

Chop half of the onion in small pieces and cut the other half in slices (for use at the end of the recipe).

Toast the tomatoes directly over a flame if you have a gas stove until they begin to burn or blister slightly, rotating as you do this (otherwise, toast in a pan). When they are toasted on all sides, wash them in a bowl of water to remove the skin.

Place a small pan over medium heat and add 3 tablespoons of oil. Sauté the chopped onion for a few minutes until it becomes translucent. Add the habaneros and cook until they begin to change color. The more golden they become, the sweeter and less spicy they will be, which will completely change their taste. Remember that habaneros are *very* spicy—use gloves or put oil on your hands before handling.

Cut the tomatoes in half and blend in the blender with the chiles, cooked onion, and raw garlic cloves.

Heat a pan with the remaining 2 tablespoons of oil and add the blended mixture, heating over medium until it begins to bubble. Add the vinegar.

Mix the salsa together with the uncooked sliced onion, oregano, and chopped cilantro to a bowl and mix well. Season with salt and pepper to taste and serve.

Salsa de Aguacate
Avocado Salsa

YIELDS 4 CUPS

This is a salsa typically served in taquerías. It can be served completely smooth or chunky (our personal preference).

3 tablespoons oil
1 pound tomatillos, husks removed
¼ white onion, julienned
3 serrano chiles
2 garlic cloves, chopped
1 large avocado, peeled, with pit removed, and cut into pieces
½ cup water or chicken or vegetable stock (optional)
Salt and pepper to taste

Pictured on the left

Heat a pan on medium and add oil. Add the tomatillos and sauté until they begin to change color. Set aside.

In the same pan, sauté the onion over medium heat until it becomes translucent. Add the serranos and sauté another 3 minutes. Add the garlic and sauté another 3 minutes.

Blend all of the above, along with the avocado, in a blender; or use a molcajete to mash the salsa until you've achieved the desired thickness. You can serve this salsa perfectly smooth or chunky. Add a little water or chicken or vegetable stock to thin out the salsa if necessary.

Add salt and pepper to taste.

Salsa Macha Roja
Red Macha Salsa

YIELDS 4 CUPS

This is the salsa you often see as a condiment on tabletops—the one with a layer of oil at the top and a thick red paste below. It's a very spicy salsa and is excellent for heating up any dish. It will last for 3 months in the refrigerator.

5 tablespoons oil
2 garlic cloves, chopped
½ cup peanuts, roasted, without salt or shells
½ cup raw sesame seeds
5 morito chiles, finely chopped
5 ounces chile de árbol, finely chopped
2 tablespoons apple cider vinegar
1 cup corn oil
1 tablespoon piloncillo or raw sugar
Salt and pepper to taste

Add oil to a hot pan and sauté the garlic until golden.

Lower the heat to low and add the peanuts and sauté, stirring constantly, and cook for 4 minutes. Add the sesame seeds; stir constantly and cook until the sesame seeds become crunchy.

Add the morito chiles with seeds and cook for 2 minutes, stirring constantly. Add the chile de árbol with seeds and cook for 2 minutes, stirring constantly.

Add the vinegar and corn oil. Cook over low heat for 1 hour, stirring often. Check the bubbles regularly. If they're very big, the salsa is too hot and you need to stir more often.

Finally, add the piloncillo or sugar and cook on low heat another 5 minutes.

Add salt and pepper to taste.

Salsa de Piña
Pineapple Salsa

YIELDS 5 CUPS

This is a fresh, exotic, and multifaceted salsa, often served with fish and pork dishes in Zihuatanejo, Guerrero.

1 pineapple
10 tablespoons vegetable oil, divided
½ medium white onion, julienned
4 garlic cloves, finely chopped
6 red tomatoes, sliced
3½ tablespoons achiote
3½ tablespoons sugar
1–3 árbol chiles, whole
¼ cup apple cider vinegar (optional)
Salt and pepper to taste

Clean, peel, and cut half the pineapple into 1-inch cubes. Clean and cut the other half into ½-inch cubes and set aside for later.

Put 5 tablespoons of oil in a hot pan and heat over medium heat. Add the onion and sauté until it becomes translucent. Add the garlic and sauté for 3 minutes.

Next, add the tomato and larger 1-inch cubes of pineapple and cook for 20 minutes on medium heat, stirring every 2 minutes or so, so that the tomato and pineapple don't stick to the pan.

Add the achiote and sugar and allow to cook while stirring for 10 minutes on medium heat, so that all ingredients incorporate together. Add 1 árbol chile and cook for a few minutes. Taste. If you want it spicier, add another 1 or 2 chiles and cook another 3 to 5 minutes.

Place the vinegar if you like and all of the above ingredients, except the ½-inch pineapple cubes and remaining 5 tablespoons of oil, in a blender and blend to obtain a thick salsa.

In a pan over medium heat, add the 5 tablespoons of oil. Once hot, add the salsa and smaller ½-inch pieces of pineapple. Simmer for 10 minutes over low heat.

Add salt and pepper to taste.

Salsa de Hormiga Chicatana
Chicatana Ant Salsa

YIELDS 3 CUPS

The chicatana ant salsa, a plate eaten to celebrate the rainy season, is indigenous to the Costa Chica—a narrow region on the Pacific Coast of Guerrero and Oaxaca. The Día de San Juan on the 24th of June is the most important day for collecting these ants. The chicatana is the common name of the species *Atta mexicana* and *Atta cephalotes*. It's possible to buy them on the internet. This salsa is great with pork, but can also be served with chicken and other dishes.

6 guajillo chiles
2–3 árbol chiles
5 ounces (150 g) chicatana ants, legs and wings removed
½ medium white onion, halved
4 garlic cloves
½ cup water
2 tablespoons manteca (optional)
Salt and pepper to taste

Slice the guajillo chiles lengthwise and remove the seeds and veins. Remove the stems of the árbol chiles.

Heat a pan on low and toast the chicatana ants for no more than 5 minutes, stirring constantly. Remove and set aside.

Turn the heat to medium and toast the guajillo and árbol chiles, onion, and garlic for 3 minutes.

Place all of the above in a blender with ½ cup of water and blend for about 3 minutes or until the salsa is perfectly smooth.

For extra flavor, heat manteca in a pan on medium. Add the salsa and heat for 5 minutes, stirring regularly.

Add salt and pepper to taste. Serve over pork or chicken.

Salsa de Mango
Mango Salsa

YIELDS 3 CUPS

Like the pineapple salsa, this isn't commonly found throughout the country, but it is regularly served with fish and pork in Acapulco and Zihuatanejo. The habaneros give it a great kick, and that's balanced with the mango's sweetness.

1 pound mango (preferably Petecon)
2 habanero chiles
2 tablespoons unsalted butter
2 tablespoons vegetable oil
¼ medium white onion, julienned
1 garlic clove, peeled and chopped
1 cup water or chicken stock
Salt and pepper to taste
¼ cup cilantro for garnish

Remove the skin and seeds of the mangoes. Cut 1 mango in small pieces (about ¼ inch). Slice the other mangoes in long slices.

Remove the seeds of the habaneros (use gloves or put oil on your hands first, and be careful not to touch yourself before thoroughly washing your hands since these chiles are hot).

Melt butter in a hot pan. Add the sliced mango and sauté for 5 minutes maximum. Set aside.

Put the oil in another pan and heat for 2 to 3 minutes. Add the onion and chiles and cook for 3 minutes or until the onion becomes translucent. Then add the garlic and cook 3 more minutes.

Blend the onion, chiles, garlic, and cooked mango in a blender to get the desired thickness (add a little water or chicken stock if necessary).

Place the salsa in a pan over medium heat until it begins to simmer. If it's very thick, add a small amount of water or chicken stock little by little until the salsa is the desired thickness.

Once the salsa has begun to simmer, add the small cubes of mango for 1 minute or so, then remove from heat.

Add salt and pepper to taste.

Garnish with cilantro.

Salsa de Ajonjolí
Sesame Salsa

YIELDS 2 CUPS

This salsa works well with tacos, chicken, and seafood dishes, or as a salsa-of-the-day with chips. You can use chicken stock to boil the chiles to obtain more flavor, if you like.

1 cup raw sesame seeds
3 medium red tomatoes
6 guajillo chiles
3 árbol chiles (optional, if you want it spicier)
1 cup water or chicken stock
3 tablespoons vegetable oil, divided
½ medium white onion, half julienned, half sliced
2 garlic cloves, peeled
Salt and pepper to taste

Toast the sesame seeds in a pan over low heat until golden, stirring constantly. Then, toast the tomatoes without oil, rotating regularly, until they are slightly burnt on all sides. Wash under cool water to remove the skins.

Slice the guajillos lengthwise and remove seeds, stems, and veins. Toast the guajillo chiles without oil for 1 minute on each side or until they begin to change color. If you want a spicier salsa, toast the árbol chiles until they begin to change color. Then place all the chiles in a pot with 1 cup of water and boil for 10 minutes or until they soften. Remove the chiles from the pan and set aside. Save the chile water for later.

Heat a pan with 1 tablespoon of oil on medium. Add the julienned onion and sauté until it becomes translucent. Next, add the garlic and sauté another 3 minutes.

Blend all the cooked ingredients in a blender. If it is very thick, add the chile water bit by bit until you have the desired thickness.

Finally, heat a pan and add the remaining 2 tablespoons of oil. Sauté the sliced onion for a few minutes Add the salsa and cook over medium until it begins to simmer.

Season with salt and pepper.

INTUITION

"Our world is going crazy because the people have forgotten how to feel."

— Noel Morales

For a USA citizen who has traveled internationally, Mexico does not feel like much of a cultural jump. It's different enough to be stimulating—challenging even—but it's no India or China. The world does not seem to have turned on its head, where what you'd assumed to be true is suddenly false, and truth is multifaceted. It's a fairly comfortable first foray into the unknown.

Until you venture beyond the tourist district.

The longer you stay and the deeper you dig, the more you will come to see that the world is not linear, not black and white; and truth is in fact a bit more flexible than you'd imagined. Once you cross that border, you might discover that the people here live between two dimensions: the seen and the unseen, the spoken and the unspoken, the rational and the felt. From Day of the Dead ceremonies and the inundation of dance, color, and music to the illogical bureaucracy and hyperbolic sense of time, Mexico clearly does not operate by the Anglo rulebook.

Things take longer. Much longer. They require a circuitous dance and three trips to the immigration office (minimum). Answers are rarely had by a simple phone call or an email; they require a personal visit. And even then, the answer you get is unlikely to be one, but three.

And why? Dear God, why? Why must it be so inefficient, so illogical, so bloody complicated? every single American and Canadian to ever have moved to Mexico has asked at one point or another. I still don't have an answer to that question, but I imagine that it has something to do with a culture that prioritizes feeling over logic, and relationships over efficiency. Even in this, we sense Mexico's celebration of the feminine. For those of us raised under the masculine perspective where logic, material, and action reign supreme, switching to this climate of femininity can be an invigorating cleanse. Or an absolutely maddening venture. Usually it's both—not dissimilar to a man's love of a woman.

Anglo thinking is to Mexican thinking what baking is to cooking. The former follows recipes, precise quantities, and exact timing. It is a science. The latter follows intuition, feeling, sensation, and subtle cues. It is not just an art, but a form of magic. Have you ever noticed, for example, the difference in how a dish turns out when you prepare it in a state of anger, depression, or stress versus the result when at ease with a glass of wine (or mezcal) at hand? As one abuelita once informed us: cooking is the first form of wizardry.

It's this focus on sentiment and relationships—with one another and with that unseen dimension—that makes native Mexico so wonderfully complex, so wildly delicious, so utterly rich. What would a mole be without the hours of chatter and consultation of generations of women standing around the *olla*? How could a two-hour barbacoa served in a restaurant possibly compare to one made up of bulls donated

31

in thanksgiving, prepared by twenty men of the community, and cooked in the earth overnight accompanied by the solicitations of musicians and masked dancers?

Cuisine is not simply about the process. Not even about the combination of best ingredients with a proven recipe. Cuisine is the product of our relationships and our intentions. Which is why in Mexico the most exquisite dishes are found in the markets, on the streets, and in people's homes. These are women and men whose dishes are made up of generation after generation of intimate knowledge of their crops, their community, their ancestry. And while there are certainly a number of phenomenal chefs and world-class restaurants in Mexico, those that offer something that dazzles the palate and leaves one's spirit in awe are few and far between compared to what one finds tucked away in the highlands and valley pueblos.

Of course, this connectivity to native roots is not something we can simply conjure up overnight. And don't worry—we're not expecting our readers to make a ten-hour beef stew from a ritually slaughtered bull while surrounded by masked dancers. The difference between good food and phenomenal food is not only in the procedure, but in the spirit you bring to it. So how, as one reading this book, can you bring that spirit into your kitchen? Well, for starters, the more you learn about Mexican culture, the more you will begin to incorporate it into your cooking. If you pair that with a pantry of ingredients you've selected by forming relationships with the farmers, breeders, market vendors—hell, even a friendly chat with the store clerk who rings up your packet of dried guajillo chiles—you may begin to notice a subtle shift in the degree of depth and harmony in your food.

Cooking is not a school exam; it is not a linear, logical process (though, of course, logic is an essential element). You can cook that way—you are free to use this book merely as a set of instructions—and your food will probably turn out pretty tasty. Our hope for you, however, is that you'll expand your peripheral vision, make friends with your intuition, forget about end results, and above all *play* with this material. You might just discover the wizard within.

Mochitlan, Guerrero: Sacred Virgins, Masked Dancers & Mezcal

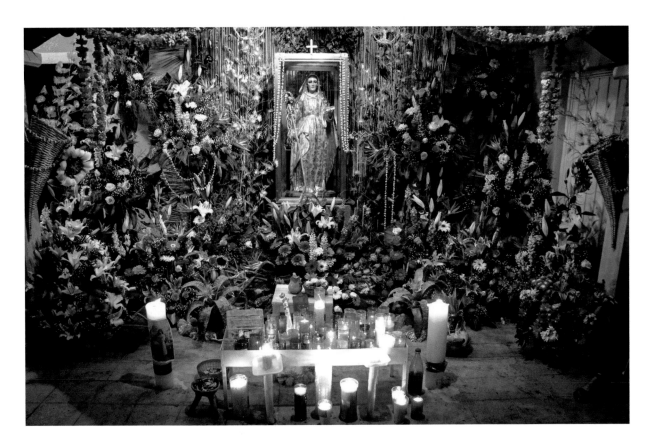

We drive the narrow road that leads from Chilpancingo to the tiny mountain village where Noel's mother was born and raised, past steep cliffs studded with stick-straight *organera* cacti and deciduous trees: *cosahuates* with their edible flowers; *huizache* whose spines are used as an antidote to scorpion bites; and *clavellino*, used for making dance masks. The mountainside tumbles into valley fields of maíz, calabaza, and cacahuate. Cows and goats roam freely along the sides of the paved road. As we drive, Noel fills me with tales of the revered Santa Ana.

"Mira, si veas una mujer vieja—pero muy *vieja—y se pide algo de ti, dáselo a ella. No piensas. Solo dáselo."*

He's prepping me for my first experience of the festival in Mochitlan—that of their patron, Santa Ana. Santa Ana, it is said, appears in the crowd from time to time as an ancient woman. She might ask for food, for money, for a bracelet you're wearing. The foolish refuse her. Those with faith don't hesitate to hand it over.

Another story comes directly from Noel's family:

Some years ago, my aunt wanted to offer a bull to the festival of Santa Ana. My brother offered to help and he found a beautiful stud, gray in color. It was an animal bred from a mix of several spectacular races and had a record of producing highly prized offspring. When they brought the bull to the festival, the farmers' association asked my aunt if they could give three regular bulls in place of this one enormous one, because this animal was exceptional. My aunt wanted to do her part and not cause problems with anyone, so she accepted the trade and took the three regular bulls to offer to the festival. The huge bull went to the corral of the farmers' association. The big surprise was that this bull was no longer capable of reproducing. They tried again and again to breed him up until he died, but the bull never sired a single calf since the day he was traded. Everyone believed it was because it wasn't what he was brought for—he was intended for Santa Ana. But because the farmers took him for themselves, he never served for anything again.

This is the power of Santa Ana.

Santa Ana is the Catholicized version of the fertility goddess—the goddess of the harvest. Because of their great devotion to Santa Ana, the people of Mochitlan—their children and grandchildren who have moved away to the city and even as far as other countries—donate what they can every year for the festival. Some put their names on a waiting list for three years to have the opportunity to donate flowers to the church; or bulls for the meals; or three-story, fire-spitting pyrotechnic towers for the after-dark celebrations. Others donate time.

We weave slowly through town, the late afternoon light warming the cobblestone road and casting its glow on the houses that line the streets in long, unbroken walls. Vendors are setting up their stands of jaguar-themed plastic toys, drums, and masks for children; carts brimming with candy; and stands for *eskimos* (milkshakes), *elotes* (corn on the cob), and rubbery pizza as found at every festival. An old man in jeans, boots, and a polished belt buckle sits on the corner of a wall, shoulders hunched, sombrero hanging low over his face, a can of Modelo at his side.

"Looks like someone was a little too eager for the party to start," I comment.

Noel smiles. "In Náhuatl we speak of the *tlahuanca*—the drunkards of the party. The drunkard is *necesario* to the party. He takes all the energy and chaos the people have inside them and lets it out. Without this release, that chaos builds up in the pueblo and explodes."

Everything has its purpose. Even drunkards.

We're searching for the posada we'd booked six months before. There are only three in town, each with just three to four rooms. We find it a few blocks from the central plaza. The owner, Doña Mariana, greets us with an enthusiastic embrace as if we're long-lost family members. Which, it turns out, we are. She is Noel's mother's cousin. I would come to discover that a third of the town were Noel's relations of some sort or another.

That evening we make a plan with Noel's sister for the following day. My intention is to document the festival for the cookbook. She is to meet me at four in the morning and escort me to the church where the many masked dance groups would be presenting themselves to the priest for a blessing at the start of the festival. We grab some quesadillas in the market before turning in to bed early.

At 9 p.m., we find Lila is running a temperature of 103°F; we spend the night giving

her cold-water baths and medicine. The room is sweltering hot: no AC and only a wheezy fan to move the air. At four, Noel's sister rings to say she is sick as well and can't take me.

Noel and I glance at each other over Lila's flushed body, each of us understanding our mistake.

"We need to ask permission," we say at the same time.

Noel leaves the hotel before dawn and makes his way to the church to ask permission of Santa Ana to document her festival in our book.

By mid-morning, Lila's fever has subsided and we head out in search of food, pushing the rickety stroller down the cobblestone streets to the mayordomo's house—one of two in town that is hosting the meals: breakfast, lunch, and dinner, free for any and all visitors. I'm keen to see the preparation of the *huacashtoro* (a regional beef stew) Noel has told me so much about—and hoping to get a recipe. Noel's brother had heard they'd be making it this morning.

A group of Tlacololeros are gathered outside the home resting from the late morning sun, slumped in their coarse henequen costumes, headdresses heavy with marigolds, faces concealed behind painted wooden masks, their left arms bound thick with more of the agave fibers

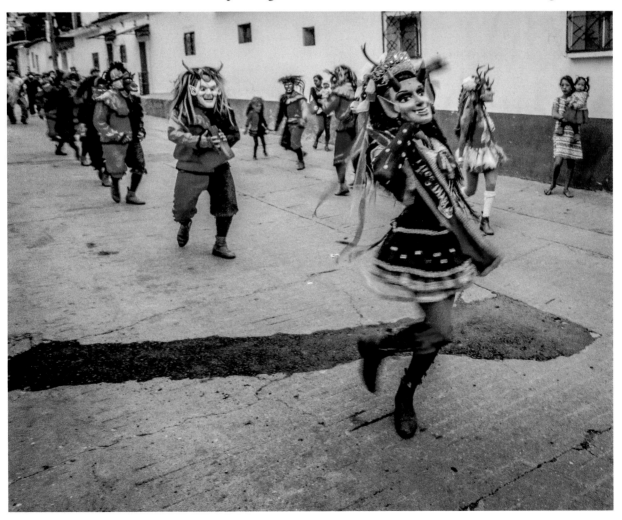

to protect themselves from the whipping they give one another during the dance. A bottle of mezcal is passed quietly among them.

Inside, a group of Diablos is dancing as a blessing to the mayordomo's family. The clacking of the *cajas de avaricia* fills the street, drawing the curious near. Red and black satin costumes; thick wigs, black and matted; more masks. The diabla (there is at least one in every group) is dancing with death. She dons a wig of heavy blonde curls, a woman's mask with vampire teeth and earrings, a short skirt, lace pantyhose, and black boots; she swirls her hips suggestively, taunting the lustful death. The she-devil is often played by a man—sometimes gay, though usually not. Women have only recently been allowed to participate.

The dance is replete with symbolism. If you look carefully, you see that each of the seven sins are represented. The she-devil is lust; the cajas de acaricia—the boxes that the dancers clack—represent where the greedy hide their money. The beautiful devil is pride; the devil in the fat-faced mask is gluttony. Masks of two colors split down the middle are envy. He who carries the *garrote* (wooden club) or trident is wrath, and the fiesta in general is slothfulness—a preference for the party over work. Death with his cloak and scythe always goes in front of the devils, because it isn't until after death that you suffer for your sins. And there is an angel—always short, usually a child—to show that our hope is very small compared to our sins. The symbolism is all quite Catholic: the natives didn't have devils, Noel tells me. This is a notion imported by the Church. The dance itself is far more primitive. It feels wild, shamanic—something that moves far beyond the reach of the church.

Many years ago in the festival of Mochitlan, the main dancer of the Diablos was an old man who lived outside of the town. Everything was ready for the festival to begin early the next morning. That night, the old dancer became terribly sick. He couldn't get out of bed the next day to go to the dance. He also couldn't let anyone know as all of his family had already left for the festival and he was alone in the house.

His family returned two days later, after the ceremonies had finished. Several of them congratulated the old dancer, saying, "Oye, hermano! Que bonito bailaste! *How beautiful you danced! And with your costume so elegant and your mask that looked so real with its face and terrible horns . . . and how you howled! You sounded like an animal the way you grunted! You were like a real demon!*"

The old dancer said, "But no—I didn't go. I couldn't even walk. My costume is hanging there right where I put it, and the mask as well. No one touched them. You all didn't know because you'd already left the house, but I didn't go to the festival. I was laid out since two days ago. I could only just stand up today."

"No, but we saw you there dancing! The same height . . . and it was your voice."

"Well, it wasn't me."

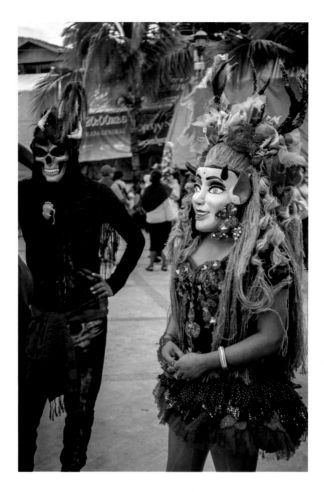

The Tlacololeros are perhaps the oldest of the native dance groups. Theirs is an agricultural dance, symbolizing the burning of the hillside in preparation, the planting of their crops, and their struggle with man's mortal enemy: the jaguar. But nothing here is cut and dried. The jaguar is also man's greatest friend, as he brings fertility and ends plagues. The *chireon* (the whip) represents both the sound of the fire with which they burn their fields and the thunder that precedes the rains.

Then we have the comedic *Costumbristas*: the Manueles and the Viejos. The Manueles formed in the 1800s as a social criticism of the wealthy criollo class (Mexican-born Spanish). The Viejos bring a humorous perspective to the process of aging, their white masks twisted and ugly.

There are brilliantly colored Santiaguerros, whose dance symbolizes the fight between the Spanish and the Moors, the leather-backed, be-plumed Aztec dancers, and the Tecuanes—a dance inspired in Guerrero, exported and modified in Puebla, and returned to Guerrero. It resembles a combination of Tlacololeros and Viejos. Their enormous, flapping straw hats—the size of which I'd never seen—reach down to the backs of their thighs; their gray beards dance at their knees. But it's the energy of their dance that overshadows all.

And then there are the handful of random people dressed in costume as if it's Halloween. I first notice a man dolled up as a woman with a wig, skirt, and heels, prancing about and blowing kisses. Later, I see a gorilla, Mister Geppetto and Pinocchio, and a lizardman. It's as if a piece of Disneyland has invaded this hidden corner of the world. I wonder if someone is trying to make a commercial mess out of a sacred tradition, but Noel corrects me:

"They are the Terrones and the Ihuaxquixcles. They both give fear, scream, and get drunk, but

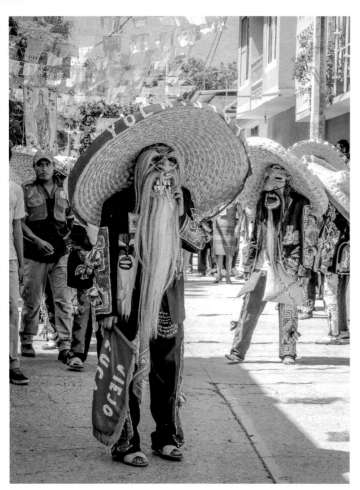

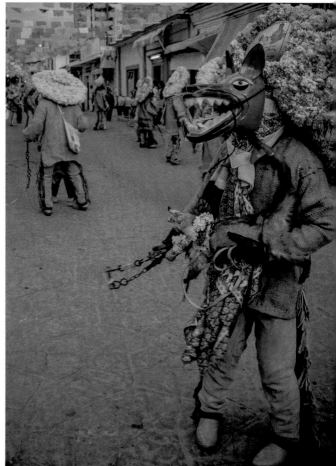

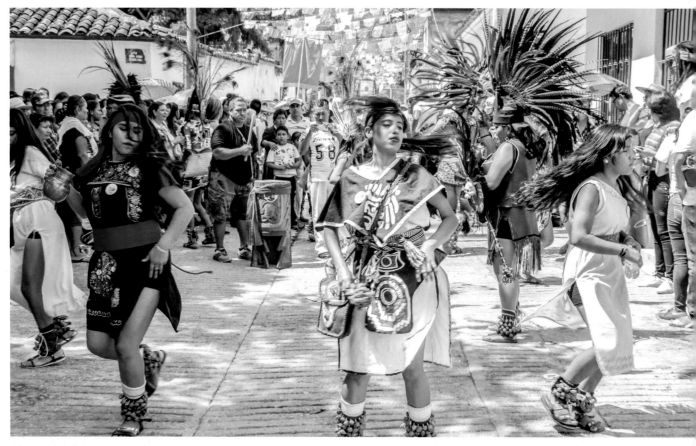

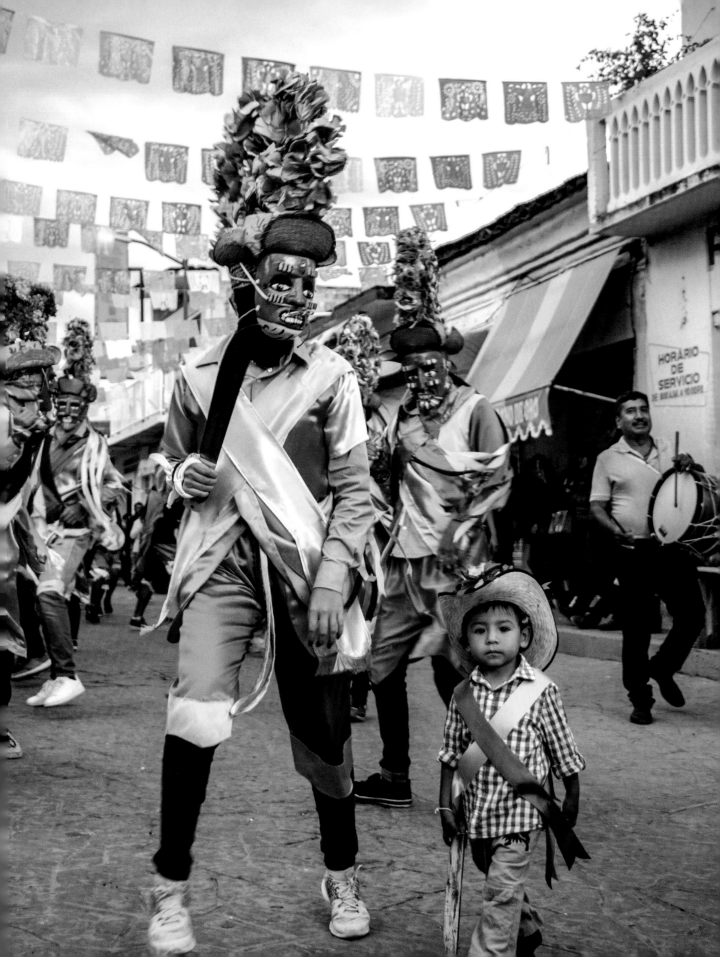

they open the road for everyone else. Screams break silence so all the spirits can move. It's the same with the bells. They're here to move the energy around the town and create chaos."

At first, I'm fascinated with the diablos and their expressive masks and the addictive snapping of their boxes. They seem to have the run of the town. That rhythmic clacking, punctuated by the roars of the diablos, accompanies me in my dreams. It's there in the mornings, in the afternoons and nights, waking me as if from a feverish dream. It keeps time for the duration of the festival, as if all movement and spirit will halt and disappear if the diablos don't maintain it. Though I come to depend on that rhythm to bind me to some semblance of reality, it soon fades to the background as my interest is pulled in other directions.

We leave the diablos and cut through the backyard of the mayordomo's house to where more than twenty men are working to butcher the seven donated bulls for the huacashtoro. Five bulls are strung from the rafters of a shelter, under which two long tables have been placed. Three men work to cut the meat from the body. The rest are focused on butchering it into

smaller pieces. A wheelbarrow sits askew, loaded with fresh ribs, marinating in a pool of blood. Around the corner are the women: four standing over comales making the endless supply of tortillas to feed the twelve thousand mouths that will pass through over the two weekends. Two others check the four pots that stand chest-high over open flames. Sacks of corn and large tubs filled with chiles left to soak are set off to the side, waiting their turn to be offered to the goddess.

We ask the tortilla ladies when they'll be cooking the huacashtoro, as I'd like to get a recipe and photos for the cookbook. "Come back in the afternoon," they tell us. And we do. And there is no huacashtoro, only pozole. "Later," they say. "Later in the afternoon." But there is no cooking of the celebrated dish then, either.

We return to the plaza to see who is dancing, meandering here and there without purpose,

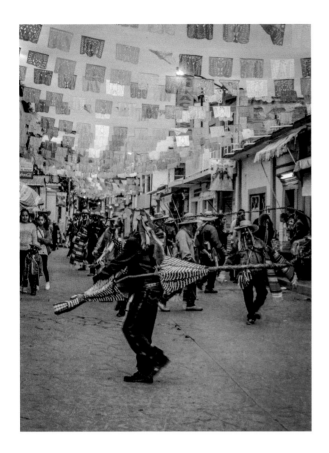

"Before, they used only white shirts and pants, so when the wire cut their skin you could see the blood seep through," Noel tells me. "There were many serious accidents back when they used thicker wire—cuts almost half an inch deep. Now they use jean jackets and pants for protection."

The alligator is one of the more important symbols in native Mexican cosmology. It represents time, cunning, and eternity.

Noel leaves before dawn the next morning to join the Aztec dancers. Lila and I stroll over to the public bathrooms where Noel's brother sets up arcade games and a stand of pirated movies for sale during festivals for a bit of extra income.

"*No van abajo pa' el huacashtoro?*" he asks me.

"The huacashtoro? They have it today?"

"*Sip!*"

"Haha, *finalmente!*"

My sister-in-law, Rosie, leads Lila and I down the hill for a late breakfast. The tables are packed and there's a line half the length of the thirty-meter garden, but whether we're supposed to stand in line or find a seat and wait for a *mesero* is unclear. We putz around for fifteen minutes before finally working our way to a packed plastic table under the circus-sized tarp, where we wait another twenty minutes for someone to bring us an *agua de jamaica* and a Styrofoam plate of the much-awaited . . . birria?

Yes. Birria, beans, and tortillas. The huacashtoro eludes me still.

But this birria . . . oh, what heaven!

I hold the warm moon in the palm of my hand, thick and full of life, and I tear a corner

happy to absorb the sights and sounds of this fantasy land. In front of the church, a long, double line of men in protective denim pants and jackets has assembled. They dance back and forth, in and out. A bundle of small wooden fish hang from their belts, which women come to collect with baskets, weaving among them. A lone man donning an alligator mask and possum pelt circles around as if one of them, but the fishermen know he is an imposter come to steal their fish. Trickery having failed, the lone man transforms into the crocodile, master of time. The crocodile has come to kill. The men taunt him with their machetes clanging on the stone floor. He hunts, slowly circling, until he has squared off with his victim. He spins, whipping his three-and-a-half-meter wire tail toward a fisherman, who attempts to jump it, but misses. His legs entangled, he falls.

of its heart and scoop the chile blood and torn flesh with the skin of Xipe Totec. I place it ceremoniously in my mouth. It melts and tingles and sweetens my soul. Another and another bite. I frown that I have to share with my one-year-old this single plate. But the kind man in the apron brings me another, along with a plastic cup of mezcal. It is not huacashtoro, but it is divine. That so much flavor, so much spirit could be held by a polystyrene plate, is astounding. I forgive my hosts for not sharing their secrets with me.

And herein lies the truth of Mexican cuisine: for all the rave reviews and media attention the celebrated culinary stars of this country receive (and deserve)—the restaurants of Mexico City that are on par with their Michelin-starred counterparts in the USA and Europe—this is where the soul of the country lies. Here on this shitty, environmentally destructive styrene plate, on a plastic table beneath a plastic tarp in the mud garden of someone's humble mountain home. You cannot buy soul; you cannot style it, sous vide it, package it, sell it, gift wrap it in pop words of "authentic" and "handcrafted." You cannot learn it in culinary school or on YouTube. Soul food is in the hands of those that craft it.

Then, as I sit elbow-to-elbow with a plump and perfumed woman; a mess of chile blood across the table, down my shirt, and smeared across my infant's face; with Santiaguerros clashing sabers in the alleyway, the first heavy drops fall. They fall with a ferocious pounding on the tarp. A torrential downpour from the heavens to match the outpouring of faith, generosity, and gratitude that shakes upward from the earth. Hailstones join the celebration—trees shake and shiver in the flood; the streets have turned into a river deep enough to float a canoeful of the

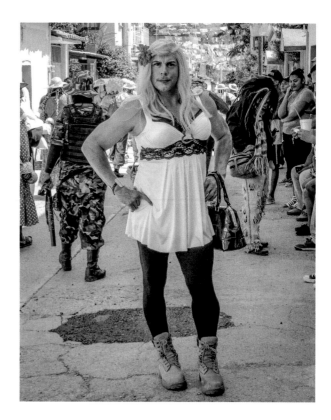

faithful. Still the dancers continue their knee-deep exaltation.

The tarp above us begins to collapse. A few young men jump atop the tables pushing it up with plastic stools to guide the water away from the middle and out to the sides. Those of us seated at the perimeter of the tarp huddle with the others in the center to keep dry and free of mud. Nervous laughter binds us as we watch in awe and trepidation, wondering if it will let up or if Mother Earth will reabsorb us into her marlacious womb.

The rain halts. Finally, without casualties. We pick our way through the mud to the street still flowing steadily, shin-deep now. Children have replaced the dancers, screaming, laughing, splashing in joyous abandon.

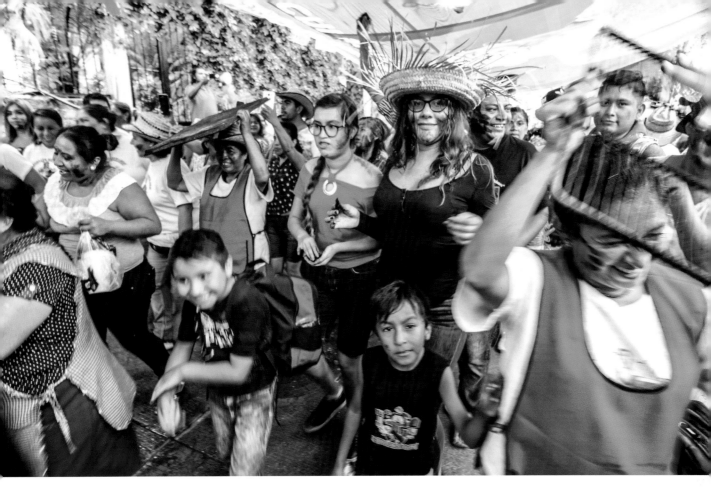

On high ground, back in the center of town, we find Noel, the Aztec dancers, and a few stray jaguars slugging mezcal from a bottle.

"*No maaaames*." Noel's eyes are shining. A fish returned to the sea. "I was playing the drum for the dancers, and just when I started to play with *fuerza*, the rain came *pooooouring* down! We kept dancing and playing in this crazy storm with rain and hail. And after, an old woman came to me and said 'How wonderful you still danced in the rain! For certain the Virgin is happy for this. Wait here. I will send you some mezcal.'"

The old woman. Santa Ana is pleased.

As the day fades to afternoon, the mezcal and food beckoning us toward siesta, a sound and song arise from the streets below, gathering force as it nears. We round the corner to find a group of townspeople parading the width of the *calle*, weaving their way throughout the pueblo. The people at the front carry a *teponatzle* (a wooden, two-toned drum), torches, and a can full of coins that they shake. They chant and sing and jump, accompanied by a brass band. Trailing behind them are a few men carrying firework launchers, which they set off at random. Their ranks grow as they continue through the pueblo, from fifteen beginning at the mayordomo's house to three hundred by the time they return two hours later.

I look to Noel for an explanation.

"This is the Mitotelixtli or Tesoro," he says. "It's a common dance—a pagan ritual. They move the energy of the pueblo. All the energy. *No hay bueno ni malo*." There's no good or bad. Just energy. "They move the energy so they can

have the resources they need to make the festival again the next year."

Over the course of the two-weekend festival, we witness at least five of these tesoros. And though there are no costumes, no masks, no dance steps involved, for me this is the most fascinating of all the rituals we see in Mochitlan. The energy the people carry is breathtaking. To sing and jump and shout for two hours straight under a tropical sun, beef stew dancing in the belly, mezcal in the veins . . . ! Even those just trailing along behind have more perseverance and devotion than I. Perhaps it's the unfading joy they put into it. Perhaps it's the fact that

these are humble townspeople on a simple mission: giving thanks to Santa Ana in the purest form available.

"Give me a few minutes," I tell Noel as he finishes packing the car. "I want to leave a candle for Santa Ana."

I'm not religious, and I don't hold much love for the Catholic Church, given its track record—particularly with indigenous peoples. But this blend with native tradition is something else. Its focus on energy, community, and daily life; its

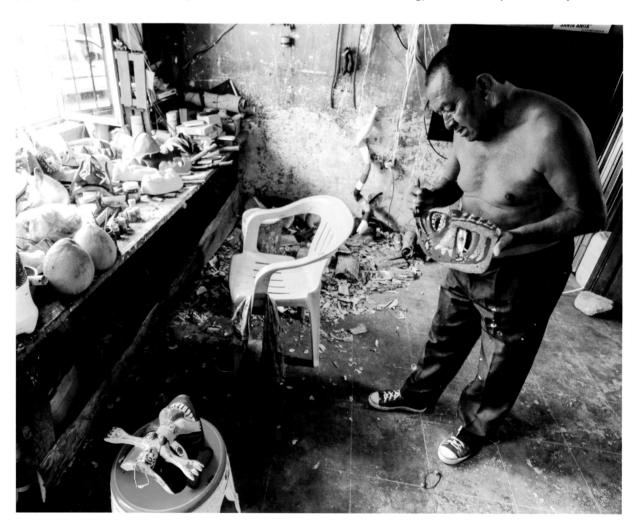

integration with agricultural and natural cycles; and its shamanic roots speak to me. I decide to make my own petition.

"You have to offer something that hurts you. That costs you," Noel had told me. "What you offer needs to reflect what you ask. The bigger the ask, the bigger the offer should be."

I wheel Lila in her stroller back to the center of town, stopping to buy a candle on the way. We enter and make our way to the front, pausing between the altars to take it all in and listen to the Virgin. We turn to the left of the altar to the veladoras; I light the candle and make my request and my offer.

At first I think in terms: how much I want in details; how much I'll give in exchange. But it feels too much like a business. I remember the why behind my actions. Why I write, why I live in Mexico, why I married Noel. I modify my ask to reflect the energy and feeling of what I want, rather than a verifiable end result. And I make my promise.

<center>***</center>

Four days later, we return, after an extended run to the Mexico City airport to pick up Meg, our photographer and friend. All the hotels are booked, so we wander around a bit aimlessly, hoping a room will somehow present itself.

"*Todo tiene una solucion menos el muerte*," Noel says. Everything has a solution except for death.

Noel leads us to Ramiro the mask-maker's house to see his extraordinary workshop where he carves and paints dance masks for the many different groups. Beasts and devils and men possessed fill the walls. Wood chips and splashes of paint carpet the floor; the ceiling has crumbled, revealing the rebar supports. Ramiro's workshop itself is as much a piece of art, albeit accidental, as the masks on display.

We continue our meandering, where Noel bumps into cousins and aunts every three blocks. We ask a handful of them when the huacashtoro will be prepared. Still no clear answer. We shift our intentions to mezcal and ask Noel's brother when he can take us up the mountain to visit a mezcalero who is supposed to be distilling mezcal from berraco agaves over the next few days. Or is it *zacatoro* he has? Or papalote?

In thirty minutes we'll go. No—in an hour. Mmmm . . . maybe in the afternoon. Noel's uncle, Serafín—our guide and key to our safety in the territory above town—is still drunk from the night before, so maybe tomorrow. Nothing is certain. We get different answers every time we pose the question, each answer given with equal confidence, like it's a sure thing.

And this is Mexico. This is what you get when you wander beyond the comfort of the known: full-frontal uncertainty. Nothing goes as planned, yet it tends to all work out. Miraculously, we find a hotel room. Newly built, clean, and only twenty-five dollars a night. Miraculously, Serafín sobers up enough to lead us up the mountain to the mezcalero. He'll take us to where there's berraco growing too, he says.

"And they're making mezcal today, right?" I ask in Spanish.

"*Si, claro!*" he tells me.

The mezcalero is not home and not making mezcal. Maybe tomorrow. Maybe not. But his wife offers us some to try. "It's capón," she says.

"That's the same as berraco," Noel tells me.

"Isn't capón a method of harvesting agave?" I ask. "Isn't this papalote?"

"No, it's capón," they repeat, as if it's its own species.

"They have zacatoro here, too," says Serafín.

"Is that a different species from papalote and berraco?" I ask.

"Yes."

"No."

"It's capón," repeats the mezcalero's wife.

Thank God I'm not writing a dissertation.

Capón: Papalote—a goat roasting on the spit; flames licking against the black of night. You watch in awe, eyes wide, as something of the dark side tugs at your heart. You sense danger, but its sweet whispers draw you closer.

Berraco—A mezcal to end all mezcals. The Rapture has arrived: your knees shake, waves of pure pleasure tickle your insides, and you wonder if it's inappropriate to fall to your knees in gratitude of this Heavenly (yet sinful) spirit.

We buy a few liters and pile into the car to head farther up the mountain to where berraco (they tell me) is growing. I'm eager to see it in the wild, as I haven't met anyone outside of Guerrero who has heard of this species. Noel drives, while the mezcalero's wife and child ride shotgun; Lila, Meg, and I in the back, and Serafín and Ismael—Noel's brother—in the far back with the door hanging open. A plastic bottle of mezcal is passed around. In the company of Ismael, the plastic bottle is always passed around.

The landscape is jaw-droppingly beautiful. Deep ravines cut through with plateaus glimmering in various shades of green; the mountainside dotted with agaves and plaited with milpa. Mule paths crisscross the slopes and lead to a solitary wooden shack sitting crookedly above it all.

"*Parate aqui*," directs Serafín.

Noel pulls over on the far side of the curb, and we're led under a fence and through a thicket to arrive on the steep, westward-facing slope, studded with voluptuous papalotes. *Were I a bat*, I muse, *I'd be feeling wildly horny right now.* As a mere lover of mezcal, I'm exceptionally titillated in this moment.

There is not a single berraco on this mountainside, but the papalote agaves are so utterly striking they seem to be sentient. Meg takes dozens of photos while I wonder if we couldn't just live here forever.

The next morning, we breakfast on *barbacoa de chivo* before heading down to the mayordomo's house in another attempt to find out when they'll be cooking the huacashtoro. We get a shoulder shrug from one of the ladies and a shake of the head from another. We ask one of the men who is watching over the seven pots boiling away on wood fires; they are large enough to hold two full-sized adults.

"*Mañana*," we're told.

Ahhhh. *Mañana.* Now I understand. The famous Mexican *mañana*—code for "maybe later, or possibly never." It occurs to me that perhaps they don't want me present to see how they make it. Family secrets? Community sacrament? Whatever it is, being the wife of the son of a Mochiteco is not enough to open the doors all the way, it seems.

The final day of the festival is when Santa Ana is paraded through the town. Her figure is hoisted up on a wooden support and carried by some twenty men. This is the day that draws the largest crowds, including more dance groups and larger, more boisterous tesoros, where participants smear one another with ash from the fires that they've cooked over for the past ten days. And, of course, the granddaddy of pyrotechnic towers: the *castillo*.

In front of the church, they'd set up two pyrotechnic towers, both taller than the church itself. The towers are constructed of squares of crisscrossed wood, stacked one atop the other. From about fifteen feet and higher are fastened a series of spinning wheels with images of Jesus, a man on a horse, a cross, a bell. A crowd of five hundred or more fills the plaza, the steps, and the bordering streets in anticipation. The first tower

is lit from below, sending the first wheel into a whizzing, popping delight, until it burns out and the fuse leads on to the second wheel, working its way toward the crown.

Meg and I station ourselves against a barricade off to the side, behind which are two rows of PVC piping standing on end, ready to blast out

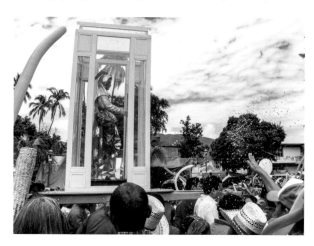

the occasional firework. Two men are in charge of these; one straddles his pipe while smoking a cigarette. A parentless young boy leans against the barricade. Clearly, this is not a litigious society.

The first firework goes off in a deafening boom, showering us with burning sparks. We move to the steps—farther from the fireworks, but closer to the castillo. We're hedging our bets, gambling that the exploding tower is less of a risk than the PVC bombs.

The fuse creeps up the castillo, igniting three panels. Like a holy trinity hosting a rave party, images of Jesus, Mary, and the cross spin wildly above, hailing sparks and smoke down on us. The crowd ducks and pushes away in unison. Many of those at the base of the tower hold a sheet of cardboard over their heads for protection from the sparks. Most go for it, fully exposed to the rain of fire.

The crown of the tower goes off, accompanied by two sets of six beastly fireworks from atop the church. A wheel ignites and spins with such fury it flies from the tower, hovers drone-like above, and lands in the crowd twenty feet away. The grand finale booms from the sky as the townspeople rejoice, dancing circles around the base of the tower, waving miniature fire-spitting castillos the size of small children, over their heads.

Meg and I laugh at the madness of the scene. I wonder why the hell I hadn't drunk more mezcal. We look at one another, a hint of terror sparkling in our eyes.

Is this a symbolic act of faith? I wonder. *An exaggerated display of bravado? Or just sheer insanity?* Whatever it is, it is damn good entertainment. Firework shows are forever ruined for me. My hometown Cincinnati's anticipated Labor Day display? Meh. Macy's Thanksgiving Day parade? Boring. Even Oaxaca . . . oh, Oaxaca! Beloved for your festivals and prismatic *desfiles* . . . you don't hold a candle to this level of savage revelry.

I'm reminded of the great festivities I've experienced in my life. In rural France, it was inflated sea creatures dancing though the streets of a tiny medieval village, bumping into the precariously strung electrical wires; while chickens packed in salt, roasted whole, were carried out to the town square via tractor trailer for communal feasting. Oaxaca City's famous Day of the Dead celebration, I recall, felt a mere shadow of its roots compared to the same celebration in a neighboring indigenous town. The bigger

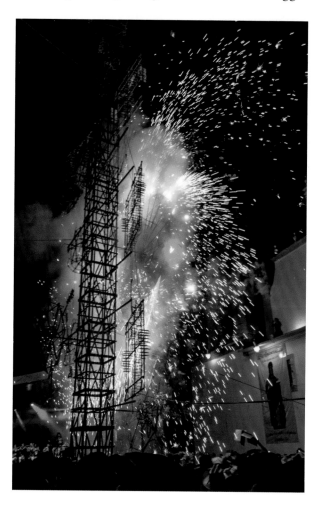

the show, it seems, the more tenuous the soul connection.

And so it is with the food we consume. When we eat at high-end restaurants, where the show of dining is more important than the people in our company or those who've grown and cooked the food, we stimulate our intellect and our sense of importance—an act that tends to separate us further from those outside our social circle. When we sip mezcal straight from a jicara, sitting on plastic chairs on a dirt floor with the mezcalero, or when we eat together as a family—in the kitchen of a stranger we've just met on our travels or on the street while conversing with the vendor—we nourish our sense of humanity. Food, after all, is the common denominator of all humans. It's what unites us across the tablet of color, belief, economics, orientation, and tradition. And aside from providing physical sustenance and palatal pleasure, isn't this the heart we seek in our culinary experiences? Whether your cooking is traditional or innovative, mediocre or Michelen-star-worthy, it is always richer when shared with others in conviviality.

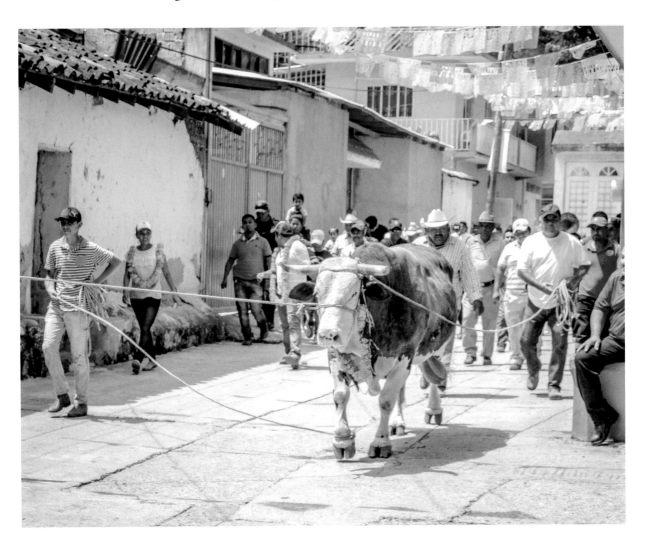

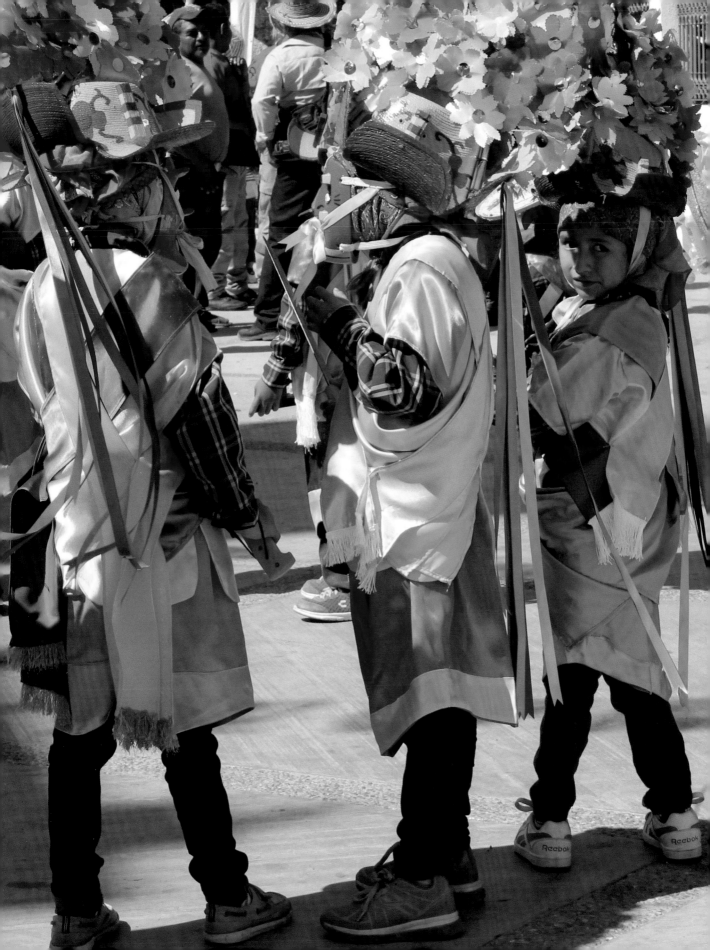

Sopas
Soups

An enormous number of soups and stews are served in Mexico.
There is something for every occasion, whether you're in the mood
for light like the sopa de milpa, energy-packed like a pozole,
or hearty like the beef-based huacashtoro.

Sopa de Milpa
Cornfield Soup

*Vegan

SERVES 6

This soup is the perfect balance of Mesoamerican cuisine, with all the essential nutrients and elements of the milpa.

6 ears of fresh corn
2 tomatoes
2 poblano chiles
3 tablespoons olive oil
1 pound green beans, each cut into 4 parts
1 pound zucchini or yellow squash, cut into large cubes
⅓ cup diced white onion
3 garlic cloves, chopped thickly
1 serrano chile, whole
8½ cups water
2 tablespoons fresh epazote (or 1 tablespoon dried)
Salt and pepper to taste
½ cup fresh cilantro, chopped, for garnish

Cut the corn kernels from the cobs.

Place the tomatoes over a direct flame on the stove and turn regularly until they become slightly burnt on all sides. Set aside. Do the same for the poblanos. Allow the tomatoes and poblano chiles to cool to the touch and remove the skins. Slice the tomatoes into cubes. Remove the seeds of the poblanos and slice into strips.

Heat oil in a pot on high. Once the oil is hot, add the green beans and zucchini and sauté for 3 minutes. Add the corn kernels, onion, and garlic and sauté 3 more minutes, then add the tomato, poblano chiles, and serrano chile and sauté for 2 minutes.

Add 8½ cups of water, epazote, and salt and pepper to taste. Bring to a boil then lower to medium heat and cover. Leave to simmer for 30 minutes. Adjust the salt and pepper as needed.

Garnish with cilantro and serve.

Sopa de Tortilla
Tortilla Soup

SERVES 4–6

A simple soup full of flavor, and a classic in Mexico.

6 pasilla chiles
3 garlic cloves, peeled
¼ medium white onion
2 red tomatoes, cut in half
7 cups water or chicken stock, divided
2 cups vegetable oil
1 pound corn tortillas, cut into strips
Salt and pepper to taste
1½ cups crema
9 ounces cotija cheese
2 avocados

Cut the chiles lengthwise and remove seeds, stems, and veins. Toast in a pan on medium without oil for 2 minutes and set aside.

Add the garlic, onion, and tomatoes to the same pan and toast on medium for 5 minutes, rotating regularly. Turn off the heat. Add to the blender along with 5 of the pasilla chiles (save the sixth chile for later) and 1 cup of water or chicken stock, and blend until smooth.

Heat a pan on medium-high and add vegetable oil; allow the oil to heat for 2 minutes. Add a large portion of the tortilla strips (as much as allows you to cook the tortillas well) and fry until crunchy. Place the fried strips on a paper towel to absorb the oil. Repeat until all the tortilla strips are fried.

Heat a pot on medium and add the blend along with the remaining 6 cups of water or chicken stock. Add salt and pepper to taste and leave to cook for 15 minutes on medium. While it's cooking, slice the remaining pasilla chile into thin strips to use as a garnish

Serve the soup in a bowl. Add a large portion of fried tortilla strips, a large spoonful of the crema, some crumbles of cotija cheese, strips of pasilla, and a few slices of avocado and serve.

Pozole Rojo
Red Pozole

SERVES 6

Pozole is a hearty, hominy-based stew, usually featuring chicken or pork. Pozole rojo is particularly common in Jalisco, but can be found throughout the country. If you decide to use pork, you'll need a few cups more water for the stock, as it takes longer to cook.

SOUP

1 pound chicken breasts or pork leg
19 cups water, divided
1 medium white onion: half julienned, half left as is
8 garlic cloves, divided
Salt and pepper to taste
1 (4.4-lb) can pozole corn
½ cup oil, divided
5–6 guajillo chiles
2–3 árbol chiles, whole, dried
1 pound tomatillos, husks removed
1 teaspoon cumin
1 teaspoon whole clove
1 tablespoon dried oregano

SIDE GARNISHES

1 head romaine, finely chopped
3 avocados, sliced
1 bunch radishes, thinly sliced
1 cup dried oregano
1 pound chicharrónes
8 limes, quartered
Chile powder
1 onion, julienned
1 bag tortilla chips
3 serrano chiles, finely chopped

Boil the chicken breasts in 17 cups of water for 1½ hours. When the water begins to boil, add the half unchopped onion, 4 garlic cloves, salt, and pepper.

Open the can of pozole, strain off the water, and rinse the kernels under fresh water. When the water from the pot is boiling, add the pozole to the pot and cook on medium heat.

Heat a pan with 3 tablespoons of oil and sauté the chiles, approximately 2 minutes. Take care not to burn them.

Place the chiles in a separate pot with the remaining 2 cups or enough water to cover them and cook for approximately 10 minutes or until soft. Remove the chiles and set aside both the chiles and the chile water for later.

Heat a pan with 3 tablespoons of oil and sauté the tomatillos, rotating regularly, until they begin to take on a golden color. Place in a blender with 1 cup of chicken stock from the pot, the guajillo and árbol chiles, remaining 4 garlic cloves, cumin, cloves, half julienned onion, and oregano, and blend well.

Once the pozole kernels are boiling, remove the chicken breasts carefully and set aside. Add the blended salsa to the pot and allow to simmer on low for 2 hours, stirring occasionally. When the water has reduced by approximately 20 percent and the pozole kernels open up, the soup is ready. Check the salt level and add more if needed.

Shred the chicken breast (or pork). Serve the pozole in a deep bowl and add approximately 3 tablespoons of shredded chicken to each bowl.

Serve the garnishes on the side in individual small bowls.

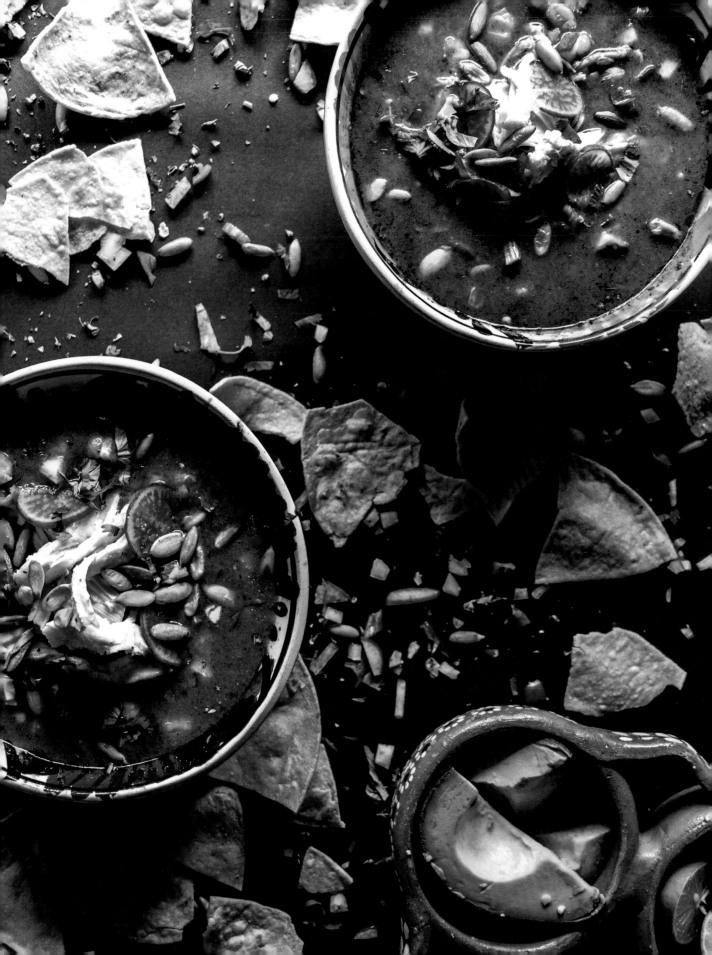

Pozole Verde
Green Pozole

SERVES 6–8

This is a traditional pozole from Chilpancingo, Guerrero; so loved that Guerrerenses have dedicated one day of the week to eating it: *jueves pozolero*, or pozole Thursdays. You can make this recipe with chicken or pork, or a bit of both. If you decide to use pork, you'll need a few cups more water for the stock as it takes longer to cook.

12½ cups water (if making with pork, use 17 cups of water)
2¼ pounds chicken breast or pork (preferably on the bone for more flavor)
1 white onion, cut in two halves and peeled
4 bay leaves
1 tablespoon dried oregano
10 garlic cloves, peeled, divided
Salt and pepper to taste
1 large (2¼-lb) can precooked pozole corn (hominy)
1 cup pumpkin seeds
12 tablespoons vegetable oil, divided
2¼ pounds tomatillos, husks removed
1 cup chard
1 cup spinach
1 cup radish leaves
1 cup fresh cilantro
1 cup fresh epazote (or ½ cup dried)
1 cup parsley
1–3 fresh serranos
4 fresh jalapeños
2 fresh poblano chiles
1 pinch clove
1 pinch cumin
1 pinch thyme
1 pinch marjoram
1 pinch oregano

For the Sides

1 cup chopped cilantro leaves
½ cup pumpkin seeds
8 limes, quartered
9 ounces tortilla chips and/or chicharrónes
4 avocados, sliced
4 radishes, sliced
1 cup dried oregano
3 serrano chiles or jalapeños, finely chopped
3 tablespoons chile powder
½ medium white onion, diced

Heat the water in a pot on medium-high. Add the chicken (or pork), half the onion, bay leaves, oregano, 6 garlic cloves, and salt and pepper to your discretion. Cook for 45 minutes or until the chicken is very soft (for pork, cook for 2 hours or until it's soft and falling off the bone). When the meat is ready, remove the meat, allow to cool, then shred. Check salt and pepper levels and adjust as necessary.

Rinse the hominy and place in the pot with the chicken stock. The stock should be one part corn to two parts water. If not, add more water. Cook on low for 1 hour before adding the salsa below.

Toast the pumpkin seeds in a pan on medium-low without oil for about 3 minutes, stirring constantly so they don't burn. Remove and set aside. Turn the pan to medium-high and heat 4 tablespoons of oil. Add the tomatillos, half chopped onion, and remaining 4 garlic cloves and sauté until the tomatillos become golden on all sides. Allow to cool, then blend in a blender and set aside.

Add more oil to the pan if necessary. Cut the chard, spinach, radish leaves, cilantro, epazote, and parsley into large pieces and sauté for 5 minutes on high. Set aside.

Slice the serranos and jalapeños lengthwise and remove the seeds and veins. Place the poblanos directly over a low flame (or in a pan on medium), turning regularly, and cook until the skin begins to burn on all sides. Remove and place in a sealed container or sealed plastic bag so the vapor concentrates (this makes it easier to remove the skins). Wait 10 minutes before taking the chiles out and removing their skins and seeds under cool water to assist you.

Sauté the chiles for 3 minutes with 4 tablespoons of oil. Blend the chiles in a blender and set aside. Blend the sautéed greens and herbs with the pumpkin seeds and some broth to facilitate blending. Set aside.

Heat a large pan on medium-high and add 3 tablespoons of oil. Add the blended tomatillo-chile mix and cook for 2 minutes. Add the blended greens, herbs, and pumpkin seeds and cook on low for 25 minutes.

Heat a new pan on low and toast (without oil) all the spices (clove, cumin, thyme, marjoram, and oregano) for 2 minutes, stirring constantly. Add to the pan with the other ingredients, stir and leave to cook for 5 more minutes for the flavors to integrate. Add this mixture to the chicken stock and cook on medium-low for 20 minutes. Check the salt and pepper and add more if necessary.

Serve the pozole in a deep bowl, making sure you get a fair amount of the pozole kernels in each bowl. Add a portion of the shredded chicken or pork. Garnish with a bit of cilantro and pumpkin seeds. Serve with quartered limes, tortilla chips, sliced avocado, sliced radish, dried oregano, finely chopped serrano, chile powder, and diced onion on the side in individual bowls.

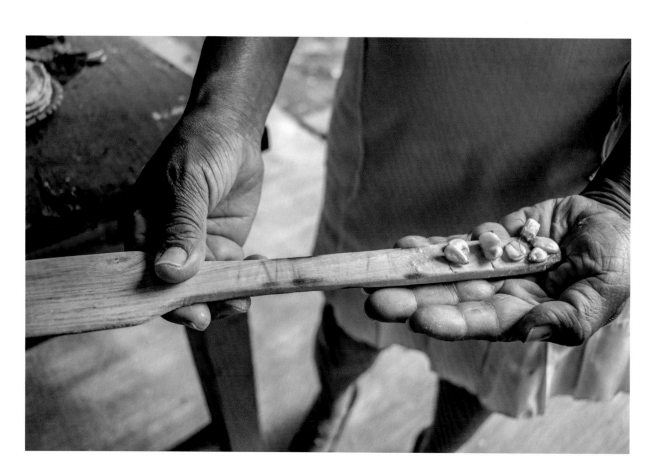

Sopa de Haba
Fava Bean Soup

*Vegan

SERVES 4–6

Fava beans are one of the oldest known cultivated crops, having popped up in the Mediterranean diet around 6000 BCE. They are high in protein, carbohydrates, folate, vitamin B, and various other vitamins and minerals. They're common in Central Mexico as a filling for *tlacoyos*, fried for a salty snack, or in a soup. This fava bean soup is one of our favorites.

8½ cups water
4 garlic cloves, divided
1 medium white onion: half cut in two, half julienned
2 pounds dried fava beans
2 tablespoons oil
2 tomatoes without seeds, cut in large cubes
Salt and pepper to taste
½ cup fresh cilantro leaves for garnish

Place 8½ cups of water, 2 garlic cloves, the half onion that was cut in two, and the dried favas into a pot on medium heat. Cook for 30 minutes in a pressure cooker. (If you're using a regular pot, use 12½ cups of water and allow to cook, covered, on medium heat for 2 hours or until the beans are soft).

Add oil to a pan and sauté the remaining 2 garlic cloves, the half onion that was julienned, and the tomatoes on medium heat until the onion is translucent. Add to the pot with the cooked favas. Stir and cook another 15 minutes. Check the salt and pepper and add more if needed.

Serve in a bowl and garnish with cilantro.

Huacashtoro Mochitlan Beef Stew

SERVES 5

Much like the Spanish invasion, this dish is a violent fusion of indigenous and Spanish elements. The natives bring the chiles and the cooking process, while the Spanish custom of angering the bull as they walk it through town is considered essential. This is the beloved dish of Mochitlan, Guerrero, eaten during the Festival of Santa Ana.

17 cups water
2 pounds beef brisket or beef chunks cut in large 1-inch squares
2 cups dried garbanzo
½ white onion, julienned
Salt and pepper to taste
2 tablespoons oil
2 pasilla chiles, seeds removed
8 guajillo chiles, seeds removed
1–3 árbol chiles
4 garlic cloves, peeled
½ teaspoon clove (powdered)
½ teaspoon thyme
½ teaspoon cumin
½ teaspoon marjoram (powdered)
4 zucchinis, cut in 3 parts
Tortillas to serve on the side

Place the 17 cups of water in a large pot on medium heat and add the beef, garbanzo, onion, and salt and pepper to your discretion. Cover and leave to cook for 2½ to 3 hours.

Meanwhile, heat a pan on low with oil and add the pasilla, guajillo, and árbol chiles, and allow to toast for 2 minutes, moving constantly, until they become darker in color. Be careful not to burn them.

Add the chiles to the blender along with the garlic, clove, thyme, cumin, marjoram, and a bit of the stock from the pot. Blend until completely smooth, then add to the pot and leave to cook for the remaining time.

When it is 15 minutes before the stew has finished cooking, add the zucchinis. Once the meat is soft, your stew is ready. Check the salt and pepper levels and adjust as necessary.

Serve in a bowl with tortillas.

Pozole Verde Vegetariano Vegetarian Green Pozole

*Vegan

SERVES 6–8

You'd be hard-pressed to find a vegetarian pozole verde in Guerrero, but we make this version along with the traditional pozole every Thursday in El Refugio, and it is outstanding!

1 cup pumpkin seeds
15 tablespoons vegetable oil, divided
2¼ pounds tomatillos, husks removed
1 white onion, half julienned, half chopped into ½-inch cubes
10 garlic cloves, peeled, divided
1 cup chard
1 cup spinach
1 cup radish leaves
1 cup fresh cilantro
1 cup fresh epazote (or ½ cup dried)
1 cup parsley
2 fresh serrano chiles
4 fresh jalapeño chiles
2 fresh poblano chiles
1 pinch clove
1 pinch cumin
1 pinch thyme
1 pinch marjoram
1 pinch dried oregano
12½ cups water
2¼ pounds precooked pozole corn
4 bay leaves
Salt and pepper to taste
14 ounces sliced button mushrooms

FOR THE SIDES

1 cup chopped cilantro leaves
½ cup pumpkin seeds
8 limes, quartered
4 radishes, sliced

1 bag tortilla chips or chicharrónes
2 avocados, sliced
1 cup dried oregano
3 serrano chiles, finely chopped
3 tablespoons chile powder
½ medium white onion, diced

Toast the pumpkin seeds in a pan on medium-low without oil for about 3 minutes, stirring constantly so they don't burn. Remove and set aside. Turn the pan to medium-high and heat 4 tablespoons of oil. Add the tomatillos, half chopped onion, and 8 garlic cloves and sauté until the tomatillos become golden on all sides. Allow to cool then blend and set aside.

Add more oil to the pan if necessary. Cut the chard, spinach, radish leaves, cilantro, epazote, and parsley into large pieces and sauté for 5 minutes on high. Set aside.

Slice the serranos and jalapeños lengthwise and remove the seeds and veins. Place the poblanos directly over a low flame (or in a pan on medium), turning regularly, and cook until the skin begins to burn on all sides. Remove and place in a sealed container or sealed plastic bag so the vapor concentrates (this makes it easier to remove the skins). Wait 10 minutes before taking the chiles out and removing their skins and seeds under cool water to assist you.

Sauté the chiles for 3 minutes with 4 tablespoons of oil. Blend the chiles in a blender and set aside. Blend the sautéed greens and herbs with the pumpkin seeds and some water to facilitate blending. Set aside.

Heat a new pan on low and toast (without oil) all the spices (clove, cumin, thyme, marjoram, and oregano) for 2 minutes, stirring constantly.

Heat a large pan on medium-high and add 3 tablespoons of oil. Add the blended tomatillo-chile mix and cook for 2 minutes. Add the blended greens and pumpkin seeds, and cook on low for 25 minutes.

Add the toasted spices to the pan with the other ingredients, stir and leave to cook for 5 more minutes for the flavors to integrate.

Put 12½ cups of water in a pot on medium-high, along with the pozole kernels, the bay leaves, salt and pepper, and all the mixed ingredients from the other pan. Leave to cook for 45 minutes. Check salt and pepper levels and adjust as necessary.

Heat a pan with 2 tablespoons of oil. Finely chop the remaining 2 garlic cloves and add them to the pan with the half-chopped onion, and the sliced mushrooms. Add salt and pepper to taste and sauté for 4 minutes on high. Set aside.

Serve the pozole in a deep bowl, making sure you get a fair amount of the pozole kernels in each bowl. Remove bay leaves if you prefer. Add a portion of the sautéed mushrooms. Garnish with a bit of cilantro and pumpkin seeds. Serve with quartered limes, sliced radish, tortilla chips, sliced avocado, dried oregano, finely chopped serrano, chile powder, and diced onion on the side in individual bowls.

Sopa de Guia Squash Vine Soup

Recipe by Vicky Hernandez
*Vegan

SERVES 6

This is a classic Oaxacan soup recipe that makes a beautiful vegan dish. It is challenging, but only in that you'll need to hunt down the ingredients. Check in a greenhouse for the herbs (or seeds), search online, or visit your local Mexican grocery store.

FOR THE SOUP

8½ cups water
1 garlic head, cut in half
1 medium white onion
Salt and pepper to taste
3 small ears of corn (preferably not the sweet variety)
3 tender green squash or zucchini
1 bunch tender squash vines
1 bunch piojito (*Galinsoga parviflora* or "potato weed")
1 bunch chepil (*Crotolaria longirostrata*)
1 bunch chepiche (*Porophyllum tagetioides*)
1 bunch squash flowers

FOR THE CORN FLOUR "LEAVES" (OPTIONAL)

3½ ounces corn dough (see masa recipe, page 72)
6 tablespoons oil (if not vegan, can substitute manteca)

FOR THE SOUP

Place 8½ cups of water in a pot with the head of garlic, the onion, salt and pepper, and the corn that is cut into 3 to 4 pieces. Cook on medium for about 10 minutes or until the corn is soft. Wash the vegetables and vines. Cut the squash into thick slices. Select the tender parts of the vines to use and slice the tender leaves of the vines into small pieces.

Cut the stems and leaves of the piojito, chepil, and the chepiche into pieces. Remove the sepal (the green part at the base) from the squash flowers and cut the flowers in two.

Once the corn is cooked, add the squash, the vines, and the herbs (and optional corn dough leaves), and cook for 10 minutes on medium.

FOR THE CORN FLOUR LEAVES (OPTIONAL)

You can add little "corn flour leaves" to the soup to give it more texture and flavor.

Mix corn dough with oil or manteca. Mix well and form small balls with the dough. Press the balls into leaf shapes with your thumb. Add these leaves to the pot at the same time as the squash.

En el Mercado
In the Market

We can't say it enough times: If you really want to understand Mexican cuisine, you need to eat in her markets and on her streets. A lot. Not only is the quality better than what you'll find in most restaurants (for a fraction of the price), the diversity is outstanding and the experience itself puts you in touch with the pulse of Mexican culture. Below are just a few of the plates you can find in these places.

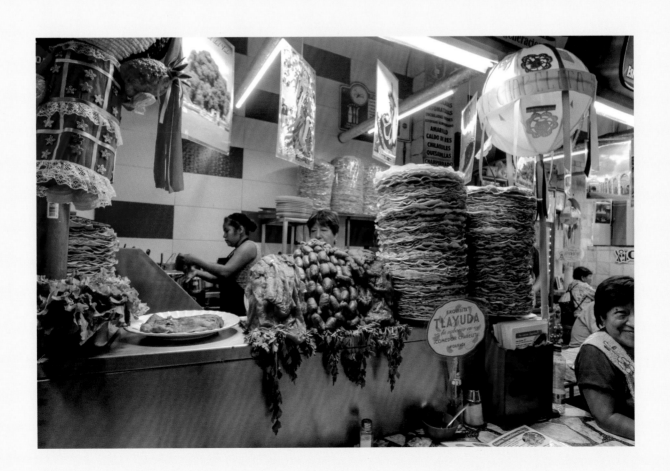

Chicharrón en Salsa Verde
Pork Rinds in Green Salsa

SERVES 6

This dish is one of the most popular in Mexico. It is usually eaten for breakfast, but at whatever hour you choose is great. It's a humble plate, but when well made, *es una chulada!*

6 tablespoons vegetable oil, divided
1 pound tomatillos, husks removed
½ medium white onion, julienned
1–3 serrano chiles
2 garlic cloves, chopped
4 cloves
1 pinch cumin
2 cups chicken stock
½ pound chicharrónes (pork rinds), broken into 3-inch pieces
Salt and pepper to taste
Tortillas to serve on side

Add 3 tablespoons of oil to a hot pan. Sauté the tomatillos until they begin to change color. Set aside.

In the same pan, sauté the onion until it becomes translucent. Add the chiles and sauté 3 minutes. Add the garlic and sauté another 3 minutes. Blend the above ingredients in a blender with the cloves and cumin. Add a little water or chicken stock if necessary.

Heat the remaining 3 tablespoon of oil in a pan on medium-low and add the above salsa. Add the pieces of chicharrónes and cook for 5 minutes. Then add 1 cup of stock or enough to partially cover the chicharrónes. Stir regularly and cook until the chicharrónes are soft (about 15 to 20 minutes). Add salt and pepper to taste. The dish should be somewhat liquid—not too thin, not too thick.

Serve in a bowl with tortillas on the side.

Tlayudas de Chapulín
Cricket Tlayuda

SERVES 4

A tlayuda is one of the more popular foods found in Oaxaca. It consists of a very large, thin, crunchy tortilla about the size of a medium pizza, topped with refried beans, quesillo, lettuce, avocado, and a protein such as pork, beef, or chapulines—crickets. It can also be made vegetarian. To give your tlayudas the most flavor, you'll want to use asientos de puerco, which can be found in many Mexican grocery stores (as can the tlayuda tortillas). If it's not available, substitute manteca.

2 cups refried black beans
4 corn tlayuda tortillas
¼ pound asientos de puerco
½ pound chapulines
½ head of romaine lettuce, thinly sliced
2 red tomatoes, sliced
¼ red onion, thinly sliced
2 avocados, sliced
½ pound Oaxacan cheese
Salt to taste
1 cup spicy salsa of your choice
4 limes, halved

First, heat the refried beans on low. Place the tortilla on the comal (or in a large pan) on low and spread 1 tablespoon of asientos de puerco on each tortilla, spreading it well.

Next, add 4 tablespoons of refried beans to each tortilla, spreading them well across the tortilla. Remove from the stove and sprinkle a handful of chapulines over each tortilla. Follow this with a handful of chopped lettuce, a few slices of tomato, onion, and avocado.

Finally, add strips of Oaxacan cheese to each and a pinch of salt, if desired. Serve 1 tlayuda per person along with a spicy salsa and lime halves.

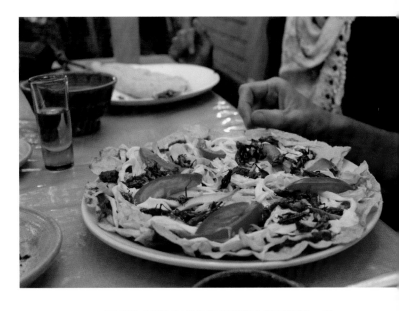

Esquites
Mexican Street Corn

SERVES 6

Esquites are a nutritious street food commonly found all over Mexico. You'll typically buy it hot in a Styrofoam cup smothered with cream, cheese, chile powder, and lime, but it also makes a great addition to a main course (see Pescado con Esquites on page 119).

6 ears of fresh sweet corn, medium size
2 tablespoons olive or vegetable oil
3 cups water
1 stalk fresh epazote (or 1 pinch dried)
2 árbol chiles
Salt and pepper to taste
1 cup crema
½ cup grated cotija or Parmesan
6 limes
1 tablespoon chile powder

Remove corn from cobs. Add oil to a pan and sauté corn over medium heat until golden. Add 3 cups of water along with the epazote and chiles and cook about 30 to 45 minutes or until the corn is a tender. Season with salt and pepper.

Serve in a small bowl or cup and for each bowl add 1 tablespoon of crema, grated cheese, juice of 1 lime, and a sprinkle of chile powder.

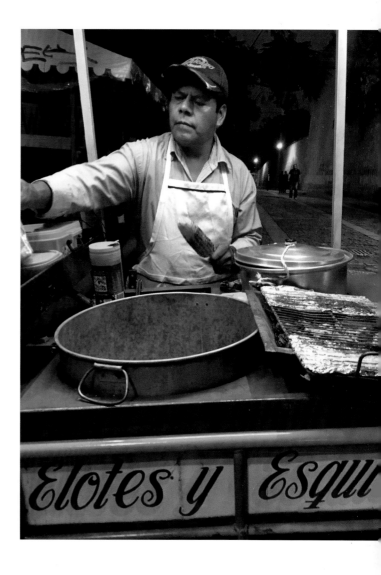

Tacos de Canasta

SERVES 5–6

"Gourmet Mexicano, barrato y sano!" calls out the man on the bicycle. If his canasta (basket) is lined with blue plastic and checkered cloth, you know he's got the good stuff. These are sweaty, messy tacos, made for—and loved by—the masses.

FOR THE ADOBO

3 guajillo chiles
2 árbol chiles
1 cup vegetable oil, divided
5 garlic cloves, peeled
½ medium white onion, chopped
½ teaspoon cumin
2 cloves
½ teaspoon black pepper

FOR THE TACOS

4 cups + 4 tablespoons water
1 pinch salt
3 medium white potatoes
½ pound chorizo
Salt and pepper to taste
30 fresh corn tortillas
1 purple onion, sliced thick
1 pound refried black beans with manteca
Salsa verde to serve on the side

TOOLS

1 large plastic bag
1 large basket, pot, or small cooler that will keep the tacos warm
Several kitchen towels
Butcher paper

FOR THE ADOBO

Slice the guajillo chiles lengthwise and remove the seeds, stems, and veins. Remove the stems of the árbol chiles.

Heat a pan on low with 2 tablespoons of oil. Sauté the whole garlic cloves and chopped onion for 4 minutes, while stirring. Next add the chiles to the pan along with the cumin, cloves, and pepper. Stir and sauté for 1 minute. Turn off the stove and allow to cool for 15 minutes before adding the ingredients into a blender with the remaining 14 tablespoons of oil. Blend well and set aside.

Heat a pan on low and add the salsa and leave to warm as you're making the tacos.

FOR THE TACOS

Put 4 cups of water in a pot on high heat along with a pinch of salt. Cut the potatoes in half and place inside the pot. Leave to boil for about 35 minutes or until cooked through. Strain and remove the skins of the potatoes. Set aside for later.

Place a large plastic bag inside your basket or pot (you can also use a small cooler without the plastic bag; the point is to have something that will maintain the heat and moisture of the tacos); place a kitchen towel over this, and then place two layers of the butcher paper on top of the towel. Make sure the inside of your basket is lined completely.

Place a pan on medium heat and add 4 tablespoons of water and the chorizo. The water will help the chorizo release its fat. Cook for 5 minutes while stirring constantly. Use your spoon to help the chorizo to break apart.

Add the potatoes to the pan with the chorizo. Mash the potatoes with your spoon as they cook (they don't need to be mashed smooth). Add salt and pepper to taste and cook for 2 more minutes. Turn off the stove and set the chorizo-potato mixture to the side.

Heat the tortillas in a pan without oil. As the second batch of tortillas is heating in the pan, fill the first batch

with the chorizo-potato mix. Use about 2 tablespoons of the mix per tortilla, and fold in half and place inside your basket. Once you have 1 layer of tacos, sprinkle some slices of red onion on top and then pour a bit of the adobo salsa over the layer. Continue until you've made 15 tacos with the chorizo-potato mix.

Next, heat the refried beans on low, stirring occasionally. While the beans are heating, begin to heat the other 15 tortillas in a pan. Repeat the above procedure using 2 tablespoons of refried beans until you've made all 15 bean tacos. Try alternating the bean tacos with the chorizo-potato tacos. Cover all the tacos with a kitchen towel and the lid to the basket or pot. Leave to "sweat" for 30 minutes before serving.

Serve directly on a plate with a salsa verde. *Y provecho!*

Quesadilla de Huitlacoche

SERVES 4

Huitlacoche is a fungus that grows on corn. In the USA it's considered a plague, but in Mexico it's eaten with gusto, as it has been since precolonial times. The huitlacoche is king of the quesadillas.

2 tablespoons oil
1 medium white onion, julienned
2 garlic cloves, finely chopped
Salt to taste
1 pound huitlacoche
1 stalk fresh epazote (or ½ teaspoons dried)
1 bunch cilantro, finely chopped
Pepper to taste
½ cup water
½ pound quesillo, asadero, or Manchego cheese
1 cup of your preferred salsa

Heat a pan on medium and add the oil. Once the oil is hot, add the onion, garlic, and a bit of salt; sauté for 3 minutes until the onion is translucent.

Add the huitlacoche, epazote, and cilantro; season with salt and pepper and stir regularly. Next, add the ½ cup of water and leave to cook until 90 percent of the water has evaporated (about 8 to 10 minutes).

Once the huitlacoche has cooked, we fill our tortillas: put 2 tablespoons of the huitlacoche and a bit of cheese in each tortilla, fold in half. Place in a pan on medium heat for 3 minutes on each side until the cheese is melted.

Serve with salsa on the side.

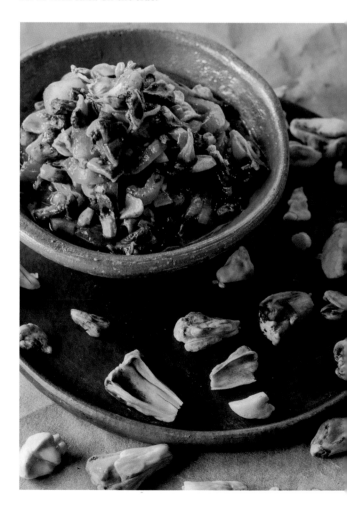

Cacahuate Oaxaqueño con Ajo
Oaxacan Peanuts with Garlic

SERVES 6–8

This bar snack is the wingman of Oaxacan mezcal. Light, crunchy, and addictive, it's served extra salty, the better to encourage your *compas* to drink up.

5 tablespoons melted manteca or vegetable oil
12 garlic cloves, with skins on
6–10 árbol chiles
1 pound raw peanuts, skins removed
Salt to taste

Heat manteca on low in a pan, then add the garlic cloves. Once the garlic is just beginning to turn a golden color, add the chiles and turn the heat to medium; cook for 2 minutes. Add the peanuts; stir constantly while cooking. Cook for 4 to 5 minutes or until the peanuts have turned a darker color.

Add a generous portion of salt to taste. This is a popular bar snack that goes great with a cold beer, and so tends to be on the salty side. Remove from heat.

Serve in a small dish at the center of your table to share.

Tamal de Cambray

Recipe by Vicky Hernandez

MAKES 8 TAMALES

The tamal cambray comes from the Isthmus of Oaxaca. In our opinion, it is the most flavorful tamal. We recommend buying the corn flour made specifically for tamales rather than trying to make your own as it requires a specific grind. (Maseca is the brand commonly used in Mexico and is available in many Mexican grocery stores or online.)

FOR THE MASA

2 pounds corn flour for tamales (can substitute corn flour for tortillas, if necessary)

4 cups warm water

1 cup manteca

1 tablespoon salt

1 tablespoon baking powder

TAMALES

9 banana leaves

½ pound chicken

½ pound pork

½ pound beef

1 pound tomatoes

1 tablespoon thyme

2 cloves

4 whole black peppercorns

3 inches cinnamon stick

½ medium white onion

4 garlic cloves

4 tablespoons manteca

1 apple

1 plantain

4½ ounces raisins

Salt to taste

4 cups water

FOR THE MASA

Place the corn flour in a large bowl. Add 4 cups of water bit by bit into the masa while mixing it by hand, checking it as you go for the right consistency. Add the manteca. Knead the masa well in a circular motion. Add the salt and baking powder and knead for another 15 to 20 minutes. You want a masa that does not stick to the hands and comes easily off the sides of the bowl.

FOR THE TAMALES

Rinse the banana leaves and pat dry. Set aside.

Boil the chicken, pork, and beef until cooked through (about 45 minutes in a regular pot or 20 minutes in a pressure cooker). Once cooked, allow the meat to cool a bit, then shred it.

Boil the tomatoes for just enough time to allow you to remove the skins (about 5 minutes). Once cool enough, remove the skins under cool water.

Blend the tomatoes with the thyme, cloves, peppercorns, cinnamon, onion, and garlic until smooth. Strain and set aside.

Heat the manteca in a pan on medium-low, then add the blended mixture. Sauté for 10 minutes.

Meanwhile, chop the apple and plantain in small pieces (about ⅓ inch). Add to the pan with the salsa. Add in the raisins and cook on low another 10 minutes.

Add the shredded meat to the pan and cook on low 5 to 10 more minutes to take the flavor of the sauce. Add salt to taste.

Take 1 heaping tablespoon of masa and spread inside the banana leaf from the center out (the leaf doesn't need to be fully covered). Add 1 tablespoon of the salsa mixture, getting a bit of each kind of meat and fruit as best you can. Be sure not to put too much liquid in the tamal.

Wrap the leaf to make a packet: fold the two sides to the middle (folding in the leaf in thirds), then the two ends toward the middle (in thirds again). Use a strip of banana leaf to tie around the packet.

Place the tamales in a large pot with a trivet, 4 cups of water, and several small coins. Steam on medium for 45 minutes.

HUMILITY

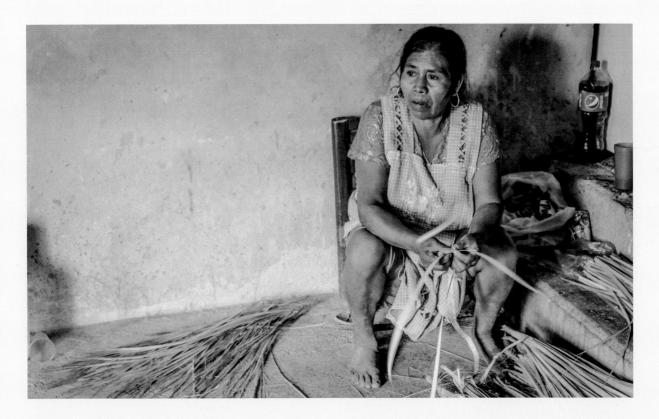

Humility is itself a humbling thing to encounter. For one who has spent their adult years fighting for "greatness" (whatever that means), it is an embarrassment to see another person happy with the simplest of lives and giving thanks for what little they have. Humility is a fifty-year-old woman working forty-eight hours a week for twenty pesos an hour, singing while she scrubs the floor—content to have work and happy to be free from an abusive spouse. It is a man giving thanks for a sheet-metal roof over his head and a dinner of two tortillas and a Coca-Cola. Humility is also allowing our life to unfold, rather than forcing it to stay within the confines of our limited vision.

Noel and I have found that it's when we've allowed our life to flow, rather than try to force

it in a predesigned direction, that greatness followed: our meeting, moving to Baja, rediscovering mezcal, opening our restaurant, having our baby, and all the many mini-miracles in between. In fact, we'd become so accustomed to this flow of things working out that it was jolting when suddenly they were not.

Just before leaving Baja to begin our epic research road trip on the mainland, Noel lost his wallet and driver's license. He managed to get a replacement before his ferry left the dock (*gracias a Dios*). Lila and I flew in to Mexico City one week later to meet him and begin the grand tour. Car packed, baby buckled in, Noel's wallet went missing again. We found it sitting where he'd left it at the coffee shop—a small miracle in one of

73

the world's largest cities. Later that day we took a wrong turn in Morelos and had to drive thirty minutes in the opposite direction before finding a turnaround on the freeway. When we finally arrived at our first destination, Mochitlan, Lila was suddenly hit with a disconcertingly high fever, scrapping my plans to photograph the festival's opening ceremony. This was no ordinary run of bad luck—our trip was looking as though cursed.

It was then that we realized our mistake of not having asked permission.

It would appear incongruous that two people who aren't religious would ask a Catholic virgin permission to photograph and write about an indigenous-Catholic festival. It's one of those things I, as a disbelieving American, had gone along with previously but had never really bought into. Right up until the necessity of such mysticism was smacking me in the face.

The request for permission is normally tied to the acts that people who want to modify their existence do: travel, ceremonies, constructions, destructions . . . everything that changes the existence of a person or a group. In the request for permission, the people offer traditional elements like incense, fruits, grains, and other elements in specific predestined locations. Or, if it can't be in those certain locations, then in circles with the involved persons. From there they perform signaling with tobacco so that if one is lost on the path, they can return to where the fire of the tobacco began. Also, people make payments of flowers and other offerings at the start of the planting season, and again when they finish their work they do the same in the form of gratitude. This is to take into account the superior energies and not believe that it's for you that the things happen. You are only

an initiator; the things can happen or not. You have the intention, but if the environment is against you, you can't do anything. If other humans are against you, it will be more difficult. Or if you yourself are against you, it will be impossible. This is what the peticiones de permiso *are for. And this has been a practice for around three thousand years in the cultures of Arido and Mesoamerica.*

Many Mexicans understand the importance of asking permission or requesting a blessing before embarking on a new journey or project, regardless of whether they're Christian, pagan, or atheist. From the native perspective, it is not about fear or subservience to an almighty god, but about energetic alignment and humility. One might say it's similar to an artist giving themselves up to their muse. The best art does not come from the logical mind, but from those moments when we let go of the I—my belief that *I* am in control—and allow something beyond ourselves to move through us, to give us direction. Without this humility, our preconceptions and fixations on what is supposed to happen, and how and why, go to battle with what is and the unimagined possibility of what could be. Our thinking mind obstructs raw creativity. Magic is what occurs beyond the realm of the rational, and in order to welcome that into our lives, we need to step to the side and allow for that greater unknown to lead the way.

Another way of putting it is to say we need to be ready to learn.

Many people today believe that all the good things they receive in life are because they're so chingon— *that they deserve it and they have a right to a life full of blessings. But for the same reason these people have huge existential crises. For the same reason*

they pay every year hundreds of dollars for therapy. Because they think so highly of themselves, and when they open their eyes the world is falling to pieces and all they have is a mask to show.

It's like in the kitchen. In the kitchen you can be the best student from the best culinary school in the country. Maybe you believe you're incredible. But maybe also some humble street cook in a corner of the world receives a Michelin star. And then what happens to you, with all your impressive studies? You enter into chaos. Because your education prepared you to be a star, and suddenly some guy that only knows how to make five plates, but who makes them with all his love, his interest, and his faith, is much more incredible than you with all your macrobiotic knowledge, your balance, your artistic concept of cuisine. And this is normal. For this reason we need to be humble. Your food should be balanced. And we should be honest: to say "I know how to make these things, but not those things." Your best plate—your best version—is what defines you. If you are very humble and you accept that you only know how to make one thing, from that moment on you'll make incredible things. Why? Because by accepting your limits you've opened yourself to learning.

This theme of asking permission dogged us throughout our serpentine road trip. Each time we entered a new state we encountered blocks. And so, each time we made for the energetic center of the city and asked permission. In Oaxaca, it was Nuestra Señora de la Soledad; in Puebla, the church of Santa Maria in Tonanzintla; in Mexico City, it was, of course, La Villa. Each time, a subtle shift occurred and the road opened up again.

You're wondering what all this has to do with your home cooking. Well . . .

Remember the best meal you ever ate? Was it made on a strict interpretation of a written recipe? Or, as each forkful radiated across your palate, was there a sense that some otherworldly and inexplicable play had occurred between the hands of the chef and the elements of his crucible, allowing you to transcend the mundane, animalistic act of consuming and digesting your sustenance? And as you hovered in that altered space of tantric pleasure, were you thinking of the exacting measurements and precise temperatures the chef must have taken? Of chemistry? Mathematics? Or were you bathing in the bliss of something akin to magic?

The greatest chefs are those who allow that *other* to guide them—who don't get in the way of their own creativity. Just as the most remarkable mezcals are made not by brands that adhere to a standardized protocol and flavor profile, but by maestros who are guided by an intuition silently passed down to them over the course of generations and who listen to that which does not speak.

Asking permission is an act of humility that opens the door and allows the intuitive, creative self (the goddess, the virgin, the muse—whomever or whatever it is that guides you to transcendence) to pass through first and lead the way. It is also a reminder to sit up, pay attention, and appreciate what we have in this moment, however little that may be. We're not suggesting our readers visit a virgin or say a prayer every time they want to cook a meal. But we do believe that by keeping this sense of humility in mind—entering their kitchen with a sense of play and letting go of what they expect the outcome to be—they open the doors of possibility. And that, my friends, is what makes the difference between someone who cooks and someone who is a culinary wizard.

Chilapa, Guerrero: A Market Feast

Every time we drive through Guerrero, I'm flabbergasted by the immense beauty of the scenery. The "Warrior State" was my first home in Mexico, and like a first kiss, first high, first soul-altering experience, the intoxication has never really left me. The drive as we approach Chilapa from Chilpancingo is as heart-wrenchingly beautiful as anything I've seen of the Italian countryside: the winding mountain roads, the farmers' shacks, the fog coming over the ridgeline. The cultivated fields—a breath away, yet seemingly unreachable—evoke a longing for that knowledge most of us will never know: an intimacy with the soil and a romance with our very sustenance. A simpler, slower life. If we could just pull over the car, plunge ourselves into this landscape, dig our fingers beneath the soil, let its song run through our veins for even a day, I am sure we would come away so much the wiser.

But the car rolls on. The car always rolls on. The door to that world doesn't open to whimsical passersby.

And when I see these places, speak with their residents, and taste the food they have prepared, my heart aches all the more. The native voices of Guerrero have not been paved over with modernity. But they have been riddled with holes. And for that, I cry.

If you are wanting to understand the cuisine of Guerrero and decide to make a road trip to do so (please don't do that without a very knowledgeable local guide), the market at Chilapa is the first place you'll want to visit. Signs of human occupation date back to at least 1200 BC; Moctezuma I gave Chilapa its official charter in 1458. That is a whole lot of time for a people to develop their cuisine.

Guerrero, like other states with a large indigenous population, has one of the highest rates of poverty: 66.5 percent of the population lives in poverty, with 26.8 percent in extreme poverty; 58 percent live without basic housing services.[1] The state has more migrants than any other in the country who leave to find work in the United States, thanks to its abysmal employment and education levels (an estimated one-quarter or more of Guerrero's population live in the United States). East of Chilapa, just over the mountains, begins an area where most of the inhabitants speak only their native languages and not Spanish: remote indigenous areas where the pay is so low it borders on slavery. This combination of destitution, hopelessness, and large swaths of agricultural land are the prime ingredients for exploitation and violence. But above all, it is America's insatiable hunger for narcotics that keeps this region in perpetual turmoil. Until the United States begins to look at the holes in its social psyche, there will be no victory in the war on drugs, and it is Mexico's indigenous who will pay the heaviest price for the vices of their northern neighbors.

We are on high alert everywhere we go. My government has advised its citizens not to travel

1 https://www.coneval.org.mx/coordinacion/entidades/Guerrero/Paginas/Pobreza_2018.aspx

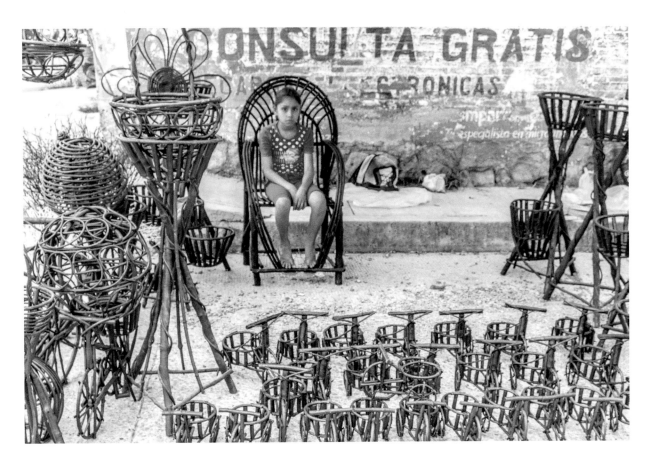

in the state of Guerrero for safety reasons. And while I take the advice of the United States Consulate with a (very large) grain of salt, the amount of bad press that Mexico gets (particularly Guerrero) does put one on edge.

The president of my country and his supporters have done much to mutilate the image of Mexicans, casting them in a foul and ignorant light. The indigenous here don't need the added abuse of their northern neighbors—they get more than enough of it in their own land. I cannot tell you the number of times I've been allowed to pass store guards with no more than a glance, while Noel has been stopped and questioned by security, or had a sales clerk suggest he can't afford their products.

"I'm screwed no matter what I do," he laments. "If I dress poorly, the people think I'm a thief; if I dress well, they think I'm a criminal."

It seems the only time native peoples are given their due respect by governments and the wealthier classes is when someone stands to make money from them: promotional videos by the tourism board, resort shows of traditional dances, fashion trends spun from native designs. And of course . . . mezcal.

We arrive to find armed federales guarding the entryway to the town, while beige jeeps of helmeted soldiers scout the boulevard. The tension is visceral. We park the car in a grassy, paid lot, along with palm vendors and other visitors. Bundles of palm *cinta* (woven strands) are being unloaded and carried off to find buyers. More than food, the Chilapa market is famous for its

palm handicrafts. Tables line the wide avenue loaded with palm hats, palm dolls, palm earrings, palm floor mats, palm flowers, palm bags and baskets—anything you can imagine and never imagined made of palm is here.

But first, breakfast.

Noel walks with purpose and confidence, our baby Lila astride his shoulders, smiling and waving at the vendors and shoppers. We follow him past the spreads of native herbs, frijoles, guajes, flowers, maíz, chiles of any and all kinds; past the mask makers, palm weavers, and basket sellers; and indoors where the fondas are located. He makes a beeline for one eatery in particular, although it's been years since he's been here with any regularity. He stops suddenly at a table in front of a nameless fonda and calls for three coffees before we've even sat. He strides over to the young owner standing behind the counter and chats for a quick minute.

And thus begins the Breakfast Blitz.

We start with *chalupas*—a kind of puffy fried tortilla round with beans, cheese, cream, chicken, and salsa—and *frijoles con chorizo*, pureed smooth and topped with avocado and cheese, served with *totopos* (tortilla chips). Not something I'd ever considered eating for breakfast, but *omuhgod*—it's divine! Then comes the *tacos dorados*, stuffed with chicken and fried until crunchy, served in caldo with salsa, cheese, and avocado. Next is *pancita de res* (cow stomach) and handmade blue corn tortillas.

"Did you order all this?" I ask Noel.

"No. But I told him we were writing a cookbook and wanted to take some photos."

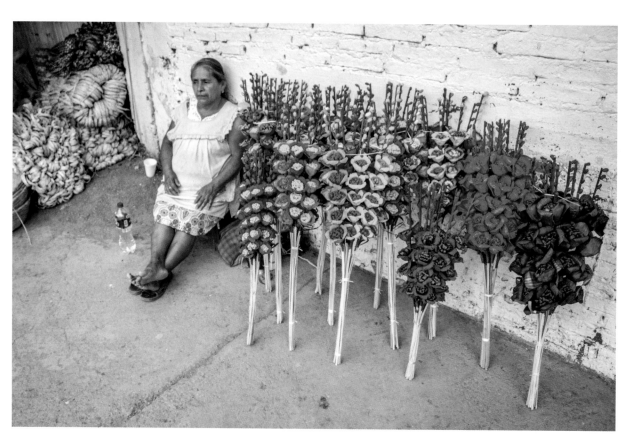

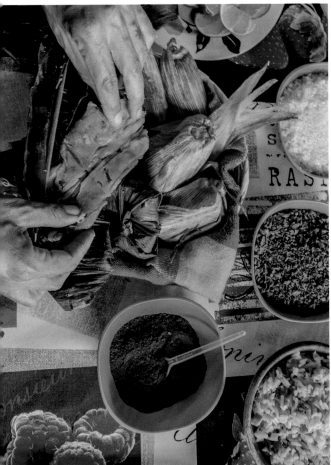

A plate of pungent mole verde, punctuated by a boiled chicken leg, hits the table, and along with it a monstrous bowl of pozole verde.

"Jesus Christ," says Meg. She had landed in Mexico the night before after fifteen hours of travel. This is her first real meal since arriving.

We make a valiant effort. The chalupas and frijoles are devoured with gusto. The tacos remain in scraps and the pancita Noel polishes off with pleasure. The mole and pozole remain half-finished, though not for lack of desire. Behind us, men young and old stop every few minutes to offer us plastic soda bottles filled with mezcal.

"Don't buy it," says Noel. "It's not mezcal; it's mixed with aguardiente and it will give you a *terrorific* hangover."

Between the rounds of mezcal peddlers are women selling avocados from plastic buckets, or herbs, or *nanche* and other seasonal fruits. All of this is accompanied by strolling musicians offering traditional songs for tips.

Oh, but it's not over yet! A bowl of seven colorfully wrapped tamales is placed in front of us: black bean, green bean, mole, and something sweet. Coffee. Atole. Along with it, a basket of breads. We thank the owner and ask to take the last courses to go, along with the check. He returns with a pink plastic bag for the tamales and breads and a bill for one hundred pesos.

One hundred *pinche* pesos. That's six US dollars for enough food to feed seven people.

I'm confused. There is no sign or name for his fonda, and unless you have a detailed description with a map of the market, it's impossible to tell it apart from all the others. Anyway, how many foreigners are really going to come to the mountains to Guerrero and search out his indistinguishable food stand in the Chilapa market?

The owner has nothing to gain from us. Noel laughs and shakes his head. *That* is the spirit of generosity that is so common in Mexico. People don't give to gain favor; they give because they are happy to share.

We leave the fonda and stumble through the market, bulging bellies leading the way. Noel points out various herbs, dried fish, and chiles, many of which I hadn't seen outside of Guerrero. We marvel at the abundance of handcrafts and their extraordinary prices, before heading to the town center where Noel remembers there is a woman who sells food from her house on the weekends.

"Her food is so *sabroso* that many times there's a line of people on the street waiting to order," he tells us. "And my *cuñado*—he is crazy for the special kind of dessert they make here."

La Casita de Abue: "Perdurable sabor Chilapeño desde 1950." The name is stickered onto the front window of a fading blue wall. We enter to find a middle-aged woman behind a long plastic table spread thick with miniature white, pie-like desserts: the *bien me sabes* (see page 243). The front room is bare concrete. At the far back is a concrete counter, and behind it, Señora Leo Diaz Ramirez and five other women are working away: over a stove, over dishes, over masa; the jefa taking orders from her clients. Between us are several tables with families enjoying a spread of food. On one side of the room is a table cluttered high with papers and packing material. Crooked prints of poorly painted landscapes hang gathering dust on the walls. A set of concrete stairs runs to a balcony cluttered with even more boxes and bubble wrap, bicycles and toys shoved haphazardly beneath. The place looks more garage workshop than home.

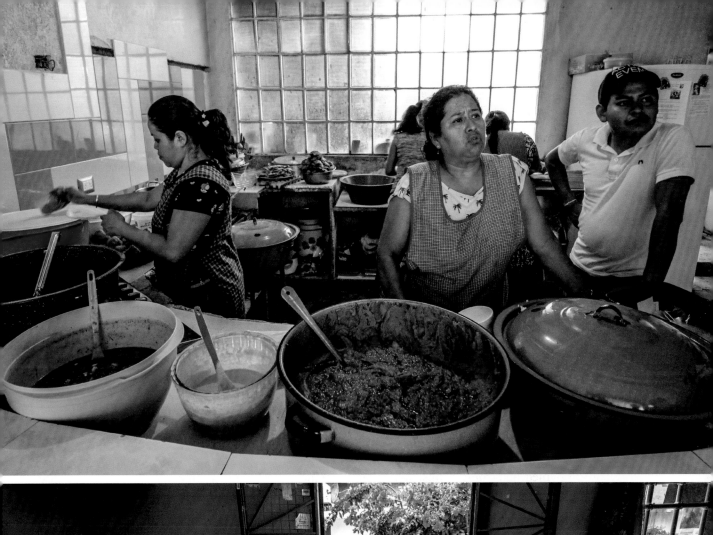

I stop to talk to the dessert lady while Noel aims straight for the kitchen. Bien me sabes, I learn, is a brandy- and port-soaked bread with a creamy milk, vanilla, and egg-yolk-based topping. It is light in flavor and absolutely delicious.

Thirty minutes have gone by and Noel is still chatting away with a group of ladies behind the kitchen counter. He's ordered chile rellenos to go and potato croquettes. We're still swollen with breakfast, but lunch *is* just around the corner. La Señora showed us the dishes she was preparing that day: *sopa de pan* (bread soup), *barbacoa de pollo, fiambre* (a dish with a mix of cold meats and vegetables), pig's feet with vegetable salad, *pulpa de res* (beef shank), and *gallina rellena*: a hen stuffed with *picadillo* (a mix of beef, plantain, pineapple, almond, raisins, pineapple vinegar, and *naranja de caldo*—see page 181). Noel, in his great wisdom, orders more food to go. Because, you know . . . eventually we'll have to eat again, and the eatin' may as well be good.

Back at Noel's mother's house in Chilpancingo, we dig into Doña Diaz's food. The chile rellenos are mouthwatering; the potato croquettes mystifying in their fullness of flavor; and the picadillo of the gallina rellena, though different, is on par with Noel's.

Our day in Chilapa reaffirms my belief that the best food in Mexico is found in the markets, the streets, the humble homes. Perhaps the fact that we shared our table with locals and that we engaged with the cooks themselves are contributing factors. Perhaps the humility of these kitchen magicians is what allows the food to speak for itself; the flavors to explode on the palate and surprise one with their symphonic complexity. And suddenly we see beyond the grimy plastic tables and disorder of a market meal, beyond the tenuous existence of the locals, beyond the fearmongering of our media and governments. We see their world for what it is: the crescendo of a centuries-old composition in tribute to their heritage.

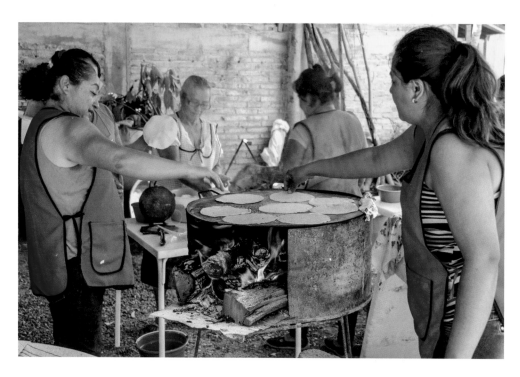

Moles

If there is one dish that represents Mexico, it is surely mole. Mole is the ancient name for salsa, except that mole is much more complex than salsa. And though there are classic moles, each person interprets a traditional recipe their own way. If mole is the first form of magic, then the mastering of a great mole makes one a culinary wizard. The recipes below include a minimum cooking time. Generally, the longer you cook a mole, the better; but you can still get a dish with great flavor with an hour or two of cook time.

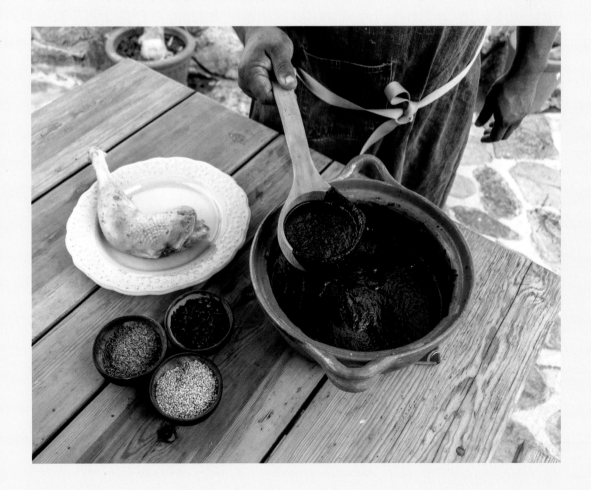

Mole Colorado

SERVES 6–8

The mole colorado (also called *mole rojo*) is a mole common to the Costa Chica—a region that spans the Pacific Coast of Guerrero and Oaxaca.

2 ancho chiles

2 pasilla chiles

6 guajillo chiles

3–5 cups chicken stock (can substitute vegetable stock or water), divided

1–4 árbol chiles (depending on how spicy you like it)

2 red tomatoes

½ medium white onion, chopped

3 garlic cloves, peeled

5 tablespoons vegetable oil, divided

¼ cup raw sesame seeds

¼ cup raw almonds

¼ cup raw peanuts

¼ cup raw pumpkin seeds

1 teaspoon whole cumin

½ teaspoon whole clove

2 teaspoons whole black peppercorns

½ teaspoon marjoram

2 bay leaves

1 inch cinnamon stick

½ tablespoon dried oregano

1 teaspoon thyme

½ plantain

2 ounces dark chocolate (optional)

Salt and pepper to taste

Chicken, pork, or Oatmeal-Seed Cakes (see page 201) to serve with the mole

½ cup toasted sesame seeds for garnish

Black beans and tortillas to serve on side

Cut the ancho, pasilla, and guajillo chiles lengthwise and remove the veins and seeds. Toast in a dry skillet for 1 minute on low heat, stirring regularly, taking care not to burn them (burnt chiles will make the mole bitter).

Next, boil the toasted chiles in 1 cup of water or chicken stock along with the árbol chiles for approximately 10 minutes or until soft. Remove the chiles from the water and blend in a blender. Use a little of the water the chiles cooked in to facilitate blending. Remove the blended chiles from the blender and set aside.

Toast the tomatoes over a direct flame, or in a cast-iron skillet, burning the skin on all sides. Rinse the tomatoes under water to remove the skin, then cut in half and blend in a blender with the onion and garlic. Use a little chicken stock to facilitate blending. Remove from the blender and set aside.

Heat 3 tablespoons of oil in a pan. Once the oil is hot, sauté the blended chiles over medium-low heat, stirring constantly to prevent burning, until it begins to simmer. Add the tomato-garlic-onion mixture little by little while stirring continuously. Bring to a simmer then turn the heat to low.

Toast the sesame seeds in the skillet on medium, stirring continuously for 2 minutes until they take on a light golden color. Remove from the heat and repeat the same process with the almonds, peanuts, and pumpkin seeds, cooking them individually for 5 to 7 minutes. Then crush and blend together with a molcajete or food processor, or use a blender with a bit of water.

Lightly toast the cumin, clove, peppercorns, marjoram, bay leaves, cinnamon, oregano, and thyme in a skillet for 1 to 2 minutes or until golden, then crush with a molcajete, food processor, or spice grinder. Set aside.

Slice and fry the plantain in the remaining 2 tablespoons of oil until it turns golden brown. Remove and set aside.

Blend the nut-and-seed mixture with the fried plantain in a blender, using a little chicken stock to facilitate blending. Remove this mixture and place in the saucepan with the salsa.

Add 1 cup of chicken stock and cook over low heat for 30 minutes, stirring regularly to prevent sticking. Add the ground spices and mix thoroughly. Let simmer for another 30 minutes over very low heat, stirring occasionally. If you like, you can add the dark chocolate to the mole here. Add salt and pepper to taste. Check the thickness from time to time and add stock or water as needed. The mole should be thick enough that it sticks to the back of the spoon.

Serve over chicken, pork, beef, or Oatmeal-Seed Cakes garnish with sesame seeds and serve with black beans and tortillas on the side.

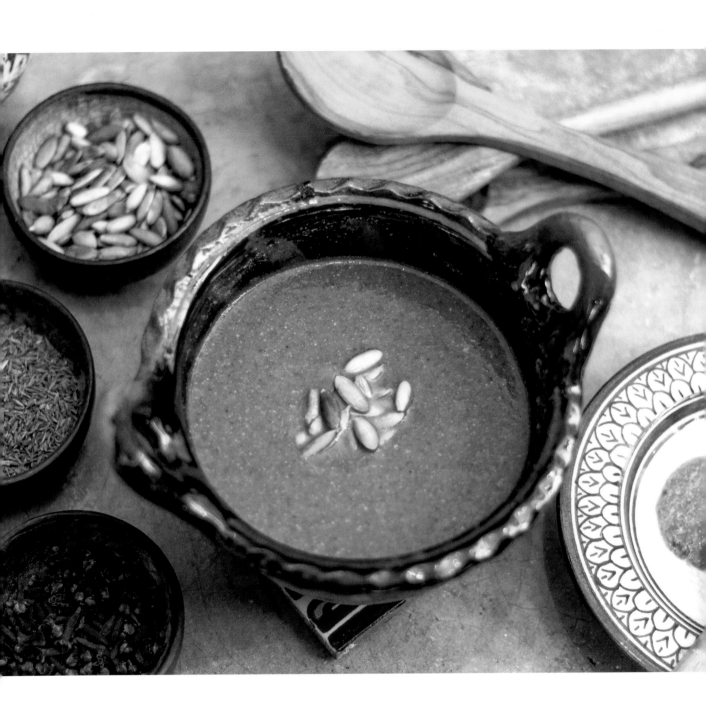

Mole Verde
Green Mole

SERVES 6–8

Fresh, vibrant, and complete in its integration of seeds, chiles, and leafy vegetables, this is our favorite mole at El Refugio, also because it's not one of the more commonly known ones. It originates in Central Mexico and is commonly found in Guerrero, Oaxaca, and Estado de Mexico.

2 poblano chiles
1 tablespoon dried oregano
½ teaspoon thyme
3 bay leaves
6 whole cloves
½ tablespoon whole cumin
2 tablespoons whole black peppercorns
1 cup raw pumpkin seeds
1–2 serrano chiles (depending how spicy you like it)
3 jalapeños
½ cup vegetable oil, divided
1 pound tomatillos, husks removed
½ medium white onion, cut in 4
3 garlic cloves, peeled
2 cups spinach leaves
1 cup radish leaves
3 cups chard leaves
1 cup fresh cilantro, stems included
2 ounces fresh epazote (or 1 ounce dried)
4 cups chicken stock (can substitute vegetable stock or water), divided
Salt and pepper to taste
Chicken, pork, or Oatmeal-Seed Cakes (see page 201) to serve with the mole
1 cup toasted pumpkin seeds for garnish

Place the poblano chiles directly on the flame of the stove (or in a pan without oil). Toast until slightly burnt on all sides. Place in a lidded, plastic container (or in plastic bag) and leave to rest 10 minutes. Then, clean by removing the skin and seeds under running water, and set aside.

Heat a pan on high. Add all of the dried herbs and spices to 2 tablespoons of oil (oregano, thyme, bay leaves, clove, cumin, and pepper) and cook for 3 minutes while stirring. Set the mixture aside.

Heat a new pan without oil and toast pumpkin seeds on high heat. When they begin to make popping sounds, stir the seeds to prevent burning. Cook about 10 minutes, or until golden. Set aside.

Cut serrano and jalepeño chiles lengthwise and remove seeds and veins. Heat 2 tablespoons of oil in a pan. Sauté the chiles, tomatillos, julienned onion, and garlic for 5 minutes. Remove from the pan and set aside.

Heat a pan to medium and add 2 tablespoons of oil. Sauté the spinach, radish, and chard leaves along with cilantro and epazote for 5 minutes. Set aside.

Blend the tomatillo mixture with a bit of chicken stock, then place in a pan with the remaining 2 tablespoons of oil and heat on low.

Blend all of the other prepared ingredients besides the tomatillos with just enough chicken stock to facilitate blending. The result is a thick paste. Once the paste is blended, add it to the tomatillos on the stove.

Add the rest of the chicken stock (about 3 cups) and simmer over medium-low heat for at least 1 hour. Cook until it has the desired thickness. If it's too thin, allow to simmer over medium heat. Add salt and pepper to taste. (When the mole sticks to the back of a spoon, it is the right thickness).

Serve over chicken, pork, or Oatmeal-Seed Cakes and decorate with toasted pumpkin seeds.

Note: for more flavor, add all the pieces of chicken to the mole and allow to simmer for 5 minutes before serving.

Mole Mancha Manteles

SERVES 6–8

This is another of our favorites. The almonds and fruits make this a rather addictive mole. The name itself means "tablecloth stainer." Although we often serve this at wedding parties, it's more commonly served at baptisms and birthdays.

10 guajillo chiles
2 red tomatoes
4 garlic cloves
½ medium white onion, cut in half + 2 slices white onion
5 cloves
1 piece star anise
2 teaspoons whole black peppercorns
1½ inches cinnamon stick
2 teaspoons cumin
4 ripe plantains
1 cup raw, peeled almonds (can use unpeeled)
¼ cup vegetable oil
4 cups chicken or vegetable stock, or water, divided
¼ cup raisins, divided
3 tablespoons melted manteca or vegetable oil
1 cup cubed red apple (¼-inch)
1 cup cubed pear (¼-inch)
1 cup cubed pineapple (¼-inch)
1 cup cubed peach (¼-inch)
1 tablespoon brown sugar
Salt and pepper to taste
Chicken, pork, or Oatmeal-Seed Cakes (page 201) to serve with the mole
Rice and tortillas to serve on side
Toasted sesame seeds for garnish

Cut the guajillo chiles lengthwise and remove stems, veins, and seeds. Heat a pan on low for 2 minutes. Place 2 chiles in the pan and toast on each side for about 1 minute on each side, taking care not to burn them. Remove and set aside. Repeat with the rest of the chiles, 2 at a time.

In the same skillet place the tomatoes, garlic, and onion and cook over medium-high heat until the tomato skin takes on a dark color. Remove from heat and set aside.

Stir all the spices (cloves, anise, whole black peppercorns, cinnamon, and cumin) in a dry skillet (no oil) over low heat for 1 to 2 minutes to toast and intensify their flavor. Remove and set aside.

Cut 2 of the plantains into ¼-inch slices. Cut the other 2 lengthwise in thin slices (these will be for garnish). Over low heat, toast the almonds for a couple of minutes, stirring continuously. Remove and set aside. Add oil and fry all the plantain pieces until they take on a dark golden color without burning them. Remove and set aside.

Put 1 cup of stock in a saucepan with the guajillo chiles. Bring to a boil and simmer for approximately 15 to 20 minutes until soft. Remove from heat, allow to cool, then blend in a blender with the toasted spices and the stock the chiles cooked in. Remove from the blender and set aside.

Blend half of the raisins, the ¼-inch slices of fried plantain, and almonds together with a little bit of chicken stock to facilitate the blending. Remove and set aside.

Blend the tomato, garlic, and onion with a little water or stock. Remove and set aside.

Heat the manteca in a saucepan with 2 slices of onion over low heat for 2 minutes. Add the blended chile-spice mix and let cook for 10 minutes, stirring continuously. Add the tomato-garlic-onion mixture and cook for 20 minutes while stirring. Add the plantain-almond mixture and cook for another 10 minutes. Add salt and pepper to taste, and chicken stock as needed.

Finally, add most of the apple, pear, pineapple, and peach (reserve a little of each of the fresh fruits to use as garnish) as well as the remaining half of the raisins. (Stir and check the level of sweetness, as well as salt and pepper levels.) Add the sugar as desired. Leave to cook for a final 20 minutes on low, stirring regularly. Check the thickness from time to time and add stock or water as needed. The mole should be thick enough that it sticks to the back of the spoon.

Serve with your choice of meat or vegetarian cakes, with rice and tortillas on the side.

For garnish, use the rest of the fried plantains, the remaining apple, peach, pear, and pineapple cubes, and the toasted sesame seeds.

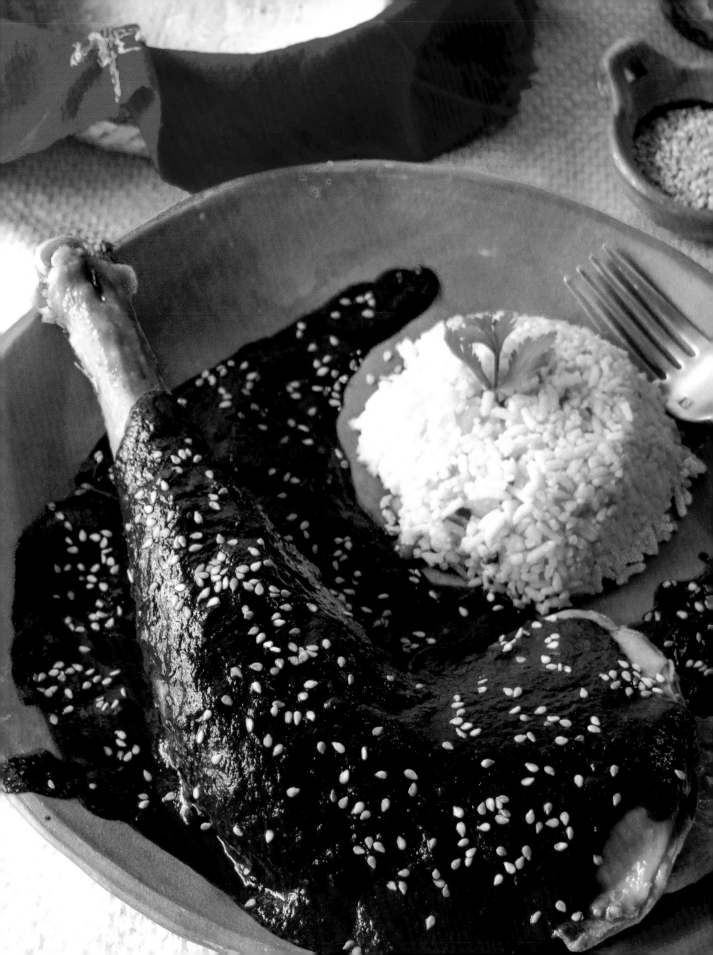

Mole Negro
Black Mole

SERVES 6–8

The mole negro—a plate endemic to the Central Valley of Oaxaca—is surely the most celebrated of all the moles. It's a highly complex dish, requiring wisdom and experience to make to perfection.

2 ancho chiles
6 pasilla chiles
6 mulato chiles
2 dried chipotle chiles
2 árbol chiles
6 chihuacle negro chiles (or substitute 6 additional pasilla chiles)
½ tablespoon whole cumin
10 whole cloves
10 Mexican "gorda" peppercorns
2 teaspoons whole black peppercorns
2 pieces star anise
2 inches cinnamon stick
½ teaspoon thyme
½ teaspoon marjoram
3 bay leaves
2 avocado leaves without stem (optional)
½ teaspoon oregano
1 tablespoon coriander seeds
¼ cup raw sesame seeds
¼ cup slivered or sliced raw almonds
¼ cup raw, unsalted peanuts
2 red tomatoes
4 garlic cloves
½ medium white onion, chopped + 2 slices white onion
4 green tomatillos, husks removed
4–6 cups chicken, beef, or vegetable stock, divided
3 corn tortillas
½ cup vegetable oil
4 ounces baguette (about 3 inches long) or similar bread, broken in pieces
2 ripe plantains, sliced in large pieces
3 tablespoons melted manteca or vegetable oil
3 ounces semisweet or bitter dark chocolate
2 tablespoons brown sugar
2 teaspoons grated nutmeg

Salt and pepper to taste
Chicken, pork, or Oatmeal-Seed Cakes (page 201) to serve with the mole
Rice, beans, and tortillas to serve on the side

Remove the stems from all the chiles. Cut the ancho, pasilla, and mulato chiles lengthwise and remove the seeds and veins. Heat a skillet over low heat for two minutes. Toast the ancho, pasilla, mulato, chipotle, and árbol chiles for about 1 minute on each side, turning a couple of times, being careful not to burn them (burning creates a bitter flavor). Remove the chiles and set aside. (Don't toast the chihuacle negro chiles at this stage.)

In the same skillet on medium heat, add the spices (cumin, clove, gorda pepper, black peppercorns, star anise, cinnamon, thyme, marjoram, bay leaves, avocado leaves, oregano, and coriander seeds). Toast the spices, stirring continually for 1 to 2 minutes. Remove from heat and set aside.

Toast the sesame seeds in the same skillet on medium, stirring continuously for 2 minutes until they take on a light golden color. Remove from the heat, set aside, and repeat the same process with the almonds and then the peanuts, heating each type of nut separately for 5 to 7 minutes.

Place the tomato, garlic, chopped onion, and tomatillos in a dry skillet over medium-high heat. Roast to a dark color, turning occasionally so that all sides are roasted. Remove from heat, wait until they cool, and then blend until smooth with a bit of chicken stock and set aside.

Toast the tortillas in a skillet over very low heat until crunchy (approximately 10 minutes), turning every few minutes. Remove the pan from the heat and set aside.

Place the chiles chihuacles directly on top of 2 of the tortillas (save 1 tortilla for later). With a lighter, light the tortillas on fire so that the chiles catch fire and burn completely to ash. Be sure to do this in a well-ventilated space as the smoke from the chiles is very strong.

Blend the tortilla-chihuacle-ash mixture in a blender with a little stock or water to create a thick liquid. Set aside.

Heat vegetable oil in a skillet over medium-high heat for 2 minutes. Add the bread pieces and the plantains. Fry to

a dark golden color, being careful not to burn it. Remove the bread and plantain from the pan and set aside.

In a saucepan over high heat, bring 1 cup chicken stock to a boil and add all of the toasted chiles (not including the chihuacle ash). Cook for approximately 15 to 20 minutes until soft. Remove the chiles (save the stock they cooked in) and add to a blender. Blend with just enough of the stock the chiles were cooked in to create a soft paste. Remove from the blender and set aside.

Blend the tortilla-bread-plantain mixture together with 1 cup of stock until smooth and set aside.

Blend the spices together with the nuts and seeds. Again, add a little of the stock to facilitate blending. Remove the paste and set aside.

Place 3 tablespoons of manteca and 2 slices of white onion in a large pot over low heat. Sauté for a couple of minutes before adding the blended chile mixture (not including the chihuacle ash). Cook for 15 minutes, stirring often.

Add the garlic-tomato-tomatillo mixture. Allow to cook for 10 minutes, continuing to stir. Add the bread-tortilla-plantain mixture, stirring all ingredients thoroughly and leave to cook another 10 minutes. Be sure to stir regularly to keep from burning. Add the rest of the chile stock and any remaining chicken stock as needed and cook for 10 minutes on low heat.

Add the spice-seed-nut mixture and continue to stir for another 15 minutes. If necessary, add another cup or so of chicken broth or water; the goal is a watery consistency as the mole will thicken upon cooling.

Add the chocolate and continue to cook, stirring constantly for 10 minutes. Taste and decide how much sugar is needed. Add the sugar to create your desired taste. Add the grated nutmeg.

Next, add the carbonized tortilla-chihuacle ash and cook for another 30 minutes, adding chicken broth if necessary. Stir constantly, and check the flavor from time to time. Season with salt and pepper as needed. Check the level of sweetness and add sugar, if desired. The taste should be slightly sweet and slightly bitter. Adjust salt and pepper.

Check the thickness from time to time and add stock or water as needed. The mole should be thick enough that it sticks to the back of the spoon.

Serve with your choice of meat, along with rice, beans, and tortillas on the side.

Mole Poblano

SERVES 6–8

The mole poblano is the most famous, the most complex, and the most widely interpreted of the moles. It's not spicy, but its multifaceted flavor is sure to impress.

6 ancho chiles
6 mulato chiles
4 guajillo chiles
6 pasilla chiles
2 dried chipotle chiles
4 árbol chiles
½ tablespoon whole cumin
8 whole cloves
1 tablespoon coriander seeds
10 Mexican "gorda" peppercorns
2 teaspoons black peppercorns
2 pieces star anise
2 inches cinnamon stick
¼ cup raw sesame seeds
¼ cup raw slivered or sliced almonds
¼ cup raw peanuts
¼ raw pumpkin seeds
2 red tomatoes
½ medium white onion, cut in half + 2 slices white onion
4 garlic cloves, peeled
½ cup vegetable oil
4 ounces baguette (about 3 inches long) or similar bread, broken in pieces
1 corn tortilla
1 ripe plantain, sliced in pieces
4 cups chicken, beef, or vegetable stock, divided
5 Maria cookies
¼ cup raisins
¼ cup walnuts
5 tablespoons melted manteca or vegetable oil
3 ounces semisweet or bittersweet dark chocolate
2 tablespoons brown sugar
Salt and pepper to taste
Chicken, pork, or Oatmeal-Seed Cakes (page 201) to serve with the mole
½ cup toasted sesame seeds for garnish
Rice, beans, and tortillas to serve on side

Cut the ancho, mulato, guajillo, and pasilla chiles lengthwise and remove the seeds and veins. Remove the stems from all the chiles, including the chipotle and árbol. Heat a skillet over low heat for 2 minutes. Toast all the chiles for about 1 minute on each side, turning a couple of times, being careful not to burn them. Set aside.

Remove the chiles, and in the same skillet, add all the spices (cumin, cloves, coriander seeds, gorda pepper, black pepper, star anise, and cinnamon). Toast the spices, stirring continually for 1 to 2 minutes. Remove from heat and set aside.

Toast the sesame seeds in the same skillet on medium, stirring continually for 2 minutes until they take on a light golden color. Remove from heat and set aside, then repeat the same process with the raw almonds, peanuts, and pumpkin seeds, cooking each type separately for 5 to 7 minutes.

Remove the seeds from the tomatoes. Place the tomatoes, 2 onion quarters, and garlic in a dry skillet over medium-high heat. Roast to a dark color, remove from heat, allow to cool, blend thoroughly, and set aside.

Heat vegetable oil in a skillet over medium-high heat for 2 minutes. Add the bread pieces, corn tortilla, and plantain. Fry to a dark golden color without burning. Remove from heat and set aside.

In a saucepan over high heat, bring 1 cup of chicken stock or water to a boil; add all of the toasted chiles. Cook for approximately 15 to 20 minutes until soft. Remove the chiles (keep the chile water for later), allow to cool, and then blend with just enough of the chile stock to create a soft paste. Remove from the blender and set aside.

Blend the tortilla-bread-plantain mixture together with 1 cup of stock, Maria cookies, and raisins. Blend until smooth and set aside.

Blend the spices together with the nuts (including the walnuts) and seeds. Add a little of the stock to facilitate blending. Remove from the blender and set aside.

Place melted manteca and 2 slices of white onion in a large saucepan over low heat. Sauté for a couple minutes

before adding the chile mixture. Allow to cook 10 minutes while stirring. Then add the garlic-onion-tomato mixture and cook another 10 minutes, stirring constantly.

Next, add the bread-tortilla-plantain mixture, mixing all ingredients completely. Check the thickness. If it's very thick, add more stock and/or chile water and cook 10 minutes. Add the spice-seed-nut mixture and cook 10 to 15 minutes. If necessary, add another 1 cup or so of water. The goal is a thinner consistency as the mole will thicken as it cooks.

Add the chocolate and cook for an additional 10 minutes. Check the level of sweetness and add sugar to create your desired taste. Leave to cook on low for another 10 to 15 minutes while stirring. Add salt and pepper to taste. Check the thickness from time to time and add stock or water as needed. The mole should be thick enough that it sticks to the back of the spoon.

Serve with your choice of meat, along with rice, beans, and tortillas on the side. Garnish with toasted sesame seeds.

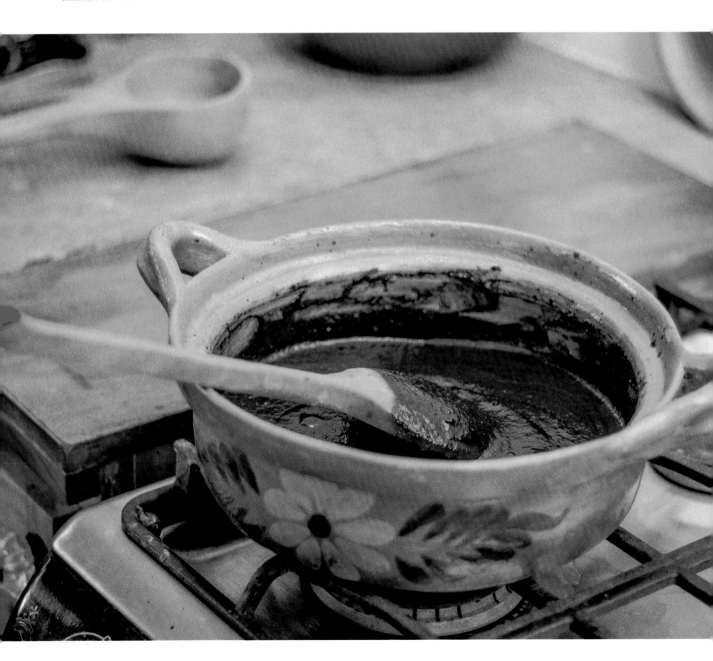

Mole Dulce
Sweet Mole

SERVES 6–8

As its name suggests, this is a sweeter mole; however, the sweetness is balanced by the acidity of the chiles and nuts.

3 ancho chiles
3 guajillo chiles
6 pasilla chiles
2 árbol chiles
½ teaspoon whole cumin
6 whole cloves
10 Mexican "gorda" peppercorns
2 teaspoons whole black peppercorns
1 piece star anise
1½ inches cinnamon stick
¼ cup raw sesame seeds
¼ cup raw pumpkin seeds
¼ cup walnut pieces
¼ cup slivered almonds
¼ cup raw peanuts
4 garlic cloves, peeled
2 red tomatoes
½ medium white onion, cut in half + 2 slices white
 onion
4 tablespoons vegetable oil
3½ ounces baguette or similar bread, broken in pieces
1 corn tortilla, broken into pieces
2 ripe plantains, sliced
6–8 cups chicken or vegetable stock or water
5 Maria cookies
3 tablespoons melted manteca or vegetable oil
2½ ounces semisweet or dark chocolate
2 tablespoons brown sugar
Salt and pepper to taste
Chicken, pork, Oatmeal-Seed Cakes (page 201), or
 Sweet Potato Nests (page 202) to serve with the mole
½ cup toasted sesame seeds for garnish
Tortillas and rice to serve on side

Cut the ancho, guajillo, and pasilla chiles lengthwise and remove the seeds and veins. Remove the stems from the árbol chiles.

Heat a skillet over low heat for 2 minutes. Toast all the chiles for about 1 minute on each side, turning a couple of times and being careful not to burn them. Remove the chiles and in the same skillet add all the spices (cumin, cloves, gorda pepper, black pepper corns, star anise, and cinnamon). Toast the spices, stirring continuously for 1 to 2 minutes. Remove from heat and set aside.

Toast the sesame seeds in the same skillet on medium heat, stirring continually for 2 minutes until they take on a light golden color. Remove from heat and set aside. Repeat the same process with the pumpkin seeds, walnuts, almonds, and peanuts, toasting each type separately 5 to 7 minutes.

Toast the garlic cloves, tomatoes, and 2 onion quarters in a pan on medium without oil. Turn occasionally and cook until just beginning to burn on all sides. Set aside for later.

Heat vegetable oil in a skillet over medium-high heat for 2 minutes. Add the bread pieces, corn tortilla, and plantains. Sauté to a dark golden color without burning. Remove from heat and set aside.

In a saucepan over high heat, add 4 cups of stock (or water) and all the toasted chiles. Cook for approximately 15 to 20 minutes or until soft. Remove the chiles and set aside. Reserve the stock for later. Once cool, add to a blender and blend with just enough of the stock they had cooked in to create a soft paste. Remove from the blender and set aside.

Blend the bread-tortilla-plantain mixture with the Maria cookies and 1 cup of stock or water. Blend until smooth and set aside.

Blend the spices together with the nuts and seeds. Again, a little of the chile-chicken stock can be added to facilitate blending. Remove and set aside.

Place the manteca and 2 slices of white onion in a large saucepan over low heat. Sauté for a couple minutes before adding the chile mixture. Cook for 10 minutes, stirring continuously. Add the tomato-onion-garlic mix and cook another 15 minutes, stirring constantly.

Next add the bread-tortilla-plantain-cookie mixture and cook another 10 to 15 minutes. Then add the remaining chile stock and cook for 10 more minutes on low, stirring regularly. Add the spice-seed-nut mixture and continue to cook for another 15 minutes. If necessary, add another 1 cup or so of stock or water. The goal is a watery consistency as the mole will thicken as it cooks.

Add the chocolate and cook for an additional 10 minutes, stirring continually. Then check the level of sweetness and add the sugar to achieve the desired sweetness. Cook on low another 5 to 10 minutes, stirring regularly. Add salt and pepper to taste.

Check the thickness from time to time and add stock or water as needed. The mole should be thick enough that it sticks to the back of the spoon.

Serve over chicken, pork, beef, Oatmeal-Seed Cakes (see page 201), or Sweet Potato Nests (see page 202).

Garnish with toasted sesame seeds for added texture and flavor. Serve with tortillas and rice.

Mole Almendrado
Almond Mole

SERVES 6–8

This is a lighter mole and easier to make, relatively speaking. It has a creamy texture and a slightly acid touch due to the pumpkin seeds.

4 guajillo chiles
4 mulato negro chiles
4 pasilla chiles
¼ cup raw sesame seeds
¼ cup pumpkin seeds
2¾ cups raw, peeled almonds
2 medium red tomatoes
2 garlic cloves, peeled
¼ medium white onion + 2 slices white onion
½ teaspoon marjoram
½ teaspoon thyme
¼ teaspoon oregano
1 bay leaf
¼ teaspoon clove
¼ teaspoon cumin
¼ teaspoon ground cinnamon
1 piece star anise
¼ teaspoon whole black peppercorns
3 tablespoons oil
2 ounces baguette or similar bread, broken in pieces
1 hard tortilla
3½ ounces mature plantain
4–6 cups chicken or vegetable stock, or water, divided
3 tablespoons melted manteca or vegetable oil
3 ounces dark or semisweet chocolate (optional)
½ tablespoon sugar (optional)
Salt and pepper to taste
Chicken, pork, Oatmeal-Seed Cakes (page 201), or
 Sweet Potato Nests (page 202) to serve with the mole
Almond slivers for garnish
Tortillas and rice to serve on side

Cut the guajillo, mulato negro, and pasilla chiles lengthwise and remove seed, stems, and veins. Toast in a pan on medium heat for 1 minute on each side, taking care not to burn them.

Toast the sesame seeds in the same skillet on medium heat, stirring continually for 2 minutes until they take on a light golden color. Remove from heat and set aside. Repeat the same process with the pumpkin seeds and almonds, toasting each type separately 5 to 7 minutes.

Heat a pan on medium and toast the tomatoes, garlic, and ¼ onion for a few minutes, turning until slightly burnt on all sides. Allow to cool and set aside.

Stir all the spices (marjoram, thyme, oregano, bay, clove, cumin, cinnamon, star anise, and peppercorns) in a dry skillet over low heat place for 1 to 2 minutes to toast and intensify their flavor. Remove and set aside.

Heat vegetable oil in a skillet over medium-high heat for 2 minutes. Add the bread pieces, corn tortilla, and plantain. Sauté to a dark golden color without burning. Blend with a bit of stock and set aside.

Place the toasted chiles in a pot with 1 cup of chicken stock or water and simmer on medium for 15 to 20 minutes or until soft. Place the chiles in a blender with a little of the stock they had cooked in and the toasted spices and blend well. Set aside.

Blend all the seeds and nuts with a little stock or water and set aside. Then blend the tomato, garlic, and onion and set aside.

Place the manteca and 2 slices of white onion in a large saucepan over low heat. Sauté for a couple minutes before adding the chile-spice mixture. Cook for 10 minutes, stirring continuously. Add the tomato-onion-garlic mix and cook another 15 minutes, stirring constantly.

Next add the bread-tortilla-plantain mixture and cook another 10 to 15 minutes. Then add the 2 cups of stock and cook for 10 more minutes on low, stirring

regularly. Add the seed-nut mixture and continue to cook for another 15 minutes. If necessary, add another 1 cup or so of stock or water. The goal is a watery consistency as the mole will thicken as it cooks.

Add the chocolate and cook for an additional 10 minutes, stirring continually. Then check the level of sweetness and add a bit of sugar if you'd like it to be sweeter. Cook on low another 5 to 10 minutes, stirring regularly. Add salt and pepper to taste.

Check the thickness from time to time and add stock or water as needed. The mole should be thick enough that it sticks to the back of the spoon.

Serve over chicken, pork, beef, or vegetarian cakes, such as the Oatmeal-Seed Cakes or Sweet Potato Nests.

Garnish with almond slivers for added texture and flavor. Serve with tortillas and rice.

Guerrero Mezcaleros

If you ask a Mexican what they think of when they think of Guerrero, they will most likely say: "Acapulco, drugs, and narcos." If you ask a Guerrerense what they think of, the response would quite likely be along the lines of: "Mexican independence, *puerco relleno*, fresh fish, pozole, mezcal, jaguars, beautiful beaches, and masked dancers." That, anyway, would be Noel's response. While Guerrero is one of the poorest states in all of Mexico, it is also one of the richest in terms of cuisine, native culture, and art. Typically, the states with the highest rates of poverty (Guerrero, Oaxaca, and Chiapas) are those where the native peoples still follow their traditions. Quite possibly it's because they rarely benefit from the country's economic growth that the traditions of these regions are still so strong—both a blessing and a curse.

Although Guerrero has a long history of mezcal production, it is not one of the states widely talked about in the market. Perhaps that's because it takes some serious *huevos* to do business here, given the dangers, and few brands choose to work within its territory. There are also only four to five different types of mezcal produced here, compared to the fifteen plus types produced in Oaxaca. And just maybe it's that underdevelopment of the mezcal market in the Warrior State that is the reason there is still so much magic to be found.

Noel's bloodline runs through the mountains of the Sierra Madre. He was raised with mezcal, and many people knew his grandfather who produced in the fifties. This connection, combined with his native looks, gives him an opening into small communities, where most are untrusting of outsiders. In one such community lives the mezcalera Rosa Flores. Noel had met her the previous year and purchased liters of her "Secas" and "Suave" (both are *Agave cupreata*, also known as *papalote*)—the former produced in the dry season, distilled to 55 percent; the latter produced at a lower level of alcohol with women in mind and used primarily in religious celebrations.

We pull up to Maestra Flores's three-story home on a Monday morning, excited to meet with one of the few female mezcal producers in the region. She welcomes us into her living room. The walls and floor are bare concrete—no paint, no tiling, no decorations. Nothing but a plastic table and a few chairs. She offers us mezcal and chats with Noel for a spell. At our urging, she begins to tell her story of how she came to produce mezcal.

Maestra Flores married at the age of fourteen, when she was earning a humble living by sewing and weaving palm into cinta, which is used to make hats, bags, and floor mats. Her newly acquired husband didn't have work. "I told him, 'I can make my money, but what are you going to do?'" He decided to move his family into the mountains and learn to make mezcal.

For nine years they camped in the mountains, harvesting agaves and producing mezcal, only returning to the village to resupply. They went up the mountain the first time with a newborn baby. I asked how she managed to care for her child while working.

"I would wear my baby tied to my back with a rebosa when harvesting," she told us. "Or I would leave him sleeping alone in the hammock while we went."

You know—as most women do.

At the end of nine years, they returned to town with five children.

She stood leaning against the cement wall in a pink, traditional dress, her hands behind her back, telling her story straightforwardly, as if what she had done was no more difficult or unusual than what any of us had done as teenagers.

El Suave: Papalote—Meet our mezcal distilled by Maestra Rosa! Sweet with a great body, but POW! She is Sateen, star of the Moulin Rouge; the Courtesan of the Round Table. So damn sexy she takes your breath away.

Rosa moves to the steps and sits beside a pile of palm, where she continues weaving. We ask if she will be making more mezcal in the coming months and are disappointed to learn she's stopped producing. Her sons have left town, and she's unable to make it without their help. She doesn't look the least bit concerned at not having mezcal sales to rely upon.

"*No voy a morir por hambre,*" she tells us with a subtle smile, suggesting that her needs are simple and her income from weaving (about seven pesos per two-meter cinta) is enough for her.

The conversation moves on to more mundane topics: the weather, the crops, how the town is nearly out of water. Forty years before, she tells us, the spring that supplies the town's water ran dangerously low. A local medicinal

man told them to send someone to the ocean to collect salt water and offer it to the spirit beneath a particular tree. They followed his instructions, placing the water in a glass bottle in the ground. Shortly after, the water returned. The spirit, it is said, is a young boy who drinks from the bottle and then pees into the well to fill it up with water for the townspeople. Every time the well runs low, someone is sent to the coast to collect saltwater and offer it to the boy who lives below the tree, and every time the water returns. But last year someone constructed a new building next to the tree and broke the bottle in the process. The spring is beginning to run low again.

Rosa admits, too, that the lack of water this time around could be due to the growth of the town. Many people from the mountains eight hours away have moved to this village.

"Pero, Doña Rosa, es un pueblo muy chiquito," I say. It's a tiny town. Why would anyone come looking for work in such a small corner of the state?

De las Secas: Papalote—If la Maestra's "Suave" is a cancan dancer, her "Secas" prefers the merengue: sweet, fun, iridescent; a cotton-candy that tickles the palate. This is pure happiness in liquid form.

Noel explains: these are people making less than three US dollars per day working twelve-hour days in the fields. Even a town with only 1,200 inhabitants provides more opportunities than where they'd come from.

We buy the few liters of mezcal Doña Rosa has left over from her last distillation, thank her, and make our way back to Chilpancingo.

Four months later, her sons return home for a visit and together they make more mezcal. Noel and I buy a share of it for the restaurant, and immediately "La Rosa" becomes the preferred *distilado* among our clientele.

The following April, Noel and I plan a trip to Hidalgo to check out an exotic food festival in a native pueblo, where everything from iguana and possum to various beetles and grubs are on the menu. But at the last minute we hear from Noel's brother that they'll be making a lot of mezcal near Chilpancingo—the last batch before the rainy season hits. We ditch our plans for the east and catch a bus in the opposite direction to Guerrero instead.

We first visit Don Zach, a mezcalero whose father worked alongside Noel's grandfather and who has won multiple awards for his mezcals in recent years. We've worked with Don Zach for years and love his mezcal (if you've been to our restaurant, you'll likely have tried our "El Don" and "Berraco" mezcals, courtesy of this mezcalero). The day we arrive, he's distilling—something I had not yet witnessed in Guerrero. We sit and chat and taste.

La Rosa: Papalote—Doña Rosa's mezcal tickles your tongue and quivers beneath your skin, like the all-consuming romance of your youth. With hints of Valentine's sweetheart candy, her punch leaves you giddy as a schoolgirl—as helpless as if you were hit by Cupid's arrow.

He and his son, Jorge, give us a try of their classic papalote; then an *ensamble* of berraco and papalote, a *gusano*-infused papalote (mezcal with the worm is mostly a tourist gimmick, but occasionally a mezcalero will produce one just for fun); followed by what I later dub *campesino* (a papalote of 130 proof, regularly drunk by those working in the field); and finally a papalote weighing in at 150 proof. The campesino I quite like—it's not nearly as harsh as I'd imagined. It has an overwhelming odor of funky cheese—enough to smell it from across the room—yet the taste is not at all of cheese, but of lemons. The 150–proof mezcal is a bit too much for me, but Noel enjoys it.

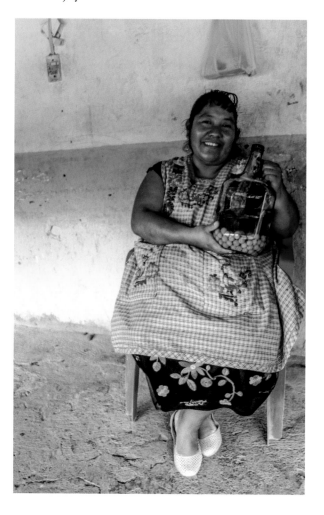

El Don: Papalote—Sweet and humid. Wet earth after a desert rain. The ancient cowboy sits mending his boot on the porch. The few words he speaks hit you like a revelation. As you stand, reeling from his wisdom, Shirley Temple tap-dances across the porch in a daffodil-yellow dress.

<div align="center">***</div>

It's six in the morning. I'm on the floor of my brother-in-law Ismael's living room, struggling to rouse myself.

"*Apurale!*" Noel says. "It's time to go!" He returns to the mattress on the floor with our daughter.

I rise, dress, and brush my teeth. "Aren't you coming?" I ask.

"No, I'm going to stay here. You go with Ismael."

"But why? Lila will be fine with Rosie." Although I prefer the idea of him staying with Lila, I'm also nervous about traveling through the wilds of Guerrero without an intimidating husband by my side.

"And what if you die?" he asks. "Who will raise our daughter?"

Ensamble Berraco-Papalote—Sweet and spiky like Betty Boop's heels.

With that thought in my head, I kiss Lila on the cheek as she sleeps and head out the door,

terrified something is going to happen and I'll never see my sweet Smunch again. For the next thirty minutes, as we stop for food and coffee in the Oxxo and make our way down the highway, I consider turning around. If Noel is nervous about safety, I should be terrified, no? Ismael assures me his brother is exaggerating. Ismael is also habituated to the violence of the region, living with it daily as he does. I remind myself that that violence is very much targeted—and not at tourists or at people minding their own business.

By the time we meet up with Jorge, my anxiety is gone. Everything is going to be fine, I realize. Not only—this is *amazing*! How many foreigners have witnessed the loading of an agave oven out in the campo of Guerrero? I'd wager only a handful.

We drive away from the village, up a mountainside, down a mountainside, past crumbling rock walls, parched fields, abandoned agave ovens, herds of cattle and horses. Wild papalotes spattered across the dry earth as far as one can see. We pass a dozen men scraping away the earth of an oven, preparing to remove the agaves. They eye my camera and I suspiciously; we continue on. The winding, rutted, rock-strewn *camino* empties out into a long valley patched with burnt and dried-up cornfields. The landscape is desolate—a striking contrast to the verdant Guerrero I'd known in the rainy season. At the far end of the valley sits the oven.

I ask why they roast the agaves so far from the town where they'll be crushed, fermented, and distilled. Ismael explains to me that it's actually cheaper to bring all the workers and the agaves (which are harvested from the wild in the surrounding areas) out to where there are plenty of rocks to use in the oven, then it is to collect and lug the rocks and agaves back to the fabrica in town. They need new rocks every time in order to obtain the optimum temperature, and the gas to transport them from the fields to town increases production costs significantly.

We arrive just as the morning is beginning to sweat. A pickup and two horses rest off to the side, waiting under the heavy swagger of the sun. My chancla-clad feet are devoured by minute mosquitos within moments of stepping out of the truck. Twenty men lounge around, digesting their breakfast before the intense work begins. Jorge and Ismael unload the cooler from the truck and invite the workers to beer and soda; two women—wives of the workers—offer us mole rojo, beans, and handmade tortillas. We gulp them down enthusiastically along with a bottle of Victoria, while listening to the ghost story of the two men who'd arrived in the night to start the oven fire.

A light appeared up there on the mountain, said one man. *It came down the mountainside and circled slowly around us; it hovered a while in the tree above, then disappeared. We were all terrified.*

Those who had witnessed it were clearly shaken, and the others listened intently to their story.

"We thought maybe it was the devil," one of the men said.

"A devil come to ask for money," another speculated.

"It must have been a really poor devil to come looking for money from me," the first joked.

Everyone thought this was a good one, and that became the story: the impoverished devil who came down the mountainside to steal money from the campesino.

Jorge, who would be buying all these agaves once cooked, introduced us to the men in charge.

I was surprised to learn that they have a fogonero—a man who is specifically in charge of the roasting process. In Oaxaca, as far as I had always understood, there is only one mezcalero in charge of the entire process, from purchasing to roasting, crushing, fermenting, and distilling. (Agaves are usually purchased from a magueyero, who harvests them from *ejido*, or communal, land). Here, the roasting is a separate, specialized trade that one spends decades mastering.

I'd planned to take video footage and photos of the process, but I can already see that the men are eyeing me with reservation. Many indigenous men and women have been lied to and exploited by mestizos, criollos, and foreigners, and as such, they eye outsiders with deep suspicion. As they gathered around the oven preparing for the labor that lay ahead, I explain to them my intention:

"*Buenos días, y gracias por invitarnos,*" I begin. "Myself and my husband—whose grandfather made mezcal with Jorge's grandfather—are writing a book about native culture, food, and mezcal. In Mexico and the United States everyone talks about mezcal from Oaxaca. But we want the people to know that Guerrero makes some of the best mezcal in all of Mexico."

The men nod in agreement and relax. I sense that as long as they feel I respect their work, they don't mind the camera.

The fogonero apologizes for his imperfect and heavily accented Spanish (Náhuatl being his mother tongue) before giving me a short explanation of the roasting process. Then the men get to work. The oven had been lit hours before to ensure the rocks were hot enough, but the fire only coals so as not to burn the agaves.

The manual loading of an agave oven is an impressive labor. I watch as twenty men spend a full hour carrying the agave hearts, whose *pencas* (spiky "leaves") had been previously removed, to the oven, loading it just so with the larger agaves in the center and the smaller ones lining the outside. Some had been cut in half and a few were so large they had to be rolled across the dirt to the oven. I can see holes in some where a worm had burrowed in. Jorge shows me how to identify which agaves are capón—a harvesting process where the flowering stalk is cut and the agave left to sit another five to ten years to collect more sugars. The oven loading complete, the men begin to hack away at the earth and pile the dirt in concentric circles over the agaves, lining each level with palm leaves.

"The leaves keep the moisture in the oven and prevent the agaves from burning or drying out," Jorge explains.

The entire process of loading and covering the oven takes the twenty men about two hours to complete.

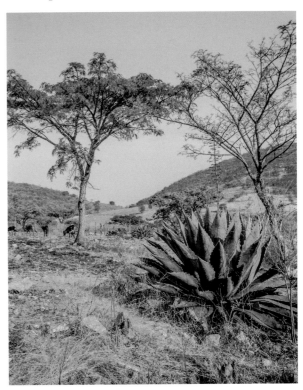

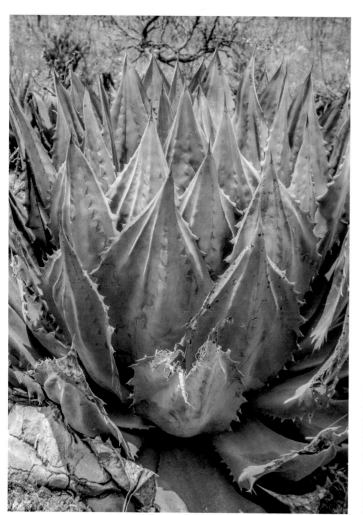
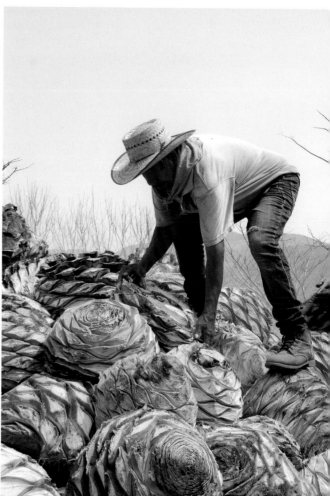
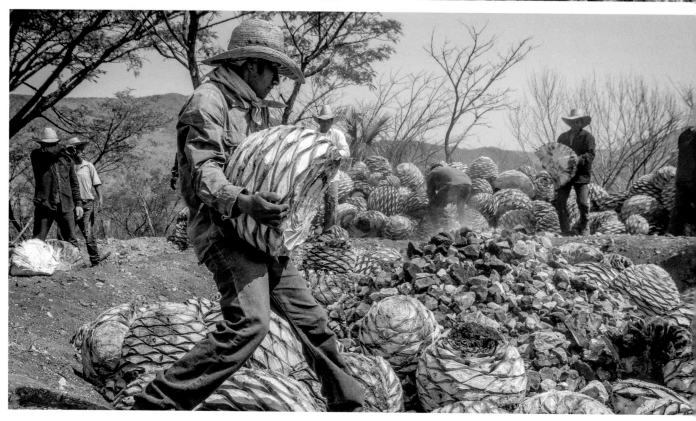

We thank the men and women for sharing with us before making our way back to Jorge's family fabrica. We stop momentarily at another oven just outside of town where they're pulling the roasted agave hearts out and weighing them on a large scale. Everything is blanketed in a thick, ashen coat—the air, the agaves, the men; even the atmosphere feels somber. It's a stark contrast to the vibrant scene we've just left. We hurry on, sensing the men's wariness, and return to Jorge's to retaste Don Zach's distillates at his insistence.

I'm anxious to get back to my little girl, but the mezcal is singing in my veins, and the arid heat and the vividness of the Guerrero campo has clung to me. My spirit is humming with inspiration. Once one has seen the amount of labor and love that goes into making a batch of artisanal mezcal, it is impossible not to respect those who bring this spirit to life. But when one witnesses mezcal being made as it has always been made—not for a brand or for huge profits, but for the community—it is humbling indeed.

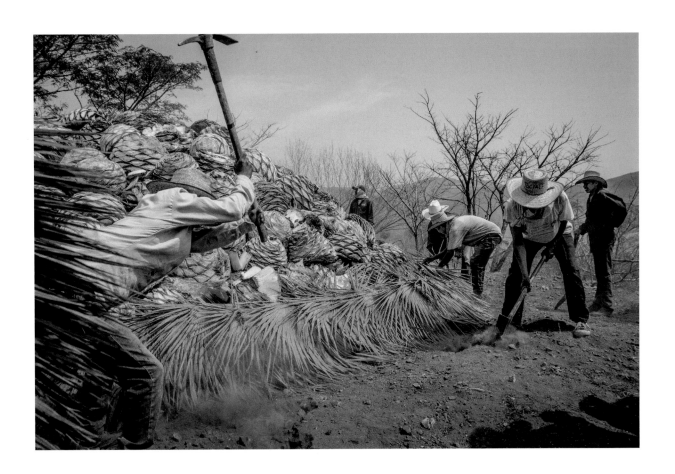

Pescados y Camarones
Fish & Shrimp

We are lucky to have access to some of the best fish in the world at El Refugio Mezcaleria, being less than three miles from the fisherman's beach. Try to use the freshest fish and shrimp possible for these dishes—it makes all the difference. You'll notice that with the shrimp recipes, we leave the shell on while cooking them so they don't reduce in size. Keep in mind, this means your guests will have to peel the shrimp themselves.

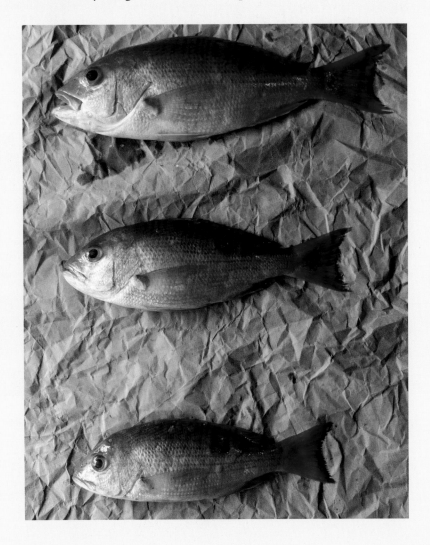

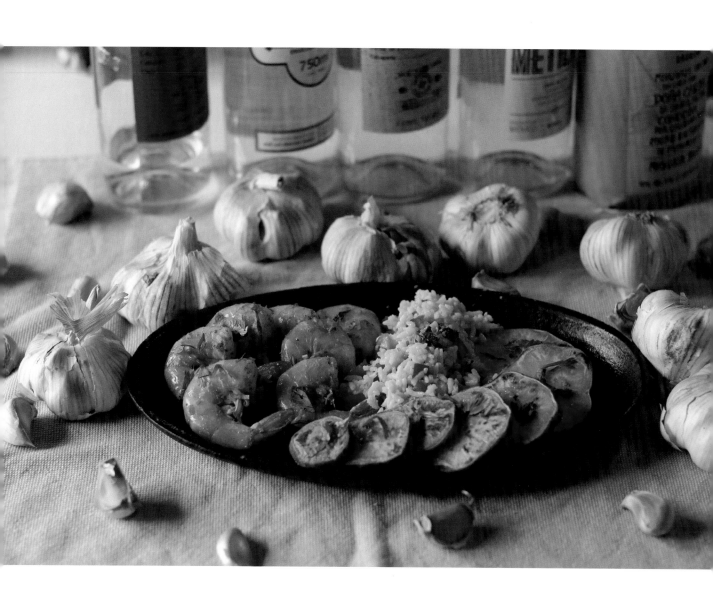

Camarones al Mezcal
Shrimp in Mezcal

SERVES 4

This is a very easy dish to make, but with a great aroma and flavor. We recommend using an artisanal espadín for the mezcal.

24 shrimp with shells
2 tablespoons olive oil
2 tablespoons butter without salt
2 garlic cloves, finely chopped
Salt and pepper to taste
2 ounces mezcal
¼ cup chopped, fresh cilantro for garnish

Clean the shrimp: slice along their backs to remove the veins, but leave the shells on. Rinse under cool water.

Heat oil in a pan over medium heat. Add butter and melt, then add the chopped garlic and sauté 2 minutes. Next, add the shrimp and cook 3 minutes. Add salt and pepper to taste. Add the mezcal and leave to reduce (cook until the mezcal disappears).

Plate, garnish with cilantro, and serve.

Pictured on the left

Camarón al Mojo de Ajo
Garlic Shrimp

SERVES 4

This is a traditional Acapulco plate. Simple, but flavorful.

24 shrimp with shells
10 garlic cloves, peeled
7 tablespoons oil, divided
¼ cup apple cider vinegar
Salt and pepper to taste
¼ tablespoon paprika

Clean the shrimp: slice along their backs to remove the veins, but leave the shells on. Rinse under cool water.

Place the garlic cloves in a blender with 4 tablespoons of oil, vinegar, salt and pepper, and ¼ tablespoon paprika and blend until homogenous. Strain the blend into a bowl and add the shrimp. Leave them to marinate for 30 minutes in the fridge.

Heat a pan with 3 tablespoons of oil to high temperature. Remove the shrimp from the marinade and place in the pan. (It's important to not include the extra marinade in the pan because the flavor will be too intense). Sauté for 3 to 5 minutes on high heat, stirring regularly.

Plate and serve.

Camarones à la Diabla Deviled Shrimp

SERVES 4

A spicy shrimp dish found all along the coastlines of Mexico.

24 shrimp with shells
2 cups water
6 shrimp heads, rinsed
¼ medium purple onion
4 garlic cloves, peeled
Salt and pepper to taste
1 tablespoon fresh epazote (or 2 tablespoons dried)
1 tablespoon chopped cilantro
1 tablespoon dried oregano
1–2 chipotle chiles and 1 habanero (optional)
1 lime, juiced
2 tablespoons oil

Clean the shrimp: slice along their backs to remove the veins, but leave the shells on. Rinse under cool water.

Boil 2 cups of water in a pot. Add the shrimp heads, onion, garlic, and salt and pepper to taste, and simmer on medium for 15 minutes.

Place the shrimp heads, garlic, and onion in the blender with epazote, cilantro, oregano, 1 chipotle chile (optional), lime juice, and salt and pepper to taste, and blend to get a thick mixture. For a spicier dish, add 1 extra chile chipotle at this point. For extra spicy, add an additional 1 fresh habanero.

Place the mixture in a bowl. Toss the 24 shrimp with salt and pepper and add to the mixture in the bowl. Leave to marinate for 30 minutes.

Heat a pan on medium and add oil. Allow the oil to heat a couple of minutes. Remove the shrimp from the mix and place in the hot pan. Sauté for 3 minutes.

Remove from pan and serve.

Torta Olmeca Prehispanic Shrimp "Pancake"

SERVES 6

This "shrimp pancake" is an unusual pre-Columbian plate hailing from Tabasco, site of the great Olmec civilization.

2.2 pounds (1 packet) corn flour
4 cups hot water
2 pounds fresh shrimp with shells
1 medium onion
4 red tomatoes
1 bunch cilantro
4 garlic cloves
5 tablespoons olive or vegetable oil
1 stalk fresh epazote
Salt and pepper to taste
Quesillo (optional)
Salsa of your choice to serve on side

Put the corn flour in a large bowl and add the hot water little by little. Knead the corn dough and continue to add water as needed until you have a firm, flexible, uniform dough.

Take a handful of the dough (about 4 ounces) and form a ball. Shape the ball into a thick tortilla, approximately 5 inches in diameter and 1 inch thick. Repeat until you've made 6 tortillas. Heat a pan on medium and cook the tortillas for about 5 minutes on each side.

Rinse, then butterfly the shrimp. Remove the heads, but leave the shells on. Cut the onion and tomatoes into 1-inch cubes. Chop the cilantro and finely chop the garlic. Set aside a handful of chopped cilantro for the garnish. Heat a pan on medium with the oil. Sauté the onion, garlic, and tomato for 5 minutes. Then add the cilantro and shrimp and sauté for another 20 minutes, stirring often. Add the stalk of epazote and cook for another 5 minutes. Add salt and pepper to taste.

Slice along the circumference of the tortillas to make a pocket (like pita bread). Remove the shells and tails of the shrimp.

Stuff the tortillas with the shrimp mixture. If you'd like to add the quesillo, do so now. Heat the stuffed tortillas in a pan on medium for about 5 minutes.

Plate and serve with your preferred salsa. Garnish with chopped cilantro.

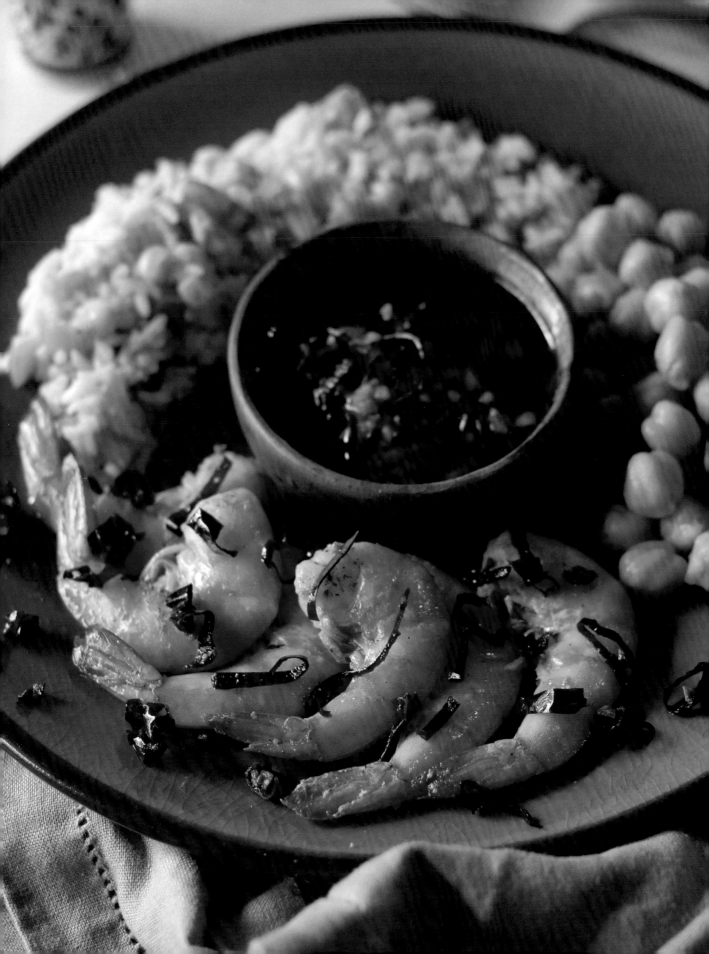

Camarón al Ajillo Shrimp in Garlic and Chiles

SERVES 4

Similar to the camarón al mojo de ajo, but with a bit of a kick from the chile peppers.

24 shrimp with shells
2 tablespoons oil
2 tablespoons butter (no salt)
6 garlic cloves, peeled and finely chopped
2 árbol chiles
Salt and pepper to taste
1 tablespoon white wine
½ cup chopped fresh parsley

Clean the shrimp: slice along their backs to remove the veins, but leave the shells on. Rinse under cool water.

Heat a pan on medium. Add 2 tablespoons oil and allow to heat for 1 or 2 minutes. Add butter and allow to heat 1 more minute. Add the garlic and 2 chiles. Sauté for 2 minutes.

Toss the shrimp in salt and pepper and add to the pan. Sauté for 2 minutes on high heat.

Add the wine and allow it to reduce (cook until the wine disappears).

Serve and garnish with fresh parsley.

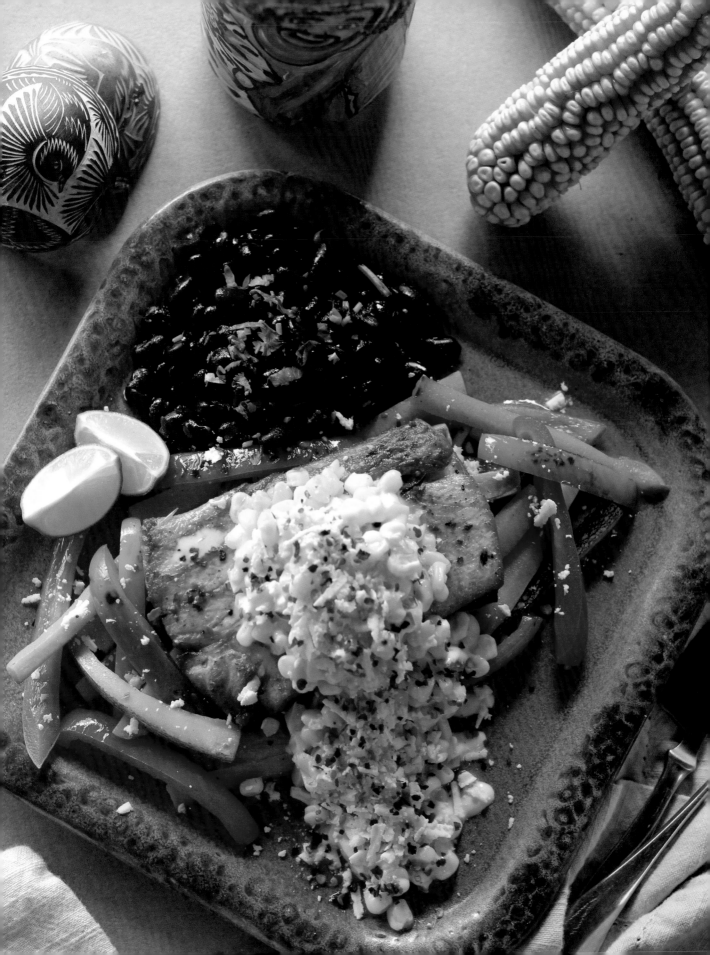

Pescado con Esquites
Fish with Mexican Street Corn

SERVES 6

This is a creation of Noel's, inspired by that much-loved street dish, esquites. It's a filling, nutritive, and colorful dish.

ESQUITES (PAGE 67)

FOR THE FISH

2 pounds fresh white fish, thick filets
Salt and pepper to taste
2 garlic cloves, finely chopped
½ cup olive oil
4 tablespoons Parmesan cheese
4 teaspoons crema
2 limes
1 cup fresh cilantro, chopped for garnish
Rice, beans, or sides of your choice to accompany

Prepare the esquites.

Marinate the fish in salt, pepper, and garlic for 30 minutes. Heat olive oil in a pan on medium heat. Fry fish for 5 minutes on either side. Add esquites and cook together for 1 to 2 minutes.

For a special presentation, serve the fish on a corn husk with esquites on top. Add Parmesan and crema to your liking, squeeze half a lime over each fish, and garnish with cilantro. Serve with rice and beans or the side of your choice.

Consomé de Camarón Shrimp Soup

SERVES 6

Planning a big night out? Cook this the day before as a cure for your hangover. This shrimp soup is packed with flavor and minerals to rehydrate, while the epazote helps with stomach discomfort.

24 shrimp with heads and shells
2 dried guajillo chiles
8½ cups water
¼ medium white onion
½ cup diced white potato
2 carrots
4 garlic cloves, peeled
Salt and pepper to taste
1 zucchini
4 tablespoons fresh cilantro, divided
1 tablespoon fresh epazote (or 2 tablespoons dried)
1 tablespoon fresh parsley
1 tablespoon oregano for garnish
½ cup chopped onion for garnish

Clean the shrimp: slice along their backs to remove the veins, but leave the shells on. Rinse under cool water.

Slice the guajillos lengthwise and remove the seeds, stems, and veins. Toast in a pan on medium, 1 minute each side, and set aside.

Heat 8½ cups of water in a pot on medium-high heat. Add the onion, potato, carrots, garlic, and salt and pepper to taste, and boil for 10 minutes. Add the zucchini and boil 3 more minutes. Add the guajillo chiles and cook another 2 minutes.

Lower the heat to the lowest setting and remove the chiles, garlic, and onion and place them in the blender along with 2 tablespoons of cilantro, epazote, parsley, and salt and pepper to taste, and blend until homogenous.

Add this mix to the pot and heat over medium-high. Add the shrimp and allow to boil for 3 minutes.

Serve in a bowl. Garnish with oregano, the remaining 2 tablespoons of cilantro, and chopped onion.

Tiritas Ceviche Zihuatanejo-Style

SERVES 4–5

This simple ceviche from Zihuatanejo is made from fish cut in long strips. The flavor of this dish is determined by the freshness of the fish, rather than the addition of other ingredients.

2 pounds very fresh fish (marlin, tuna, yellowtail, mahi)
2 medium purple onions
1–2 fresh serrano chiles
15 limes, juiced
½ cup fresh cilantro, chopped
½ teaspoon oregano
Salt and pepper to taste
Tortilla chips and/or saltines to serve on side
1 sliced avocado for garnish

Cut the fish into strips approximately 2 inches long and ½ inch thick. Slice the onions thinly. Slice the chiles in thin rounds (remove the seeds if you want it less spicy). Mix all of the above and add the lime juice, cilantro, oregano, and salt and pepper. Leave to sit, covered, 30 to 90 minutes, or until white and soft.

Serve with tortilla chips and/or saltines on the side and garnish with avocado.

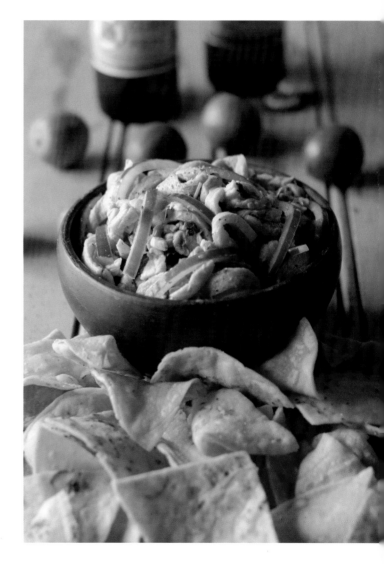

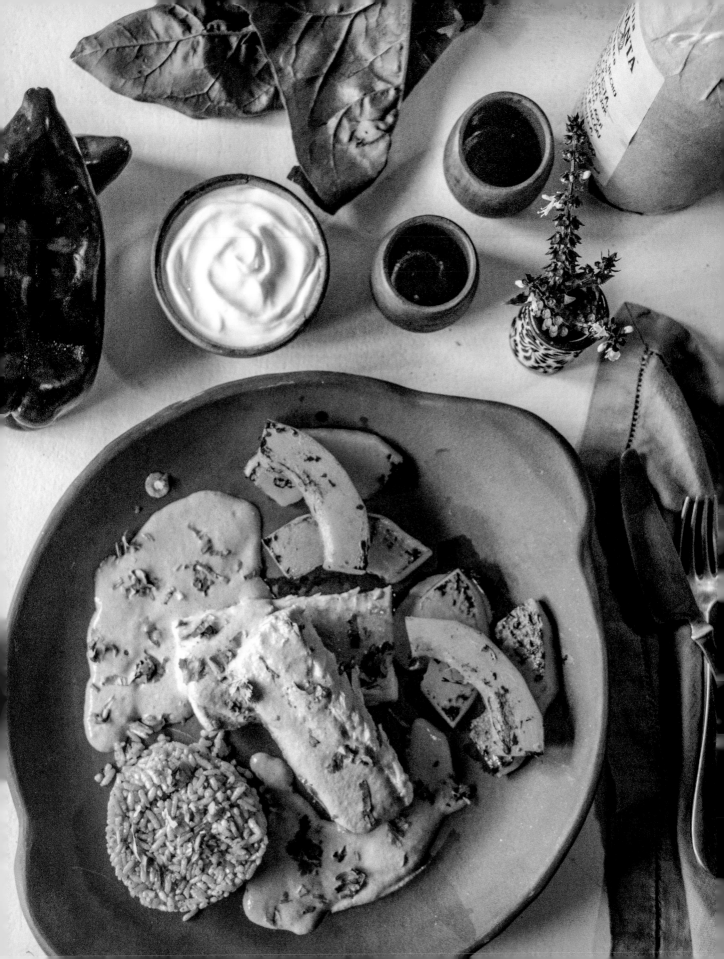

Pescado al Poblano
Fish in Poblano Salsa

SERVES 5

The poblano salsa gives this dish a beautiful color, as well as an incredible flavor.

2 pounds fish fillet (yellowtail or similar)
Salt and pepper to taste
3 poblano chiles
Vegetable oil for sautéing
3 garlic cloves, peeled
½ medium white onion, julienned
½ fresh chile serrano, seeds removed if you want less spicy (optional)
½ cup crema
½ cup fresh cilantro
1 cup spinach
Yellow corn kernels for garnish

Season the fish fillets with salt and pepper.

Heat a pan on medium-high and toast the poblanos for 5 minutes on each side, turning until they begin to burn equally on all sides. Remove from the heat, and place in a plastic bag or a bowl with a top so the steam slowly loosens the skin. Once cool to the touch, remove the skins and cut open and remove seeds under running water. Set aside for later.

Next, heat some oil in a pan on medium-high. Add the garlic and onion and sauté 3 minutes. And chile serrano and sauté for another 3 minutes. Add these along with the poblanos, ½ cup of crema, cilantro, and spinach to a blender and blend until you get a creamy texture.

Add the salsa to a pot and heat on low for 10 minutes. Add salt and pepper to taste.

Heat a pan on medium-high with some vegetable oil and cook the fillets for 3 minutes on each side.

Plate the cooked fish and pour over the warm salsa poblano.

Garnish with yellow corn kernels.

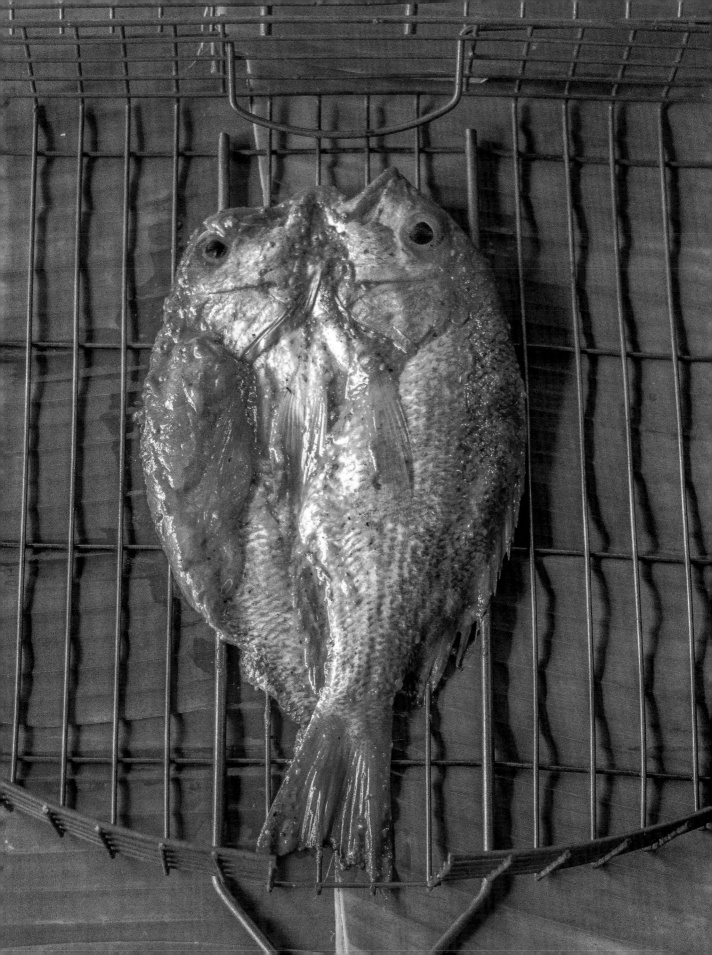

Pescado à la Talla
Whole Grilled Fish with Chiles

SERVES 2

This impressive dish, served as a whole fried fish, is originally from the Barra Vieja of Acapulco. It's commonly found on the coast of Guerrero and Michoacan.

5 guajillo chiles
2 red tomatoes
4 tomatillos, husks removed
4 whole cloves
2 bay leaves
¼ tablespoon cumin
1 tablespoon dried oregano
1 cinnamon stick
1 cup fresh cilantro
3 garlic cloves
½ orange, juiced
1 tablespoon apple cider vinegar
Salt and pepper to taste
2 whole fresh fish with scales, head and fins on (red snapper is best)
¼ cup vegetable oil
Pico de gallo for garnish

Cut the guajillo chiles lengthwise and remove seeds and veins. Heat a pan to medium-high and toast the chiles, inside part facing down, for more than 2 minutes, making sure they don't burn. Remove and set to the side.

Place the tomatoes and tomatillos in the same pan and toast them for a few minutes until they begin to just slightly burn. Rotate them so they're evenly cooked all around.

Turn off the heat and place the chiles, tomatoes, tomatillos, cloves, bay leaves, cumin, oregano, cinnamon, cilantro, garlic, orange juice, vinegar, and salt and pepper in the blender. Blend until smooth.

Next, put the salsa in a pan over medium heat and cook for 10 minutes. Remove from heat and set aside.

Rinse the fish under cool water. Cut the whole fish, dorsal side, into 2 parts from tail to head without separating them. Spread the halves out flat (like a butterfly's wings). Salt and pepper the fish on both sides, then spread the salsa on the inside part of the fish. Cover and leave to marinate 30 minutes.

Heat a large pan on medium, add oil, and allow it to come to full temperature. (Alternatively, this fish tastes fantastic when cooked on the grill). Place the fish in the pan and cook 4 to 6 minutes on each side until it has a crunchy texture and dark golden color.

Plate and garnish with pico de gallo.

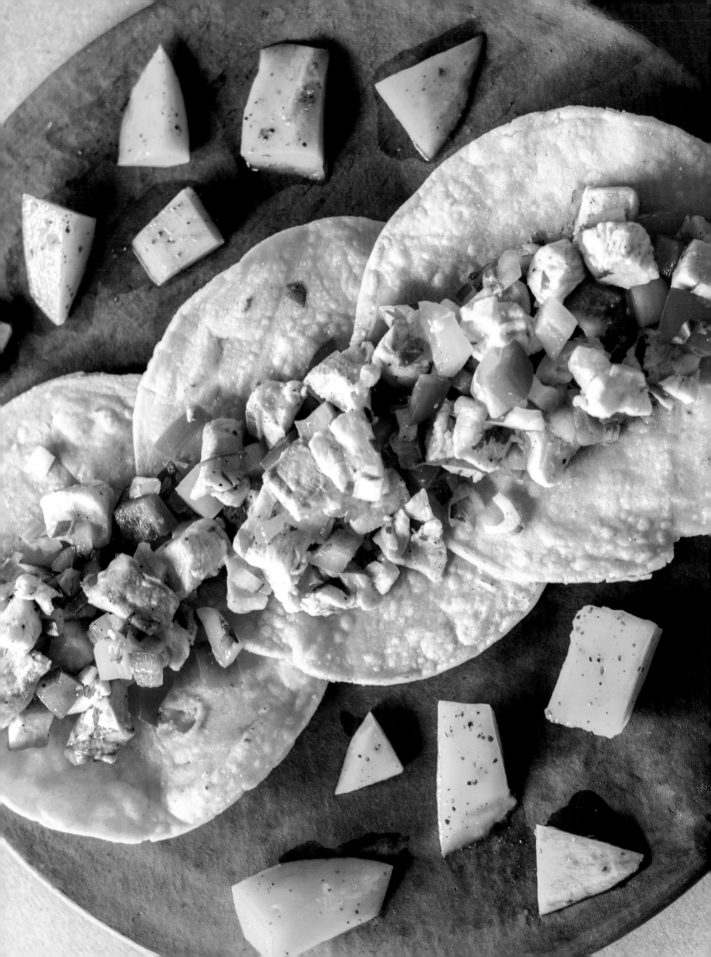

Ceviche Arco Iris
Rainbow Ceviche

SERVES 8

A colorful ceviche to brighten your table. Fresh and light enough to serve as a starter, although we often eat it as a full lunch!

3 bell peppers: 1 red, 1 yellow, 1 green
1 purple onion
1 cucumber
2 red tomatoes
2 fresh jalapeños, seeds removed
15 limes, juiced (use the small, key lime type)
2 oranges, juiced
2 pounds very fresh fish (marlin, mahi, yellowtail, or grouper)
Salt and pepper to taste
1 cup fresh cilantro
Tortilla chips and/or saltine crackers to accompany
3 avocados, sliced

Cut the peppers, onion, cucumber, and tomatoes into 1½-inch cubes; dice the jalapeños. Soak all of the above in one-third of the lime and orange juices for 1 hour.

Meanwhile, season the fish with salt and pepper, then cut the fillets into ¾-inch cubes. Leave to soak in the remaining two-thirds of the lime and orange juices for 15 to 20 minutes.

Once everything has finished soaking in the lime juice, mix the vegetable and fish mixtures together with the cilantro. Check salt and pepper and add more if needed. Place in the fridge, covered, for 1 hour.

Serve cold with tortilla chips or saltines on the side. Garnish with avocado.

Pictured on the left

Pescado en Hoja Santa
Fish in Hoja Santa

SERVES 5

The hoja santa leaf is an aromatic herb used in prehispanic times to add a distinctive flavor to plates. Its flavor is unique, perhaps most closely resembling eucalyptus or mint. Fish in hoja santa is a plate found on the coast of Guerrero, Oaxaca, and Veracruz. It's light, but full of flavor.

4 garlic cloves
4 tablespoons olive oil
2 pounds fresh, white fish filet, cut ¾-inch thick (yellow tail or red snapper are best)
Salt and pepper to taste
4 large leaves hoja santa
4 pieces aluminum foil (approx. 10" x 10")
3 cups water
Rice and vegetables, or sides of your choice to accompany

Blend the garlic cloves with the olive oil in a blender until homogenous. Season the fish fillets with salt and pepper, then bathe them in the garlic oil. Massage the oil into the filets on all sides and leave to sit for 5 minutes.

Meanwhile, place 1 hoja santa leaf on each piece of aluminum foil. Place 1 serving of fish on each leaf. Wrap the leaf around the fish and make a packet with the foil so the juices don't escape when the fish cooks.

Set a pot with a trivet for steaming and 3 cups of water on medium-high. When the water begins to boil, place the fish packets inside the pot, cover, and allow to steam for 15 to 20 minutes.

Remove the packets from the pot. Carefully open the foil and remove the fish wrapped in the leaf. Place on the plate with rice and vegetables or sides of your choice.

FAITH

What makes Mexico such a deliciously complex and colorful country is, quite obviously, its culture. And that culture has its feet firmly planted in its faith. That faith may be in the Catholic Church or it could be in a pantheon of native deities. Quite commonly, it is in a blend of the two that is now so complexly interwoven that the differences are often no longer noted. This blending of spiritual beliefs manifests itself perfectly in one central figure: the Virgin of Guadalupe.

It may come as a surprise to foreigners that in a country known for its patriarchy, its machismo tendencies, and its devotion to the Catholic church, the figure that reigns supreme is a goddess. Her image is omnipresent from Tijuana to Quintana Roo. When you do come across an altar dedicated to a different virgin (of which there are a dizzying number), rest assured: it's one of her deputies. The Virgin is, in fact, more visible and more celebrated than Jesus Christ himself.

The reason goes back to precolonial times. The Virgin is quite simply a Catholic representation of Tonantzin Tlalli: the goddess, Mother Earth, the provider of all our needs. You've most likely heard of Quetzalcoatl, the feathered serpent; but

to truly understand Mexican culture, you must understand the importance of Tonantzin Tlalli.

The Nahuatlacah did not actually have gods or devils, "good" or "bad;" they had energies they revered and utilized. The Spanish, for lack of understanding and vocabulary, dubbed them as gods and demons. And in their attempts to convert the indigenous populations to the Catholic faith, they built their cathedrals on top of sacred native temples and set the dates and images of Catholic saints on to those of native "gods."

The story of the Virgin of Guadalupe is that she appeared to the native Juan Diego on Tepeyac Hill just outside the former Tenochtitlan (in what is now Mexico City) and instructed him to ask the bishop to build her a church. To help Juan Diego convince the bishop that he was not lying (and therefore subject to torture or death), she told him to pick the castellano roses that were growing around her. When Juan Diego opened his *ayacate* (cape) filled with roses before the bishop, an extraordinary and detailed image of the virgin had miraculously appeared on it.

In all likelihood, it's a story made up by the Catholic church to convince the indigenous populations to convert. It was presented after twelve years of eager genocide committed against the natives, when the Spanish realized that perhaps it would be a better political move to get them to join the team rather than eradicate them completely. But what makes the Virgin of Guadalupe so incredible is not just the story of her appearance and success, but of her actual image.

Her gown is embroidered with sacred, hallucinogenic plants; the black ribbon around her waist was a symbol used by natives to signify a woman was pregnant; the cloak of stars is said to be a map back to Pleiades, where the Nahuatlacah believe they first came from. Her left foot is raised, just as an Aztec dancer always begins with her left foot.[4]

The Virgin may well have originated as one of the better scams the Church has pulled off, but the truth is, she has allowed native Mexicans to carry on many of their beliefs and values under the guise of Catholicism these five-hundred-plus years. That mother that cares for her family and community is still the jefa of all jefes. Family comes before anything else—before career, before wealth, before friends and parties, before material accumulation. And for all of Papa's strut and swagger, it's Mama who rules that roost.

So why the discussion of Catholic iconography in a cookbook? Simply put, this

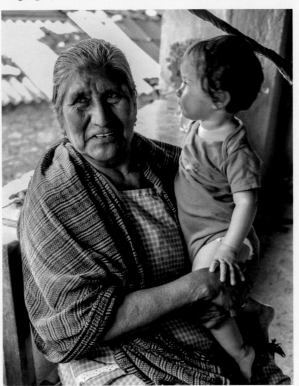

4 To dive deeper into the fantastic symbolism of the Virgin, look for John Mini's book, *The Aztec Virgin*.

Catholic-Indigenous belief system is the central nervous system of the Mexican psyche, and if you're aspiring to make the mera Mexican food (i.e., the real deal), it would help to take a few turns around the block in their shoes. The pantheon of Native-Catholic god-saints powers a calendar replete with holy days, pueblo parties, and agro-fiestas, along with the savory dishes that accompany them. Tonantzin Tlalli and her army of Holy Virgins play a lead role in these celebrations and in daily life in general—from a reliance on intuition and feeling, to a love of color and dance, to the deep respect given toward mothers. So when you're patting out a tortilla, or mixing a mole, it's the spirit of these lovely ladies you'll want to keep in mind (Gordon Ramsey and the likes have no place in a Mexican kitchen). And if native goddesses and Catholic virgins are more than you can swallow, light a candle for your abuelita instead.

Faith is an uncommon phenomenon in the world these days, because the people have become accustomed to verifying their status, their ideas, their feelings. They no longer trust themselves. And for the same reason, most people have maaaaany problems. Because they simply stop believing, and eventually they stop believing in all the synchronicities that occur in this world. Because this world is so complex and interconnected in ways we can't see, it requires faith to develop ourselves. When you have faith—first in yourself, and later in other things— your energy increases because you feel protected. For example, if you have faith that you're going to overcome your economic problems, this will give you the energy to look for a way to generate resources, and

you'll end up ahead. When you don't have faith, whatever obstacle that torpedoes your direction in life becomes enormous, and many times you fail.

Faith is very simple act: it's the act of believing that the things are going to happen the way you think they will or the way you need them to. If you can't believe in something you can't have faith. If you can't have faith, your life will become more complicated, because you need to revalidate yourself each and every day. Because you base your existence—your sense of self—in only what you know intellectually, not in what you believe. And this makes a huge difference.

Reverence for Catholic virgins or Náhuatl deities that I knew nothing about was more than I could conjure in my first years with Noel. Faith wasn't something I was instilled with as a child. Triumph over hardships, I was taught, was won not through faith, but through hard work and common sense alone. The examples of faith I saw growing up seemed more about the show than about genuine belief.

It was Noel who helped me to see that it's not only about believing in a particular something. As I traveled with him and listened to the conversations of dancers, farmers, and mezcaleros, I began to see that faith has less to do with what one believes and more with how one incorporates that belief into daily existence. Where I would believe an end result was possible and obsess over it while stubbornly bushwhacking my way through any obstacles, I saw these men and women steadily doing the work without agonizing about the outcome. The outcome, they know, is largely unpredictable and out of their control.

It's a peculiar irony: the analytical mind tends to obsess about the future, using the logic of the moment to extrapolate what might come tomorrow, disregarding the possibility of anything that does not conform to the facts as they are known today. Whereas those immersed in the native ways seem to hold their presence in today, while trusting their faith to take care of tomorrow. They take what they have, use their intuition in conjunction with their logic, and do their best. The analytical mind has been trained to believe it is in control of its circumstances and to be skeptical of that which cannot be validated by scientific method. It needs exact instructions and measurements and relies heavily on the expert advice and the opinions of others to dictate its direction. It lives in a world obsessed with perfectionism and regulated by logic; it requires renewed validation each and every day. Logic based on scientific facts, however, can only show us where we are and what we know up until this moment.

It's faith in the unknown possibility that leads us into tomorrow. And while the skillful use of logic and action are necessary, it is faith that tips the scales in one's favor.

I have been—and to a greater degree than I would like, still am—the person who rests her vision of reality in what she can see, touch, and explain. Who evaluates herself each and every day and weighs up the hard edge of that reality against the wavering light of being and becoming. Who reconstructs her worth each morning based, to some degree, on the values the modern world flaunts across her cell phone screen. Scientific materialism is a stubborn opponent, and a hard habit to kick. But I've found that by allowing space for possibility—even, at times, improbability—my potential vastly outpaces the limits of my logic. And as I fall deeper into this rabbit hole of native vision, I find there are fewer brambles to bushwhack and, every year, a greater rain of blessings.

Juquila, Oaxaca: A Pilgrimage

"Since the beginning of time, one force has pushed mankind to move forward, to fight for what he wants, to make possible what is unimaginable. This force—the starting point, the path, and the end; what gives the certainty of obtaining that which one longs for; the conviction of what one doesn't see, but feels, and gives meaning to life itself—we call faith."
— Documentary film, *Juquila, Tierra de Fe; Oaxaca, de la Esperanza*

Noel has been telling me about a sacred site tucked deep in the sierras of Oaxaca since we first met. Juquila has been an important pilgrimage site for native Mexicans for centuries. It's not just another native goddess dressed in Spanish robes; not another Catholic church placed upon a pyramid. The energy there is palpable, intense—its native origins still breathing. I'd been wanting to visit for the past seven years, but each time we'd made the intention, we were unable to see it through for one reason or another. This year we nearly canceled our plans to visit as heavy rains were predicted, which would make the route treacherous. As we head south from Sola de Vega, our luck holds: only fluffy, innocuous clouds float slowly through a sea of sunshine.

"She must want you to come," Noel observes. "Not a drop of rain."

I admit: I'm a touch nervous about this trip. Not because of the road, which is hazardous enough without rain, but because I feel like a fraud. This analytical American, full of questions and doubts, skeptical of life's gray areas. But more to the point: deficient in gratitude, meager in faith. Who the hell am I to ask any favors of Juquila? Too white to be accepted by the native goddess, too contemptuous of the Church to be granted any favors by the Catholic Virgin.

There are different stories about Juquila, but the most widely accepted is that the image of Mary was brought to the Sierra Sur region by the Dominican priest Frey Juan Jordan, and in time the concept of Mary combined with the native belief in a central, female fertility figure to produce the Virgin of Juquila. Her statue is said to have been the only thing to have survived the fire that burned down the entire village where she was kept, as well as several other fires in the centuries that followed. Her figure remained intact, with only her skin blackened, inspiring her nickname, *La Quemadita*—the burned one.

But there's another story—one you're not so likely to hear. This story tells that she existed as a Chatino goddess before the Spanish arrived, and that the church, eager to convert the indigenous population, placed their image of Mary on top of the native goddess and blended their characteristics to create the Virgin of Juquila. With her dark skin and hair, she's identifiable to the natives; with her Catholic robes, she is accepted as a virgin of the Catholic Church.

This area is magnetically very powerful. Juquila is the Chatino Mother Earth. She represents the same thing for the Chatinos that the Virgin of Guadalupe does for the Náhuatlacah. You'll see: her stone sculpture isn't a virgin; it's a totem. She's not a painting; she's not made of plaster as all the Catholic idols are. She was made by natives in the native style. But as she is so powerful, the church had to make up a legend—just like the Virgin of

Guadalupe—to maintain control of her. And the people had to accept it.

The Catholic Church doesn't enter where the pedimento is. The pedimento is where her totem is and where the people come to ask for favors. This is where all the power is. The church—where her Catholic image is—it's . . . well, it's a church. The heaviest, the most powerful—the place where we dance—is the pedimento. They say that if you stay up on the mountain near the pedimento at night you can sometimes see a little girl running naked. This is her—this is Juquila.

"It's interesting that a Chatina goddess appears as a little girl, not as a powerful woman," I say.

Noel disagrees. "You know what the greatest gift is?" he asks. "The innocence."

Noel navigates the precarious highway: a two-lane, potholed road with thousand-foot drop-offs and no shoulder. Nothing but food stands and bathrooms lie between Sola de Vega and Juquila, save one small town. It's two-and-a-half hours of twisting mountain roads. We pass donkeys tied to trees two feet from the edge of the pavement, a twelve-year-old slowing down traffic while her father collects wood from a tree he'd felled from above, and a car mindlessly parked in the middle of the road just after the curve, its passengers simply staring at the mountainside ahead. Noel regales me with stories of the visits he's paid to Juquila; this will be his tenth.

"If she doesn't want you to come, you won't make it," he tells me. "Once we were held up for eight hours on a bridge because of a protest before we finally had to give up and turn around."

On the other hand, if Juquila wants you, she'll protect your journey.

Another time, our truck broke down in the middle of nowhere on the coastal road from Guerrero, right on a curve. There was no shoulder to put the truck on, so we pulled all our things out to the edge of the road—sure a car would come around the corner and smash us. Right when we finished taking everything out, a huge emergency tow truck came around the corner, picked us and our truck up, and towed us to the nearest town. The mechanic in this little town, by some error, had just that morning received the exact piece that we needed. Two hours later we were back on the road. I told my friend that if we'd called for a tow truck we wouldn't have got one so professional. And if we'd have had to order the part, it would have taken days to arrive.

The faithful go to Juquila to give thanks and to ask a favor: resources to start their own business, a new house, the healing of a sick child. In exchange, they offer her something to spread her name: to visit her every year, or to name their new business after her. A good friend of ours from Noel's Aztec dance group had a daughter who had regular seizures for the first two years of her life. She went to Juquila and asked her to heal her daughter. In exchange, she promised to always dance in Juquila's name. Eight years have passed and her daughter hasn't had a single seizure since.

There are thousands of stories like this surrounding Juquila.

We're only half an hour out when we round a bend to find a tow truck parked horizontally across the road. Its towline hangs over the edge of the cliff out of sight. They wave us to pass, and as we go around the next curve, I see no sign of the car but a long streak of shattered glass running down the cliff face. There's about a 1 percent chance those passengers are still alive.

"They were probably driving very tired or didn't have much experience on these types of roads," Noel says. "Did I tell you it was easy to get to Juquila? Noooo."

We arrive suddenly. The dirt path that leads to her is lined with *puestos* selling her image, charms, candles, sodas and chips, and all the usual Chinese-made bits and bobs you find at popular pilgrimage centers. Trucks loaded with pilgrims are parked among regular cars: some beaten and battered, others looking like they were driven new off the lot that very day. The license plates state the origin of the pilgrims: Estado de Mexico, Chiapas, Guerrero, Morelos, Distrito Federal, Puebla. Several trucks are stacked high

with blankets and cookware, having traveled for days, loaded with a dozen devotees. Other pilgrims arrive by public bus, bicycle, or on foot, traveling three days or more over mountain paths to pay their respects to Juquilita.

A small sanctuary has been built for her at the pedimento. Its entrance has pews facing her Catholic icon; the ceiling is painted with murals. Large canvas signs line either side. At first I take them for business advertisements, but on a second look, I realize they are photos and words of gratitude for receiving her gifts: a fleet of tour vans for a transportation business, a herd of pigs, a new house. We pass the pews and move toward the back of the sanctuary to where the original Juquila stands—her Chatino name lost to history. Noel tells me he's searched

for her native name for years but has never been able to find it.

I'm surprised to find her stone figure is no more than a foot-and-a-half tall. She stands on an alter covered by a miniature gazebo. She's been given a black wig and is dressed in red silk, in the triangular shape common to so many of the Mexican virgins. Gold charms representing the fulfilled wishes of fertility, love, miracles, and healings are pinned to her cloak. The only part of her native origin the church has left visible is her stone face. In contrast to her Catholic image as a grown woman, it is very clearly that of a young girl. Around her feet are palm-sized houses and trucks representing the wishes of Juquila's devotees. Behind her, more examples of her blessings: marriage photos, baby photos, a young girl in a wheelchair.

We sit with her for a moment, thank her for all we have, make our *pedidos*, and offer our promises. Then we take our candles to the veladora and place them there for her. Clouds begin to roll through the mile-high evergreens, socking in the town of Juquila below.

The following morning, we climb the steep street to the official *santuario*, where the Church houses her Catholic statue. It's September, so there are very few people. December 8 is the day of Juquila, and in the weeks before and after, the town is so overrun with pilgrims there is no place to sleep. Long lines of railings leading into and out of the church keep things somewhat orderly when devotees flock to visit her. The walkways are broad and unblemished, the bathrooms sparkling clean—the amenities are on par with a modern megachurch. The church even has a large room with *petates* (palm mats) for rent for pilgrims who have no money for a room in town.

As we return to Oaxaca City, I reflect on my place in this world of Native-Catholic belief. It is true that at times I feel too much of an outsider to participate: not humble enough, not faithful enough, not grateful enough. I am an imposter in the world of the mystic faithful. Yet it is also true that every human is on their own journey of discovery—the belief and disbelief of their spirits eternally at war.

I have wondered often what it is that makes these miracles in a modern world so intent on disbelief. Is it the geographic location of a sacred temple? The idol? The precision of ritual? The joke on all of us is that we'll never actually know what is fundamentally true and what is not. The only thing left to do, then, is to find what works for oneself and to put the full force of one's being into that. Chatino goddess? Catholic Virgin? In the end, these are only costumes worn over the heart of the matter: one's own faith. It is this faith itself that is the creator of miracles.

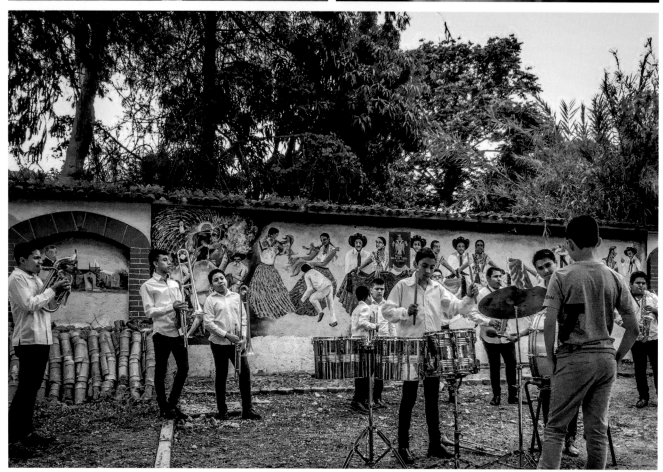

Aves
Birds

Aves are one of the most common sources of protein in Mexico: from the classic quick bite, chicken tinga, to the centuries-old mixotes de pollo. But it's not all about chicken—turkeys originated in the Americas, while quail is a much-loved Sunday brunch in Central Mexico. Whichever your bird of choice, there is something for every occasion.

Pollo Quinceañera Stuffed Chicken Breasts

SERVES 8

This is a dish served at quinceañera parties, as it's viewed as an elegant plate. At El Refugio, we like to give it an extra elegant touch by plating it as a tower. This requires a bit of skill, however. You can also serve it as a stuffed fillet.

FOR THE CHICKEN

2 yellow bell peppers
2 red bell peppers
2 green bell peppers
10 ounces mushrooms
½ pineapple
Vegetable oil as needed
3½ tablespoons butter, divided
1⅓ cup chopped white onion
4 cloves garlic, chopped
3 cups chopped cilantro
Salt and pepper to taste
1 pinch clove
1 pinch black pepper
1 pinch cumin
1 pinch cinnamon
8 boneless chicken breasts, butterflied
9 ounces asadero cheese, grated

FOR THE CHIPOTLE SAUCE

4 red tomatoes
½ medium white onion
1 tablespoon oil
2 cloves garlic, peeled
2 chipotle chiles in adobo sauce from a can
1½ cups water
Salt and pepper to taste

FOR THE CHICKEN

Chop the peppers in pieces no larger than 1 centimeter and set aside. Slice the mushrooms and chop the pineapple into small cubes. Preheat the oven to 350°F.

Heat a saucepan on medium, and add a little oil with 1 tablespoon of butter and the chopped onion and garlic. Leave to sauté 3 minutes and then add the chopped peppers. After 2 minutes, add the mushrooms, pineapple, and chopped cilantro. Season with salt and pepper and the ground spices (clove, pepper, cumin, and cinnamon). Leave another 5 minutes to cook and remove from the stove.

If the chicken breasts aren't of even thickness, pound them until they're about ¼-inch thick. Cut squares of aluminum foil big enough to cover the chicken breasts when they're rolled into a burrito shape. Add salt and pepper on both sides to the chicken breasts and then top with the mix of sautéed onion, garlic, peppers, mushrooms, and cilantro. Add the asadero cheese, and roll the chicken breasts as if you were making a burrito. Before you cover them with aluminum foil, spread the chicken with the remaining 2½ tablespoons of butter. After you add the butter, wrap the rolled breast in aluminum foil. Repeat the procedure until you finish with all 8 chicken breasts.

Roast for 30 minutes at 350°F. Halfway through the roast, at about 15 minutes, turn the chicken breasts and add a little water to the pan if they have run out of liquid. Add more liquid as necessary until they've finished cooking.

FOR THE CHIPOTLE SALSA

Cut the tomatoes in halves and julienne the onions. Heat oil in a saucepan over medium, then add the onions and garlic. Leave to sauté 3 minutes and then add the tomatoes and chipotles. Add 1½ cups of water. Leave to cook for 15 minutes. Blend the ingredients in a blender and then sauté another 5 minutes. Add salt and pepper to taste.

Unwrap the stuffed chicken breasts and serve along with sides of your choosing. Top the chicken with the chipotle salsa. If you'd like to do an impressive plating of this dish, carefully cut off one end of the roll so that you can stand it upright on the plate. Then pour on the salsa.

Tinga de Pollo
Chicken Tinga

SERVES 6

Chicken tinga is one of the most common taco and quesadillas fillings found throughout Central Mexico. It's fairly simple to prepare and has a hint of spice.

4 cups water
Salt and pepper to taste
1 pound chicken breasts
5 garlic cloves: 3 whole, 2 finely chopped
5 bay leaves, divided
2 tablespoons vegetable oil or lard
3½ ounces chorizo
½ pound white potato, peeled and cut into ½-inch cubes
⅔ cup julienned medium white onion
3 chipotle chiles from a can
1 teaspoon ground cumin
Tostadas or tortillas (for quesadillas)
1 cup crema
7 ounces cotija cheese
Beans to serve on side (optional)

Place 4 cups of water in a pot. Add a dash of salt and pepper. Place the chicken breasts, 3 whole garlic cloves, and 3 bay leaves in the pot and boil on medium-high for about 45 minutes. Once finished, remove the chicken from the broth and set aside the broth for later. Shred the chicken.

Heat a frying pan on high. Add oil or lard. When the oil is hot, add the chorizo. Stir while cooking for 3 minutes, then lower heat to medium-high.

Add the potatoes and allow to cook for 4 minutes, stirring regularly. Add the onion and chopped garlic and allow to cook another 2 minutes. Then add the shredded chicken and 1 cup of the chicken broth that had been set aside earlier. Stir and add salt to taste.

Next, blend the chipotles or simply crush them with a spoon. Add the cumin, black pepper to taste, 2 remaining bay leaves, and the chipotles to the pan with the chicken. Allow to cook for 10 to 15 minutes more or until nearly all the liquid has evaporated and the potatoes are soft.

Serve on top of tostadas with crema and cotija cheese. To serve as a quesadilla, place the tinga in a tortilla, fold in half, and heat in a pan for 2 to 3 minutes on each side. Serve on its own or with beans on the side.

Mixotes de Pollo, Costeña-Style Chicken Mixotes, Coastal-Style

SERVES 6

The name *mixote* refers to the agave leaf that is typically used to cook this dish. On the coast, however, they use banana leaves, which make for a beautiful presentation.

2 pasilla chiles
6 guajillo chiles
2 árbol chiles
8 cups water, divided
1 medium white onion, julienned
2 garlic cloves
1 tablespoon dried oregano
½ teaspoon clove
½ teaspoon cumin
½ teaspoon marjoram
½ teaspoon thyme
½ teaspoon whole black peppercorns
6 bay leaves
1 tablespoon apple cider vinegar
Salt to taste
2 chayotes
2 carrots
2 large potatoes
2 zucchini
2 mature plantains
6 chicken legs with the muscle
Pepper to taste
2 pounds banana leaves
6 avocado leaves

FOR THE SIDES

6 limes
Salsa verde (page 20)
Rice, tortillas, and salt and pepper to serve on side

Slice the pasilla and guajillo chiles lengthwise; remove seeds, veins, and stems. Place in a pan on medium heat along with the árbol chiles and toast for 1 minute on each side. Remove and place in a small pot on medium-high heat with 2 cups of water. Leave to simmer for 15 minutes or until soft. Once soft, place the chiles in a blender with ½ cup of the water they cooked in, along with the onion, garlic, oregano, clove, cumin, marjoram, thyme, peppercorns, bay leaves, vinegar, and salt. Blend thoroughly and set aside for later.

Julienne the chayotes, carrots, potatoes, and zucchini. Cut the plantains into half-inch slices. Place everything in a bowl, along with the chicken, salt, and pepper. Pour the mixture from the blender into the bowl and mix well. Cover and leave to sit for at least 2 hours, or preferably overnight.

Once the chicken has finished marinating, place the remaining 6 cups of water in a pot with a trivet and 5 pennies or small coins. If the pot runs out of water, the coins will begin to rattle inside the pot to let you know you need to add more water.

Turn a large pan upside down on medium-low heat and place the banana leaves one at a time on top. Take a wet cloth and pat the banana leaf as it warms on the pan. This will prevent the leaf from breaking in the pot.

Line the inside of the pot with banana leaves, with the avocado leaves on top. We'll use the remaining banana and avocado leaves to wrap the chicken and vegetables. Cut the leaves into approximately 8" x 8" squares, and place the chicken in the center along with a bit of each type of vegetable and plantain, and 1 avocado leaf. Pour a small amount of marinade over the top. Close the four corners of the leaf to make a package. Cut a strip of banana leaf long enough to use as a string to tie the packet, similar to tying a gift box (you can also use a cotton string if you prefer). Place the mixote packets in the pot faceup.

Once all the mixotes are in the pot, cover them with another banana leaf. Cover the pot with the lid and bring the water to a boil. Once boiling, cook on medium-low heat for 1½ to 2 hours. Check occasionally to make sure the water hasn't run out. After 1 hour, check the chicken with a fork.

Serve the packet unopened with rice, salsa verde, lime, salt and pepper, and tortillas.

Codorniz con Especias
Quail with Spices

SERVES 4

Quail is not a plate you find in abundance in Mexico, but it is eaten in Central Mexico—often for almuerzo on Sundays. This preparation is simple and incredibly flavorful. It's a great way to show off to your guests for dinner or brunch. (Just don't let them know how easy it is!)

6 cloves
½ tablespoon cumin
½ tablespoon marjoram
½ tablespoon whole black peppercorns
½ tablespoon cilantro seeds
6 garlic cloves, peeled
4 quails, cleaned and butterflied
Salt to taste
2 cups oil for frying
1 head garlic, cut in two

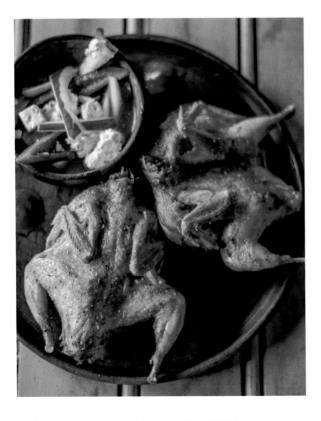

Use a molcajete or food processor to grind the spices: place all the spices (cloves, cumin, marjoram, peppercorns, and cilantro seeds) inside along with the garlic cloves. Grind thoroughly and set aside.

Place the quail in a bowl and season with salt, then season with the ground spices and garlic. Be sure to cover the quail thoroughly on all sides. Cover and place in the fridge for at least 30 minutes up to 4 hours—the longer the time, the more concentrated the flavor.

Place oil in a pan on low, then add the two halves of the garlic head. The oil will slowly heat the garlic and take on its flavor. Once the oil is hot, turn the heat to medium and wait another 1 or 2 minutes before removing the garlic from the pan.

Place the quail in the pan and cook for about 5 minutes before turning over. Cook for another 5 minutes. If you'd like it extra crunchy (as we do), cook up to 15 minutes total. Remove from the pan and place on a paper towel to absorb the extra oil.

Serve one quail per plate with sides of your choosing.

Barbacoa de Guajolote
Turkey Barbacoa

SERVES 8

The turkey originated in Mexico and is usually reserved for fiestas. This pre-Columbian plate might be just what you need at your next Thanksgiving.

6 pounds turkey in pieces (legs, muscles, breast, etc.)
Salt and pepper to taste
12 guajillo chiles
4 ancho chiles
6 garlic cloves
1 medium white onion, sliced into quarters
2 chipotle chiles from a can
1 teaspoon cumin
1 teaspoon thyme
1 teaspoon marjoram
1 teaspoon ground cinnamon
2 teaspoons whole black peppercorns
8 pieces clove
2 tablespoons apple cider vinegar
6 cups water, divided
1½ pounds cambray potatoes
2 pounds banana leaves
12 dried avocado leaves
2 shots mezcal
16 radishes, in slices
16 limes halved
Salad and refried beans to serve on side (optional)

Season the turkey with salt and pepper and set aside in a large bowl. Slice the guajillo and ancho chiles lengthwise; remove seeds and veins. Remove the stems. Heat a pan on medium and add the guajillo and ancho chiles to the pan and toast for 1 minutes on each side. Set aside.

In the same pan, toast the garlic cloves and onion for 3 minutes on each side (or until they are slightly burnt on all sides). Remove and add to the blender with the guajillos, anchos, chipotles, cumin, thyme, marjoram, cinnamon, black peppercorns, clove, vinegar, and 1 cup of water. Blend until smooth.

Add the salsa to the bowl with the turkey. Wash and cut the potatoes in 2 or 3 pieces; add the potatoes to the bowl. Mix well to cover the turkey and potatoes thoroughly with the salsa. Leave to marinade for a minimum of 1½ hours, but preferably overnight.

Once the turkey has finished marinating, place the remaining 5 cups of water in a pot with a trivet and 5 pennies or small coins. If the pot runs out of water, the coins will begin to rattle inside the pot to let you know you need to put more water.

Turn a large pan upside down on medium-low heat and place the banana leaves one at a time on top. Take a wet cloth and pat the banana leaf as it warms on the pan. This will prevent the leaf from breaking in the pot.

Line the inside of the pot with banana leaves, with the avocado leaves on top. Then place the turkey and potatoes inside; pour the remaining marinade over top. Cover with another banana leaf, place the lid on the pot, and bring the water to a boil. Once boiling, cook on medium heat for 1½ to 2 hours. Check occasionally to make sure the water hasn't run out. After 1½ hours, check the turkey with a fork.

When the turkey has finished cooking, turn off the heat. Lift the top leaf and pour the mezcal over the turkey. Replace the lid and leave to sit another 5 minutes. Salt and pepper to taste.

Serve with radish slices and lime, with salad and refried beans on the side.

Rio Balsas, Guerrero:
Into the Mystic—Mexico's Shape-Shifters

Many years ago, my father loved the outdoors and loved to hunt. He hunted deer, wild boar, and rabbits. And we, his sons, always wanted to go, but we were very young. We would beg and beg. Finally, he took me with him to hunt javali *(wild boar). It is a shy species. And they had to run them out of the canyons and gullies toward the plain. My father wanted to hunt in the night before dawn, but I was only six and couldn't handle so many hours following him through the forest. So he looked for a place in a tepehuaje tree so I could sleep. And he tied me up in the tree so I wouldn't fall. I fell asleep right away, but I heard strange sounds all night. The next morning, my father and his friends arrived all*

dejected because they didn't find a single javali, even though the site had promised great hunting. So they returned to me and sat down to rest and chat. And they suddenly began to laugh and laugh.

They'd spent the night searching the five square miles of terrible, rocky, irregular land full of spiny bushes, looking for the boar . . . and this herd they were searching for—some twenty or twenty-five javalis—had been sleeping with me below the tree I'd been tied in all along. They realized it because the land was dug up where the boar had made their nests and there was excrement all around.

Maybe it was my nahual they were attracted to.

The Nahual: one of the more potent and feared beings of Mexican lore. Nahuales are shape-shifters: humans who can take their animal form when they choose. In many communities, nahuales are considered brujos: witches or wizards who shapeshift into their animal form to kill, steal, and generally cause problems. But among other groups, it's accepted that those who can control their nahual are healers and protectors of people, local traditions, and the environment.

"A nahual is someone who has made a compromise with the 'dark side'—the animal side," explains Noel. "In exchange for having their animal senses—keen vision and smell, heightened intuition—they sometimes have to act to maintain the balance. In ancient native belief, there is no good versus bad. There is only the balance of energies. If a human enters a jaguar's territory and the jaguar kills the human, the jaguar

isn't bad. The human invaded his territory. He's merely maintaining the balance."

We're driving along the highway heading from Morelos to Chilpancingo as Noel explains the philosophy of the nahual to Meg and I. He points out the small village of Huitziltepec and launches us into another memory.

My grandfather once told me a story about a friend of his who left to go hunting in the mountains at night. He went walking and a huge owl attacked him over and over. The man tried to scare off the owl and stop it from attacking him, but couldn't. So the man threw a handful of dirt up into the air to confuse the owl, and then shot it. The owl fell to the ground. But this wasn't a normal animal; it was huge—it was bigger than the arms of a human, and the claws were disproportionately large. My grandfather's friend took the owl to his house. The strange thing was, his dogs that accompanied him did want to go near it. In fact they ran away from it. The next day, he saw the owl in the light and how rare it was: huge, and dark, and rough-looking, with black feathers. The man tried to give it to his dogs to eat, but the dogs fled in terror. And since it was a small town, the news of this event went running. The man took the owl outside of town. Not one animal tried to come close to it while he carried it through town—not a dog, not a cat. Nothing. The man burned the owl, left the ashes, and returned to his house.

One week later, a woman arrived from another town asking if anyone had killed a huge owl. The townspeople referred him to my grandfather's friend. She went to the man and asked if he'd killed this enormous animal; the man said, "Yes, I killed it and burned the body. Why do you ask?" The woman replied, "This owl is a nahual. I need its parts to bring it to the man who is the other half of this animal. When you killed the owl, a part of the man died. He has been lying on the edge of death since then. I need to close the circle."

The man led her to the burned body of the owl. To his surprise the claws and the heart were still whole, but as if they were made of stone. The woman put the parts and the ashes in a bag and invited the hunter to follow her to see what would happen.

When the dying man was given the ashes of the owl, he immediately passed away.

Maybe these seem like simple ghost stories, made up by uneducated people who don't have a better explanation, or who have too much time on their hands and not enough TV to fill their imaginations. Maybe they're true, maybe they're not. Maybe it doesn't even matter. These are the stories that shape a people, that add depth and character to their lives, that give meaning to what they do. Maybe the point is not how right one is, but how rich is one's life. If we were to replace all of life's magic and mystery with reason and facts—if all the unknown became known—would it still be worth living?

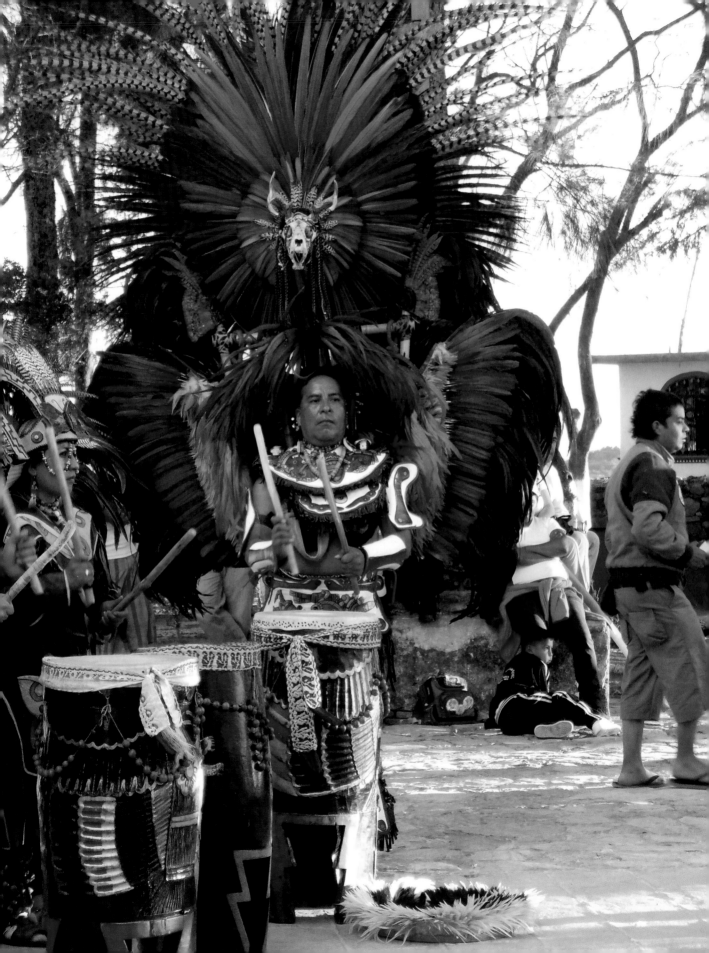

Puerco
Pork

Although domesticated pork didn't exist before the Spanish arrived, javalí (wild boar) was eaten. These days, pork is easily the favorite meat of many Mexicans. Here, you'll find some of our most spectacular recipes, from the perfectly balanced pork in tamarind salsa, to Chiles en Nogada—a dish that has attracted a cult following to El Refugio. (And while I may be biased, I have to say: I haven't found one better than my husband's).

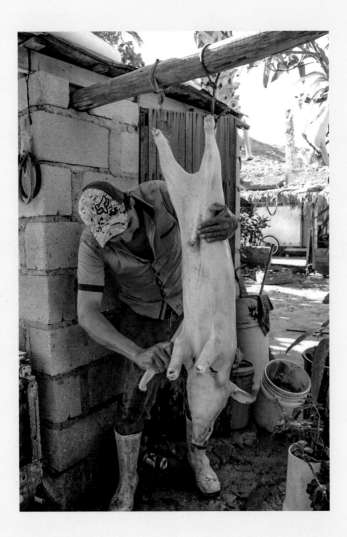

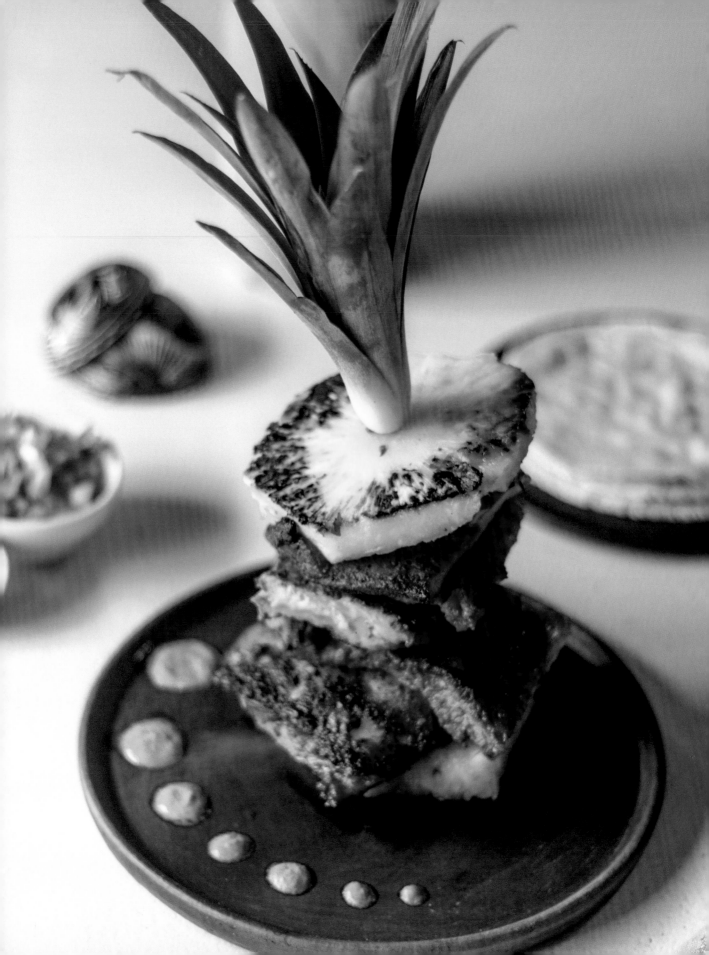

Fiesta al Pastor
Al Pastor Tacos

SERVES 6

The *taco al pastor* is the most popular taco in Mexico. It's inspired by the Lebanese technique of cooking meat on a sharwarma spit-grill, known as a *trompo* in Mexico. Tacos al pastor is *the king* of tacos in Mexico. At El Refugio, we like to layer the meat and pork vertically on a kebab stick when we plate it, transforming it from a simple taco into a fiesta.

6 guajillo chiles
2 cups water
3 garlic cloves, peeled
¼ medium white onion, cut in half
2 chipotle chiles from a can
1 orange, juiced
2 tablespoons apple cider or pineapple vinegar
½ teaspoon ground cumin
½ teaspoon thyme
1 tablespoon dried oregano
½ teaspoon ground clove
½ teaspoon marjoram
½ tablespoon ground black pepper
½ teaspoon cinnamon powder
1 tablespoon achiote paste
2 pounds pork tenderloin or leg, cut in 1-inch-thick filets
Salt and pepper to taste
2 pounds whole, fresh pineapple
¼ cup vegetable oil
½ red onion
1 bunch fresh cilantro
4 limes
12 fresh corn tortillas
Red or green salsa to serve on side

TOOLS
6 kebab sticks (optional)

Slice the guajillo chiles lengthwise and remove the seeds, veins, and stems. Heat a pan on medium; once hot, add the guajillo chiles and toast for 1 minute on both sides. Remove from the pan and place in a pot with 2 cups of water. Leave to simmer on medium for 15 minutes or until they soften. Remove and set aside. Reserve the chile water for later.

Heat a pan on high and add the whole garlic and onion and toast for 3 minutes on all sides (or until slightly burnt on all sides). Turn off the stove and add the garlic, onion, guajillo chiles, and chipotle chiles to a blender, along with the orange juice, vinegar, cumin, thyme, oregano, clove, marjoram, black pepper, cinnamon, achiote paste, and ½ cup of the chile water. Blend until smooth.

Season the pork with salt and pepper and place in a large bowl, piece by piece, while adding the blended mixture. Massage the mixture into all sides of the pork. Leave to marinate for a minimum of 2 hours, but preferably overnight.

Once the meat has finished marinating, peel the pineapple and cut into 1-inch thick slices. Set aside. Next you will cook the pork—either on a charcoal grill or in a pan. If cooking in a pan, heat oil on medium-high before adding the pork and the pineapple. The cooking time will depend on the thickness of the cut—a 1-inch cut should take about 4 to 5 minutes on each side.

Finely chop the red onion and cilantro, slice the limes in half, and heat the tortillas. Serve these on the side along with your preferred salsa. For an impressive presentation, you can serve the pork and pineapple slices layered on a kebab stick standing vertically.

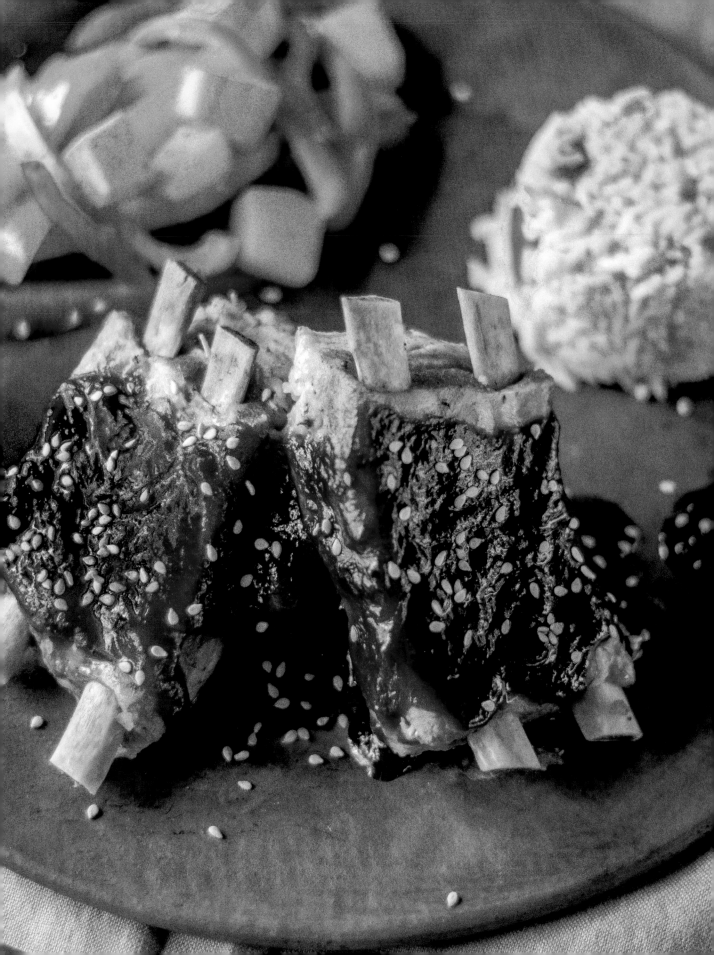

Puerco en Salsa Tamarindo Pork Ribs in Tamarind Salsa

Recipe by Ricardo Tiburcio Clemente

SERVES 4

Tamarind is a much-loved fruit in Mexico, usually served as a candy or as an agua fresca. This dish is a specialty of our sous chef, Ricardo. It is a simple, yet exotic dish with a taste of Asia accented by Mexican spice. The tamarind salsa is bittersweet and well-balanced.

FOR THE PORK

1 cup oil for sautéing
2 pounds pork ribs, separated
Salt to taste
8 cups water
½ medium white onion
4 garlic cloves, peeled
1 tablespoon dried oregano
½ tablespoon ground black pepper
4 bay leaves
Cilantro and sesame seeds for garnish

FOR THE TAMARIND SALSA

2 pasilla chiles
1 morita chile
2 chiles de árbol
2 medium tomatoes
2 garlic cloves, peeled
¼ tablespoon ground star anise
4 cloves
¼ tablespoon cumin
¼ teaspoon cinnamon powder
¼ tablespoon ground black pepper
6½ cups water
1 pound tamarind pulp
1 cup brown sugar
Salt to taste
Rice and vegetables to serve on side

FOR THE PORK

Heat a pan with oil on high. Sprinkle the ribs with salt. Once the oil has come to temperature, add the ribs to the pan and sear them for about 2 to 3 minutes on each side, or until each side has a golden color. Remove from the pan.

Add the ribs to a pressure cooker with 8 cups of water (or 12 cups if using a regular pot). Add the onion, garlic, oregano, black pepper, bay leaves, and salt to taste. If using a pressure cooker, bring to a boil and cook for 35 minutes on medium heat; if using a regular pot, cook for 1½ hours on medium. When the meat is soft and comes easily off the bone, it's ready. Set aside. Save 1 cup of the stock from the pot for the tamarind salsa.

FOR THE TAMARIND SALSA

Slice the pasilla and morita chiles lengthwise and remove the seeds and veins. Next remove the stems, along with just the stem of the chile de árbol.

Place the tomatoes and the garlic in a pan on medium and leave to burn slightly (about 15 minutes), rotating regularly. When most of the skin has a darker color, remove from the pan. Place the chiles in the same pan and cook about 20 seconds on each side. Remove from the pan and add to a blender along with tomato, garlic, anise, cloves, cumin, cinnamon, black pepper, and some water to facilitate blending. Blend thoroughly and set aside for later.

Place 6 cups of water in a pot over medium-high heat. Add the tamarind pulp and sugar, stir well, and leave to cook (stirring occasionally) with the water for about 35 minutes or until the liquid has reduced by 60 percent.

Once the tamarind sauce has reduced to about the thickness of simple syrup, turn off the stove and strain the sauce to remove any seeds or bits of the shell.

Next, add the tamarind sauce to a pan on medium-low along with the mix from the blender and 1 cup of stock from the ribs. Stir well and add salt to taste. If the mix is still a bit acidic, add a little extra sugar or blended tomato. Leave to simmer for about 15 more minutes. The salsa should have a consistency that sticks perfectly to the meat.

To serve, place the ribs on a plate and pour over the tamarind salsa. Garnish with sesame seeds and fresh chopped cilantro. At El Refugio, we typically serve this dish with rice and vegetables.

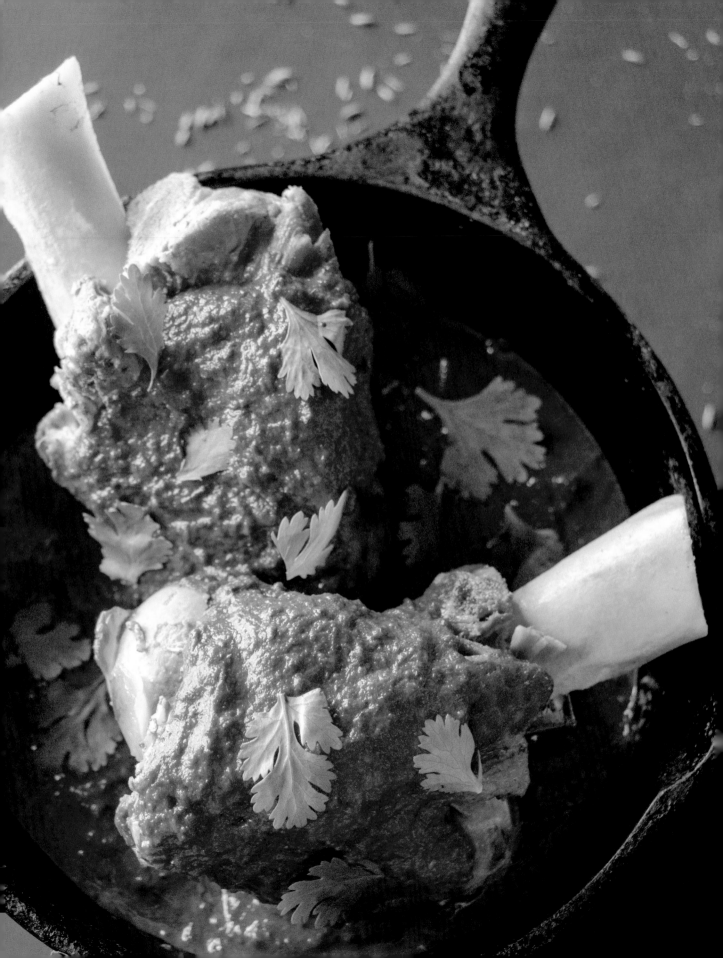

Chamorro de Puerco en Salsa Pasilla
Pork Hock in Pasilla Salsa

SERVES 6

This plate celebrates the aroma and taste of the pasilla chile. It's powerful, simple to make, and a great dish for parties and galas.

6 pasilla chiles
1 pound russet potatoes with skin on
1 chile de árbol
3½ ounces tomatoes
2 garlic cloves
½ teaspoon cumin
½ teaspoon marjoram
½ teaspoon thyme
4 cloves
1 teaspoon black pepper
1 teaspoon sea salt
2 cups chicken or beef broth, divided
¼ cup lard or vegetable oil
4½ pounds pork hock with bone, cut in two, lengthwise
Rice, beans, and tortillas to serve on side

Slice the pasilla chiles lengthwise and remove the seeds and veins. Cut the potatoes in quarters.

Heat a pan on low and add the pasilla and árbol chiles. Cook them for 1 minute on each side, then remove. Turn the heat to high and add the tomatoes and garlic. Cook and rotate occasionally until evenly cooked and just beginning to burn. Remove and add to the blender along with the roasted chiles.

Add the cumin, marjoram, thyme, cloves, black pepper, sea salt, and 1 cup of chicken broth to the bender. Blend thoroughly, then set aside for later.

Heat a pan to high, then add the lard. Once hot, place the pork leg in the pan. Cook the meat on very high heat for about 4 minutes on each side, or until it has a golden color. Remove and set aside.

Add the mix from the blender, the remaining 1 cup of stock, the leg, and the potatoes to a pressure pot. Stir, cover, and heat on high. Once the pot begins to boil, lower the heat to medium and cook for 45 minutes. If using a regular pot, put an extra 2 cups of water and cook on medium-low for 1½ hours. Check to make sure the liquid doesn't run out.

Allow pressure to release from the pot before removing the lid and checking that the meat is done.

Serve with rice, beans, and tortillas.

Carnitas Rancheras

SERVES 6

For this unique dish, we need to find a whole pork belly (pancetta) of around 3 pounds. This cut is perfect for this recipe as it should have various layers of skin, fat, and meat. These carnitas are traditionally cooked in a large copper pot, but if that is not available, a deep, conventional pot will work.

3 pounds pork belly (pancetta)
2 pounds manteca
1 head garlic, cut in half
1 cup evaporated milk
1 orange, juiced
3 tablespoons salt

FOR THE SIDES

Chiles en Curtidos (page 225)
1 cup chopped onion
1 cup fresh cilantro, chopped
Salsa of your choice

Cut the pork into two pieces. Remove the skin from one piece, separating it completely from the meat, and set aside. It's important not to cut through the skin as it will reduce considerably in size. Cut the remaining meat from that same piece into 4 large sections. These pieces will also reduce considerably in size due to the amount of fat.

Cut the second piece of the belly (with the skin) in two, lengthwise. With a sharp knife slice into these strips about 4 times, penetrating all the layers except the skin so that it can keep them together.

If the traditional copper pot is unavailable, place a deep, conventional pot over high heat and add the manteca. Once liquefied, lower the flame to low or until it has small bubbles, and add the garlic and cook for 2 minutes. Then add all the pieces of the pork, except for the skin, into the pot. Add the evaporated milk and orange juice. Stir regularly and with patience, as the carnitas must be cooked slowly over low heat.

Cook for about 30 minutes, stirring every few minutes. There should be no bubbles or only small bubbles visible in the lard (make sure you don't get big bubbles from the manteca). We are looking to slow cook and not to fry, and the bubbles tell us the proper amount of heat.

After 30 minutes, add the skin and cook for another 20 to 25 minutes more. The meat should reduce as the fat liquefies. Look for a dark golden color. When the proper texture and color is achieved, add salt and stir. Remove from heat, strain to drain the fat, and place on a paper towel.

The traditional serving is chopped roughly as taco filling in corn tortillas, accompanied by Chiles en Curtidos chopped onion, and fresh cilantro; or with a good salsa.

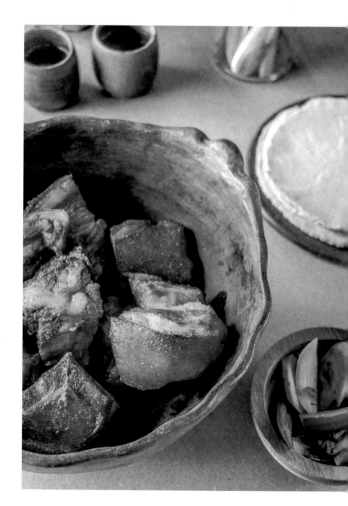

Chiles en Nogada

SERVES 6–8

This is one of Mexico's most beloved plates—the red, green, and white represent the colors of the Mexican flag. It is said that it was first made by nuns for the general Iturbide when he passed through Puebla during the Mexican War for Independence. It is one of the most Baroque plates of the country when perfectly made: complex and full of flavor, yet perfectly balanced. Though it's traditionally only seen in the month of September to celebrate Independence Day (September 16), it tastes like Christmas wrapped in a chile.

FOR THE NOGADA SAUCE

2 cups crema
9 ounces cream cheese
½ cup walnuts
½ cup peeled and sliced almonds
¼ cup whole milk
½ teaspoon ground black pepper
Salt to taste

FOR THE CHILES

6–8 poblano chiles of a good size
1 cup diced pineapple
1½ red apples
1½ yellow apples
1½ pears
2 peaches
5 ounces dried fruits of your choice
1 ripe plantain
1¾ cups diced red tomato (¼-inch pieces)
1 cup fresh cilantro
3 red pomegranates
2½ cups vegetable oil, divided
2⅓ cups diced white onion (¼-inch pieces)
½ pound ground pork
½ pound ground chicken meat
2 bay leaves
Pepper to taste
½ teaspoon ground clove
½ teaspoon cumin powder
¼ teaspoon star anise
¼ teaspoon ground cinnamon
7 tablespoons butter
½ cup raisins
½ cup walnuts
½ cup peeled and sliced almonds
1⅓ cups flour
4 eggs
Rice and pureed sweet potatoes for sides (optional)

FOR THE NOGADA SAUCE

In a blender, place the crema, cream cheese, walnuts, almonds, milk, ground black pepper, and salt to taste. Blend thoroughly. We want a moderately thick consistency. Pour everything in a bowl and refrigerate.

Keep in mind that when the temperature drops, the mix will become thicker.

FOR THE CHILES

Cook the poblano chiles over a direct flame. Place them in such a way their skins blacken, but without burning more than the first layer of skin. Turn them constantly so they are cooked uniformly. Then, place them in a lidded bowl or Tupperware and close it. Let them sweat for 15 minutes. This will make the process of removing the entire layer of skin easier.

Remove the chiles from the container. Next, make an incision lengthwise. Remember that we'll be stuffing them, so take care with your incision—make sure the chile isn't going to fall apart. Carefully remove the seeds and veins. Rinse the chiles under cool water to remove the outer, burnt skin and any remaining seeds. Reserve for later.

Chop the pineapple, apples, pears, peaches, and dried fruits you've selected into ¼-inch cubes. Cut the plantain into slices about ½-inch thick. Set aside for later.

Chop the cilantro finely and set aside. Remove the pomegranate seeds and reserve for later.

On a pan over a high fire, place ¼ cup of oil, and once it is hot, add the onion, sauté for 3 minutes and when it is crystallized, add the pork, chicken, tomato, bay leaves, and pepper to taste. The meat will release its juices and change its color to a gray. At this point, add clove powder, cumin powder, star anise, and cinnamon. Mix thoroughly and wait for the liquid to evaporate. Then, when there is less water, let it stir-fry for about 4 to 5 minutes, until the meat has a darker color without being too dry. When it is ready, reserve for later and turn off the stove.

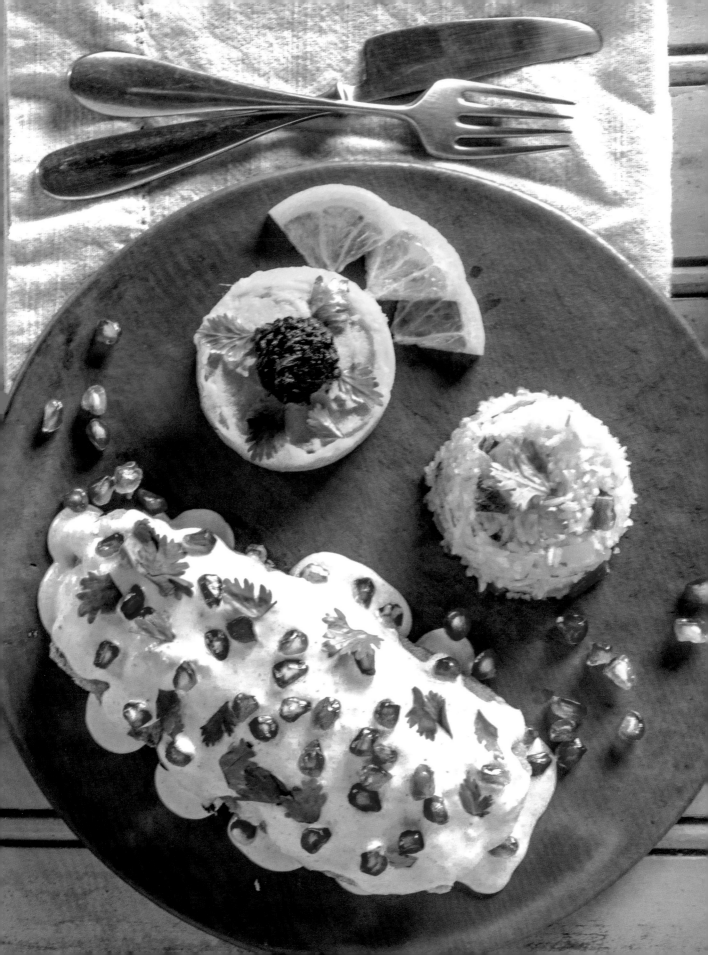

In a pan, add the butter and 2 tablespoons of oil on medium-high heat. When hot, add the pineapple and plantains, wait for 2 minutes, and stir. We wish to obtain a caramelized mixture, where their color darkens a little without burning. Cook for approximately 5 to 7 minutes. Reserve for later.

On a pan over medium-high heat, add 2 tablespoons of oil. Once hot, add the apples and pear and sauté for approximately 4 to 5 minutes. Turn off the fire and reserve for later.

Next, heat a large pan on low and add everything you've previously sautéed. Stir the meat and fruits together. Add in the raisins, walnuts, almonds, and the dried fruit. Cook for 5 minutes, stirring occasionally Add the peaches, stir, and immediately turn off the stove.

Now that the filling has finished cooking, we stuff the chiles using a spoon or by hand, taking great care to not tear the chile. Stuff each chile full and press gently to compact the filling so it doesn't fall out.

Next, put the flour on a plate and cover the outside of each chile with flour. Shake gently to remove excess flour and set aside.

Beat the eggs with an electric whisk for 4 minutes on medium speed. If beating the eggs by hand, do so for 12 minutes without pause. The eggs will become foamy. If they begin to turn liquid again toward the end of the process, beat them a bit longer. Pour into a dish large enough so you'll be able to dip the chiles in the egg.

Heat 2 cups of oil in a pan on medium. While it's heating, quickly and carefully dip the chiles in the beaten eggs, coating the outside of each. Then add to the hot oil. Leave to cook about 2 to 3 minutes on each side, turning them regularly. Once the chiles have a spongy, golden coating, they're ready. Remove from the pan and place on an absorbent paper towel. Repeat with all the chiles.

To serve, place one chile on a dinner plate and pour on a generous amount of the nogada salsa to cover everything except the stem. Garnish with cilantro and pomegranate seeds. Serve with your preferred sides— our favorites are rice and pureed sweet potatoes with Jamaica marmalade.

Lomo de Puerco al Arriero
Muleteer's Pork Tenderloin

SERVES 4–6

This is a simple plate that highlights the flavors of the meat and the charcoal. Noel's grandfather used to prepare this for him. It's a dish that was made by men while walking for days on end, transporting salt and other ingredients from the coast to Mexico City. You'll need a grill with charcoal for cooking.

2 pounds whole pork tenderloin
¼ cup whole walnuts
¼ cup whole almonds
¼ cup raisins
½ teaspoon ground black pepper
8 cloves, whole
2 limes, juiced
4 garlic cloves
Salt to taste
5 tablespoons olive oil
2 cups water
Mashed or sweet potatoes, vegetables, or sides of your choice to accompany

Take the tenderloin and cut multiple, small incisions into it. This is where you will stuff the nuts and raisins. Once cut, insert 1 walnut, 1 almond, and 1 raisin into each incision.

Place the black pepper, cloves, lime juice, garlic cloves, salt and pepper, and olive oil into a blender and blend well. Massage this mix well into the entire tenderloin and leave to sit 1 to 2 hours.

Preheat the oven to 350°F. Light the charcoal on the grill. Once the flame is red, place the marinated tenderloin on the grill and sear 3 minutes on each side to seal the meat. Once evenly seared, place the tenderloin in a pan with 2 cups of water and place in the oven. Roast for 45 to 55 minutes (if making more or less, roast for 45 to 55 minutes for every 2 pounds of meat). Check with a knife to see if the pork is cooked. Once the pork is cooked, remove from the oven and allow to rest for 10 minutes.

To serve, cut the tenderloin into 1-inch slices. Serve with mashed potatoes, sweet potatoes, vegetables, or sides of your choice.

Otras Carnes
Other Meats

There is plenty more protein available in Mexico aside from the standard fish, chicken, pork, and beef. In some regions, you'll find it common to eat iguana, possum, insects, and armadillo. (We've only included recipes for meats you're likely to find in the United States, however). Borrego is particularly popular, and goat is perhaps the most sustainable meat we can eat. Have fun trying something new!

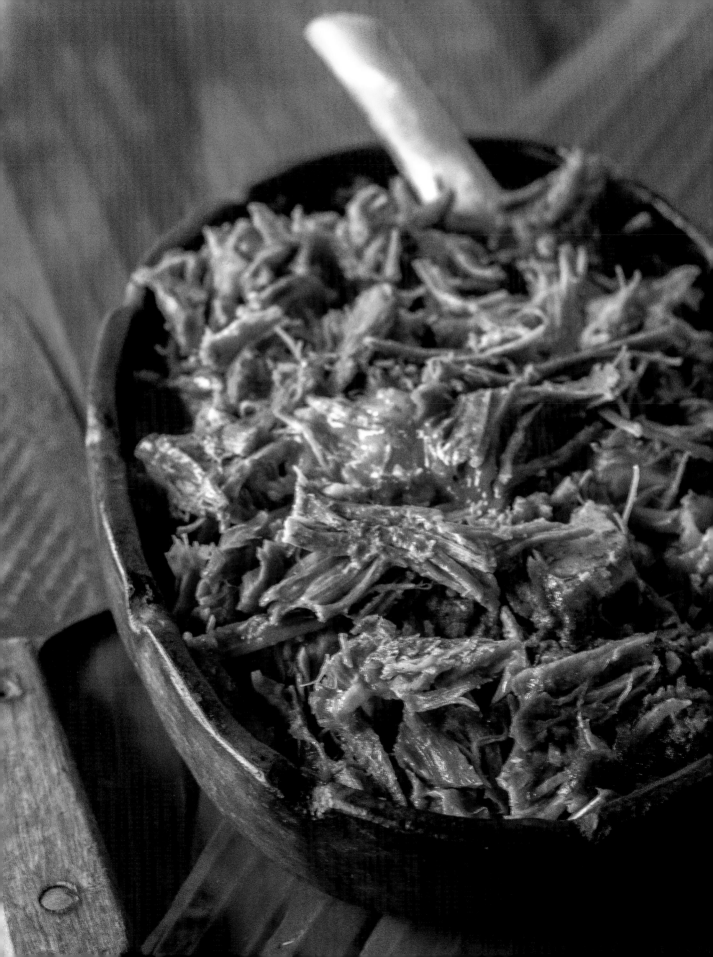

Barbacoa de Borrego
Lamb Barbacoa

SERVES 4

This is a classic Sunday family dish, made to share. While this recipe is for four, it's a plate that's usually shared in large groups, made with all parts of the lamb. It's ideal for the most important celebrations: weddings, quinceañeras, and baptisms. For this dish, we want the lamb to be in large pieces as it will reduce during cooking.

2 tablespoons salt
1 tablespoon black peppercorns
1 teaspoon thyme
6 cloves
1 pinch ground cinnamon
1 teaspoon dried oregano
½ teaspoon marjoram
2 bay leaves
1 pound lamb leg on the bone
1½ pounds lamb ribs
12 cups water
½ cup rice
2 canned chipotle chiles
½ medium white onion
1 head garlic, cut in half
3½ ounces garbanzos
2 pounds banana leaf

FOR THE SIDES

Red or green salsa
½ cup chiles encurtidos
1 cup fresh cilantro, chopped
4 limes, halved

Crush salt, black peppercorns, thyme, cloves, cinnamon, oregano, marjoram, and bay leaves in a molcajete or a food processor. Cover each piece of the lamb leg and ribs thoroughly with the mix and leave to sit for minimum 2 hours in the fridge, or preferably overnight.

Once it's finished marinating, put 12 cups of water, rice, chipotles, onion, garlic, and garbanzos in a large stovetop pot, then place a trivet inside and line the pot with banana leaf. Put the lamb inside and cover with more banana leaves and place the lid on the pot. Heat on medium-low for 2 to 3 hours. Check the meat after 2 hours to see how it's progressing. The lamb is ready when it's soft and comes easily off the bone.

Serve on a plate with salsa, chiles encurtidos, fresh cilantro, and limes. Put a bit of the broth from the pot in a small bowl to serve alongside.

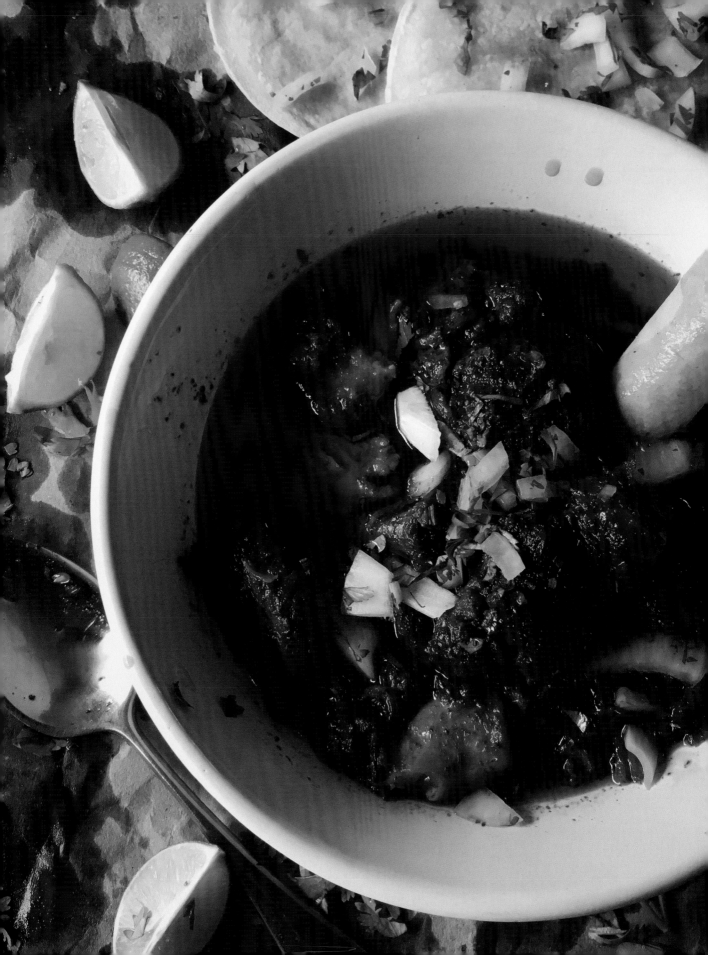

Birria de Borrego Mutton Stew with Chiles

SERVES 5

This plate is made from the parts of the mutton with less meat, such as the hock and legs, as the bones are what gives it so much flavor. It's mostly made in Guerrero, Oaxaca, and Chiapas, though is not commonly found today.

5 guajillo chiles
2 áncho chiles
7 cups water, divided
½ medium white onion, cut in half
8 garlic cloves, peeled
2 tablespoons dried oregano
4 cloves
½ teaspoon whole cumin
½ teaspoon thyme
½ teaspoon marjoram
1 tablespoon whole black peppercorns
4 bay leaves
2 pounds lamb, cut in 3-inch cubes
Salt to taste
1 cup dried garbanzos

FOR THE GARNISH

½ medium white onion, julienned
1 bunch fresh cilantro, finely chopped
6 limes, halved

FOR THE SIDES

Fresh tortillas and salsa of your choice

Prepare the guajillo and áncho chiles: slice lengthwise and remove the seeds, veins, and stems. Heat a pan on medium and add the chiles. Cook 1 minute on each side, and remove. Put 1 cup of water in a small pot and boil. Once boiling, add the chiles and leave to simmer for 5 to 10 minutes or until they're soft. Remove from the water and set aside. Save the water they cooked in.

Heat the same pan to medium-high and place the onion and the garlic cloves. Cook while rotating regularly until they're slightly burned on all sides. Remove from pan and set aside.

Place the chiles and the water they cooked in into a blender along with the onion and garlic, oregano, cloves, cumin, thyme, marjoram, pepper corns, and bay leaves. Blend thoroughly.

Place the lamb pieces in a bowl and season with salt. Pour the mixture from the blender over top, mix well, and leave in the fridge to marinate at least 2 hours, but preferably overnight. Once it's finished marinating, place the lamb and the garbanzos in the pressure cooker or pot with the remaining 6 cups of water. (If using a regular pot add 12 cups of water. You'll need to check the salt and water levels from time to time and adjust as necessary. There shouldn't be less than 6 cups of water in the pot at all times with a regular pot.) Bring the pressure cooker to a boil and leave to cook for 45 minutes on medium (or 2½ hours on medium-low in a regular pot). The meat is ready once tender.

Once the meat is ready, shred it using tongs. Return the meat to the broth.

To serve, put some of the broth and the meat in a bowl. Garnish with julienned onion, cilantro, and lime on the side. Serve with fresh corn tortillas and your preferred salsa.

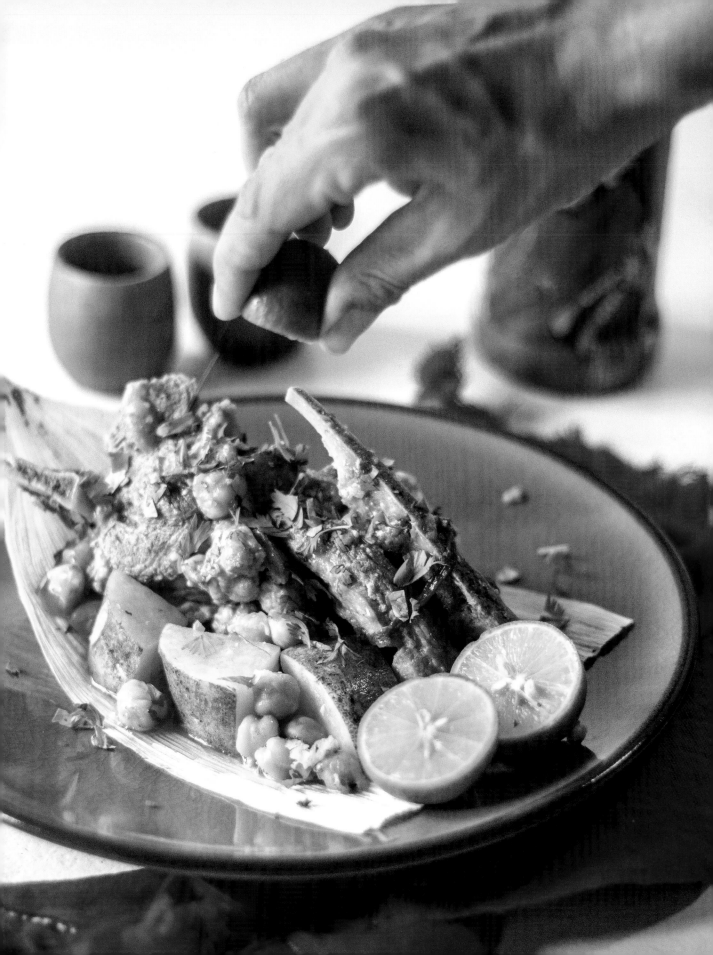

Asado de Chivo
Grilled Goat

SERVES 5

Originally, people would toast all the ingredients before boiling, hence the name *asado de chivo*. These days, it's cooked in a pressure cooker. If you want to make this dish in the most traditional way, sear the goat and toast the onion, garlic, tomatillos, and spices in a pan without oil before putting them in the pressure cooker.

3 pounds goat meat on bone
Salt to taste
1 tablespoon olive oil
2 guajillo chiles
1 pound cambray potatoes
1 cup raw garbanzo beans
½ medium white onion
8 garlic cloves
3 tomatillos, husks removed
½ teaspoon marjoram
½ teaspoon cumin
½ teaspoon thyme
1 teaspoon whole black peppercorns
1-inch cinnamon stick
6 cloves
4 bay leaves
6 cups water
1 cup fresh cilantro, chopped for garnish

Season the goat meat with salt. Rub the goat meat with olive oil. Heat a pan (or grill) on high and sear the meat for 2 minutes on each side.

Slice the guajillo chiles lengthwise and remove the seeds, veins, and stems.

Wash off the potatoes. Place the raw garbanzo beans, onion, garlic, tomatillos, and all the spices (marjoram, cumin, thyme, peppercorns, cinnamon, cloves, and bay leaves) in a pressure cooker with 6 cups of water (or 12 cups in a regular pot). Cover and cook on medium heat. Once the pot has begun to boil, cook for 40 minutes (or 2 hours in a regular pot).

Turn off the stove and allow the pressure to release before removing the lid to check if the dish is ready. The garbanzos should be cooked through and the meat tender and falling off the bone. Remove the bay leaves if you prefer.

Serve the goat and garbanzos with some of the stock and sides of your choice.

Garnish with fresh cilantro.

Caldo de Chivo
Goat Soup

SERVES 4

Goat meat is much-loved in Mexico. It's delicious, filling, and also one of the most sustainable meats we can eat. This is another excellent cure for the *crudo* (hangover). Be sure to serve with fresh tortillas.

2 medium tomatoes
1 medium white onion
4 garlic cloves, peeled
3 guajillo chiles
1 dried chipotle chile
½ teaspoon ground thyme
½ ground marjoram
½ teaspoon black pepper
2 pounds goat meat (preferably with the bones)
5 cups water
Salt to taste

FOR THE SIDES

1 cup onions, julienned
1 cup fresh cilantro, chopped
8 limes, halved
Tortillas

Heat a pan to medium-high, then add the tomatoes, onion, and garlic. Cook until their skins become a bit dark, rotating to cook them uniformly, then place them in a blender.

Slice the guajillo chiles lengthwise and remove seeds and veins. Heat the pan to medium and add the guajillo chiles and the whole chipotle (remove the seeds if you don't want spice). Toast for 1 minute on each side, then add to the blender with the tomatoes, onion, and garlic. Add the thyme, marjoram, and black pepper and blend well. Add a little water to facilitate blending. Set aside for later.

Cut the goat meat into large pieces (about 1½- to 2-inch cubes). Add 5 cups of water to a pressure cooker along with the meat. Add salt to taste and the blended mixture. Cover and place on high heat. Once the pot begins to boil, turn the heat to medium and leave to cook for 45 minutes.

To check that the meat is ready, turn off the heat and allow the pressure to release. Then open the pot and check to see if the meat is soft. If it's still a bit tough, seal the pot and cook another 10 minutes.

Serve the goat meat in a bowl with the broth. Serve with julienned onions, fresh cilantro, and limes on the side, as well as warm tortillas.

Conejo al Ajo
Rabbit in Garlic

SERVES 4

This is one of the meats that prehispanic peoples ate since rabbit was common. Its importance in the Mesoamerican diet is demonstrated by the fact that the rabbit is included in the Aztec calendar. Rabbit is a white meat, soft and solid, and yes—it tastes like chicken. But like *really good* chicken.

1 rabbit (3–4 pounds), quartered
8 cups water
½ medium white onion
4 bay leaves
Salt and pepper to taste
¼ cup olive oil
20 cloves garlic, peeled and minced
½ cup white wine
Rice and vegetables, or sides of your choice

In a saucepan over medium-high heat, place the rabbit, 8 cups of water, onion, bay leaves, and salt and pepper to taste. After bringing to a boil, lower the heat to medium and cook for approximately 40 to 45 minutes until the meat is tender but not completely coming free from the bone. Remove from heat and strain off the liquid.

Heat the olive oil in a skillet over medium-low heat, add the garlic, and stir for 10 seconds before adding the rabbit. Increase the heat to medium-high and fry the meat on each side for 3 minutes until it takes on a golden-brown color. Add the white wine and a little salt and pepper, and lower the heat to the minimum until the alcohol has evaporated. Dress each portion with a little of the garlic and oil that's left in the pan before serving.

Serve with rice and vegetables, or your preferred sides.

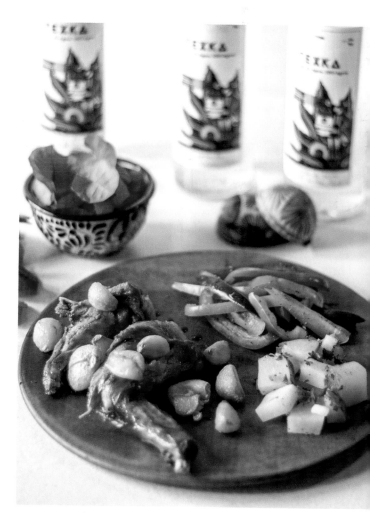

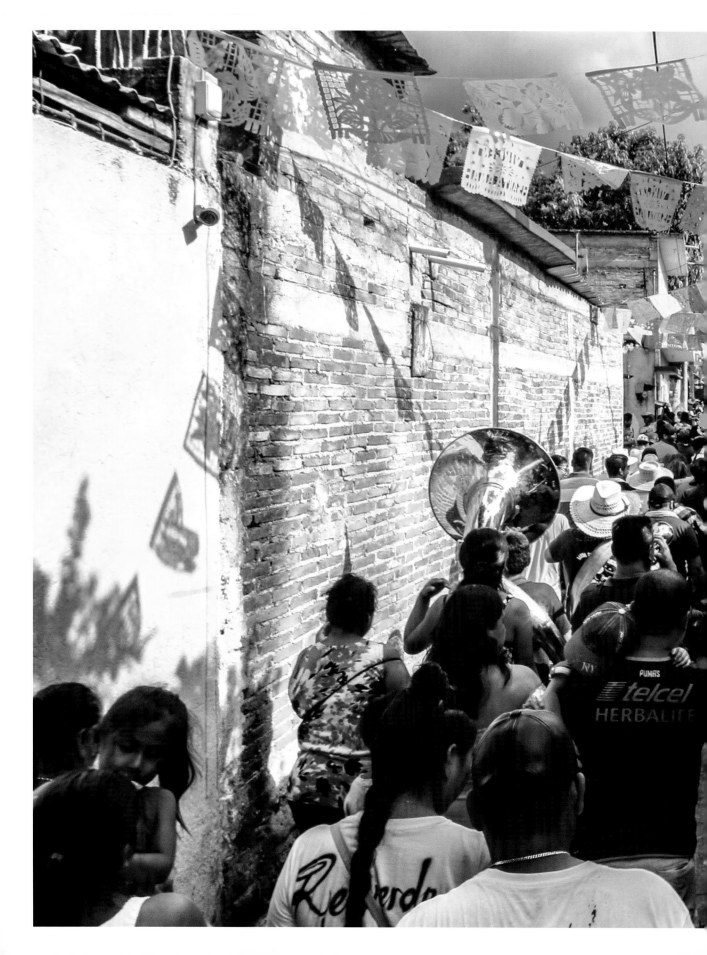

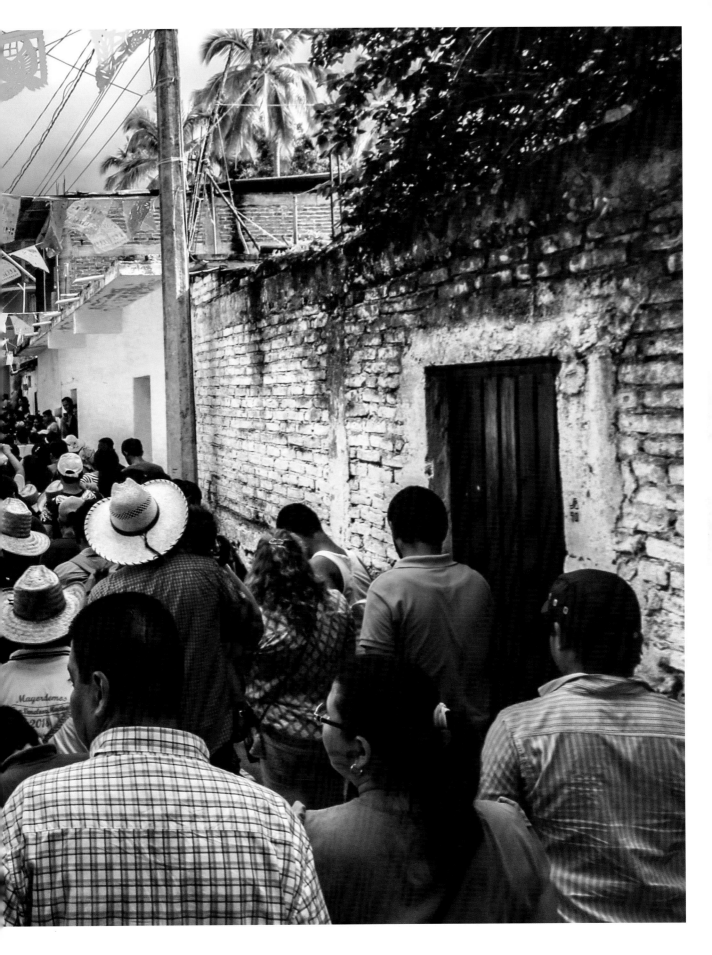

COMMUNITY

"In Mexico, family is *the* most important thing in life," Noel regularly tells students in his cooking class. "Second is the party—your relationship with friends and the community—and last is work."

Whatever one personally believes, our modern consumer culture certainly emphasizes the reverse: work is what defines our worth in the world. Then our social circles, then family.

If there was one thing I lamented about my Midwestern upbringing, it was the lack of community. We barely knew our neighbors; we bought our food, clothes, and home goods from big box stores in strip malls. While I'd always sensed a gaping hole in the society I grew up in, I didn't know what was missing until I experienced neighborhood meetings, farmers' markets, and co-ops years later. In Mexico, as in many other parts of the world, these markets and town gatherings are the social glue that keeps a community functioning and, to some degree, self-sufficient.

Mexico has birthed five major civilizations and many minor ones, each with vast resources and technological advances. Maintaining the harmony of these empires and cities required complex social structures and practices. It's no surprise then that the cuisine of Mexico is as intricate and storied as it is. (What is surprising is that it's taken the world so long to recognize it as such.) Many of these traditions are carried on today—particularly in rural towns with a predominantly native population. Traditions such as the Guelaguetza are what help to preserve indigenous cuisine, dance, and customs; while

the tequio cultivates relationships among community members. *Ferias* (town fairs or festivals) in honor of the patron saint, a local trade, an important crop, or harvest season bring people together in celebration, and it's these celebrations that call for complex dishes, bygone family recipes, and the very best batches of booze.

Of course, it's not all about the party. These community ties are also what help people survive through difficult times, whether it's a series of bad harvests, a natural disaster, or even banding together to kick out corrupt officials (Cherán, a town in Michoacán, did exactly that and is now autonomously run). Imagine what would happen in your neighborhood should there be a nationwide, weeks-long power outage, should food or water supplies run out, or should the Internet crash on a global scale. Most of us would be helpless without government intervention. (Many of us would be helpless even with government intervention.)

It isn't that community is important in Mexican culture—community is what makes *Mexican culture. All the relevant daily activities are cultural phenomena. Many communities are being broken in Mexico now, because of the arrival of different creeds and religious sects that break popular tradition. One example is the tequio, which is community work that everyone participates in to prepare a town for a hurricane or earthquake or flood. Many times, this tequio is affected by the entrance of new religious sects that negate that community work, which has a terrible effect on the community. For example, the people don't keep a dry riverbed clear*

of obstructions as they usually would, and the town risks flooding.

In some communities, this is a grave problem because it generates acts of violence. Many of those who profess different creeds and customs to those who are native to the place are people who've been expelled from that community, because they generate division and the dissolution of the community with their foreign ideas—normally exported from other countries—that affect the development of the community. And instead of strengthening the community, they weaken it. This is what's happening in many parts of Mexico. The first state where this problem is very serious is Chiapas. Chiapas has numerous problems of community dissolution, because of the various religious sects that have implanted new ideas, and the community can't continue with its traditions. But these traditions exist because, one way or another, they help these social groups to survive.

These community ties are the backbone of Mexican culture and the central nervous system of its cuisine. They are what sustain people in times of hardship and in times of abundance. They are the procreator, not just of culture and food, but of a hopeful future, of social wholeness, and of individual sanity. These native customs that put the whole before the individual come as a much-needed cure in a time when many societies are experiencing an ever-deepening social divide and a struggle to maintain community connection in the face of an increasingly individualistic, ego-driven culture.

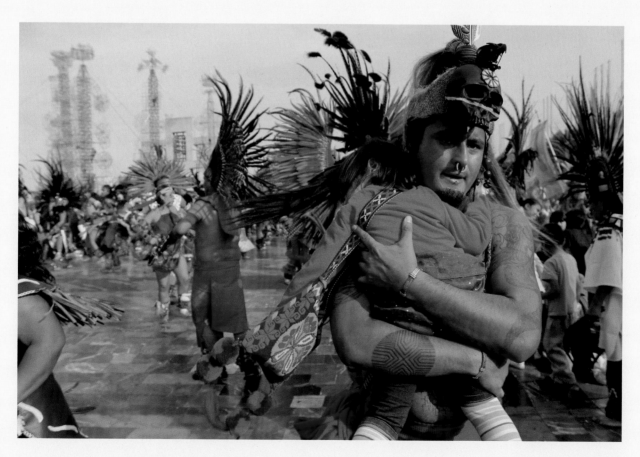

Oaxaca: The Mezcal Mecca

Oaxaca is where everyone who wants to taste, to understand, or to profit from mezcal goes. It is not the only region of mezcal production, but it is by far the most famous, and the most prolific.

For many in the industry, the current mezcal boom is both a thrilling opportunity and a cultural violation that leaves a sticky residue. After centuries of propaganda that classified mezcal as the poor man's moonshine—a drink unfit for the upper-class Euro-Mexicans—indigenous Mexicans now find themselves courted by Hollywood stars and big-city entrepreneurs to produce the newest line of high-end liquor. And it's not just a recipe these foreigners are after.

They want the story: the process that's been preserved over the centuries against all hope. They want to taste the dirt the agave grew in, fill their senses with smoke and stone and starlight. As if drinking this elixir might reunite them with that pure sense of self that's been lost in the wash of hyperconnectivity, electronic addiction, and the American Hustle. We're proud to know the names of the farms that produce our local tomatoes, and the couple who makes our kombucha. Now we want the same for our booze. And as well we should! We *need* that connection more than ever these days, if for nothing else than to hold on to those dwindling threads of humanity that still unite us.

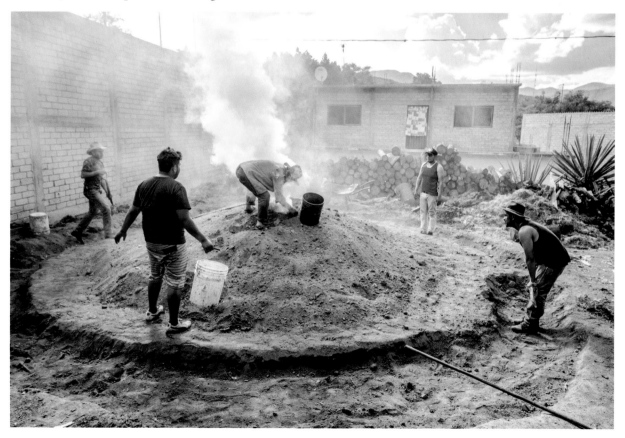

> **Espadin Especial**—Ready to rage? This mezcal is as solid as a satisfying Facebook rant, with a cleanse that leaves you feeling like a new being. It seems that purification can come through vice.

So why the sticky residue?

The problem is this: maguey *is divine*. Mezcal is the spirit of the gods. It is not owned by anyone. It cannot simply be bottled en masse, shipped abroad, consumed like cosmopolitans at a nineties sorority party, and still hope to retain its inspirational potency. The problem is that so many want to capitalize on its story without respecting its story. To make an exceptional mezcal, the maestro cannot be led by fashionable cocktail preferences, chemical standards required by bureaucratic offices, or written procedures ordained by board members. The maestro must listen to his intuition and be guided by the interplay of ancestral knowledge, life experience, and real-time conditions. If you think this is romantic puffery, I invite you to visit a traditional, small-batch mezcalero; sit by his still and sip his distillate, and tell me how it compares to those industrially produced mezcals found on the grocery store shelf.

"It's so interesting the difference in drinking mezcal in native circles in Mexico versus in a bar in the US," I comment to Noel in one of our conversations. "In the US, we're focused on flavor profiles, the effects of terroir, and judging a mezcal; whereas in Mexico—with you anyway—the only comment I ever hear is '*está bueno.*' That's what you say about almost every non-branded mezcal we try. I have yet to hear a mezcalero talk about citrus notes or astringent qualities. It's just 'good,' or 'pretty good,' or '*puta madre! 'ta buenisma!*"

"You know, basically a mezcal is good when I end up drunk—when I keep drinking it," Noel says. "Maybe I cry, maybe I laugh too much, do stupid things. Maybe my nahual needs these things. But when I begin to speak about the flavors . . . I'm no longer a part of this mezcal and it's not a part of me."

In other words, the analytical brain overrides the animal senses, and a good mezcal is made with—and for—those animal senses.

> **Tobalá**—a savage black stallion gallops into your boudoir, bellowing with a passion so intense, your panties drop to your ankles of their own accord. Though he makes you tremble upon first encounter, this king of Mezcals ends the night with sweet caresses.

"At the end of the day," he continues, "the mezcal is to socialize, not to brutalize. Is not *barbario*. It's for ritual. The mezcal is for everyone . . . it brings us together. In the ritual, the dance, the

"NO HACEMOS MEZCAL... DESTILAMOS LOS SENTIMIENTOS DE NUESTRA TIERRA"

Fermin Arrazola, Maestro Palenquero

festival *por un santo*, there's no rich or poor. No white or brown. Only people who come together to celebrate a tradition."

We are fortunate that there are as many bartenders and brands committed to protecting the tradition as there are. But it's no simple battle, and even the best of intentions often go awry. There are some whose idea of protecting both tradition and agave species is to break everything down into quantifiable data and reproduce it piece-by-piece with scientists at the helm. There are others who speak passionately about helping indigenous communities by creating a semi-industrial brand to sell large volumes, because, logically, the more money you make, the more you have to pour back into the community. If

only history hadn't taught us otherwise. Rarely have indigenous peoples benefitted by trading in self-sufficiency for a fiscal handout. Mezcal is just the latest in a five-hundred-year-long list of cultural appropriations.

Tepestate—Like tracking a satyr through Norwegian wood on a snowy night. He is cold smoke, pine, and intrigue. Forever just out of touch, yet so enticing you can't help but follow.

That is not to say that non-natives shouldn't drink, sell, or even own a mezcal brand, but that mezcal, like all other cultural treasures, deserves

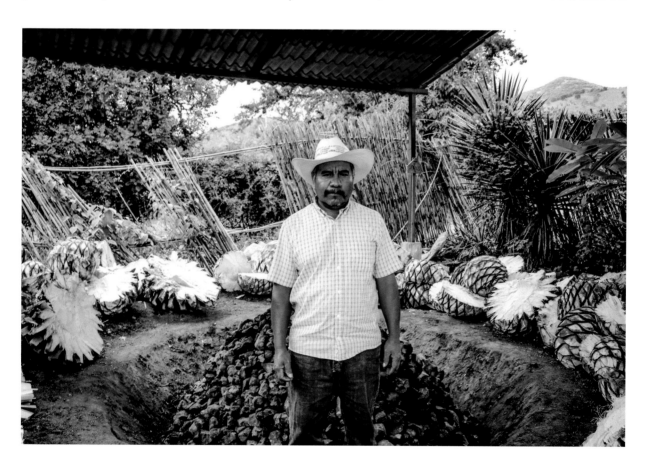

our respect—that the conversation shouldn't just be about bottle price, branding, and flavor profiles. Above all, it should be about the people that produce it, for without their cultural and ancestral knowledge, there is no mezcal. There's only booze made from agaves.

There are multiple brands available both in and outside of Mexico that work tirelessly to create conversation around the producers and their traditions, and who fight for the conservation of these as well as the sustainability of agaves and the industry itself. We encourage you to seek them out and give them your business.[5] The difference in price is often the difference between respect and exploitation, and will help to ensure the drink that you love still exists in the decades to come.

Coyote—teenage nights of smoking cigarettes and planning the revolution with your friends, when the lust for freedom and exploration swelled your veins. This coyote stirs the fire in your blood and throws you headlong into your heroic convictions. (User Advisory: may trigger heated arguments in groups of mixed political persuasion).

5 A great way to learn more is to join The Mezcal Collaborative Agave Academy.

Res
Beef

In Mexico, beef is so much more than a steak! While you'll find some more familiar cuts in these recipes, don't be afraid to try liver, stomach, and tongue—they are often the preferred cuts.

Picadillo de Res
Minced Meat

SERVES 4–5

This dish can be eaten on its own, but it is more commonly used as a filling for chiles relleno, quesadillas, and tamales, or as a stuffing for roast chicken.

2 tablespoons unsalted butter
¼ cup vegetable oil, divided
3½ ounces plantain, cut into ½-inch slices
3½ ounces pineapple, cut into ½-inch cubes
3½ ounces green apple, cut into ½-inch cubes
3½ ounces red apple, cut into ½-inch cubes
3½ ounces white onion, julienned
2 garlic cloves, finely chopped
1 pound ground beef
Salt and pepper to taste
½ teaspoon cumin powder
½ teaspoon thyme powder
½ teaspoon clove powder
⅓ cup toasted, unsalted peanuts
⅓ cup whole, roasted almonds
¼ cup toasted sesame
⅓ cup raisins
3½ ounces peach, cut into ½-inch cubes

Heat the butter and 1 tablespoon of oil in a pan on medium. Once hot, add the plantain and pineapple and sauté for 5 minutes, stirring occasionally. Remove from stove and set aside for later.

Heat the pan to medium-high and add half of the remaining 1 tablespoon of oil. Once the oil is hot, add the green and red apples and sauté for 5 minutes, stirring occasionally. Set aside for later.

In the same pan, add the rest of the oil. Once hot, add the onion and garlic and cook for 3 minutes or until the onion becomes translucent. Add the ground beef and cook on high, stirring occasionally. Add salt and pepper to taste. When the meat begins to release its juice and has changed color, add the cumin, thyme, and clove. Stir and allow to cook until all the water has evaporated. Once the meat has changed to a darker color, add the previously stir-fried ingredients along with the peanuts, almonds, sesame, and raisins and cook for about 15 to 20 minutes on medium. Be sure to not let the mixture dry out—add water if necessary.

Turn off the heat and add in the peach. Mix and remove from pan. Use for a filling for tamales, quesadillas, chile relleno, or as a stuffing for whole roasted chicken.

Costillas de Res en Salsa Chipotle
Beef Ribs in Chipotle Salsa

SERVES 4

A commoner's plate, but when made with love this plate will make you a devotee of chipotle chiles.

FOR THE CHIPOTLE SALSA

2 tomatoes
2 garlic cloves
3 chipotle chiles, from a can
½ teaspoon cumin powder
½ teaspoon thyme
½ teaspoon clove powder
½ teaspoon marjoram
½ teaspoon black pepper

FOR THE RIBS

10 tablespoons manteca or vegetable oil, divided
2 pounds beef ribs
3 garlic cloves
½ medium white onion
4 bay leaves
3 cups water
1 teaspoon brown sugar
Salt to taste
½ cup fresh cilantro for garnish
Rice or your preferred sides to accompany

FOR THE CHIPOTLE SALSA

Heat a pan on medium. Add the tomatoes and garlic cloves and cook over medium-high, rotating regularly, until they darken. Remove from the pan and add to the blender along with the chipotles, cumin, thyme, clove, marjoram, and black pepper. Blend thoroughly with a bit of water and set aside for later.

FOR THE RIBS

Heat 8 tablespoons of the manteca in a pan over high until it melts, then add the ribs and cook for 3 minutes on each side until the meat turns a golden color. Remove and place in a pressure cooker with 3 garlic cloves, onion, bay leaves, and 3 cups of water. Add brown sugar, and season with salt to your discretion. Cover and bring to a boil. Once boiling, lower to medium and leave to cook for 40 minutes.

Turn off the heat to allow the pressure to release before opening the pressure cooker. Remove the ribs from the pot and reserve the stock. Heat a pan to medium and add the remaining 2 tablespoons of manteca. Add the chipotle salsa along with ½ cup of the beef broth and cook for 5 minutes. Place the ribs in the pan with the salsa and a bit more salt, and leave to cook for 5 more minutes, so the ribs incorporate the flavor.

Remove from the stove, plate, and garnish with cilantro. Serve with rice or your preferred sides.

Barbacoa de Res
Beef Barbacoa

SERVES 4

The barbacoa de res has many different versions, but it's always a mix of chiles, spices, and aromatic herbs. It's delicious on its own, but when served with a salsa verde, salt and pepper, and, of course, tortillas on the side, the result is celestial.

3 guajillo chiles
2 pasilla chiles
1 chile de arbol
1 medium white onion
1 tomatillo, husk removed
5 garlic cloves, divided
½ teaspoon dried oregano
4 bay leaves
1 teaspoon cumin
1-inch cinnamon stick
8 cloves
½ teaspoon thyme
½ teaspoon marjoram
½ teaspoon cilantro seeds
½ teaspoon whole black peppercorns
6 gorda peppercorns
4 ounces cambray potatoes
1 plantain (not too ripe)
2 pounds beef (chest, leg, or neck)
Salt to taste
2 cups water
1 tablespoon sea salt
2 chipotle chiles (dried)
1 pound banana leaves
2 avocado leaves
Tortillas and beans to serve on side

Cut the guajillo and pasilla chiles lengthwise and remove the seeds and veins. Heat a pan on low and place the chiles in, facedown, along with the árbol chiles. Cook for 1 minute on each side, then remove.

Chop two-thirds of the onion in large pieces. Turn the heat to high and cook the tomatillo, along with the chopped onion. Cook until the tomatillo changes to a golden color and the onion becomes translucent. Remove from the pan and place in a blender along with the chiles.

Add 3 garlic cloves, oregano, bay leaves, cumin, cinnamon, cloves, thyme, marjoram, cilantro seeds, black pepper, and allspice, along with a bit of water to permit blending. Blend thoroughly and set aside for later.

Cut the potatoes in quarters if using larger potato such as russet, or leave them whole if using cambray. Leave the skin on. Cut the plantain into 2-inch slices.

Chop the beef into large pieces, approximately 3 to 4 inches squared. Place in a bowl with the potatoes and plantain and add salt to taste. Add the mixture from the blender and leave to marinate for 1 hour.

Place 2 cups of water in a stovetop pressure cooker with 1 tablespoon of sea salt, the chipotle chiles, 2 whole, peeled garlic cloves, and the remaining unchopped onion. (If you don't have a pressure cooker, use a regular pot with 12 cups of water and cook on medium for 2½ hours).

Place a trivet in the bottom of the pot, then put the banana leaf on top, lining the entire bottom and sides. Save a piece of leaf to cover the meat. Next, add in the marinated meat, potatoes, and plantain; discard the extra marinade. Place the avocado leaves on top of the leaf, cover with a banana leaf, seal the pressure cooker, and turn the stovetop to high. When the pot begins to boil, lower the heat to medium-low and leave to cook for 45 minutes. Once the 45 minutes is up, turn off heat and allow the pressure to release before opening the pot.

Plate a portion of meat, potato, and plantain on a plate; cover with a bit of juice from the pot. Serve with tortillas and beans.

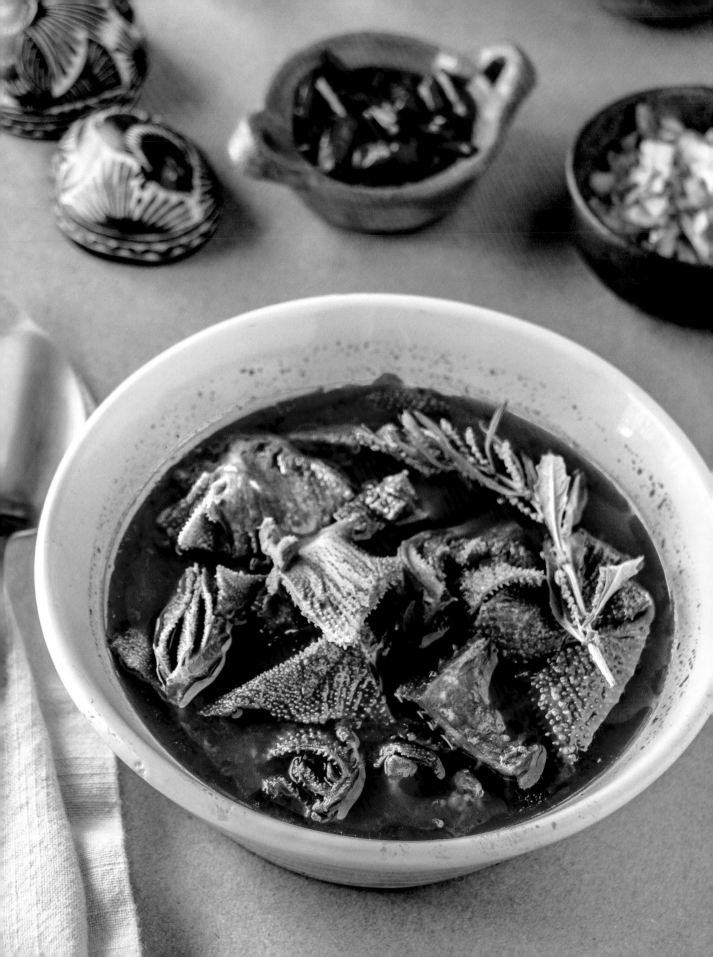

Pancita
Cow's Stomach

SERVES 6–8

God save the King! Pancita has been the king of hangover cures for hundreds of years. This is the perfect dish to restock your minerals and nutrients. The epazote calms a nauseous stomach; the oregano and salt hydrate. This plate is practically sacred for Mexicans.

5 guajillo chiles

7 cups water, divided

2 árbol chiles + more for garnish

2 teaspoon dried oregano + ½ cup dried oregano for garnish

8 bay leaves

2 tablespoons whole black peppercorns

1 pinch ground cumin

3 cloves

2 pounds beef stomach

1 medium white onion

½ pound cow foot

½ head garlic

½ cup fresh epazote (or ¼ cup dried)

Salt to taste

1 cup fresh chopped cilantro

6 limes, halved

Slice the guajillo chiles lengthwise and remove the seeds, stems, and veins. Toast in a pan on medium for 1 minute on each side. Boil 1 cup of water and place the guajillos and árbol chiles in the pot. Simmer on medium for 5 to 10 minutes or until soft.

Place the chiles in a blender along with 2 teaspoons of oregano, bay leaves, peppercorns, cumin, cloves, and a bit of the chile water. Blend thoroughly and set aside.

Cut the beef stomach into approximately 2-inch cubes. It's important that you don't cut them too small as their size will reduce during the cooking process.

Cut the onion in two. Dice half the onion and set aside for the garnish. Cut the other half in two pieces. Place the remaining 6 cups of water in a pressure cooker along with the pancita and cow foot, the half onion cut in two pieces, and garlic. Add the mix from the blender, the epazote, and the salt to taste. Seal the pot and heat on high until it begins to boil, then lower to medium-low and leave to cook for 1 hour. (If using a regular pot, put 16 cups of water and cook on medium-low for 3 to 5 hours.) The pancita is ready when it begins to break apart.

Ladle the broth, pancita, and cow foot into a bowl and serve with the remaining chopped onion, fresh cilantro, and lime halves on the side. If you want extra spicy, toast 1 árbol chile per person, chop, and add to the soup.

Lengua à la Mexicana Mexican-Style Cow Tongue

SERVES 6

La lengua makes for the most expensive taco in the country. Noel's mother would make it as a prize for her children when they returned from school with good grades. The meat is very smooth in texture, similar to veal, with a delicate flavor. If you're sensitive to spice, remove the seeds of the poblano before cooking.

1 whole cow tongue (about 2 pounds)
4 cups water
1 whole head garlic + 2 garlic cloves, julienned
½ teaspoon cumin
½ teaspoon marjoram
½ teaspoon thyme
5 cloves
1 teaspoon whole black peppercorns
1 poblano chile
½ medium purple onion, cut in half
1½ teaspoons sea salt
2 tablespoons vegetable oil
1 cup white onion, julienned
1 cup sliced tomato
1 jalapeño, sliced
Tortillas
1 cup fresh cilantro
Salsa of your choice

Place the whole tongue, 4 cups of water, and 1 whole garlic head in a pressure cooker along with the cumin, marjoram, thyme, cloves, black peppercorns, whole poblano chile, purple onion, and sea salt. Seal and bring to a boil. Once boiling, cook on medium for 50 minutes. (If using a regular pot, use 8 cups of water and cook for 2 to 3 hours on medium-low or until the tongue is cooked through). The tongue is cooked once it has a soft texture.

Take the meat from the pot and remove and discard the membrane. Slice the tongue into pieces approximately 1 inch thick. Set aside. Reserve the broth the meat was cooked in.

Heat a pan on medium with oil. Sauté the 2 julienned garlic cloves and the white onion for 3 minutes, then add the tomato slices and cook another 2 minutes. Add in the jalapeño slices with seeds (if you don't like spice, remove the seeds) and sauté 1 minute more.

Add in the sliced tongue and 1 cup of the broth it was cooked in. Season with salt and a pinch of marjoram, thyme, and black pepper. Cook for about 4 minutes, or until the water evaporates. We want the tongue to be soft, but not dry.

To serve as tacos, chop the tongue in pieces and place on fresh corn tortillas with chopped cilantro and salsa.

Tacos de Higado Encebollado
Liver and Onion Tacos

SERVES 6–8

The endemic street taco. The best *tacos de higado* are those in the market of Tepito in Mexico City. This is probably the most nutritious taco there is in Mexico, perfect for people working long, hard days (like the market workers of Tepito).

2 pounds cow liver
2 jalapeños
2 garlic cloves
3 tablespoons manteca or oil
2 cups julienned white onion
Salt and pepper to taste
Juice of 1 orange

FOR THE GARNISH

25–30 fresh corn tortillas
Salsa of your choice
6 limes, halved
1 cup fresh, chopped cilantro
1 cup diced onion

Remove the membrane that covers the liver. Filet it in thin pieces and then slice in strips approximately 1½ inches thick. Slice the jalapeños lengthwise and remove the seeds and veins, then julienne them. Chop the garlic finely.

Heat a pan on medium-high and add manteca. Once the oil is hot, add the onion, jalapeño, and garlic. Sauté for 4 minutes, then add the liver, along with salt and pepper to taste. Stir and allow to cook for 5 more minutes, stirring regularly.

Next, add the orange juice and cook for 15 minutes or until all the liquid has disappeared. Sauté for 2 more minutes, then remove from the stove.

Serve the liver with corn tortillas to make tacos, along with your preferred salsa, a bit of lime, cilantro, and diced onion.

Oaxaca de Juárez, Oaxaca: A Cooking Class

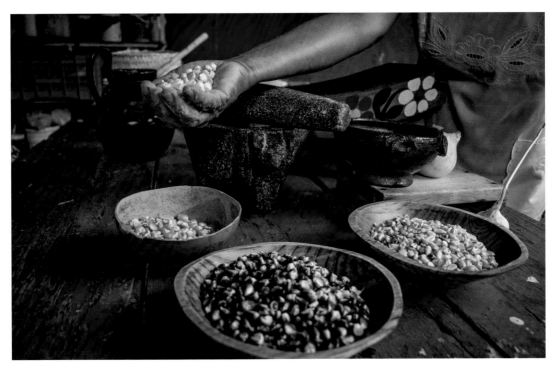

Any foodie who dies without having visited Oaxaca has lived an incomplete life. This great city is only recently becoming recognized on the global stage as a destination for culinary enthusiasts, but without a doubt it contends with the world's top food-famous cities. While the city boasts fabulous restaurants, one would be missing the point entirely if they didn't spend a substantial number of calorie points eating in the markets. This is where so many of the maestros of Oaxacan cuisine—the keepers of tradition—can be found. If said foodie wanted to dig in even deeper into the culture, then a cooking class must be on the agenda. And those with a keen interest in prehispanic techniques and ingredients could do no better than to have Vicky Hernandez as their teacher.[6]

It was on my second trip to Oaxaca in 2013 when I met Vicky at a two-week class in a Spanish language school. The course included an extracurricular activity. I signed up for the cooking class in Spanish and had the great fortune to come to know her. Vicky is an incredible instructor on prehispanic cuisine, and despite the fact that many of her students speak little to no Spanish, they are able to follow along as she communicates her ideas slowly and clearly. She specializes in corn-based foods, such as tamales, tortillas, and atoles, as well as moles and well . . .

6 If you plan to visit Oaxaca and would like a cooking class with Vicky, you can contact her via her page: www.facebook.com/cocinaprehispanica/.

almost any dish that can trace its roots back to precolonial days. She is also an absolute fountain of knowledge on medicinal plants, and it was this point that caused her, Noel, and I to spend so much time together on that trip, as well as every trip we've made to the city since. On our last visit, Noel was interested in learning how to make *mole amarillo*, so we arranged a private cooking class with the maestra.

Vicky has all of her ingredients arrayed on the table, along with earthenware bowls, a metate, and two molcajetes. A fire burns in the stove; she has coffee and her handmade tamales ready for our breakfast. She takes us step-by-step through the process of making a vegetarian mole amarillo. After lunch, Vicky tells us about her new job: cooking for the young women who live at Protección a la Joven de Oaxaca—a social organization that provides housing and food to rural indigenous women who've come to the city to study. She also has an arrangement with the institution that allows her to teach her cooking classes in their outdoor kitchen. Her dream is to one day open her own cooking school beside her house on the slopes of Monte Alban where she'll give classes on prehispanic cuisine and medicinal herbs.

Vicky visits us in the house we've rented several times over the next weeks. One day, she brings all the ingredients for the tamales, and we get her and Noel in the kitchen kneading the dough as I take photos, write the instructions, and ask for her thoughts on her native cuisine and culture.

Prehispanic cuisine is a term that's difficult to define. Noel figures that the only dishes that have remained unchanged since they were first created in precolonial times are tamales and tortillas. Everything else has been influenced by the European introduction of domesticated pigs, beef, chicken, foreign spices and nuts, wheat, and, more recently, processed foods. I ask Vicky what she considers prehispanic cuisine.

"*Prehispánica* means to keep preserving the products used by the prehispanic peoples, such as the corn, beans, herbs, squash, etc.—all local."

It also refers to the type of equipment used, she tells me. The native people of Oaxaca used wood and jicaras to make their own cups and bowls; clay for their jars, pots, and plates; stones shaped into molcajetes and metates. Vicky uses all of these things in her classes.

I ask her why she thinks it is that Oaxacans are so very proud of their native ancestry when it seems that so many other indigenous groups across the country have (subconsciously) accepted the propaganda that white, European culture is superior.

"Oaxacans are proud to be native for their culture and traditions," she tells me. "Maybe in part because Benito Juárez (Mexico's president from 1861 to 1872) was from Oaxaca. He was an indigenous campesino—very poor and humble. But he became a well-educated politician and put together laws of the Reforma. He is an example to many. Also," she adds, "we are proud of our pyramids, our food, our history and buildings.

"We are a very humble people and give great hospitality. To be Oaxacan means to uphold our traditions: our food, our muertos, our calendas (joyous community parades), and the Guelaguetza."

Those familiar with Oaxacan culture will have heard of the Guelaguetza. It's an annual indigenous cultural event in Oaxaca City (and surrounding villages) that features groups of native dancers from around the state, parades, native foods, and indigenous dress. Each village has their own

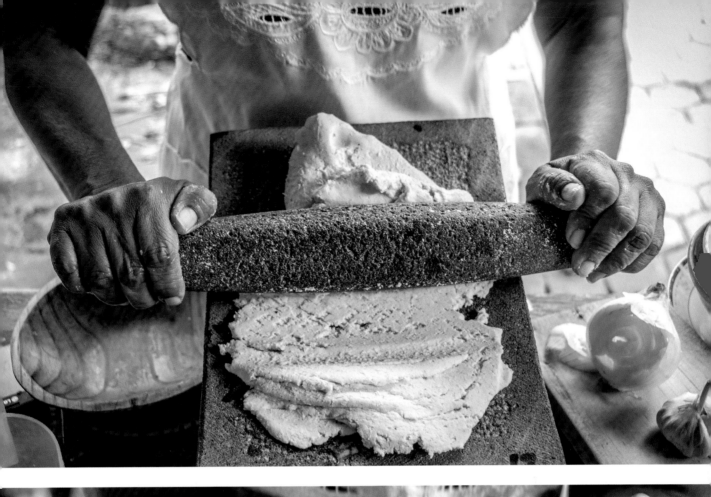

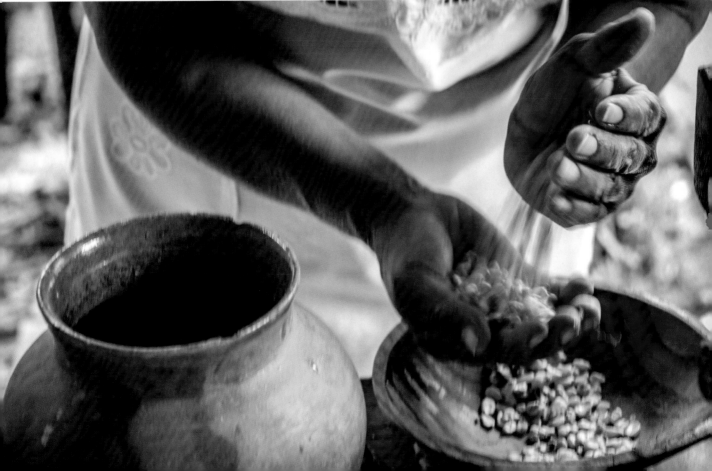

food and traditions and variations in dress. It has become the city's most important tourist attraction; however, its significance is much deeper.

"The Guelaguetza," says Vicky, "means 'I help you, you help me'—in the form of food." For example, if someone's daughter is getting married, the parents host the party, but rarely would they have enough resources to do it all themselves. One neighbor offers the tortillas, another the beans, another the mezcal. Each family contributes what they can according to their ability. In return, that host family will make their contributions to their neighbors' parties in the future. In this way, community ties are strengthened. The formal Guelaguetza—where members of different communities throughout the state came together in Oaxaca City to celebrate—is a way to strengthen the connections between towns.

I think back to the fiesta Vicky invited us to when we first met her: her barrio was celebrating Señor de los Rayos—a Catholic version of the Zapotec deity of rain and lightning, Pitao Cocijo. Women shared the work of making an enormous pot of mole colorado and handmade tortillas, while young boys passed around cold beers and shots of mezcal as a live band blasted cumbia. At one point, an American friend who had joined us had half the neighborhood doing the limbo—including an ancient abuelita. It was one of those intimate pueblo parties that foreigners dream of attending when visiting Mexico— the kind that lives on in memory like a semi-hallucinogenic dream. I have the sense that the party was so vividly surreal for the very fact that it was made with the participation of the entire neighborhood. There is an elevated energy in festivals that require the work of the entire community—a

sensation that can't be reproduced in those put on by only a few.

In Oaxaca, every day is a fiesta. It is rare indeed that one passes more than a few days in the city without witnessing a calenda. The city is a vibratory cleanse of color, light, music, and dance, and it is these aspects of Oaxacan life— the Guelaguetza, the tequios, and the calendas, along with the abundance of indigenous food and art—that make it so. Few visit this city and her surrounding mountains, valleys, and villages without falling head-over-heels in love with her magic. And that magic exists one hundred percent thanks to native traditions and values kept alive and thriving by its people.

Platos Vegetarianos
Vegetarian Plates

When we first opened El Refugio, I insisted that we have a vegetarian dish available every night (we only serve four plates per day, which change daily). This has inspired our kitchen to get creative—most of these recipes were invented in our kitchen. Keep it simple with stuffed squash or tortas de coliflor, or get exotic with a torre de jamaica or stuffed nopal. If you're looking for a vegan option to go with mole, we recommend the tortas de avena. And for brunch, my favorite is the nido de camote with a fried egg! (Pro tip: Serve it with a mezcal bloody mary).

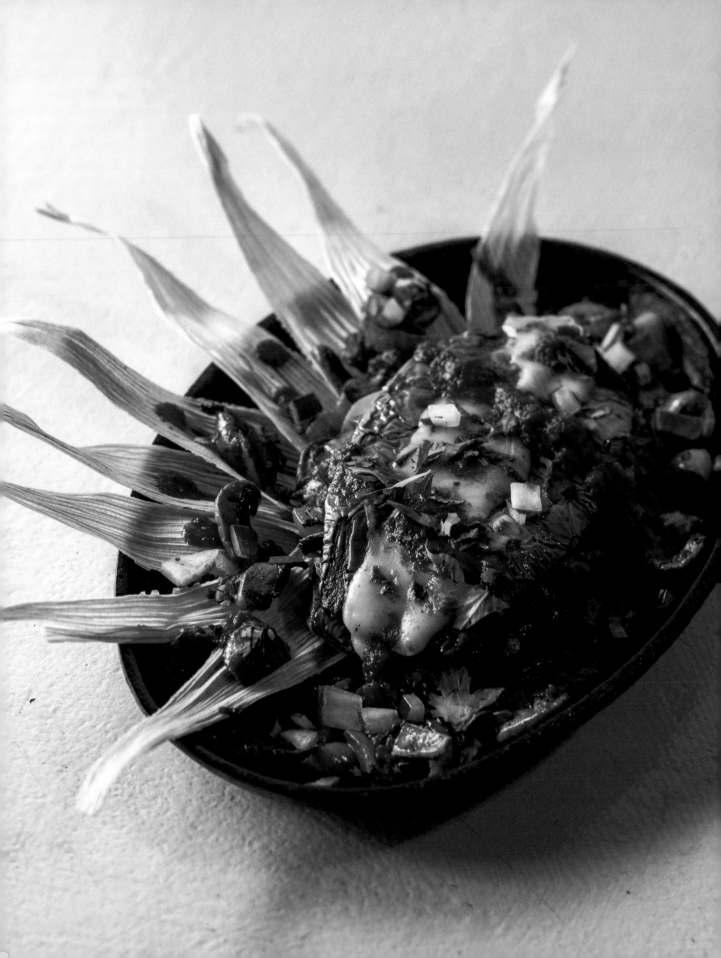

Nopal Relleno con Salsa Guajillo
Stuffed Nopal with Guajillo Salsa

SERVES 4

The nopal is an extremely important part of the diet of indigenous peoples in Central Mexico. It's rich in fiber and antioxidants, can help to regulate blood sugar, and has neuroprotective properties. It has a soft flavor and nice texture, which are contrasted by the cheese and salsa in this recipe.

6 tablespoons olive oil, divided
3 garlic cloves, peeled and chopped
1 medium white onion, julienned
14 ounces mushrooms (white or baby portabello)
Salt and pepper to taste
8 nopal paddles
Salsa Guajillo (page 20)
7 ounces Oaxacan cheese
Toasted sesame seeds for garnish

Heat 3 tablespoons of oil in a pan over medium-high heat. Add 3 finely chopped garlic cloves along with the onion and sauté for 3 minutes. Next, add in the mushrooms, salt and pepper to taste, and sauté another 5 to 8 minutes until the mushrooms have changed color and released some of their liquid. If necessary, add a bit of water to the pan. The mix should not have much liquid, but should be slightly damp and soft. Once the mixture has reached this point, turn off the heat and set aside for later.

Add salt and pepper to the nopal paddles and cut small slices into the paddles if they're thick to allow the heat to distribute evenly. Heat 2 tablespoons of oil in a pan over medium-high and add the nopales. Leave them to cook until they change from bright green to pale green, about 5 to 8 minutes. Flip and repeat on the other side. When they have changed to a uniform pale green and are soft, they're ready. Lower the heat to medium and remove half of the paddles from the pan.

Heat pot on low and add the remaining 1 tablespoon of oil. Once the oil is hot, add the guajillo salsa. Allow to cook until it begins to bubble, then remove from heat.

Next, place a generous portion of the mushroom stuffing on half of the nopal paddles and cover with another paddle to make a sandwich. Cover each with a portion of cheese. Cover with a lid and leave to cook for 2 to 3 minutes so the cheese melts. (You can cook the cheese directly in the pan to help it melt before adding it to the nopal.)

Plate the nopal "sandwiches" and cover with the warm guajillo salsa. Garnish with toasted sesame seeds and serve with sides of your choosing.

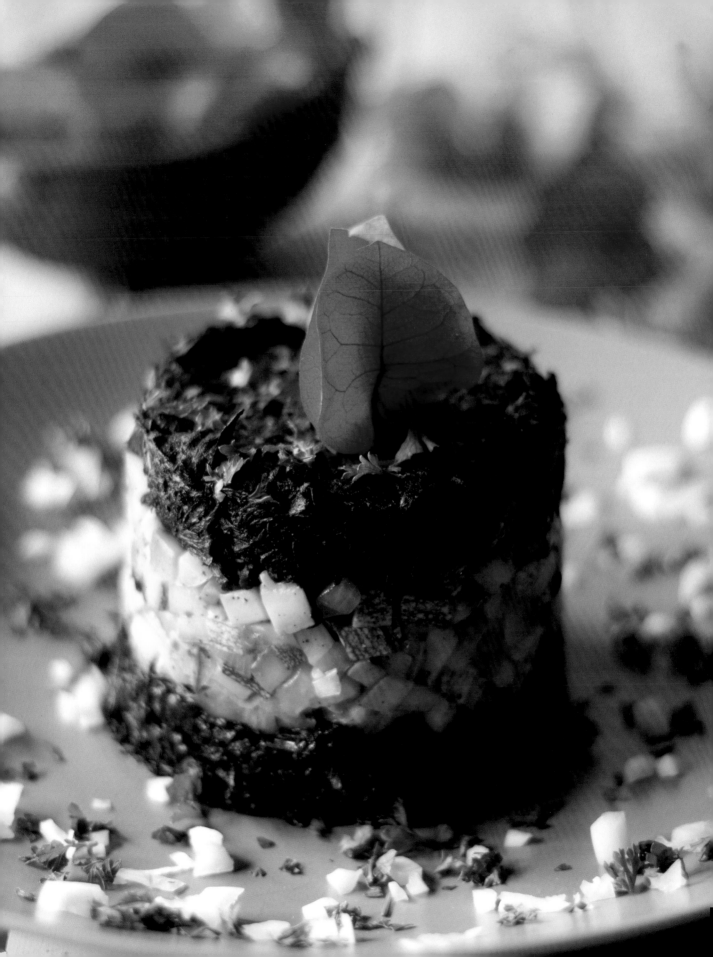

Torre de Jamaica
Jamaica Tower

SERVES 6

The jamaica flower is rich in vitamin C and antioxidants and is a natural antiseptic. It's seen throughout Mexico usually served as an agua fresca; however the flowers are also edible. The flowers are somewhat acidic, and they are balanced by the sweetness of the zucchini in this dish.

7 cups water, divided
11 ounces dried jamaica flowers
6 tablespoons olive or vegetable oil, divided
2 cups white onion, diced, divided
2 cloves garlic, finely chopped, divided
¼ pound red tomato, diced
14 ounces zucchini, cut in small cubes
½ tablespoon ground, dried oregano
Salt and pepper to taste
¼ teaspoon ground clove
⅛ tablespoon cinnamon powder
¼ teaspoon ground cumin
2 tablespoons brown sugar
Fresh, chopped cilantro for garnish

TOOLS
Medium circular mold

Bring 6 cups of water to boil. Add the dried jamaica flowers. Boil for approximately 40 minutes, or until the flower softens and hydrates perfectly. Then, strain and reserve the water for later.

In a pan over medium-high heat, add 3 tablespoons of vegetable oil, 1 cup of diced onion, and half of the finely chopped garlic clove. Sauté for a couple of minutes and add the tomato. Sauté 2 more minutes and add the zucchini, oregano, and salt and pepper to taste. Stir well and add 1 cup of water. Let it cook for approximately 10 to 12 minutes until nearly all the liquid has evaporated. Remove the pan from the stove and set aside.

In a pan over medium heat, add the remaining 3 tablespoons of oil, remaining 1 cup of onion, and remaining garlic. Sauté for 3 minutes and add the previously strained jamaica flowers, along with the clove, cinnamon, cumin, salt and pepper to taste, and ½ cup of the water previously used to cook the jamaica flower. Add brown sugar, stir well, and cook for approximately 6 to 8 minutes until almost all the liquid has evaporated. Remove from the stove.

Use a circular mold. Place a 2-inch layer of the jamaica flowers into the mold, followed by an equal portion of the zucchini mix on top, and then another layer of the flowers. Press the layers so that a uniform and resistant support can be created. Remove the mold to obtain the circular tower.

Garnish with cilantro and serve with the sides of your choice.

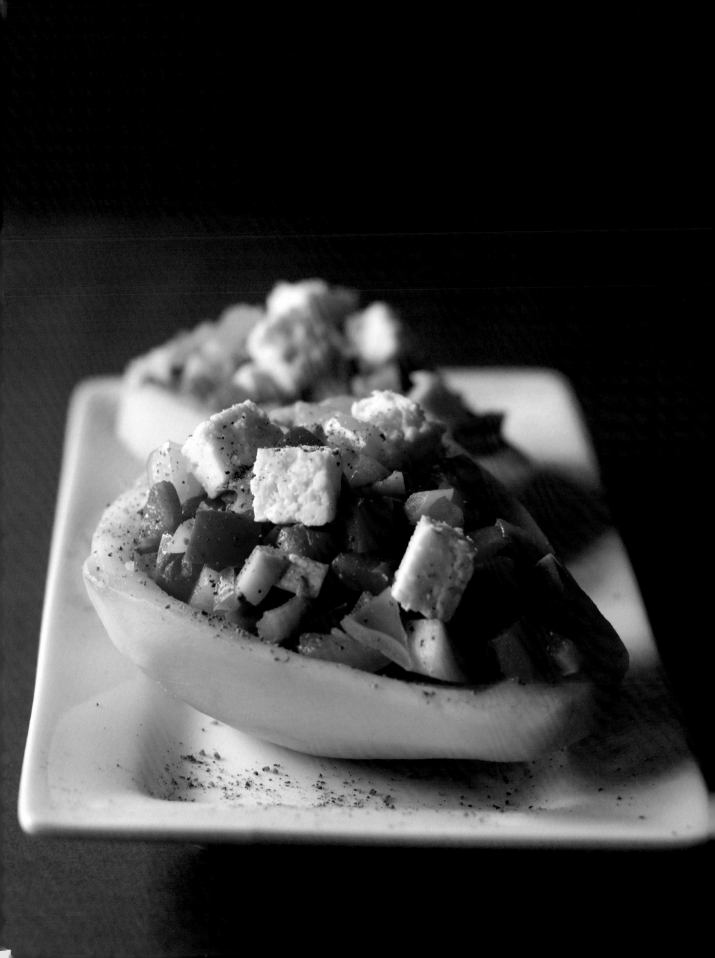

Chayote Relleno
Stuffed Chayote

SERVES 6

The chayote is a native legume with a soft taste that works well with a number of different flavors. Be aware that some people have a reaction to the sap that a chayote releases when cut while raw. To avoid this, we don't peel the chayotes before cooking them.

6 whole chayotes
1 red bell pepper
1 yellow bell pepper
1 green bell pepper
9 ounces white mushroom
4 tablespoons butter
3 garlic cloves, julienned
¼ medium white onion, julienned
⅔ fresh corn kernels
Salt and pepper to taste
1½ cups cilantro, chopped
10 ounces asadero cheese

Place the chayotes in a medium saucepan. Cover with water and add a little salt. Boil over high heat until they are very soft, about 30 to 40 minutes. Cut the chayotes in half, lengthwise, and remove the pulp and seed with a spoon, taking care not to damage the shell. Crush the pulp and the seed thoroughly.

Chop the bell peppers into small cubes (about ¼-inch pieces) and slice the mushrooms. Melt the butter in a large pan over medium. Sauté the garlic and onion. Then place in the bell peppers in the pan along with the sliced mushrooms, corn kernels, and chayote pulp. Season with salt and pepper. Add the cilantro and let cook for ten minutes. Remove from heat.

Fill the chayote shells with the sautéed vegetable mix and arrange them in a large casserole dish. Add asadero cheese over each chayote. Bake for about 15 minutes on 250°F until the cheese is melted and golden brown.

Serve with sides of your choosing.

Tortas de Avena
Oatmeal-Seed Cakes

*Vegan

SERVES 6

This is an excellent vegan option to serve with mole or most of the salsas listed in this book. The seeds and nuts add an excellent flavor and texture of the cakes.

3 cups raw oatmeal, divided
½ cup toasted sesame
½ cup pumpkin seeds
½ toasted, unsalted peanuts
Salt and pepper to taste
Approx. 1 cup hot water
1 cup oil for sautéing
Salsa or mole and sides of your choice to accompany

Add 1 cup of oatmeal to the food processor and grind to make a powder.

Place the oatmeal powder in a bowl along with the other 2 cups of oatmeal, the sesame seeds, pumpkin seeds, peanuts, and salt and pepper. Mix well, adding the water little by little until you have a compact mixture that you can make cakes with. Be sure to add only enough water to be able to form the cakes, and not so much that they're very wet and falling apart.

Once you have the right consistency, take a small handful and form into a ball. Gently press with your palm to give it the form of a patty. You can make them the size that you want as long as they're under 1 inch thick.

Place a pan on medium-low and heat oil. Once hot, place the oatmeal cakes in the pan and cook between 2 to 3 minutes on each side or until they have a slightly golden color and are also cooked through on the inside. Remove from the pan and place on a paper towel to absorb excess oil.

Serve with your preferred salsa or mole and sides of your choice.

Nido de Camote
Sweet Potato Nests

SERVES 6

A plate full of energy, this is great to start the day. It's easy and quick and makes for an interesting twist on potato pancakes.

½ cup raw oatmeal
1 pound sweet potatoes
Salt and pepper to taste
¼ cup raw sesame seeds
Approx. 1 cup hot water
1 cup oil for sautéing
Salsa and sides of your choice to accompany
6 fried eggs (optional)

Place the raw oatmeal in a food processor to grind to a powder. Peel the sweet potatoes, then grate them on a cheese grater over a bowl. Season with salt and pepper. Add the oatmeal powder, sesame seeds, and enough water to help the mixture form the "nests." Mix well.

Take a handful of the mixture and form it into individual cakes using your hands or using a mold. The size should be about that of your palm, about 1 inch thick. Press to compact it.

Place a pan on medium-low, add the oil, and allow it to come to temperature. Once hot, place the "nests" in the pan and cook for 3 minutes on each side. Remove from the pan and place on a paper towel to absorb the excess oil.

Serve with your preferred salsa and sides of your choice. These are also great for breakfast with a fried egg on top.

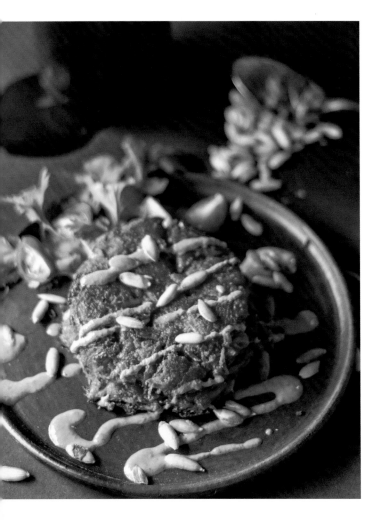

Tortas de Coliflor
Cauliflower Cakes

SERVES 6

This is one of our most popular vegetarian dishes at El Refugio. It has a mild flavor and nice texture. It goes well with a simple tomato or chipotle salsa.

FOR THE CAKES

1½ pounds cauliflower
2 cups water
5 ounces panela or cotija cheese
¼ medium white onion, julienned
⅔ cup bread crumbs
Salt and pepper to taste
3 egg whites + 2 egg yolks
Vegetable oil for frying
3 tablespoons all-purpose flour

FOR THE TOMATO SALSA

2 tablespoons vegetable oil
2 large garlic cloves
½ cup chopped onion
1⅓ pounds red tomato, diced
1¼ cups water
1 jalapeño
Salt and pepper to taste

FOR THE SIDES

Rice, salad or sides of your choice

FOR THE CAKES

Cut the cauliflower from the stalk and chop into pieces. Steam the cauliflower in 2 cups of water for 15 minutes, strain and allow to cool.

Place the cold cauliflower in a large bowl and crush to drain it further. Add fresh cheese or cotija cheese, as preferred. Add the chopped onion and bread crumbs to form the cauliflower cakes. Improve the flavor by adding salt and pepper if necessary, as the cheese may be very salty.

To make the coat, whisk the egg whites and yolks in a blender or with a fork, adding a little salt. Heat a pan with oil on medium heat. Coat the cakes with flour first, then with the beaten eggs. Next, fry them in the oil until they turn a golden color. Flip and repeat on the other side. Remove from the pan and place on a paper towel to remove the excess oil.

FOR THE TOMATO SALSA

In a saucepan, heat vegetable oil with the garlic clove, onion, and tomatoes. Sauté for 10 minutes.

Next, add 1¼ cups of water and boil for 5 minutes. Then blend well.

Place the salsa in another saucepan with the whole jalapeño and cook for 5 minutes. Add salt and pepper as needed.

Serve two cauliflower cakes per person, topped with the salsa. Serve with rice, salad, or the sides of your choice.

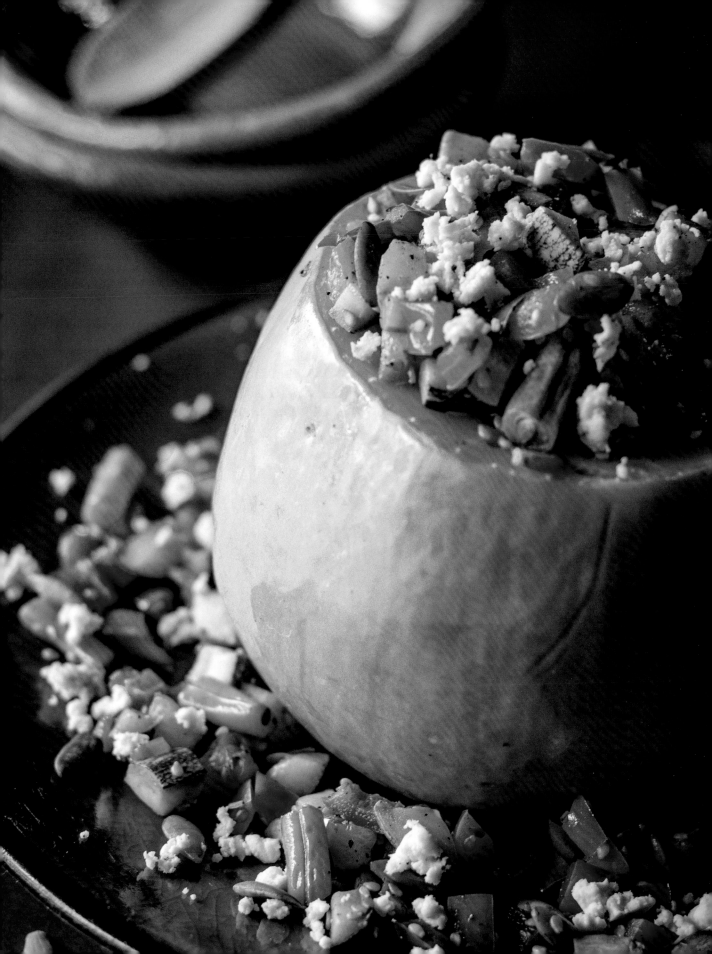

Calabaza de Mantequilla Rellena Stuffed Butternut Squash

SERInES 4

One of our favorite vegetarian plates, this is easy to prepare as a vegan dish. It's simple to make, but the rainbow of colors make for a beautiful presentation.

4 small butternut squashes of a good size
6 cups water
1 red pepper
1 yellow pepper
¼ pound green beans
1 zucchini
3 tablespoons avocado oil or other oil for sautéing
2 garlic cloves, finely copped
½ medium white onion, julienned
Salt and pepper to taste
½ cup toasted pumpkin seeds
¼ pound cotija cheese, grated
Rice and beans or sides of your choice to accompany

First, cut the neck of the squash so you're left with just the round part. If you like, you can peel and chop the neck to use as part of the stuffing along with the other vegetables. Remove the innards of the squash using a spoon.

Place a trivet in a large pot and add 6 cups of water and plenty of salt, and bring to a boil. Once boiling, place the squash inside, cover, and leave to steam for 20 minutes or until cooked through. Check with a fork to make sure the inside is soft. Turn off the stove and set the squash aside for later.

Cut the peppers in medium-sized squares and remove the seeds and veins. Remove the ends of the green beans and cut each into 4 parts. Slice the zucchini lengthwise and remove the seeds with a spoon, then cut into medium cubes.

Next, heat a pan on medium-high and bring oil to temperature. Add the garlic and onion to the pan, and cook while stirring for 1 minute before adding the peppers, beans, and zucchini. Season with salt and pepper and cook for 4 minutes. The vegetables should be al dente.

Turn off the stove, add the pumpkin seeds, and stir. Place this mixture into the butternut squash and sprinkle with cotija cheese.

This plate is impressive served on its own, but you could serve it with sides such as rice or beans if you like.

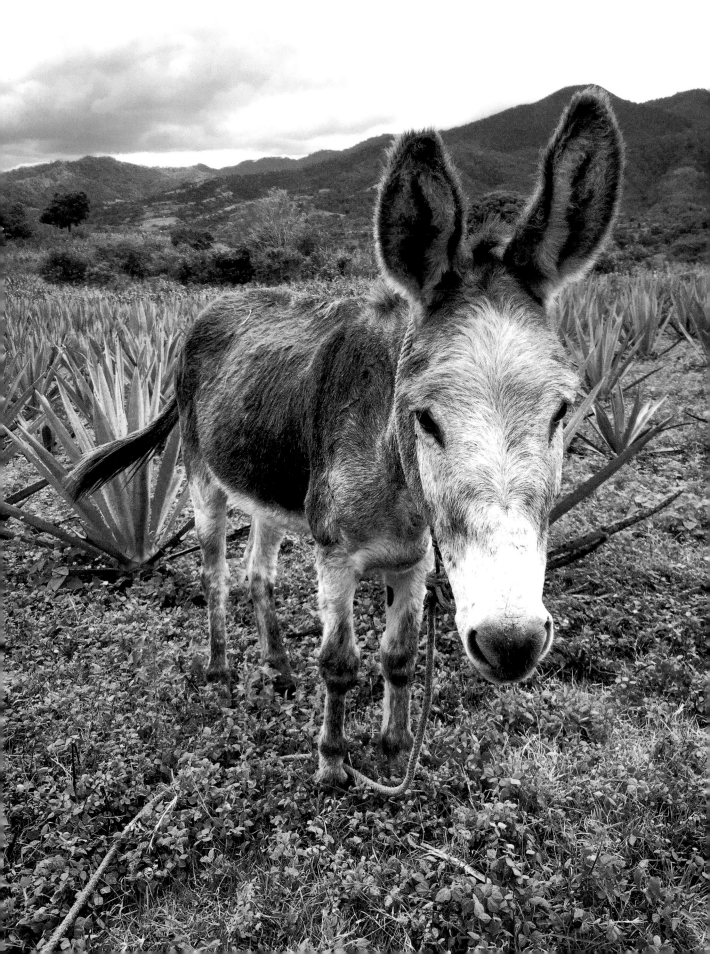

Sola de Vega, Oaxaca: Mezcal y Más Allá

In the land impaled by the mezcal craze, one has to go farther afield to find a planeque with a truly exceptional distillate. And as is true with most travel, the farther afield one goes, the deeper one will be immersed in the roots of a culture. Which was why we were so keen to visit Sosima Olivera's palenque in Sola de Vega.

Sosima Olivera is the president of the mezcal cooperative, Tres Colibrís, and is a well-respected voice among those fighting to protect the traditions of mezcal. She speaks regularly about the need to classify mezcal based on its regional differences and the importance of consumer education. Olivera—a third-generation mezcalera originating from San Miguel Suchixtepec—began learning the production process when only a child. For her, the work and success of the community are more important than that of the individual; everything she does supports this philosophy.

It was our second-to-last evening in Oaxaca when Olivera rang us up to tell us that Sola de Vega was hosting a mezcal festival. The next day.

Early Saturday morning, we hit the road, Lila and my visiting father in tow. Once you get beyond the sprawl of greater Oaxaca, heading south, the landscape flattens out into a broad, grassy plain, bordered by rolling hills. The highway to Sola de Vega is a meandering two-lane affair littered with speed bumps.

After about an hour of winding through cornfields and small towns, we cut inward, toward the mountains. The shoulder drops hundreds of meters to the valley floor, with nothing but patches of trees and shrubs to serve as a barricade. Down through gulches we roll, and up over ridges offering views to make the soul ache, until, finally, we arrive, hungry and ready to do our fair share of drinking.

The festival is held under a large tent that covers the width of the plaza. Mezcaleros have set their tables lined up along either side; bottles labeled with the family's name, logo, and contact information. Not a tax label or CRM[7] certification sticker on a single one. We head first to a food stand to line our bellies with meat, grease, cheese, and tortillas (all the better to taste with, my dear). At the head of the plaza stands a row of *corazones de agave tobalá*, as a speaker announces the participants in the competition for largest tobalá agave heart. Groups of children and teens in traditional dress rotate in and out of the plaza, performing their dances, as adults gather at the mezcaleros' tables tasting and retasting their distillates.

We leave Lila in Grandpa's care ("Sorry, Dad—work is calling") and approach the tables

7 *The CRM is the *Consejo Regulador de Mezcal*—the office that regulates which agave spirits can be sold as a mezcal under the Denominations of Origin. It is an expensive and complicated process to get certified, and most small-batch producers don't have the money to pay; many others don't believe in paying to certify what they've been doing for generations without outside oversight. For this reason, we're beginning to see more bottles on the market labeled as a *destilado de agave* instead. The product is the same.

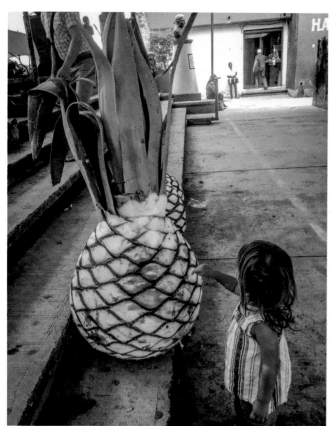
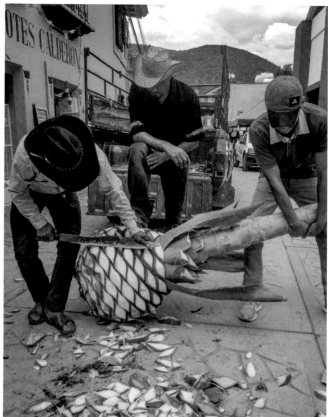
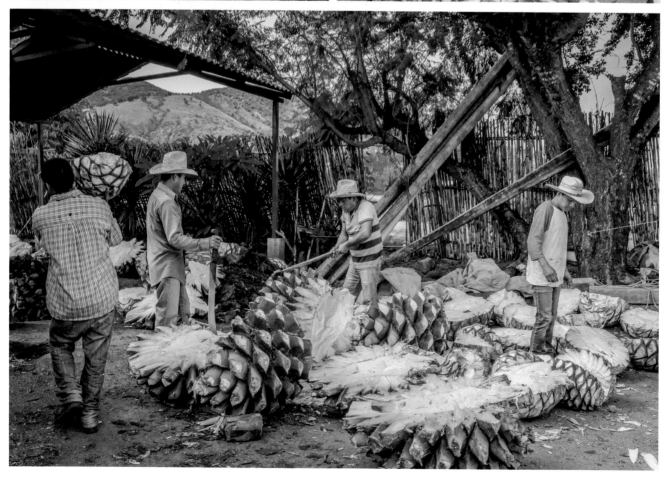

in anticipation. There is coyote, jabalí, tobasiche, arroqueño, and a plethora of tobalá. Much of it had been distilled in clay pots—a method of production rarely used for commercialized mezcals as it's less efficient. Some, oddly, had been distilled in stainless steel because, we are told, the government had gifted steel alembics to the mezcaleros. Most of them are very good, and a few absolutely exceptional. All of them taste like the real deal.

> **Tobalá de barro**—Holidays on the Austrian lakeside: you passed out as a fat kid on the grassy shore after OD-ing on sugar-coated gummy worms. A summer downpour wakes you. As you make your way home through the pines, the clouds clear and you realize you've become a man.

Just as we are reaching that mezcal-inflected, afternoon sleep state, Sosima arrives, ready to guide us to her palenque. We pile into the RAV4 and drive along more fields of maize and agave out to the hinterlands where magic is made.

Tres Colibrí Cooperativa presents itself as a clean, smoothly run operation. Mezcal cooperatives are exactly what they sound like: everyone who participates in the production of mezcal at this palenque shares a piece of the work and gains a piece of the profit, though there is always only one maestro mezcalero in charge of the distillation. When a mezcalero is ready to harvest, roast, or distill, he'll send someone out to light cohetes (fireworks) to call the other members to work. It's all for one and one for all. Samuel, the cooperative's secretary, takes us and another couple who has arrived out to the agave field to show us what

they'd planted and what was nearly ready for harvest. The cooperativa, like a number of mezcal producers, has begun planting what are normally wild species. As the demand for mezcal skyrockets, so does the concern that there won't be enough agaves to meet that demand in the coming years. Agaves take between seven and twenty-five years to mature (for the most commonly used species); it's no quick turnaround. A lot of forethought and advanced planning are required.

Sosima walks us to the back of the palenque where the underground oven for roasting is situated and explains the process to my father, whose eternal curiosity has no limits. The process is more laborious than most, if not all, other spirits on the market. After waiting so many years for the agave to mature, it's harvested by hand, the spines removed and the corazon—the heart of the agave—cut free from its roots and brought to the palenque. It takes about three days to harvest enough agave to fill the average oven, followed by three to seven days of roasting, and then another two to three days to crush it. A fire is lit in the pit oven and lined with rocks. When the rocks have reached a sufficiently high temperature, the agave hearts are placed inside, covered with palm or banana leaves and dirt, and left to roast for about three days. Roasting time depends on a variety of factors, including agave species and size, oven size, climate, and season. Once they have roasted long enough, they're removed and mashed. Here in Oaxaca, the tradition is to use a *tahona*—a large stone wheel pulled by a mule—to crush the agave fibers to a pulp. In Noel's home state of Guerrero, they don't have this tradition and use hatchets instead; or, more commonly these days, a wood chipper. Once the agave is crushed, it's placed in a wooden *tina* (barrel) with water

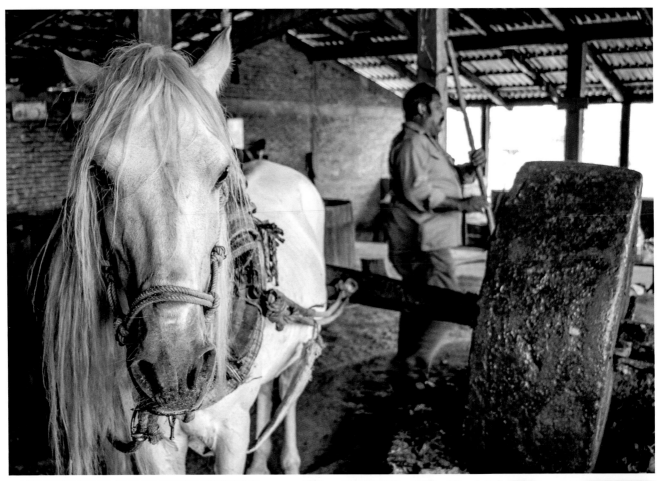

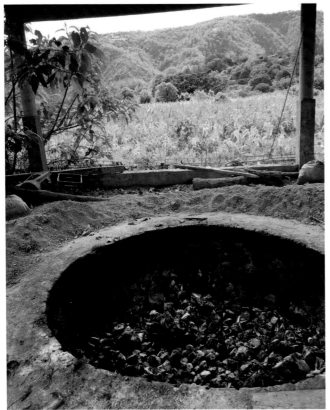

and left to ferment naturally with airborne yeasts. This process of natural fermentation is one of the main factors that makes artisanal mezcal unique in the spirit world—it is almost unheard of for another spirit on the market to rely on fermentation by wild yeasts as it means the resulting flavors are completely unpredictable. Fermentation in Sola de Vega is generally between five and ten days. And then comes distillation.

> **Coyote de barro**—You've exiled yourself in the remotest corner of the Shetland Islands while the rest of the world awaits the Zuckerberg-ian Apocalypse, content to scratch out your sustenance from rocky earth and frigid sea. The end time finds you living in an untouchable peace, grounded in your own salt-encrusted independence and enchanted solitude.

An ancestral mezcal will be distilled in clay pots. Most mezcaleros these days use copper distillation as it's much more efficient. Sosima has both at her palenque, as each type of alembic produces a different flavor. She tells us that with the copper still they put in about 200 to 250 liters and get out approximately 125 liters.

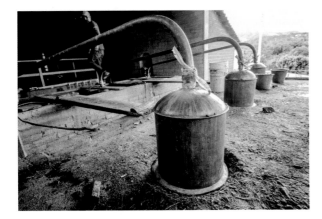

With clay pot distillation, for every 60 liters that goes in, they get about 12 to 15 liters of mezcal out—25 percent or less. That's a significant loss of product. The entire process from harvest to final product takes about one month. At the Tres Colibrís palenque, they harvest about four to five tons of agave in their most productive months, resulting in approximately three hundred liters, or four hundred bottles of mezcal.

How does a mezcalero producing four hundred bottles of mezcal a month (in a good month) compete in an international market? Simply put, they don't. But for someone who loves mezcal traditions the way Sosima does, it's not important. In fact, up until the last couple of decades, mezcal was never a mode to get rich or even to

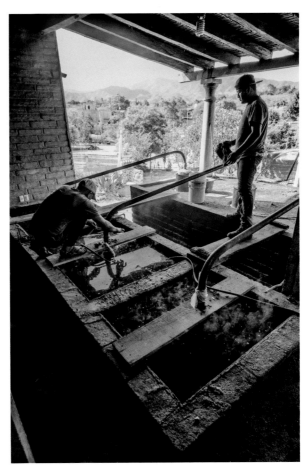

move from poverty to middle-class living. Mezcal has always been a supplementary income made by campesinos—by the natives working the land.

"You know, *siempre* when I ask a mezcalero how many liters he produces, he always says '*lo que Dios quiere*,'" Noel says. "It's not what he wants—it's what God wants. He is not the owner of the mezcal. Nobody is the owner of mezcal."

Tequila, in contrast, was made by wealthier, hacienda-owning families to augment their wealth or, in the case of the highly successful, create a dynasty. Tequila grew in leaps and bounds by that model. Communities in Oaxaca (and the same could be said for most, if not all, of the states where mezcal is traditionally made) have historically put their focus on the milpa: growing food for their families and to sell or trade. The milpa was, and still is for many, the central focus of life. Mezcal was secondary—generally made for festivals, weddings, and the various celebrations that pop up throughout the year. It was given as gifts and donations, in exchange for work done, and sold here and there. While tequila became Mexico's workhorse, mezcal remained a sacrament. For the indigenous populations, at any rate.

By the time tequila received its Denomination of Origin in the seventies, it was already popular in mainstream US culture. Demand for Blue Weber agave skyrocketed and those at the crest of the industry pushed for a relaxation of the rules making up its D.O. For example, where once a tequila had to be 100 percent Blue Weber agave,

by the 1970s a non-premium tequila could be made up with up to 49 percent other things: cane sugar, colorants, preservatives, etc. The majority of industrialized tequila is now prepared by roasting the agaves in large steel ovens called autoclaves; many companies also use diffusers to strip the maximum amount of sugar from the fibers—sometimes even with the aid of sulfuric acid wash.[8] Sadly, most of the tequilas on the market these days are owned by international corporations, using agaves cultivated from clones of clones on enormous swaths of land, where that romantic image of the jimador they proudly display in their marketing material is likely no more than an underpaid employee, stripped of his patrimony. These days the demand is so high that the industry can't keep up. It has become such a problem that we are now hearing reports from mezcaleros that tequila companies are buying up agaves in Oaxaca to supplement their supply, breaking their own D.O. rules and threatening the agave supply for mezcaleros.[9]

Javalí de barro—Gene Kelly is knocking at the door. It's raining and he wants to share a song and dance with you. But this ain't no twinkle toes musical. With dirt on his sole and one squinty eye, this mezcal is more like Clint Eastwood as Mr. Kelly's understudy.

Fortunately, many mezcaleros are looking at the tequila industry as an example of what *not* to

8 Bowen, Sarah "Whose Rules Rule?" *Divided Spirits: Tequila, Mezcal and the Politics of Production*. California: University of California Press, 2015. 68–80. Print.

9 All this said, there are traditional, responsible brands out there. We encourage you to seek them out. One place to start is with the Tequila Interchange Project.

do. While there are a number of enormous industrial brands making swill that doesn't deserve to be called mezcal, there are quite a lot of artisanal brands, bartenders, drinkers, and independent producers, such as Sosima, working to protect the ancestral traditions of mezcal, as well as the sustainability of the industry. The key is largely in education. The more people know and care about what they drink, the more support there will be to maintain the traditions of mezcal. It is also, of course, about the constant vigilance of those working toward that goal and fighting to create regulations that protect these mezcaleros and the agaves.

Sosima guides us into the bodega where the mezcal is mixed to the desired proof before being bottled. A room of cleanly stacked boxes filled with unlabeled bottles leads to a second, smaller room holding a large steel tank, a filtration and bottling machine, and several ten- and twenty-liter jugs of mezcal. She shows us how she mixes a bit of this distillate with a bit of that—both from the same distillation, but at different parts of the process, therefore containing different alcohol percentages—to achieve the proof and flavor she wants. The proof she can gauge quite accurately solely by eye: the size and duration of the bubbles the mezcal creates as it flows from bamboo tube into a jicara tells the experienced eye everything. Once she's achieved the desired proof, she re-creates this ratio with the rest of the mezcal in the large tank before bottling.

She fills a jicara with *mezcal Mexicano* for us to share. It is everything a mezcal should be: pure, powerful, complex, and soul-lightening. Lila takes the nearly empty jicara from my hands, lifts it to her face, and slurps at the bottom, sucking up any residual distillate.

Hovering on mezcal in the toasty afternoon light, we leave the palenque happy and inspired, but with time nipping at our heels. A two-hour drive awaits us, along with an order of eighty handmade clay mezcal cups we need to pick up and a lot of packing and cleaning before we can get on the road at 4 a.m. to beat the traffic on the way to Puebla. As it tends to go in Mexico, the more of a time crunch you're under, the more she kicks up her heels to slow you down and give you (yet another) lesson in patience.

Arroqueño de barro—A field of yellow poppies sways back and forth under the sweet caress of the sun. The smiles painted on the faces of each flower remind you of a 1960s cartoon. But you're not in search of twenty-first-century graphics. You are the Dude, blissed out in a perfect technicolor mezcal trip.

Within twenty yards, we are stuck behind a meandering parade of folks heading toward the church to pay homage to their patron saint. We inch along in the RAV4 ("El Chapulín"—"The Cricket") at the pace of the eighty-year-old couple trailing behind the others, holding hands, a bundle of yellow flowers tucked under one arm. On either side of the road, fields of maíz radiate a golden green, as if the sun is illuminating them from within. Serenaded by the brass band, we doze and plod forward. I slide off the leather seat and trail behind the group, trying not to intrude, yet wanting to immerse myself in the glow of their faith and perseverance. I am a river rock tumbling behind a school of fish, woven with perfect synchronism into the folds of their surroundings, in vain hope of adopting their steady breath of peace.

This. This right here is mezcal. This meditative procession, the sun striking the maíz, the donkey in the field of agaves, the smell of burning cohetes, the *bompa-bompa* of the tuba, the soft shuffle of chanclas on the dirt road as the abuelos slowly, determinedly tread toward church. This, as much as the species, the process, the fermentation time, and distillation type, are what makes a real mezcal.

Mezcal is not just a "simple distillation process." These elements of the pueblo life—of grandfather passing on his particular time-honored traditions to grandchildren, of ritual practices, of community gatherings, of subsistence agriculture—all have an imperceptible, yet vital, impact on what mezcal is. Mezcal is spirit; it is soul. Its depth and complexity are proportional to the community that produces it: their relationship with one another, with the land, and with their personal faith.

Arroz y Frijoles
Rice & Beans

Rice and beans are commonly served with many plates in Mexico.
We've included just a few recipes of each. Feel free to mix and
match them as you like. For the beans, if you buy in bulk, rinse and check
for pebbles. If you want to cook the beans fast, leave them to soak for
8 to 12 hours the night before, which will reduce cooking time by 30 minutes.

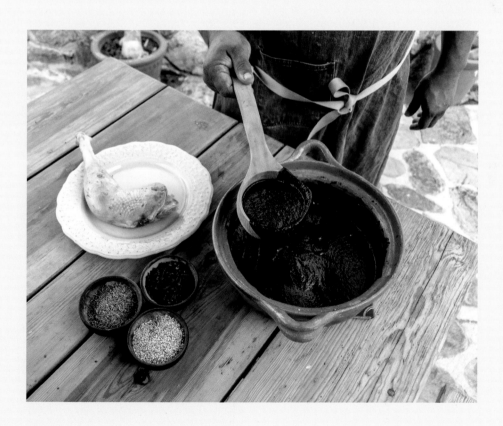

Arroz à la Jardinera
Gardener's Rice

SERVES 4

2 tablespoons oil to sauté
1 cup long grain white rice, washed
1 garlic clove, finely chopped
¼ medium white onion, julienned
1 ripe red tomato, washed
3 cups hot water
1 medium carrot, cut into ½-inch pieces
1 medium zucchini, cut into ½-inch cubes
¼ cup fresh corn kernels (or canned)
½ cup fresh or frozen peas
½ cup cubed white potato
1 tablespoon unsalted butter
Salt and pepper to taste

Heat a pan on medium with oil; add the rice and cook until it begins to change color, stirring constantly.

Blend garlic, onion, and tomato with a just enough water to facilitate blending; stir into the rice and cook for 2 minutes. Then add 3 cups of hot water and cook 2 to 3 minutes.

Next, add all the vegetables (carrot, zucchini, corn, peas, and potato). Leave to cook on medium until the water evaporates. When the water is almost gone, add the butter and stir in. When the butter has melted, season with salt and pepper. Turn off the heat, cover with lid, and leave to sit 5 to 10 minutes before serving.

Serve alongside your favorite main dish.

Arroz al Cilantro
Cilantro Rice

SERVES 4

4 tablespoons oil for sautéing, divided
2 garlic cloves, peeled
½ medium white onion, cut in half
1 cup fresh cilantro
1 cup long grain white rice
2½ cups hot water
Salt and pepper to taste
1 tablespoon unsalted butter

Heat a pan to medium-high and add 2 tablespoons of oil. Sauté the garlic, onion, and cilantro for 2 minutes. Add the sautéed ingredients to a blender and blend with a little water until homogenous. Set aside for later.

Heat the pan again to medium-high and add the remaining 2 tablespoons of oil. Allow the oil to come to temperature, then add the rice and sauté for 3 minutes. Next, add the blended mixture, the 2½ cups of hot water, and salt and pepper to your discretion. Cover and lower the heat to low. Cook until all the water has been absorbed. Once the water has been absorbed, add the butter, stir, cover again, and leave to sit for 5 minutes before serving.

Serve with your favorite main plate.

Arroz al Achiote
Achiote Rice

SERVES 4

2 tablespoons oil for sautéing
¼ medium white onion, cut in cubes
1 garlic clove, finely chopped
1 cup white rice
1 tablespoon unsalted butter
1 tablespoon achiote paste
2½ cups hot water
Salt and pepper to taste

Heat a pan to medium-high and add the oil. Sauté the onion and garlic for 2 minutes. Add the rice and sauté 5 minutes. Then add butter and achiote paste and sauté another 3 minutes while stirring. Spread the achiote throughout the rice.

Next, add 2½ cups of water, lower the heat to low, cover, and cook until all the water has been absorbed. Once the water has been absorbed, stir, cover again, and leave to sit for 5 minutes before serving. Add salt and pepper as needed.

Plate and serve alongside your main dish.

Frijoles con Carne
Pork and Beans

SERVES 6

6 guajillo chiles
1–3 árbol chiles (depending on how spicy you like it)
2 tomatillos, husks removed
2 red tomatoes
½ teaspoon cumin
4 whole cloves
1-inch cinnamon stick (or a pinch if using ground)
1 teaspoon whole black peppercorns
8 cups water
1 pound pork ribs
1 pound dried mayocoba beans, rinsed (can use pinto)
½ cup fresh epazote (or ¼ cup)
½ white onion, cut in 2
5 garlic cloves
Salt and pepper to taste
½ cup chopped onion for garnish
½ cup chopped cilantro for garnish
Tortillas to serve on side

Cut the guajillo chiles open lengthwise to remove the seeds, stems, and veins. Toast them facedown, 2 minutes each side, on medium. Be careful not to burn them. Toast the árbol chiles whole.

Put the tomatillos, tomatoes, cumin, cloves, cinnamon, black peppercorns, toasted chiles, and a bit of water in the blender and blend until perfectly smooth.

Place 8 cups of water in a pot on medium-low with the ribs, beans, epazote, onion, garlic, and salt and pepper to taste. Add the mixture from the blender. Cover and leave to cook 2½ hours. If you've soaked the beans the night before, check after 1½ hours to see how fast they're cooking—sometimes they cook much faster.

If at the end of 2½ hours the beans still aren't soft, add a bit more water and leave to cook a little while longer, checking regularly, until the meat and beans are ready to eat. The dish is perfect when the liquid is thick.

Garnish with chopped onion and cilantro and serve with tortillas.

Frijoles Charros

SERVES 6

This is a dish to satisfying the hungriest of rancheros. With bacon, chorizo, sausage, and ham, this *frijol* dish easily makes a main course.

4 guajillo chiles

1–3 árbol chiles (depending on how spicy you'd like it)

2 tomatoes

1 teaspoon cumin

6 cloves

1-inch cinnamon stick

Salt and pepper to taste

1 pound mayocoba beans, rinsed (can use pinto)

8 cups water

4 garlic cloves

1 medium white onion, cut in 4

¼ cup fresh epazote (or ⅛ cup dried)

2 tablespoons oil

7 ounces thick bacon or pancetta, cut into cubes

7 ounces chorizo, shredded

7 ounces sausage, cubed (hot dogs are also commonly used)

7 ounces ham, cut into cubes

½ cup fresh chopped cilantro

1½ ounces jalapeños in vinegar

½ cup chopped onion for garnish

½ cup chile powder for garnish

Cut the guajillo chiles open lengthwise to remove the seeds, stem, and veins. Toast them on both sides for 2 minutes on medium. Be careful not to burn them. Toast the árbol chiles whole as well. Remove and set aside.

Turn the heat to medium-high and toast the tomatoes in a pan, rotating every few minutes, until their skins just begin to burn on all sides. Add the chiles, tomatoes, cumin, cloves, cinnamon, and salt and pepper to your discretion to the blender with a little water. Blend until uniform.

Place the beans, 8 cups of water, garlic, onion, epazote, the mixture from the blender, and salt and pepper to your discretion in a pot. Cover and cook on medium for 2½ hours.

While the beans are cooking, heat a pan on medium-high, add oil, and add the bacon and cook until crunchy. Remove and set on a paper towel. Then add the chorizo and cook 15 minutes while stirring. Set aside for later. Add the sausage (or hot dog) and cook through. Set aside. Finally, cook the ham for 5 minutes, stirring regularly.

When the beans are finished cooking (the dish is perfect when the liquid is thick), put all the meat in the pot along with the cilantro and jalapenos (not the vinegar) and stir and heat on medium for 10 minutes. Check the salt and pepper levels and adjust as needed.

Serve in a bowl and garnish with chopped onion and powdered chile.

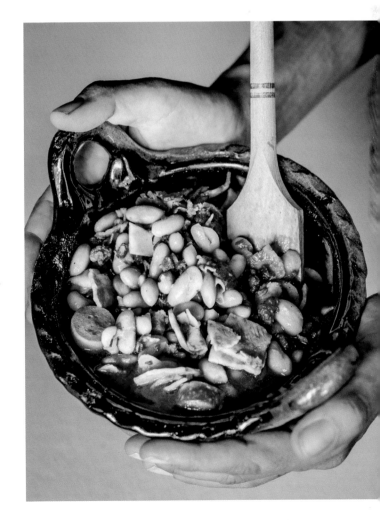

Frijoles Negros con Hoja Santa
Black Beans with Hoja Santa

SERVES 6

The hoja santa is an aromatic herb used in many indigenous plates and as a medicine. If you can't find it locally, substitute dried *aguacatito* leaves (these are from a very small variety of avocado, with an edible skin) to give the beans a different, but equally delicious, flavor.

1 pound dried black beans
8 cups water
2 ounces hoja santa leaves, with stem (can substitute
 3 leaves dried **aguacatito** leaf)
Salt to taste

Place the beans in a pot with 8 cups of water. Cook for 2½ hours on medium. When the beans are just about finished, add the hoja santa and simmer for 10 minutes more. Finally, add salt to taste, and serve.

Verduras para Acompañar
Vegetable Sides

The diversity of Mexican vegetables and legumes is astounding (though not often found beyond the border). These are a few of our favorites. Some, like the ensalada de pajaro loco, and chiles en curtidos, are ubiquitous throughout the country. Others, such as the ejotes, are not quite as common, but very much worth a try!

Ensalada de Pajaro Loco
Crazy Bird Salad

SERVES 6

This is a very fresh, simple salad, often served at street side stands throughout Mexico. You'll need a circular mold.

5 carrots
17 ounces jicama
Salt to taste
4 limes
1–2 tablespoons *botanero* chile powder, such as Tajin

Pictured on the left

Peel and grate the carrots and place them in a bowl. Peel and grate the jicama into a separate bowl. Add a bit of salt to each and mix well.

Place a medium circular mold on a plate and add in a layer of jicama about 2 inches thick. Next add in a layer of carrot. Press well to form a tight mold, then continue adding layers until you've used all your carrots and jicama. Remove the mold.

Squeeze the juice of 2 limes over the tower and sprinkle a bit of the *botanero* chile powder to taste. Serve fresh with a bit of extra lime on the side.

Setas Estilo Monte Real
Wild Mushrooms with Chile and Epazote

SERVES 4–6

These are the mushrooms we ate with the brewmaster Rogelio Calderón in Monte Real, Hidalgo. Rogelio used "basurita" mushrooms, which is a common name that applies to several species. Use a meaty, wild mushroom of your choice. We recommend serving it with Rabbit in Garlic (page 169).

2–4 serrano chiles
2–3 tablespoons melted manteca
1 medium white onion, julienned
2 pounds wild mushrooms
2 tablespoons fresh epazote, chopped (or 1 tablespoon dried)
Salt and pepper to taste

Remove the seeds of the serrano and chop finely. Heat the manteca in a wide pot (if you have a clay pot, we recommend it). Once hot, add the onion and sauté until the onion turns a bit golden; then add the chiles and cook for 5 minutes.

Next, add the mushrooms and heat until they're cooked through. Add the epazote and cook another 3 minutes while stirring. Season with salt and pepper. Serve as a side to a simply prepared main dish, such as Rabbit in Garlic.

Ensalada de Nopal
Nopal Salad

SERVES 6

The nopal—the cactus seen on the Mexican flag—is an extremely important element for the indigenous peoples of Mexico for its fiber, its high vitamin C and antioxidant content, and its anti-inflammatory effects. This prehispanic salad is commonly served with tacos de barbacoa, but it also makes a colorful side dish to many meals.

2 pounds nopal (cactus paddle)
½ medium white onion
3 medium red tomatoes
1 bunch cilantro
¼ pound cotija cheese
8 cups water
Salt and pepper to taste

Pictured on the left

Clean the cactus paddles of any remaining spines. Cut into 1-inch squares.

Chop the onion and tomatoes into small pieces. Remove the tomato seeds. Finely chop the fresh cilantro. Grate the cotija cheese. Place all of the above except the nopales into a bowl.

Add 8 cups of water to a pot or deep pan and bring to a boil. Once boiling, add salt and the nopales and leave to cook on high for 25 minutes. The nopales should change to a dark green color. Once the nopales have cooked, strain and rinse with cool water.

Next, add them to the bowl together with the tomato, onion, cilantro, and cheese. Season with salt and pepper as desired and mix well.

Serve as a side to any main dish.

Chiles en Curtidos
Pickled Chiles

YIELDS 10 CUPS

An accompaniment found on many tables, these are an easy way to add a bit of spice to any plate, though they're most commonly served with sandwiches and *tortas*.

4 medium jalapeños
2 medium carrots
1 purple onion
4 cups water
½ cup white vinegar
½ tablespoon salt
2 tablespoons oregano
4 bay leaves
2 cloves

Cut the jalapeños into 4 long slices. Peel the carrots and cut into ½-inch slices. Slice the onion in thick pieces.

In a saucepan over high heat, place 4 cups of water, vinegar, salt, oregano, bay leaves, and cloves. Once boiling, add the jalapeños, carrots, and onion. Stir and immediately remove from heat. Leave in the hot water for about 5 minutes then strain, reserving the cooking liquid for later use. The goal is to parboil the vegetables, leaving a semi-crunch texture to the carrots, with the chiles and onion softened.

When the water has cooled, add it back to the ingredients until they are just covered. Discard any extra water. The vegetables can be kept in the refrigerator for approximately 20 to 30 days. Use as an accompaniment to any foods for spicy, acidic flavor.

Ejote con Cacahuate y Chile de Árbol
Green Beans with Peanuts and Árbol Chiles

SERVES 6

This side adds a great texture to your meal. As long as you don't split (or bite!) the árbol chiles, it's not very spicy. The important thing to remember when making this dish is to have the pan really hot before adding the green beans.

1½ pounds fresh green beans
¼ cup vegetable oil
6 whole garlic cloves
8 árbol chiles
1 cup roasted peanuts without skins
Salt and pepper to taste

Remove the ends of the green beans and cut in two.

Heat a large pan or wok on low heat. Heat the oil. Once the oil is hot, add the garlic cloves and leave to cook until they've changed to a golden color, stirring occasionally. Remove and set aside.

Next, add the árbol chiles, taking care that none of them are cut or broken so their spice isn't released, only their flavor. Sauté on low 1 minute or so until they change to a slightly darker color. Remove and set aside with the garlic.

Turn the heat up to high. Once the oil has come to temperature, very carefully add the green beans and continuously stir them without pausing for 4 to 6 minutes or until mostly cooked. Then add in the garlic, chiles, peanuts, and a sprinkle of salt and pepper, stirring well. Sauté for 2 minutes before turning off the stove. The green beans should be al dente and should not lose their color or firmness.

Puré de Camote con Mermalada de Jamaica Sweet Potato Puree with Jamaican Sorrel Marmalade

SERVES 6–8

This is a crowd pleaser for sure: the sweetness of the potatoes is balanced by the acidity of the marmalade, with a hint of spice from the chipotle. At El Refugio, we serve this as a side to our Chiles en Nogada (page 157).

FOR THE PUREE

2 pounds sweet potato

6 cups water

Salt to taste

½ cup crema

2 chipotle chiles from a can

Pepper to taste

FOR THE MARMALADE

5 cups water

½ pound dried jamaica flowers

3 tablespoons olive oil

½ medium white onion, julienned

4-inch cinnamon stick

¼ cup brown sugar

FOR THE PUREE

Cut the sweet potatoes in half. Heat 6 cups of water on high. Once boiling, add the sweet potatoes and salt. Leave to boil for 30 to 35 minutes or until cooked through.

Once cooked, strain (but reserve ½ cup of the water), then very carefully remove and discard the skins. Place the sweet potatoes in a deep pan on low heat and add ½ cup of the water they were boiling in, crema, the chipotle chiles, and a sprinkle of pepper. Mash the potatoes and thoroughly mix all ingredients with a potato masher or large spoon until you have a thick consistency. Adjust the salt and pepper as desired. Leave on the stove for 3 more minutes, stirring continuously.

FOR THE MARMALADE

Place a pot on high heat with 5 cups of water and the jamaica flowers; leave to boil for 25 minutes or until the flowers have become quite soft. Turn off the stove, then strain the water into another container and save for later.

Add oil to a pan on medium heat. Once the oil has come to temperature, add the onion and sauté for 2 to 3 minutes. Add the flowers, cinnamon stick, ½ cup of the hibiscus water, and sugar. Stir well and leave to simmer for 12 to 15 minutes, or until the water has reduced by 80 percent and the sugar has caramelized. We're looking for a sweet marmalade with just a touch of acidity.

Serve a portion of the sweet potato puree along with the main course, and top with a small spoonful of the marmalade.

HAPPINESS, GRATITUDE & GENEROSITY

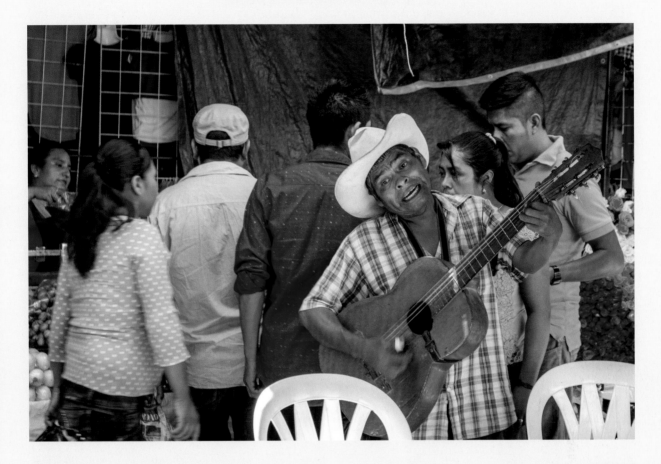

During our first winter in Todos Santos, we rented a small, palapa-roofed studio on the property of a local family with three children. I remember that winter vividly as the most impoverished period of my life: we lived from week to week, depending entirely on the sales of Noel's leather and feather work in the Sunday market. For months, we only just managed to pay our $175 rent; our diet consisted of eggs, beans, and tortillas. More than once, Noel spent our last fifty pesos on a *caguama* of beer and a bag of totopos to offer a friend who'd popped in. I spent most of that winter nearly shitting myself with anxiety.

One day, as I scoured the internet looking for one-off writing jobs, shaking with fear for our future, I heard the voice of the landlord's cleaning lady ringing out. She was singing a Mexican pop song as she scrubbed the floor. It wasn't unusual. She sang every day. But this was the first day I'd paid attention. Angelica came five days a week to clean, wash the clothes, and chase after the landlord's three bratty children. I asked her one day how much she was paid.

"Twenty pesos an hour," she told me. About $1.30 at the time. And yet she was one of the happiest people I'd ever met.

I looked at myself: a university-educated woman from an upper-middle-class white family, sick with stress from lack of money. And here was this fifty-year-old woman, with few employment options, singing like a songbird because she had enough to buy beans and tortillas.

And that is when I realized I had a lot more to learn.

An expression of gratitude is something one cannot fail to miss when in the company of native Mexicans. Everything, from a *"gracias a Dios"* (a statement expressed by the vast majority of Mexicans, religious or not) to the contentment of so many with a humble home and a simple diet, is a testament to this sense of gratitude. That spirit of gratitude springs from humility and manifests itself in a kind of compulsive generosity.

A friend we made on our investigative road trip told us of the time he left his home in Puebla with four hundred pesos in his pocket and hitchhiked around the country on a journey of self-discovery. Out of necessity, he regularly went to restaurants to ask if they had work he could do in exchange for a meal.

"Ninety percent of the restaurants said no," he told us. "But most of the market vendors gave me their extra food for free."

My own experience in Mexico, Asia, and elsewhere has shown me that it's those who have the least to give who are the most generous with others. Perhaps it's because they know what it's like to go without. Or maybe it's because they've gone so long with so little that they're confident of their ability to survive, even if they give away their last tortilla.

Noel thinks it's more than that.

When I tell him my thoughts on the gratitude and generosity I've experienced in Mexico,

he says, "Generosity is the wrong word. It's not generosity. Generosity is when you give something because you hope to get something back. It's happiness. The people here give because they are happy with their life, they're happy with the little they have, and they're happy to share."

We're driving on Highway 19 on our way to La Paz from Todos Santos when I share my musings with Noel on the cookbook. We're talking about the sacrifice of the bull for the festival in Mochitlan and how the collective energy of the town goes into the food and how that magic is what makes the food so incredible.

"No one reading this book is going to cook a bull that has been killed by a town with masked dancers honoring a virgin," I say. "But we can all get a sense of that magic in our cooking just with our presence with family and community. With the relationships that we create."

"There is something quicker," Noel says. "Being grateful."

Being grateful when you're about to eat. Being grateful because you have something to experiment with—that you can eat. Because a lot of people aren't grateful—they just eat and pull out their cell phones and fuck around. This is being grateful: putting all your intention into eating, not in anything else. Because in that moment you're acquiring the energy that helps you to think and helps you to oxygenate your body and to move. And so you should put everything else aside: if you're angry, then calm down; if you are sad, try to focus on the flavor in the food. If you are happy, that's good! If you're with company— even better. If you have extra, then share. Because in that same moment that you are eating something you had the opportunity to choose, a lot of people don't

have the opportunity to choose, and many more are hungry or have to work very hard to have food.

If you are not grateful, then you are very stupid, because you can be the king of the world but you are still dust in the wind; you are a nobody. In mathematical terms, in cosmic terms, you're nothing. But if you're grateful and you use that gratitude to make your own magic, then you are amazing. Why? Because if there are more conscious people, the world will be a better place. But if you're eating a pinche hamburger from McDonald's and you're talking badly about your coworkers . . . better you don't eat. You'll only make yourself sick. But if you are eating a cheese taco and you're grateful because you are eating a cheese taco with a glass of water and salsa, that food will last the whole day. You'll feel strong, and you'll work well.

You don't need a god or a creed—you only need to say thank you because you are eating. If you want, give thanks to yourself. If you believe in a deity or creed, go for it. But the idea is to accept that we are dust in the wind and that we are nothing incredible.

I pause and reflect on my own eating habits. According to Noel's ideas, I'm without a doubt "very stupid."

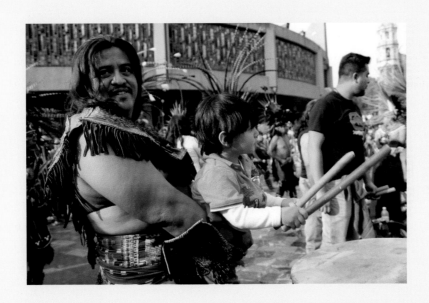

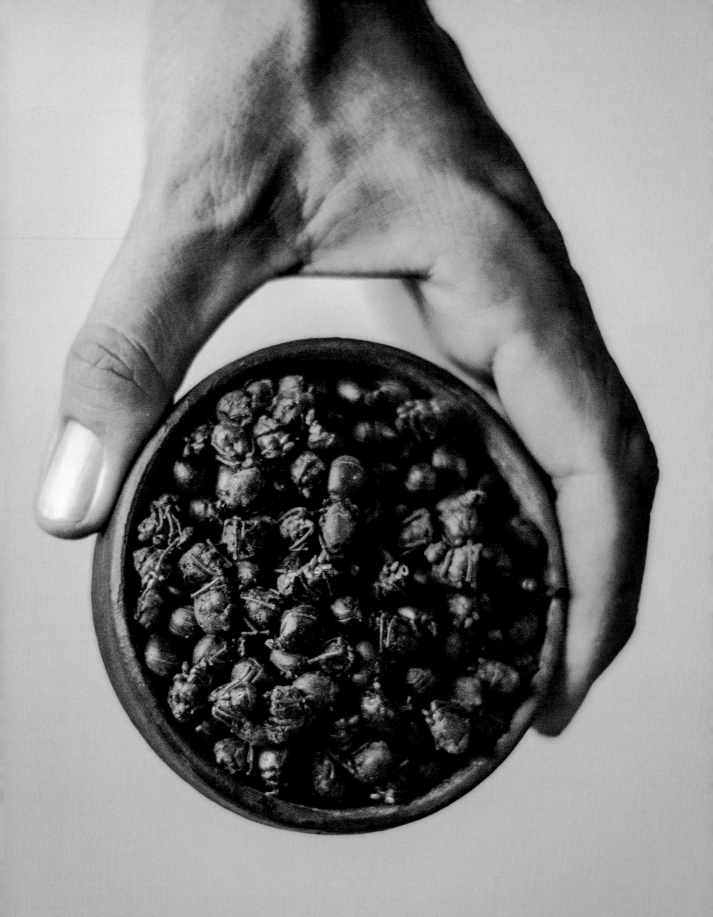

Hidalgo: Land of Pulque & the Edible Everything

Insects and pulque. That's what predominantly drove us to Hidalgo. We had no contacts and little former knowledge, but we knew that it boasted itself as the primary producer of pulque, and it hosted an exotic food festival every year. So when we met a local director who had made a documentary about these same exotic foods and who had offered to take us to a market to try them, as well as to a local pulque producer, we knew luck had blessed us yet again. And all without having first asked the permission of a virgin. Imagine!

Rogelio Calderón Jiménez, owner of Cervecería La Viscaína, runs a small operation on the cobbled streets of Mineral del Monte—a former mining town heavily invested in by the Brits. The mines closed down in his grandfather's time, and today this *pueblo magico* relies predominantly on tourism. Rogelio took us one Friday afternoon to visit Francisco "Pancho" Mariano Hernandez Monroy—a man whose family has been producing agua miel and pulque on the same land for over one hundred and forty years.

Agua miel is the sweet liquid that's collected from the center of an *agave pulquero*. Pulque is produced when the agua miel ferments and becomes a milky, white beverage with an alcoholic content similar to that of beer. Both beverages have been popular with Mexico's indigenous peoples for thousands of years. Aside from the jovial buzz it provides, pulque is also incredibly rich in proteins and probiotics and has multiple traditional medicinal uses, from calming indigestion to fortifying women just after labor and increasing fertility in men.

We arrive at a green-walled compound on the upper slopes of town and wait. Pancho's nephew shows up and points us around the back where we sidle through a metal gate. To my surprise, a five-acre agave field, invisible from the street, lines the hillside above the house. Pancho—a tall, lean man in his seventies—greets us in a navy-blue Centro de Salud uniform and a cheerful smile. He leads us up the terraced hillside, past his barn for breeding rabbits and past his horses, mules, and sheep, to where *magueys* of medium to large size have been planted in neat, wide rows. A light wind kicks up; the sky threatens rain. Clouds hang low over slopes so intensely green I could easily mistake it for England were it not for the presence of the giant succulents.

We follow behind Pancho as he collects that afternoon's batch of agua miel, striding from plant to plant, explaining the process. First, a wide hole is cut into the heart of the agave, to stop the quiote (flowering stalk) from growing—the plant's final step in its life cycle, which allows for pollination. The agave is then left for four to five months (or sometimes up to a year or two). When the tlachiquero (the one who collects the agua miel) is ready to begin his harvest, he carries a tool that looks something like an exaggeratedly wide spoon; an elongated, dried gourd with a hole at either end (or in Pancho's case, a rubber tube attached to a two-liter soda bottle); and a collection container. The spoon is for scraping the inside of the agave heart. This causes the plant to "bleed" more agua miel. The tlachiquero then inserts the neck of the gourd into the heart and sucks through a small hole in the other end, drawing the liquid into the gourd. He then deposits the agua miel into his container and moves on to the next plant. An agave pulquero in this region can produce approximately two liters per plant per day for about fifteen to twenty years. Pancho himself collects about ten liters, twice a day from the agaves on his land.

As Pancho scrapes and sucks his way through the field, he talks about the other uses of the plant. The leaves he gives to his cows and sheep to eat. It's hard to imagine; they are so thick and dense that we're standing on them to get a better look into the agave heart. Pancho scrapes the inside of those agave hearts twice a day to remove the *mechal* (the meat of the agave), which is given to his horse to eat; the quiotes (when left to grow and flower) are used to build fences and roofs. There's also a significant market for *chiniquiles*—the larvae that live in the agave. These worms are rich in protein and are commonly consumed in Hidalgo and other parts of Mexico—fried up and eaten straight like popcorn or stuffed in a taco.

Pancho takes a soft, young penca, still coiled around itself, from the center of one agave and unfurls it. He shows us the thin, plastic-like coating that covers it and how to peel it off. This part is often used to wrap meat when preparing barbacoa, and the leaves themselves are put into the pit oven to roast along with the meat, providing extra moisture and flavor. He then takes the leaf and bends it into a vessel to show us how it can be used as a cup for drinking agua miel and pulque.

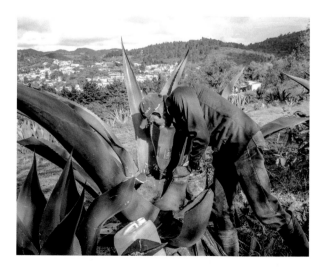

Pulque, Rogelio explains to us, is finicky. It must always be the same person who makes it, otherwise it won't ferment properly. It used to be that only men made pulque, as Mayahuel, the goddess of agaves, is a jealous woman. Apparently, she's loosened up of late: these days, it's Pancho's sister who makes the pulque out of the agua miel he collects. To do this, she adds the *seminal de pulque* to kickstart the fermentation. The seminal is a type of wild yeast found in certain regions. In other regions, they'll use *timbre* instead—an acacia or calliandra root.

As you drive into Hidalgo from Estado de Mexico, you see sign after handwritten sign advertising pulque and the insect of the season for sale at roadside tables. But in Mineral del Monte, we only see a handful of places advertising the prehispanic drink. Up until the 1980s, there were two hundred cantinas found in this small town, due to the large number of miners in need of a fortifying, but inexpensive, alcoholic beverage. Pancho's family used to sell one to two hundred liters per day—an impressive number considering they were only one family serving one town. Recently, other producers have been bringing their pulque to Mineral de Monte to sell door-to-door, which has proven difficult for him to compete with.

Pancho doesn't seem overly bothered about the decline in sales, nor does he seem particularly put out that his sons and nephews have little interest in continuing the family business. Despite its rebirth in Mexico City, pulque isn't selling like it used to in the mining towns of Hidalgo, where families carry the tradition. And while we could see it becoming wildly popular in the United States and abroad, the fact that pulque must be consumed fresh nixes that opportunity. (There are a few businesses that have canned pulque to ship and sell, but the taste and nutritional benefits don't compare.) It would seem that the only options for revitalizing the pulque market are through a combination of express delivery, educational marketing, and tourism.

The next evening, we join Rogelio and his wife, Esmerelda, at their cervecería for a rabbit dinner—raised by Pancho, cooked by his sister. Noel and I bring a decadent chocolate cake, as it happens to also be Lila's birthday (likely making her the first child in history to be raised in a mezcaleria and celebrating her first birthday in a brewery; in another five years I expect she will be a fermentation specialist). The cervecería is little more than a small bar, three taps, a brew room,

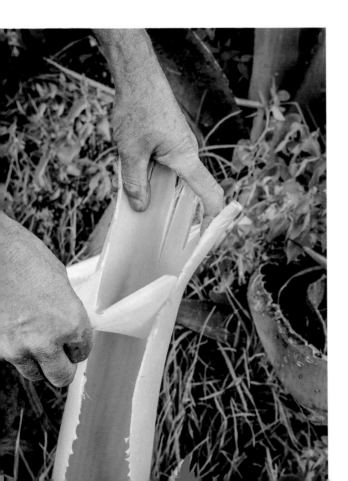

and a storage room. There's no kitchen, stove, or dishware, and we're unsure how they plan to heat up the food. But *ni modo*, as they say. In Mexico, the details always seem to work themselves out.

After sharing his house-brewed beer infused with agua miel, Rogelio disappears into the back room with a batch of wild mushrooms he'd bought earlier in the day. Curious as to how he plans to prepare the mushrooms, I follow him into the brew room and find him stirring them in a clay dish over the gas burner used for brewing. Mexicans, I must say, are nothing if not resourceful.

Dinner is exquisite. The rabbit is simply prepared with garlic (page 169). The mushrooms are some of the best I've ever eaten: a variety locally known as *basuritas* ("trash can mushrooms"), cooked with epazote, serranos, and manteca (page 223).

The following day, we pick up Rogelio and Esmerelda at their house in Pachuca and make the drive to the Central de Abastos market in Actopan, where we'll be able to taste various insects and grubs, pulque and barbacoa. The market is full of all the foods you'd expect and more I'd never seen. We head directly for the insect vendors. There we find chiniquiles, *escamoles* (ant larvae), chapulines, and little fried fish. The beetles and ants are dead and toasted; the agave worms still wriggling. We buy a selection of them to taste and carry them to the indoor fonda where Rogelio orders a round of coffee and barbacoa for our breakfast. We munch on beetles, grubs, miniature lobster-like critters, crickets, and ants, intermittently sipping watery mercado coffee as we wait for the main meal. It arrives like a feast for the poor: no pomp or circumstance, but enough sustenance to strain the seams—a

monstrous, steaming platter of vegetal-wrapped meat. There is enough pork leg, pork shoulder, and chicken breasts and thighs to feed eight hungry men, all rubbed down with chiles, spread on a bed of nopal and onion, wrapped in thick maguey leaves. We make a valiant effort and ask for the remains to go.

As we waddle our way outside and through the parking lot toward the antique market, I am suddenly hit with severe cramps. I can't go on. The pain is too intense. I don't want to believe it was the insects that I'm reacting to, but it's hard to think otherwise.

"I'll go find a pharmacy and buy an antacido," Noel says.

"Why don't you drink a pulque?" suggests Esmerelda.

"*Aye, buen idea,*" Noel agrees.

We return to the market and order a liter of natural pulque. I sip from my clay jarrito, and

slowly the pain subsides. The milky, probiotic-rich liquid soothes my stomach, and within ten minutes the pain has disappeared entirely. It's a cure I would take any day over Pepto-Bismol.

We drive back from the blistering Actopan valley up into the frigid mountains of Real de Monte, where a warm summer day feels like deep November in Vermont. Noel and I thank our guides profusely and invite them to visit us in Baja. We make potential plans for them to show their documentary, *Si Corre o Vuela . . . a la Cazuela*, at our restaurant the following winter, and for us to return for the exotic food festival in the spring.

So many of the blessings bestowed upon us in our travels through Mexico have been due to the kindness and generosity of such strangers-cum-amigos. It is one of the great boons of travel, this gracing of one's life by new acquaintances, but it is a boon that Mexicans in particular dole out in heaping portions. The only way to know Mexico, I would argue, is to place yourself in the hands of her people for an afternoon, a week, or even an indefinite number of years. For Noel and I, it is in large part the meals and knowledge gifted us by strangers that have led us happily to where we are today.

Estoy casado con la muerte,

la vida y yo...

Solo amantes!

Postres
Desserts

Every country has its sweet side, and Mexico is no exception. Here, you will find classics, such as churros, and regional specialites, like the bien me sabes. And of course, there's no shortage of xocolatl—what was once consumed by the Náhuatlaca as a beverage and valued as a currency and for tribute—we have transformed it into mousse with chile and truffles with mezcal. Provecho!

Mousse de Chocolate y Chile

Chocolate-Chile Mousse

Recipe by Ophelia Blanco

SERVES 4–6

This is one of the most popular desserts we serve at El Refugio. It's smooth and super chocolatey with a nice hint of spice. You can also make it with mezcal instead of chile—the smoke of the mezcal pairs really well with the rich chocolate.

FOR THE MOUSSE

4 ounces cacao paste or (⅔ cup semisweet chocolate chips)
2 tablespoons unsweetened cocoa powder
7 ounces cream cheese at room temperature
2 tablespoons honey
1 cup cow's milk (can substitute almond, soy, or coconut milk)
2 tablespoons chile oil (see below) or 1 large shot mezcal joven (2–3 ounces) (optional)
¼ ounce gelatin powder
Whipped cream for garnish
Powdered cinnamon, or cocoa powder for garnish

FOR THE CHILE OIL (OPTIONAL)

7 tablespoons peanut oil
2-inch cinnamon stick
1 whole dried chipotle

FOR THE MOUSSE

Melt the cacao paste (or chocolate chips). Mix the melted chocolate, cocoa powder, cream cheese, and honey in a large bowl. Add the milk little by little. If you'd like a bit of spice, add in the chile oil at this stage; if you prefer smoke, add in the mezcal instead. Once all the ingredients are well mixed, melt the powdered gelatin in a microwave and mix in with the rest.

Pour the mixture into a container (or several small containers) with a lid, and leave in the refrigerator for 2 hours before serving.

Serve with a twirl of whipped cream and a dusting of cinnamon, cocoa powder, or a garnish of your choosing.

FOR THE CHILE OIL (OPTIONAL)

For the chile oil, heat the peanut oil with cinnamon and chipotle for 5 minutes on medium. Remove from heat and allow to cool. Strain and reserve in a lidded jar.

Nieve de Platano y Chocolate Banana-Chocolate Sorbet

Recipe by Ophelia Blanco

SERVES 4–6

*Vegan

A healthy dessert! Banana, chocolate, and almond butter give you the sweetness you crave without a big sugar spike.

6 whole bananas
2 tablespoons unsweetened cocoa powder
½ tablespoon cinnamon powder
2 tablespoons honey
2 tablespoons almond or peanut butter (optional)

Cut each banana into 4 pieces and place in freezer for about 1 hour until somewhat frozen.

Blend the bananas, cocoa powder, cinnamon powder, honey, and almond butter thoroughly in a blender or food processor.

Pour into a container, cover, and place in freezer for 4 hours or more until frozen.

Mango en Almibar

SERVES 4

In Guerrero, *mango en almibar* is typically eaten as a light dinner and is usually accompanied by *atole de masa*. The flavor is best with a sweeter variety of mango.

2 pounds green mangoes
6 cups water
½ tablespoon cal
2-inch cinnamon stick
1 cup brown sugar

Peel the mangoes with a potato peeler, then slice long slits into them. Heat 6 cups of water with the cal, cinnamon, and sugar. Once boiling and the sugar has dissolved, place the mangoes in the pot and simmer on medium heat for 1½ hours.

Remove the mango from the pot and serve in a bowl with a bit of the syrup on top.

Bien Me Sabes Brandy-and-Sherry-Soaked Sponge Cake with Custard

Recipe by Matt Champagne, inspired by La Casita de Abue

SERVES 6–8

Bien me sabes (which translates to "I taste good") is a spongy cake called *pan de marquesote*, soaked in sherry and brandy and topped with a thick custard. This is the dessert we tried in Chilapa, Guerrero. The trouble is, when a traditional cook in Mexico gives you a recipe, it doesn't usually come with quantities, timing, or very clear instructions. The following is the recipe that our experienced baker-friend extracted from her instructions and his own experience. The result, you'll find, is delectable.

FOR THE CAKE

5 eggs, separated
¾ cup powdered sugar
5 heaping tablespoons all-purpose flour
1 teaspoon baking powder
½ teaspoon salt
Powdered cinnamon or sliced almonds for garnish

FOR THE BRANDY-SHERRY SOAK

¼ cup brandy
½ cup sherry (or vino de Jerez)
2-inch cinnamon stick

FOR THE CORN CUSTARD

2 cups whole milk
80 grams (a scant ½ cup) white sugar
1 cinnamon stick
1 teaspoon vanilla extract
40 grams (a scant ¼ cup) cornstarch
½ cup water
3 egg yolks
¼ cup almond flour (optional)

FOR THE CAKE

Whip egg whites to soft peaks. Beat the sugar into the egg yolks and gently add to the egg whites. Sift the flour, baking powder, and salt, then fold it into the egg-sugar mixture.

Next, place the batter gently into a greased and floured 9" x 13" pan and bake at 350°F for 20 to 30 minutes until golden brown.

Remove from pan before completely cooled (it will stick a little). Cut the cake in half to make two layers and make sure they line up.

FOR THE BRANDY-SHERRY SOAK

Heat all the ingredients together in a saucepan until simmering. Remove from heat and set aside until cool. Strain to remove cinnamon.

FOR THE CORN CUSTARD

Heat the milk, sugar, cinnamon stick, and vanilla over medium heat until boiling, stirring continuously. Reduce the flame and cook over very low heat for five minutes, stirring continuously, then turn off the heat and remove the cinnamon stick.

Dissolve the cornstarch in ½ cup of water, then add the cornstarch mixture to the milk. Slowly stir half of the mixture into the egg yolks (and almond flour if desired), then combine all ingredients and cook over very low heat for 1 to 3 minutes until thickened. Remove from heat and set aside.

ASSEMBLY

Assemble the cake before the custard cools completely. The goal is to apply the custard while still pourable so as to achieve a smooth appearance. Pour half of the brandy-sherry mixture over the first layer of cake. Pour one-third of the custard onto this layer and top with the other layer of cake. Then pour the rest of the brandy-sherry mixture followed by the remaining two-thirds of the custard over the entire cake, using an offset spatula to cover the sides completely.

Garnish with powdered cinnamon and/or sliced almonds. Chill before serving.

Churros con Chocolate
Churros with Extra-Thick Hot Chocolate

Recipe by Ophelia Blanco
FOR 4–6 SERVINGS

A classic in Mexico, and my number one antojo *(craving) while pregnant. You can fill them with sweetened condensed milk, chocolate, or cajeta, as many in Mexico do, or eat them plain or dunk them in extra-thick hot chocolate. Eat fresh while still warm for the best taste. You'll need a pastry bag (or resealable bag).*

FOR THE CHURROS

1 teaspoon white sugar
1 tablespoon cinnamon powder
1 cup flour
1¼ cups brown sugar
¼ teaspoon salt
2 eggs
¼ cup unsalted butter, melted
1 cup water at room temperature
2 liters vegetable oil for frying
Sweetened condensed milk, cajeta, or chocolate for
 filling (optional)

FOR THE EXTRA-THICK HOT CHOCOLATE

1⅓ cups semisweet chocolate chips
3½ tablespoons unsalted butter
½ cup crema, cold or 1 cup cold whole milk, depending
 how thick you'd like it
¼ cup mezcal or rum (optional)

FOR THE CHURROS

Mix the white sugar and cinnamon in a bowl and set aside. In a separate pot, heat the flour 1 minute, stirring with a wooden spoon. Add in the brown sugar and salt. Remove the pot from the heat, and add in the eggs one at a time. Mix and add the butter and 1 cup of water a little bit at a time. Stir with force, continuously, to achieve a thick, smooth mixture.

In a large pot for frying (large, but not deep), heat oil on medium.

Meanwhile, pour the mixture into a pastry bag with the tip of your choosing, or in a resealable plastic bag with the corner cut. Test your oil temperature by squeezing a small amount into the hot oil.

If the temperature is good, continue with larger quantities: squeeze the dough into the pan in long strips, or in spirals, as you prefer. When the dough has a uniform golden or caramelized color, remove and place on a paper towel to remove excess oil.

Roll the fried churros in the sugar-cinnamon mixture.

Optional: if you like your churros filled, before rolling in the sugar-cinnamon mix, *carefully* make a hole in the churro lengthwise using a kebab spear. Take care not to go through the other side, otherwise the filling will spill from two ends. Place the filling of your choice (sweetened condensed milk, cajeta, or chocolate) in a pastry bag or resealable plastic bag with a small hole cut at the end. (To make the chocolate for churro filling, follow the recipe for Extra-Thick Hot Chocolate, adding in the cold crema or milk, and the mezcal or rum, if you'd like). Carefully squeeze the filling into the churro.

FOR THE EXTRA-THICK HOT CHOCOLATE

Melt the chocolate chips on low with the butter. Add the cream or milk and mix well. Then add the mezcal or rum if you like. Stir well. If the chocolate is for the churro filling, it must be very thick. If it's for dipping, you can make it the consistency you'd like by adding the cream or milk and mezcal or rum a bit at a time, until you have your desired thickness.

Serve in a small cup along with fresh churros.

Trufas de Mezcal
Mezcal Truffles

Recipe by Rachel Glueck

MAKES APPROXIMATELY 25 TRUFFLES

Chocolate and mezcal—two of Mexico's most divine gifts to the world. These make the perfect after-dinner indulgence for those who want just a morsel of sweetness. Incredibly easy to prepare, they're great for dinner parties, as gifts, or for late-night chocolate cravings! Our favorite is dark chocolate (70 to 80 percent), but you can make them with white or milk if that's your preference. Get creative with toppings: nuts, cocoa powder, coconut flakes, and finely chopped dried fruits are all great choices.

8 ounces chocolate (70–80 percent)
½ cup heavy cream
3 tablespoons butter
5 tablespoons mezcal joven
Cocoa powder, crushed almond, walnuts, or pumpkin seeds, or coconut flakes to decorate

Chop or shave the chocolate into fine pieces and set aside in a bowl. Heat cream and butter together on low heat in a pan. When melted, add to the bowl of chocolate. Stir well until all the chocolate has melted and the mixture is completely smooth. Stir in the mezcal.

Leave the mix to sit in the refrigerator for about 1 hour until it has cooled enough that you can roll it into balls. Once cooled sufficiently, roll the mix into balls in the palm of your hand. Roll the balls in the topping of your choice to finish.

Keep in fridge. Truffles can be served straight from the fridge or taken out about 20 minutes before serving. Keep no warmer than room temperature.

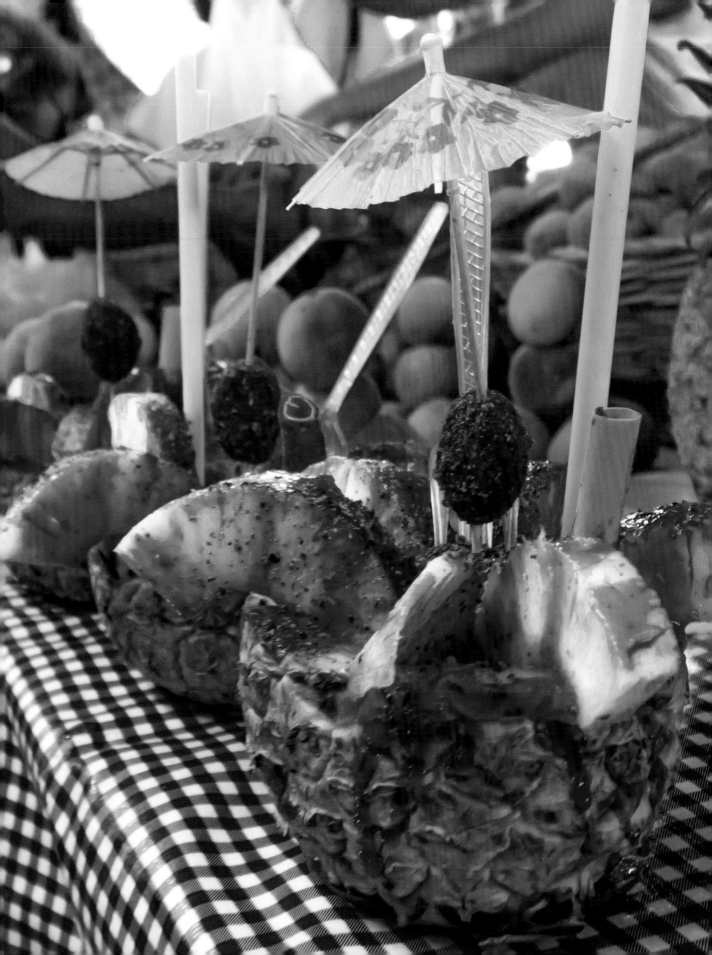

Bebidas
Drinks

Agua de Jamaica
Hibiscus Water
Reduction

SERVES 12

Jamaica is one of the most ubiquitous beverages in Mexico. These hibiscus flowers are a different variety compared to that most commonly known in the United States, but they can easily be obtained at most Mexican food stores or online. They contain antioxidants and are purported to have various health benefits, including reducing blood sugar and lowering cholesterol. The jamaica reduction can be made in advance and kept in the fridge for up to 2 months for use in cocktails, or mixed with water as a refreshing nonalcoholic beverage.

6 cups water
1½ cups dried jamaica flowers
1 cup brown or unrefined sugar
Ice and lime wedges to serve

Bring 6 cups of water to a boil. Add jamaica flowers and sugar and lower heat to a simmer. Stir well. Allow to simmer until volume has reduced by half. Allow to cool and strain off liquid.

To serve as an agua fresca, add 2 ounces of the syrup to 6 to 8 ounces of still or mineral water. Serve over ice with a lime wedge.

Jugo Verde
Green Juice

Recipe by La Esquina Café

SERVES I

One (or many) of the great things about Mexico are the juices. Not only are they in abundance, but they are always served freshly prepared. In every town and city, you'll find street and market stands selling one-liter cups (for prices you won't believe) of freshly cut fruit and juices prepared in any combo request. The *jugo verde* is perhaps the most ubiquitous of juices. It's prepared in any number of ways (try adding ginger, apple, or jalapeños!). The recipe below is a straightforward one we really like, brought to you by La Esquina Café in our town, Todos Santos.

½ nopal (cactus paddle)
1 large handful fresh spinach leaves
1 small handful fresh parsley, without stems
1 large celery stalk
3 cubes fresh pineapple (approx. 2 inches)
¾ cup freshly squeezed orange juice

Clean any spines from the nopal. Wash the spinach, parsley, and celery. Place all the ingredients in a blender with the pineapple and orange juice and blend smooth. Serve chilled or at room temperature, as you prefer.

Chilate Chocolate-Cinnamon-Rice Drink

SERVES 12

Chilate has its origins in the Costa Chica of Guerrero, where the blending of African and indigenous customs resulted in the birth of this refreshing, deeply satisfying chocolate-rice drink. Chilate is commonly found in the coastal and central regions of Guerrero. The mix will last 3 to 5 days in the refrigerator.

1 cup white rice
14¼ cups water, divided
¼ pound whole cacao
4 inches cinnamon stick
¾ cup brown sugar
Ice to serve

Soak the rice in 2 cups of water for six hours, then strain.

Toast the cacao on medium for 5 minutes, stirring regularly. Once cool, remove the skins.

Blend the toasted cacao with ¼ cup of water. Add in the rice, cinnamon, and sugar, and blend thoroughly for about 10 minutes.

Strain the mixture through a cheesecloth. Add the remaining 12 cups of water and place in the fridge for 2 hours.

When you're ready to serve, you'll need to aerate the chilate: place it in a wide-mouthed pot. Fill a cup with the chilate and pour it back into the pot from above head height. Repeat several times before serving.

Serve over ice and enjoy!

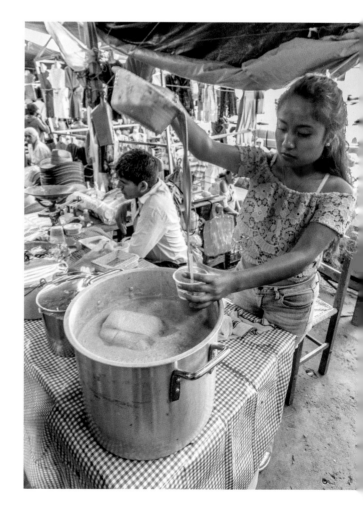

Atole de Piña
Pineapple Atole

This is an ancient drink made from corn. It is flavored many different ways, but pineapple is one of the most common. Traditionally, one drinks atole with tamales.

5 cups water at room temperature, divided
1½ pieces piloncillo or 1½ cups brown sugar
2 inches cinnamon stick
2 pounds fresh pineapple
1¼ cups corn flour
1 cup condensed milk (optional)
1 pinch salt
½ cup baking soda

Place 4 cups of water, the piloncillo (or sugar), and the cinnamon in a pot on medium and leave to heat for 10 minutes or until the sugar melts.

Clean and cut the pineapple into 2-inch cubes. Put the pineapple and 1 cup of the cinnamon-sugar water into a blender and blend well. Strain through a metal strainer to remove any large pieces and add the rest of the cinnamon-sugar water. Heat and stir regularly for 8 to 10 minutes or until it boils.

Place the corn flour and the remaining 1 cup of water into the blender and blend well. Strain and add to the pot with the pineapple, sugar, and cinnamon. Heat and stir constantly for 10 minutes.

If you'd like to add the condensed milk, do so now. Heat and stir another 3 minutes. Add the salt and baking soda, and heat for 2 more minutes.

Check the taste and add more sugar if necessary. Serve hot or cold.

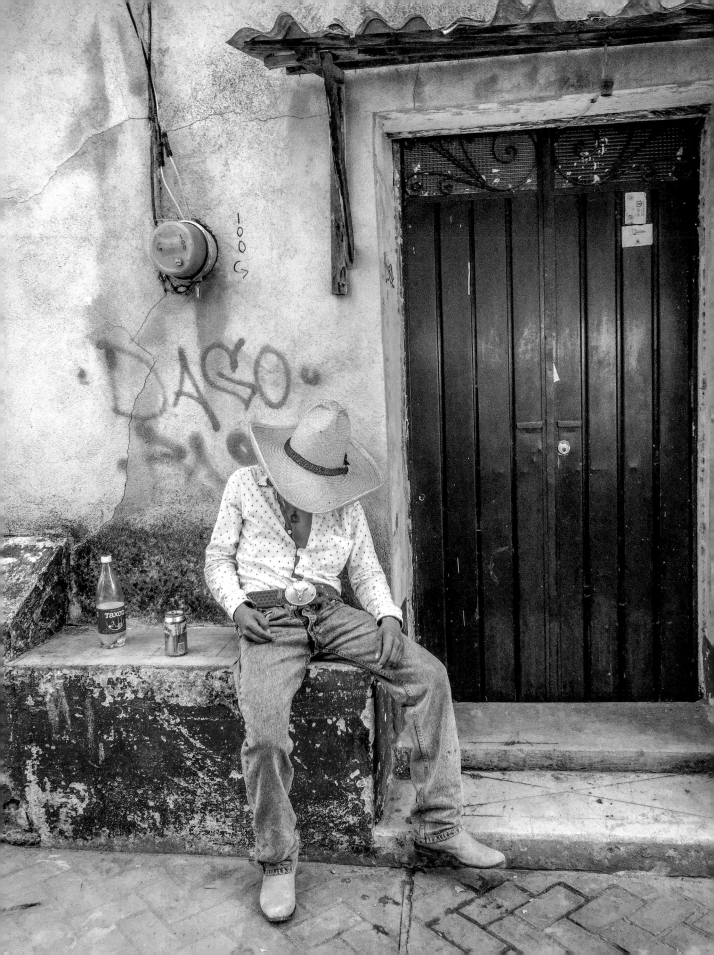

Cócteles
Cocktails

We tend to drink our mezcal straight at El Refugio, but we can't deny that it does make some pretty killer cocktails. We have something for entry level to advanced mixologists. The most popular at our place are the margaritas and gitanas, but our friend Jorge at nearby Jardín Alquimia is the real cocktail master. So get yourself a decent bottle of artisanal mezal and start mixing it up!

La Gitana
The Gypsy

MAKES 1 COCKTAIL

This is one of our most popular cocktails at El Refugio. It's light, thirst-quenching, and easy to drink.

2 medium and 1 small basil leaves
1½ ounces espadín mezcal
½ ounce lime juice
3 ounces jamaica reduction (page 250)
Ice to serve
Splash of soda water

Muddle 2 medium basil leaves with mezcal and lime. Add jamaica reduction. Shake with ice and serve with the ice in an 8-ounce glass. Top off with soda water and garnish with a small basil leaf.

Mezcalita
Mezcal Margarita

MAKES I COCKTAIL

Will any cocktail ever knock the margarita from its throne as the king of Mexican cocktails? Probably not. But we think that once you have it with mezcal, you'll never go back to the mainstream margarita. And once you know it with fresh lime juice (not margarita mixers, *please*!), you'll see that the extra, tiny step of squeezing a lime is worth it a thousand times over.

1½ ounces espadín mezcal
1 ounce Cointreau
¾ ounce fresh lime juice
¾ ounce simple syrup or agave nectar
Ice to serve
Salt for the rim of glass (optional)
1 splash mineral water
Lime wedge for garnish

Place the mezcal, Cointreau, lime juice, and syrup in a shaker with ice. Salt the rim of the glass if desired. Shake well and pour in an 8-ounce glass. Add a splash of mineral water and top off with more ice as needed. Garnish with a lime and serve.

Tecuin

Recipe by Jorge Ochoa Acuña

MAKES 1 COCKTAIL

In some Mexican ethnic groups, *tejuino* (a beverage of fermented corn) is seen as an almost sacred elixir, present in social, religious and even sport festivities of the community. It is used as a vehicle for the intake of medicinal plants and is a nutritious supplement in their daily diet. Thus, this cocktail is not just for recreational purposes; it is also meant to rejuvenate the body and soul.

FOR THE TEJUINO (MAKES 3 LITERS)

12 cups water
1 pound cornmeal
6 inches cinnamon sticks
3 pieces cloves
10 grams salt
1 pound of sugar

FOR THE COCKTAIL

2 ounces espadín mezcal
2 ounces homemade tejuino
½ Reyes Ancho liquor
½ ounce fresh lime juice
½ ounce simple syrup
1 pinch sea salt
Crushed ice to serve
1 dried lime wheel
1 dried corn husk

FOR THE TEJUINO

Boil 12 cups of water and incorporate the cornmeal slowly until a uniform mixture is made. Then, add the cinnamon, cloves, salt, and sugar and stir until everything is integrated into the mixture. Let cool, and store in refrigeration. If left outside the fridge, the *tejuino* will begin to ferment.

FOR THE COCKTAIL

Put all the ingredients except the lime and corn leaf in a shaker, and shake well for 15 seconds. Strain into a tall glass filled with crushed ice. Garnish with the dried lime and dried corn husk.

Mezcalpache

Recipe by Jorge Ochoa Acuña
MAKES 1 COCKTAIL

Tepache is one of the oldest and most traditional Mexican beverages that is still enjoyed today. Because of its low alcohol content, it is the favorite drink of children and adults, especially on hot days. We enhance this fermented beauty of the gods by adding a little mezcal magic, giving life to this tropical master piece. (And rendering it unsuitable for kids, of course.)

FOR THE TEPACHE (MAKES 2 LITERS)

1 whole ripe pineapple
1 cup sugarcane
2 inches cinnamon stick
3 pieces cloves
8 cups water

FOR THE CINNAMON SIMPLE SYRUP (MAKES 2 CUPS)

2 cups water
3½ ounces cinnamon sticks
¼ pound sugar

FOR THE COCKTAIL

2 ounces *cupreata* mezcal
2 ounces tepache
½ ounce fresh lime juice
½ ounce cinnamon syrup
3 drops Angostura bitters
3 drops Peychaud's bitters
Ice to serve
2 pieces pineapple leaves
1 piece dried lime wheel

FOR THE TEPACHE

Wash the pineapple very well, and then cut into small pieces. Place the pineapple, sugarcane, cinnamon stick, and cloves in a large mason jar (or similar), and fill it with 8 cups of water. Cover the mix with plastic wrap slightly, allowing it to breathe. After 24 hours, remove the white foam that forms on top. Cover the plastic again and let rest again for 24 more hours. Remove the white foam again. Strain and refrigerate.

FOR THE CINNAMON SIMPLE SYRUP

Heat 2 cups of water until it boils and add the cinnamon sticks. Let it infuse until the water is a little warmer than room temperature and strain to remove the cinnamon sticks. Right after, add the sugar and stir until completely mixed.

FOR THE COCKTAIL

Put all the ingredients except the pineapple leaves and lime in a shaker and shake well for 10 seconds. Serve in your favorite tiki glass with ice and garnish with 2 pineapple leaves and 1 dried lime.

Molli

Recipe by Jorge Ochoa Acuña

MAKES 1 COCKTAIL

For this cocktail, award-winning mixologist Jorge Ochoa uses a Pechuga mezcal infused with chiles and spices, sesame oil, fresh lemon, simple syrup, and Angostura bitters. Mole, which is a sauce or mixture of ingredients, comes from the Nahuatl word *molli*. Our cocktail is inspired by that ancestral sauce and is made in the same manner as a traditional old-fashioned.

FOR THE MOLE-INFUSED MEZCAL (MAKES 750 ML)

4 grams guajillo chiles without seeds
4 ounces ancho chiles without seeds
4 grams pasilla chiles without seeds
⅓ cup whole cacao seeds
2½ teaspoons sesame seeds
1 bottle pechuga mezcal (750ml)
4 inches cinnamon stick
1 piece star anise
1 small piece (1-inch) rosemary
8 grams tamarind

FOR THE COCKTAIL

1 slice fresh lemon
3 drops Angostura bitters
1 splash sesame oil
½ ounce simple syrup
2 ounces mole-infused mezcal
1 pinch salt
1 dried orange wheel

FOR THE MOLE-INFUSED MEZCAL

Cut the chiles in small pieces. Toast the chiles, cacao seeds, and sesame seeds in a dry pan for 5 minutes on medium. Next, crush them lightly in a molcajete or with a mortar and pestle, and mix with the mezcal. Add the rest of the ingredients and let the mix steep for 7 days. Shake the mix at least once a day. After 7 days, strain with a cheesecloth.

FOR THE COCKTAIL

Muddle the lemon wedge along with the Angostura, sesame oil, and simple syrup for about 10 seconds. Add the mezcal and pinch of salt and stir for 15 seconds. Strain into an old-fashioned glass with a big ice cube. Garnish with a dried orange wheel.

El Chanequito
The Little Chaneque

MAKES 1 COCKTAIL

Chaneques are mischievous creatures of Mexican folklore. They're typically described as a childlike being with a very large penis, often found near the water. This is a fairly boozy cocktail we adapted from the magazine *Saveur*'s "Little Devil," with a kick of spice from the Ancho Reyes and a hint of smoke from the mezcal to balance out the sweetness of the Luxardo cherry liquor.

3 orange slices, divided
1 ounce espadín mezcal
1½ ounces Ancho Reyes
¾ ounce Luxardo
¾ ounce fresh lime juice
½ ounce simple syrup or agave nectar
½ cup ice
1 cherry for garnish

Muddle 2 orange slices with the mezcal in a shaker. Add in the Ancho Reyes, Luxardo, lime juice, simple syrup, and ice. Shake well and serve in a rocks glass. Garnish with the remaining 1 orange slice and cherry.

Tepoztlán, Morelos: The Future Is in Our Past

Scattered throughout the country of Mexico are men and women who know the value of their patrimony, and who work day in and day out to keep that knowledge alive for future generations with nothing less than a heart full of joy. It was our great fortune to come to know two such people in the months we spent in Tepoztlán.

We first arrive in the pueblo magico in October of 2016 in search of a traditional midwife who could help me to conceive. Tepoztlán is a weekend destination for Mexico City residents, sitting only one hour away from the thronging capital. It's known for being the birthplace of Quetzalcoatl, for its incredible biweekly market, for a seemingly endless line of michelada vendors lining the road to its famed pyramid. It's also a hot spot for healers. "Lift up a rock in Tepoztlán and out jumps a shaman," jokes Noel. But despite the abundance of pseudo-shamans and *chilango* drunkards, there is a lot of magic to be found in this little town.

We ask a friend who lives locally if she knows of a good midwife and are referred to one Angelina Martinez. Angelina, we're to discover, is notoriously difficult to pin down. By some miracle we manage to get an appointment with her in the three days we're planning to be in Tepoztlán.

We pass our time until the appointment wandering the cobblestone streets and eating everything we can in the market. As Noel dives into the piles of cecina and chorizo, I am elated to discover a vendor of delectable vegan cakes. I return daily to get my vegetal fix topped with one of three different moles, and served with a half-liter clay cup of his freshly made, entirely natural, sugarless agua fresca. Hansel, the owner of the food stand El Cuatecomate, is not the only producer of *tlaltequeadas* in the market, but he is surely the most passionate and knowledgeable. He speaks to me at length about the indigenous ingredients that go into his tlaltequeadas, their

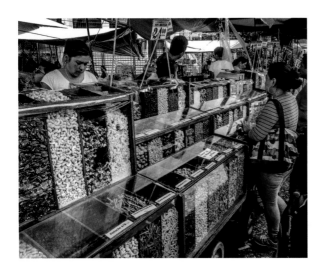

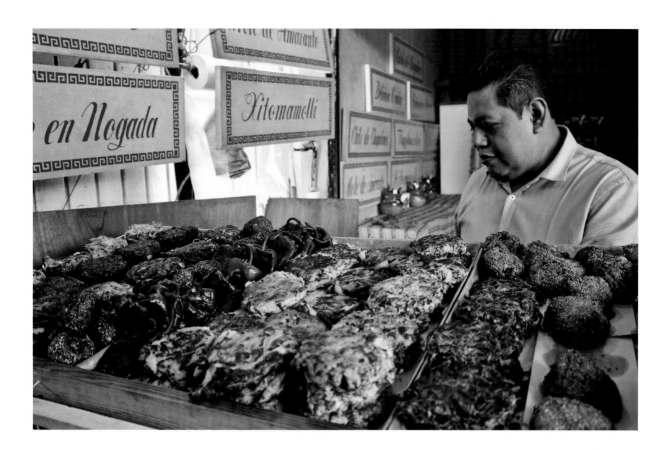

nutritional value, and the ousting they experienced at the hand of Spanish-imported meats and, in particular, US processed foods.

Hansel has about nine different types of tlaltequeadas available. All are vegan except one, which contains chapulines. All feature herbs, seeds, or vegetables endemic to Mexico, such as *quelites* (a general term for wild-foraged, leafy herbs), chia, or amaranth. Hansel studied as a biochemist before opening his market stand, which gives him a solid background in the nutritional benefits of these superfoods.

Unfortunately, with the takeover of the Spanish grew the belief that native foods were inferior to those of the wealthy, European class. Even so, indigenous Mexicans by and large continued to eat the way they always had—up until the influx of US foods. Within two generations, the urban diet

had been replaced by processed corn flour, white breads, processed meats and cheeses, and mountains of sugar. In many small towns, the indigenous diet continued as normal, with the exception of the rapid integration of that ubiquitous beverage:the world-dominating, glucose-spiking champion of diabetes, Coca-Cola. These days, as more and more towns get access to refrigeration, indigenous communities begin to incorporate more of these processed foods into their diets.

Hansel's hope is to recover the diverse gastronomy of indigenous Mexico and eradicate illness by creating "conscious food." He views every aspect of his business as integral to creating the change he hopes to see in his country.

We sit outside Angelina's home waiting for her to arrive for our appointment. At last she does. And then we sit inside her house for another hour. I begin to get restless.

"*Relajate*," Noel says. "It's normal to have to wait a long time for a real curandero."

All my frustration melts away once I'm in her care. Angelina is one of those rare humans that makes you feel like you are the center of the universe when you're in her presence. This and her fifty-plus years of experience are what makes her the most sought-after midwife in the country. (And beyond—she has taught midwifery at numerous European universities.) She massages me from the waist down while her assistant circles thick cigars stuffed with medicinal herbs centimeters above

my ovaries. She then cuts a few herbs from the vines growing on the street and instructs Noel to put them in a bottle of mezcal and honey for five days, after which I am to take one shot every morning until the tincture runs out.

I hadn't pinned my hopes on Angelina's massage and herbal remedies, but I figure one month of drinking medicinal mezcal every morning isn't the worst option. And it's certainly worth a try before diving into the long, expensive route of fertility treatments.

The result? Six weeks after starting her treatment I become pregnant with our daughter, Lila.

Angelina began attending births with her grandmother when she was only nine years old. She applies the knowledge of her ancestors—the use of herbs, massage, and rebosas—along with a few more modern pieces of equipment, such as urine test strips and a blood pressure gauge, to monitor the hundreds of pregnant women she attends to in a year. She has traditional cures for most of the ailments associated with pregnancy: corn silks for swelling, *muitle* for anemia and high blood pressure, *iztafiate* for hormone regulation. Conditions that often lead doctors to recommend cesareans (small pelvis, breech baby, twins, high blood pressure) are not a deterrent for Angelina. Of the thousands of home births she has attended, very few of them have resulted in a trip to the hospital. (In fact, Angelina even delivered the last of her five children by herself when she suddenly went into labor while home alone.) That said, she *always* advises mothers intending a homebirth to have a plan B.

Although she has more than enough work attending expectant mothers, Angelina also trains young women to become doulas and midwives. She is always accompanied by one or two

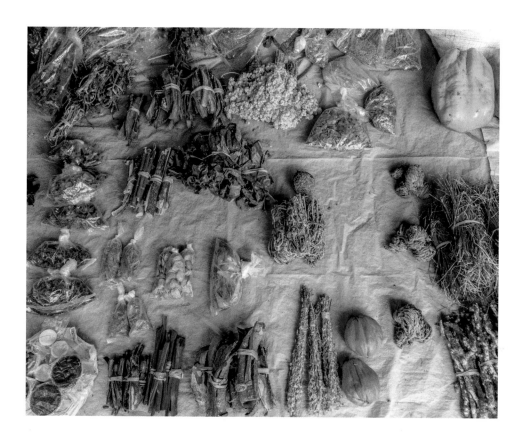

of these women in training and regularly recommends those with more experience to take her place when she cannot attend a birth. This army of midwives take on a growing importance in a country with one of the highest C-section rates in the world (49 percent)—more than three times the rate recommended by the World Health Organization.

What Angelina and Hansel give they give in joy. Hansel could, no doubt, lower his costs and increase his profits by mixing cheaper, industrialized products into his tlaltequeadas, but that would take the integrity out of what he does. Angelina does not advertise her services—she has no website, no business card with the title "Curandera," no social media account (#bruja) for her practice. She does not hold shamanic fire ceremonies or dress in special outfits; she doesn't evangelize her work or seek fame for it. She

certainly could. She could just as easily charge far more than she does while working half the number of hours (she often asks for only a donation, particularly from women with few resources). But her love for these mothers and their children is what keeps her tirelessly committed to sharing her experience and knowledge as widely as possible.

Angelina and Hansel are vivid examples of the spirit of many Mexicans today: taking less for themselves so that they can give more to those around them. Without these men and women carrying forward their native knowledge, the future of our children will be entirely in the hands of a patriarchy who view birth as a surgical process rather than a sacred act, and nutrition as a business opportunity rather than a human right. Their generosity is not simply one of time and money, but a generosity of spirit.

Medicinales
Medicinals

The plant kingdom has been humankind's main source of medicine for thousands of years. Today, herbal remedies are often dismissed as ineffective or even dangerous. Part of this is due to a lot of misinformation or incomplete information, inexperience, and/or use of less potent herbs. (Keep in mind that pharmaceutical companies stand to lose a lot of money when people begin to grow and use their own medicine, so it's no surprise that big money and big lobbyists disseminate the idea that natural medicines are useless or risky.) It is also certainly due in part to the fact that not all bodies are the same—what works for many is not going to work for everybody, just as a pharmaceutical drug will work for some, but not for others; what is harmless to most can create negative side effects in others.

Most of the following recipes have been given to us by women who have been taught by their mothers and grandmothers, who carry forward generations of traditional knowledge, and who make use of medicinal herbs regularly. Others, such as the cough suppressant and edema remedy, are commonly known in Mexico. If at all possible, see a curandera[10] about your particular condition. These are only the smallest sample of traditional remedies—there are often several different treatments for the same illness, and an *experienced* curandera will know which is best for you.

DISCLAIMER: Take these remedies at your own risk. It is important that you check with your regular doctor before using the recipes below. We cannot promise effectiveness, nor can we guarantee there will be no side effects from these treatments. We also recommend starting with a lower dose to see how your body reacts.

10 There are curanderos throughout the world (more often called *shamans* in English); however, to find one who has real knowledge and decades of experience takes a lot of deep searching. Shamanism is such a hot trend now that many people tout themselves as such after a mere few months of study (making shamanism/brujeria yet another case of cultural appropriation). An experienced curandero is someone who is born with the gift and who also has decades of firsthand experience. The *mero mero* curandero will not promote him or herself as such. That said, there are many who are studying medicinal herbs who can still be helpful in pointing you in the right direction.

Cough Suppressant

MAKES 6 CUPS

This simple tea works surprisingly well for a stubborn cough. Best of all, the ingredients are easy to come by.

1-inch slice onion
6 cups water
1 handful bougainvillea flowers
6 tablespoons local honey
6 limes
12 ounces mezcal (optional)

Chop the onion slice into large pieces. Boil 6 cups of water with the flowers and onion for 5 minutes. Strain and serve in a cup with 1 tablespoon of honey, juice of 1 lime, and 2 ounces of mezcal (optional). Any remaining tea can be kept in the fridge for up to 3 days.

For Stomach Pain, Menstrual Cramps, and Hernias

Recipe offered by Vicky Hernandez

MAKES 1 DOSE

Vicky first encountered this recipe after being told by doctors that she'd need an expensive surgery to remove a hernia. A curandera gave her this instead, which removed the pain and reduced the hernia to the extent that she no longer needed surgery. She also uses it for herself and her students for a variety of stomach issues: nausea, bloating, constipation, diarrhea, and general pains.

3-inch sprig salvia de castilla (sage or *Salvia officinalis)*
3-inch sprig hierba de araña (*Heliotropium angiospermum*)
2 cups water

Boil the herbs in 2 cups of water for 5 minutes to make a tea. Drink. You'll notice your tongue will go numb, but this passes quickly.

For Cuts and Wounds

Recipe offered by Vicky Hernandez

MAKES 1 DOSE

Vicky used this recipe on a Canadian friend with a wound in her forearm. The infection had grown to her elbow and she was at risk for having to have her forearm amputated. Vicky helped her to apply this powder until it healed, saving her friend's arm.

2 hoja santa leaves
2 cups water
3–6 leaves of hierba de araña (*Heliotropium angiospermum*)

First, boil the hoja santa leaves in 2 cups of water for 5 minutes. Set aside and allow to cool until warm.

Next, toast 4 of the leaves of the hierba de araña in a dry pan. Toast them thoroughly until they turn a coffee color. Then, crush the toasted leaves in a molcajete or with a mortar and pestle to make a fine powder. Set aside.

Wash the wound with the warm hoja santa tea to clean it well. The scab from the wound might come off easily, in which case try to remove it. Once thoroughly cleaned, gently squeeze any excess moisture from the wound area. For example, if you had a wound on your forearm, run your hand slowly and with a bit of pressure along the length of your arm to remove excess moisture as best you can.

Finally, carefully sprinkle the powder over the wound to cover it completely. Cover the wound with the remaining leaf of the hierba de araña if possible, or use medical bandaging. Be sure to wrap loosely so there's no constriction of blood flow. The bandaging is merely to protect the wound from bumps and to keep the powder in place.

Repeat once per day for 3 days or more. The wound should begin to shrink. If not, you can apply 2 to 3 times per day as needed.

For Diabetes

Recipe by Vicky Hernandez

MAKES 1 DOSE

This is Vicky's preferred recipe for lowering blood sugar. Remember that everyone's body is different, so you might want to start with half the quantity and see how you do. Cinnamon tea made with cinnamon sticks is also commonly used to lower blood sugar. Noel has personally had the best luck with a simple tea made from mango leaves.

2 Chaya leaves
2 lime leaves
2 cups water
1 cup ice (optional)

Blend the Chaya and lime leaves in a blender with 2 cups of water to make an agua fresca. Pour over ice if desired and serve.

For Fertility

Recipe by Angelina Martinez

MAKES 20–30 DOSES

This is the recipe given to me by Angelina to help me conceive. I took it every morning for about one month, until I'd finished it. Two weeks later, I was pregnant with Lila. Angelina encouraged both Noel and I to take this every morning (he did on occasion), though at a minimum, the mother-to-be should take it.

1 bunch iztafiate (*Artemisia ludoviciana*)
1 bunch capitaneja with roots (*Verbesina crocata*)
1 bunch epazote with roots
½ liter artisanal mezcal
½ liter local honey

Place the herbs in a large glass container with the mezcal and honey. Shake well to mix and leave to sit for 7 to 10 days. Take 1 shot each morning until you've finished the elixir. (And don't forget to have lots of sex).

Muscle Relaxer and Sleep Inducer

Recipe offered by Vicky Hernandez

MAKES 1 DOSE

This herbal bath is said to help you relax and sleep well. Using it as a bath is similar to going for a *temazcal* (a prehispanic sweat lodge) where the heat from the steam opens your pores so that you absorb the herbs. It's ideally used in a closed (versus open or airy) bathroom. Be sure to wrap up well afterward to stay warm. For best results, repeat the recipe each day for 3 days in a row.

4 sprigs rosemary
4 sprigs basil
4 hoja santa leaves
4 sprigs piru (peppertree or *Schinus molle*)
3–4 gallons water

For Edema

MAKES 4 CUPS

Corn silks are used for a great many ailments in Asia as well as North America. This recipe was prescribed to me by my midwife in the late stages of pregnancy when my feet swelled up beyond recognition. (If you have edema during pregnancy, please check with your doctor as it is sometimes a sign of preeclampsia, as it was in my case.)

Silk from 4 ears of corn
4 cups water

Boil the silks in water for 5 minutes. Strain and serve.

Wash the herbs of any debris. Boil in 3 to 4 gallons of water for 20 to 30 minutes. Remove from heat and leave to cool on the counter. Do not cool by pouring back and forth; this will decrease the effectiveness of the herbs.

Once the tea has reached a temperature comfortable for you to bathe in (hot is good, but be sure you won't burn yourself), prepare for a shower. After you've finished showering, pour the tea over your body using a large cup or container. Pour cup by cup until you've used the entire batch of tea. Do not rinse the tea off, and do not towel dry yourself. Wrap yourself in a towel, blanket, or pajamas, and sleep as so.

Conversion Charts

METRIC AND IMPERIAL CONVERSIONS
(These conversions are rounded for convenience)

Ingredient	Cups/Tablespoons/Teaspoons	Ounces	Grams/Milliliters
Butter	1 cup/ 16 tablespoons/ 2 sticks	8 ounces	230 grams
Cheese, shredded	1 cup	4 ounces	110 grams
Cream cheese	1 tablespoon	0.5 ounce	14.5 grams
Cornstarch	1 tablespoon	0.3 ounce	8 grams
Flour, all-purpose	1 cup/1 tablespoon	4.5 ounces/0.3 ounce	125 grams/8 grams
Flour, whole wheat	1 cup	4 ounces	120 grams
Fruit, dried	1 cup	4 ounces	120 grams
Fruits or veggies, chopped	1 cup	5 to 7 ounces	145 to 200 grams
Fruits or veggies, pureed	1 cup	8.5 ounces	245 grams
Honey, maple syrup, or corn syrup	1 tablespoon	0.75 ounce	20 grams
Liquids: cream, milk, water, or juice	1 cup	8 fluid ounces	240 milliliters
Oats	1 cup	5.5 ounces	150 grams
Salt	1 teaspoon	0.2 ounce	6 grams
Spices: cinnamon, cloves, ginger, or nutmeg (ground)	1 teaspoon	0.2 ounce	5 milliliters
Sugar, brown, firmly packed	1 cup	7 ounces	200 grams
Sugar, white	1 cup/1 tablespoon	7 ounces/0.5 ounce	200 grams/12.5 grams
Vanilla extract	1 teaspoon	0.2 ounce	4 grams

OVEN TEMPERATURES

Fahrenheit	Celsius	Gas Mark
225°	110°	¼
250°	120°	½
275°	140°	1
300°	150°	2
325°	160°	3
350°	180°	4
375°	190°	5
400°	200°	6
425°	220°	7
450°	230°	8

Recipe Index

Index